WHY THE HINDENBURG HAD A SMOKING LOUNGE

WHY THE HINDENBURG HAD A SMOKING LOUNGE

Essays in Unintended Consequences

EDWARD TENNER

APS Press
The American Philosophical Society Press

Copyright © 2024 The American Philosophical Society Press

All rights reserved. Except for brief quotations used for purposes of review or scholarly citation, none of this book may be reproduced in any form by any means without written permission from the publisher.

Published by
The American Philosophical Society Press
Philadelphia, Pennsylvania 19106-3387

www.amphilsoc.org

Printed in the United States of America on acid-free paper
10 9 8 7 6 5 4 3 2 1

Library of Congress Cataloging-in-Publication Data
Hardcover ISBN: 978-16061-8027-3

ALSO BY EDWARD TENNER

Tech Speak

Why Things Bite Back

Our Own Devices

The Efficiency Paradox

In Loving Memory
DAVID S. TENNER
1951–2023

CONTENTS

Preface . i
A Note on Themes . xi

RISK

Why the Hindenburg Had a Smoking Lounge 3
A Model Disaster . 9
The Wreck After the Titanic . 15
Heroic Capitalism . 19
Chronologically Incorrect . 25
The Dark Sideof Tinkering . 41
When Systems Fracture . 47
If Technology's Beyond Us, We Can Pretend It's Not There . . 53
The Shock of the Old . 59
The Virus and the Volcano… and Don't Forget the Fugu 65
In Conversation with… Edward Tenner, PhD 79
COVID-19 and the Swiss Cheese Effect 89

TECHNOLOGY: LEAVING IT AND LOVING IT

The Meaning of Quality . 97
Digital Dandies . 109
There's the Rub . 113

Plain Technology . 117
Technophilia's Big Tent . 121
Confessions of a Technophile. 127

ORGANIZATIONS, POLITICS, AND TECHNOLOGY

The 737 MAX and the Perils of the Flexible Corporation . . 149
Digging Across Panama . 163
Steel into Gold. 171
Lasting Impressions . 175
Mother of Invention. 185
The French Connections. 193
The Importance of Being Unimportant. 197
The Trouble with the Meter . 209
Engineers and Political Power . 213
When Big Data Bites Back . 217

DESIGN

How the Chair Conquered the World 225
The Life of Chairs . 239
Talking Through Our Hats . 253
Suiting Ourselves . 267
Body Smarts. 273
Adam Smith and the Roomba®. 281
Pantheons of Nuts & Bolts. 289
Oppenheimer and the Technological Sublime. 303
The Icon of Icons . 311

INFORMATION

From Slip to Chip: . 319
Keeping Tabs . 333
The Mother of All Invention . 337
"Information Age" at the National Museum 341
 of American History
Paradoxical Proliferation of Paper 351
The Perpetual Passion for Paper. 363
The Prestigious Inconvenience of Print. 369
The Impending Information Implosion. 377
The Rise of the Plagiosphere . 389
Writers, Technology, and the Future 393
Journalism in the Age of Page Views 403
Edward Tenner: Philosopher of Everyday Things, 409
 Interview with Steven Heller

ARTIFICIAL INTELLIGENCE

Rook Dreams: . 419
Checkmate: Can Artificial Intelligence Win the Long Game? 423

ANIMALS

What Wall Street Can Learn from the Dung Beetle. 437
Constructing the German Shepherd Dog 445
Citizen Canine . 473
Why Dogs Bite Back. 489

INNOVATION AND THE FUTURE

World's Greatest Futurist . 501
We the Innovators . 511
Future and Assumptions. 521
The Future is a Foreign Country . 537
A Place for Hype . 549
Tomorrow's Technological Breakthroughs: 561
 Hiding in Plain Sight
The Shadow: Pathfinder of Human Understanding 567

Sources. 577
Index . 581

PREFACE

Why the Hindenburg Had a Smoking Lounge began nearly 40 years ago. I had arrived at Princeton University Press as its newly appointed science editor with a limited scientific education (my Ph.D. dissertation was on early nineteenth-century German social history) and equally limited experience in book acquisition (an ill-fated Bicentennial publishing venture led by a crusading former Harvard Rhodes Scholar a few years my senior). My true background was a research assistantship kindly arranged by one of my graduate teachers, the University of Chicago historian William H. McNeill, for navigating the French- and German-language medical history literature, supporting his future best-selling study of pandemics and history, *Plagues and Peoples* – an apprenticeship in authorship, though in my gratitude to have any employment at all in the brutal 1970s market, I did not yet see it that way.

The publicity department of the Press monitored publication of advertising by clipping issues of magazines and journals, and I was free to browse them before they were discarded. In the December 1974 issue an essay caught my eye, "The Nation States

of Trees," by the Ohio State biologist Paul Colinvaux, a frequent contributor on science topics. Colinvaux was not nearly as well-known as Lewis Thomas or Stephen Jay Gould, but he was a natural essayist in the British tradition (Jesus College, Cambridge): lucid, urbane, and literate, a unique voice. I soon found a series of other pieces he had written for the Review; he was a Duke Ph.D. but had done post-doctoral work at Yale. Encouraged by what I read, I wrote to him and discovered that he had indeed been thinking of collecting his essays as a book, to be called *The Real Ecology*. He was an environmental advocate like nearly all biologists, but he drew a firm line between science and political movements.

I was lucky. Colinvaux did not need a big advance or have (as I remember) a literary agent. My counterparts at Yale University Press apparently had not approached him. I understood that I need to act swiftly. ("But Ed, you like to compete," a less aggressive Princeton colleague once reproached me. I demurred: "I don't like to compete. I like to win.") We were soon talking about a contract. Fortunately, I had the enthusiastic support of the Press director, Herbert S. Bailey, Jr., and the editor-in-chief, R. Miriam Brokaw. But that was not enough. I needed the approval of a faculty editorial board famed for its conservatism – except when it was called on to review the publishing program, when it faulted the staff for undertaking few risky books. What it really wanted, I observed at one meeting, was *safe* risky books.

After receiving two favorable reports from scientists on *The Real Ecology*, I presented the book to the editorial board, precipitating a long discussion of the appropriateness of a popular book, even though Princeton had published several o them in the less rigorously academic board regime of the 1950s and 1960s. Several faculty members were uncomfortable, but not the scientists. The project was firmly approved, and the director and author signed the contract. Now we needed to work on the title. Laypeople who

thought of themselves as ecologists were a large part of our potential audience. We could hardly imply that their movement was unscientific.

When I met with the marketing department one essay title jumped out at us: *Why Big Fierce Animals Are Rare*. It's obvious that there must be far more apex predators than prey animals, but it takes sophisticated science to explain energy transfer in a food web. The essay is a perfect illustration of science as informed common sense. Likewise, the title essay of this book, inspired by Colinvaux, expresses the realities of marketing luxury transportation in the Great Depression to a sliver of the transportation market, up to half of which are confirmed smokers.

The success of *Why Big Fierce Animals Are Rare* led the Princeton marketing department to package the paperback edition as the first of a series called the Princeton Science Library, with over 75 titles in print as the present book was going to press. Meanwhile with Herb Bailey's encouragement I was beginning to write more and more on my own time – thanks in part to my newly acquired TRS-80 personal computer and daisy-wheel printer. My experience as an editor in turn helped inform my writing. From sponsorship of *Big Fierce Animals* and bird field guides I began to write on science. "What Wall Street Can Learn from the Dung Beetle," on animals as investors, published in the personal finance magazine Money, cited Paul Colinvaux. Encounters with engineering jargon led to a short satirical book, *Tech Speak* (1986), my first taste of real authorship and media interviews. One of the few hippies in my college graduating class, a Vietnam veteran and experimental musician, sent me a long, handwritten letter congratulating me on becoming "a small-time celebrity." One must start somewhere.

Meanwhile Princeton University Press was becoming a leader among university presses in working with digital manuscripts.

As science editor I was among the first to get the latest personal computers; I was corresponding with European scientists by email over the (still academic/military) internet in the late 1980s. And I was noticing the unexpected turns the new technology could take, for example the ever-growing mounds of paper in our recycling bins, contrary to predictions of the paperless office. (According to Statista.com, global consumption is projected to rise from 417 million tons in 2021 to 476 million tons in 2032.) This obvious trend was the basis of my essay, "The Paradoxical Proliferation of Paper" – itself reprinted several times, thus contributing to the phenomenon it analyzed.

In 1986 I realized one of my publishing dreams, sponsoring a book by Richard Feynman: *QED: The Strange Theory of Light and Matter*, which was soon added to the Princeton Science Library. After a little more than 10 years I had done what I set out to do in publishing. Meanwhile I had begun sponsoring books in the history of technology and had become friends with leading scholars in the field, at Princeton and elsewhere. This was the beginning of a new professional identity, one that presented me with a dilemma. Both publishing and writing were demanding. It was becoming more difficult to give each my best effort. The choice was resolved when I received a John Simon Guggenheim award and a visiting position at the Institute for Advanced Study at Princeton in 1991, leading to publication of *Why Things Bite Back* in 1996. With the grant and an advance from Alfred A. Knopf, I was able to become a full-time writer and speaker, which I have remained, publishing two further books with Knopf, *Our Own Devices* (2003) and *The Efficiency Paradox* (2018).

In the over two decades from *Bite Back* to *Paradox*, my perspective on unintended consequences of technology gradually changed, Initially I focused more on technologies themselves and the unexpected results of their adoption. Increasingly I realized

that economic sociology is as important as analysis of devices and systems. The title essay is a good case in point. What seems an absurd concept considering the 1937 tragedy in Lakehurst, New Jersey, makes perfect sense as a commercial reality. A smoking lounge reflected a form of sociability that was impossible to deny for even a few days. The technology of a negative-pressure room and other means was a response to demand, and there I have found no criticism of this arrangement before the crash. On the other hand, profit-and-loss alone do not explain the risks taken by Eastern Pennsylvania's anthracite entrepreneurs, in search of heroic standing in their communities – a situation that neither classical liberal nor Marxist economics can explain.

My writing has been almost entirely solo. Yet it has also been highly social. The essays in this book could never have been published without the judgment, encouragement, and friendship of outstanding magazine and newspaper editors. John T. Bethell, Jean Martin, and John Rosenberg worked with me at *Harvard Magazine*, helping me reach a dream audience. Landon Y. Jones and Caroline Donnelly were my editors at *Money* in the 1980s. (Lanny Jones also invited me to write an essay on quality, reprinted here, for a pilot issue of a proposed journal of the same name.) In the following decade I published frequently in the *Wilson Quarterly* – I was a fellow of its parent organization, the Woodrow Wilson International Center for Scholars, in 1995-96 – where I worked with Jay Tolson and Steven Lagerfeld. As a contributor to the *Chronicle of Higher Education* I worked with Ted Weidlein and Sarah Hardesty Bray, and at *U.S. News* with Tim Appenzeller. Fred Allen, with whom I served on the initial advisory board of the Smithsonian's Lemelson Center for the Study of Invention and Innovation, encouraged me to explore new topics in *American Heritage of Invention and Technology*. Near the start of the new millennium, Charles Cegielski of Britannica Yearbooks encour-

aged me to write about futurism both as a flawed but unavoidable form of speculation, and as a niche consulting profession. A few years after the new age began, Frances Stead Sellers of the *Washington Post* opinion pages invited my analysis of America's biggest power grid failure.

In 2005 the new editor of *Technology Review* recruited me as a columnist, and some of my monthly contributions are reprinted here. Kevin Finneran gave me another prestigious forum at the National Academy of Sciences magazine *Issues in Science and Technology*. Nick Schulz invited me to join the American Enterprise Institute *The American Magazine* – in the spirit of the classic years of *Fortune* – and Eleanor Bartow was my editor when the publication went online. I am especially grateful to the for the opportunity to publish the title essay of this book; its present title is my own. Trish Hagood brought me into the scintillating, eclectic circle of her unique yearbook *Oxymoron*.

More recently, James Gibney, who had edited some of my op-ed essays in *The New York Times*, invited me to be one of the Atlantic's first bloggers and, for a few issues, a columnist. Jackson Lears, Board of Governors Distinguished Professor of History at Rutgers University, invited me to join the editorial board of *Raritan Quarterly Review* and published some of my favorite essays there. Luke Mitchell helped me turn a Titanic centennial lecture into an investigation of the wreck of the Costa Concordia in *Popular Science* magazine. Paul Myerscough at the *London Review of Books* gave me a chance to reflect on the paradoxes of technophilia as explored by a formidably iconoclastic British historian of military technology. The design historian Steven Heller and the hospital safety advocate Robert Wachter M.D. honored me with interviews. After my brief appearance in a PBS documentary on the Panama Canal, Anna Gillis of *NEH Humanities Magazine* invited me to contribute an essay on the paradoxes of the project.

Many of my most recent essays have appeared in the Milken Institute Review, in print and online. I am especially grateful for the generous encouragement and deft editing of Peter Passell, who has made the Review one of the most stimulating general interest publications on economic life – and has given me the chance to explore its social, psychological, and historical aspects.

Having lost all the college and graduate school mentors who taught me so much, I am happy to acknowledge the brilliant peers from whom I have also learned. Shortly after we met in the Harvard Society of Fellows, the applied mathematician Joel Cohen responded to my question about his field: "I don't have a field. I study problems." (True to his word, he defined his own chair and has for many years been Abby Rockefeller Mauzé Professor of Populations at The Rockefeller University and Columbia University.) That declaration has inspired me ever since, and I proposed it as the motto of the Freshman Seminar I taught at Princeton in fall 2025, "Understanding Disasters." I am equally grateful to another Harvard colleague, Benjamin Friedman, William Joseph Maier Professor of Political Economy at Harvard, for his advice and support. Arthur Molella, now emeritus director of the Lemelson Center for the Study of Invention and Innovation at the Smithsonian's National Museum of American History helped me establish my current identity as a historian of technology. Gary Alan Fine, James E. Johnson Professor of Sociology at Northwestern University, and Mitchell Duneier, Professor of Sociology at Princeton, encouraged my engagement with their discipline. At the beginning of the Covid-19 pandemic, Professor Piet Hut, now emeritus director of the Program in Interdisciplinary Studies at the Institute for Advanced Study, arranged a visiting appointment that let me write some of the essays in this book.

Why the Hindenburg Had a Smoking Lounge would never have come together without the enthusiasm, friendship, and

forbearance of Peter Dougherty, director emeritus of Princeton University Press and editor-at-large at the American Philosophical Society Press. Amid daunting challenges of reviving a centuries-old imprint, he helped me overcome obstacles that would have exhausted the patience of most other publishers and gave the project the resources it needed. I share with Peter Dougherty the APS founder Benjamin Franklin's belief in the usefulness of all knowledge. I like to describe my work as applied humanities.

Special thanks are also due to Mary Rose MacLachlan for clearing of permissions in an often-bewildering media landscape, and to David Carpenter and Kevin Connor for their indispensable help in preparing the manuscript for publication. Dave Price, Kevin's colleague at Modern SBC, channeled the spirit and imagery of my essays in a masterpiece cover design and elegant text specifications.

My life as a writer would not have been possible without support of my family, my brothers Larry and David (to whose memory this book is dedicated), my sister-in-law Anne and nieces Elana and Miriam, my fellow writer and frequent editor Richard K. Rein, my academic friends Stanley N. Katz, and James and Kapka Katz, my architectural guru John Steigerwald, AIA, and the many friends among my Princeton classmates, celebrating our 60th Reunion in June 2025.

Edward Tenner
Plainsboro, NJ
May 17, 2024

x

A NOTE ON THEMES

Life is lived forward and understood backward, as Søren Kierkegaard memorably put it. I wrote each essay as an idea or an invitation came to me; in retrospect my writing on technology and culture can be organized not chronologically but thematically. The power of unintended consequences for good as well as for evil is what unites them.

Theme 1: Risk.

My first scholarly book, *Why Things Bite Back*, emerged from a file folder of clippings and photocopies begun in the 1980s, which I labeled as Pushing the Envelope. The phrase originated as test pilot jargon in the 1970s. Tom Wolfe popularized it in his best-seller on the space program, *The Right Stuff*, decades later. It originally referred to the enthusiasm of elite pilots for exceeding the official limits of aircraft safety to explore possible breakthroughs in performance. As Chuck Yeager, its leading exponent and the first person to fly at the supersonic speeds that were once considered fatal, explained, "[T]he real barrier wasn't in the sky but in our knowledge and experience of supersonic flight."

There seemed to be less many less exalted versions of pushing the envelope in everyday terrestrial life. Legislation and industry standards set many boundaries of safety, usually with a margin of error. For some people, "an abundance of caution" (to use a favorite phrase from the peak Covid-19 years) is an excess, and progress – or mere profit – demands exceeding the limits. In that sense nearly every motorist pushes the envelope regularly by driving a few miles above the posted speed limit.

Some risk analysts have suggested further that safety technologies such as seat belts and antilock brakes may be futile because they lead to riskier behavior that offsets the savings in injuries and deaths. As I examined such arguments in *Why Things Bite Back*, automotive safety statistics suggest that they are mistaken as general long-term rules, though they may apply when innovations are novelties. (I recall a colleague demonstrating antilock brakes to me on an icy back road.) On the other hand, football helmets may cushion shocks to the brain but are still unable to prevent chronic traumatic encephalopathy (CTE) from repeated blows.

My essays on risk since 1996 further explore how safety technologies can fail. In the case of the Hindenburg, lit smokes did not cause the fatal explosion of 1937, but my question was why both Zeppelin management and passengers were willing to ignore what posterity considers an unacceptable risk. I also explored how solutions could produce a false sense of security and even contribute to new disasters, as additional lifeboats destabilized an excursion ship in Chicago harbor, which capsized as it was being loaded, killing hundreds. (The Costa Concordia disaster also reminded passengers that when ships list, at least half of the "lifeboats for all" may be unavailable.) Risk taking could also be a social and cultural norm, as it was for some of the mine operators in the anthracite district of Eastern Pennsylvania in the early nineteenth century. The terrorist hijackings of September 11 demonstrated

how apparently innocent devices can be repurposed in fatal ways. In the early months of the Covid-19 pandemic the scientific sanitation protocols of cruise of cruise ships were upended because they had prepared for the wrong virus; meanwhile early in the pandemic adventure tourists were going out of their way to expose themselves to the thrills of risk. Covid-19 showed that while a new pandemic had been anticipated since the mid-1990s, the new virus and the nature of world trade and social media revealed issues and risks that were impossible to predict.

Theme 2. Technology: Leaving It and Loving It.

Not long after the September 11 attacks, the self-identified neo-luddite author Kirkpatrick Sale spoke to a small group at Princeton. We started to discuss neo-luddism and he assured me that I was not a neo-luddite despite the occasional inclusion of *Why Things Bite Back* in anti-technology reading lists. I am, however, closer to the tradition of technology criticism represented by thinkers like Lewis Mumford, Jacques Ellul, Neil Postman, and David Noble than I am to the cornucopianism of Nicholas Negroponte, Kevin Kelly, Ray Kurzweil, and other prophets. I believe technological progress is best served by the critical imagination, and that while unrealistic optimism may be necessary to overcome obstacles, only historically based skepticism can keep this spirit from destroying itself.

When I was invited to explore the idea of quality for the pilot issue of a planned Time-Life magazine – during the height of the 1980s boom and its anxiety about Japanese competition – I tried to show how complex the topic was, and how many positive as well as negative measures existed. As a *Technology Review* columnist, I wrote a series of essays on the paradoxes of technology and quality. The quest for high-tech style often conflicted with

performance, I suggested, citing ultra-thin wristwatches that sacrificed robustness and accuracy for minimalism. (Little did I suspect that the new age of smartphones would make the need for any kind of traditional watch moot.) In another piece I argued that innovations like wheeled luggage could undermine themselves by increasing total weight and overpacking. I also cited recent scholarship about the Amish to underscore that community's symbiosis with the surrounding society. Amish craftsmen, working with compressed air rather than electric motors, are valued by local industries, producing high-quality critical components as well as consumer furniture; Amish workmanship even has branding value.

In the National Academy of Sciences magazine *Issues in Science and Technology*, I reviewed Kevin Kelly's provocative book *What Technology Wants*. Kelly was one of the pioneers of internet culture as a founder of *Wired* magazine in the 1990s technology boom and his book offered a uniquely sophisticated overview of technology's evolution. But it also overlooked the sophistication of some earlier societies and occasionally appeared blind to values I supported, in places seeming to embrace the idea that people should conform to their inventions rather than vice versa.

Finally, *Raritan Quarterly Review* gave me a chance to review my personal experience of technology as a child and teenager in one of the great cities of an earlier industrial age. It had many downsides – notably air pollution and racial injustice, often together – but it also was a proudly industrial center in which an astounding number of often high-quality goods were manufactured in the decades before globalization. Sears Roebuck was still the Amazon of its time, and the giant R.R. Donnelly Lakeside Press pumped out millions mail-order catalogs, national magazines, and especially the city's still-mammoth tele-

phone books. That order will never return, and I would never wish it to, but I believe its positive side is still worth celebrating.

Theme 3. Organizations, Politics, and Technology.

This section begins with one of my later essays, on the two fatal flights of the new Boeing 737 MAX and the circumstances that led to them. It reflects my growing interest in the role of corporate organization in technological decisions, a dimension that was not so prominent in *Why Things Bite Back*. In it I introduced the concept of the deep organization, a form that has included not only industrial and financial corporations but universities, government organizations, and religious bodies with missions of planning for the long-term future.

In previous essays I had investigated some of these. The Panama Canal and John A. Roebling's Sons Company were two of the prime American examples from the early twentieth century. Much of the original equipment of the Canal is still functional under Panamanian jurisdiction, and Roebling cables have sustained the Golden Gate Bridge for almost 90 years. At a party for the hundredth anniversary of *Harvard Magazine*, an editor mentioned that he was planning a cover story on the footwear in one of the university museums, and I joked about writing a contribution on Harvard and the shoe industry. Looking further I discovered the close links between the university and the Microsoft of 1900, the United Shoe Machinery Corporation, target of long-running antitrust litigation but at its peak a world standard-setter.

In the twentieth century, AT&T and its research arm, Bell Laboratories, would be many people's prime example of a deep organization. In a review of Jon Gertler's excellent history, I identified the principles that made it such a powerful source of innovation – especially its unique position as a major defense contractor

as well as civilian utility. This status long deflected the kind of scrutiny that beset United Shoe Machinery, until its form of benevolent autocracy began to fall apart in the 1980s, leading to the parent company's breakup.

I explored other aspects of deep organizations, especially the underrated contributions of French science and technology to America, starting with the influence of the École Polytechnique on the foundation of the U.S. Military Academy at West Point. I looked at the most intriguing alternative to the deep organization, the niche monopoly, the small but indispensable part of big systems, a situation that economists had shown could allow impressive profit margins. (Thread was the most striking case. The father of Karl Marx's financial angel, Friedrich Engels, was a sewing thread producer, as were the families of the art historian Lord Kenneth Clark and the photographer Henri Cartier-Bresson.)

Finally, I have investigated paradoxes of technological change in other organizations. I pointed out, for example, that adopting "the metric system" implies not only converting weights and measures but adopting new standards like A4 paper sizes that are incompatible with ubiquitous existing hardware like filing cabinets. Likewise, the influence of Europe's elite engineering academies was limited by the desire of American corporations to train engineering graduates rather than deal with a profession on the model of lawyers and physicians. Hence fewer engineers rise to political importance in the U.S. than elsewhere. The section concludes with a problem common to business and political organizations: the perils of statistics and sampling.

Theme 4. Design.

Design was my first interest as a writer. At the age of 8 or 9, in the early 1950s, I wrote an elementary school paper deploring new

thin necktie styles and regretting the decline of the wide splashy prewar ties in my father's closet. As a grownup writer I have tried to give a holistic account of design that includes production methods, body techniques (in the phrase of the French anthropologist Marcel Mauss), and interfaces with other technology.

Chairs first intrigued me when I was studying world history and the interaction of Europeans and the great majority of the world's peoples with mat-level cultures. My graduate teacher William H. McNeill once noted how the handshake had spread from the ancient Mediterranean to societies around the world with conquest and the expansion of trade, so often sealed by handclasps. It struck me that chairs had spread in a similar way, at first as furniture in European diplomatic missions and commercial settlements, then in Western-style rooms of local elites, and ultimately as a replacement for traditional mat-level lifestyles. "How the Chair Conquered the World" led to my chapters on desk chairs and recliners in *Our Own Devices.*

In the West as elsewhere, as I suggested in "The Life of Chairs," seating had a double role: promoting comfort and health and expressing power. Early in my study of chairs I had lunch with Emilio Ambasz, an architect and designer whose Vertebra Chair pioneered the ergonomic category. Its hinged backrest invited healthful small shifts in position. Yet in the office furniture marketplace, the height of the backrest also expressed status. The headrest, Ambasz explained to me, was there as a nimbus for the executive; he personally used his secretarial model. Frank Lloyd Wright candidly rejected comfort for the aesthetic unity of his structures and their furnishings; one three-legged model became known as the suicide chair to employees attempting to cope with it.

McNeill's comment on handshakes also led me to investigate headgear. In Europe and North America until the seventeenth cen-

tury, elaborate codes dictated who could wear a hat in whose presence. "Bowing and scraping" was a courtier's carefully practiced ritual for fluid removal and replacement of a hat when walking through a corridor and encountering a superior. Early Quakers' refusal of "hat honor" seemed deeply subversive; Quakers popularized the handshake as an egalitarian alternative, which it has remained except during pandemics.

The conservatism of other customs is also striking. The construction of Western men's suits is a direct outgrowth of the techniques of medieval tailors of protective garments for wear under armor. Smart clothing and other high-technology wearables, like the ill-fated Google Glass, have consistently fallen short of predictions. Automated vacuum cleaners are fascinating to watch but do little to improve life satisfaction – illustrating a point made by Adam Smith in his *Theory of Moral Sentiments*, the book that made Smith's reputation and secured the aristocratic patronage that later enabled him to write The Wealth of Nations.

Technology museums are a design challenge of another kind. Traditional presentations focused on the objects as works of art as well as science; many curators now are more concerned with the social context of the objects. My essay on the subject prompted an indignant letter to the editor from a computer science professor mistakenly accusing me of partisanship toward the latter trend. (If anything, I prefer to see more objects.) My love for overengineered technology is reflected in a piece I wrote on 60mm IMAX film and other extreme analog technologies. Finally, recalling the graphics in my family's *World Book* encyclopedia as I was growing up, I considered the history of information design as promoted by the eccentric Viennese philosopher and economist Otto Neurath. Created to raise worker consciousness, his symbols are now most familiar as the signage of global capitalism.

Theme 5. Information.

My interest in the history of information was born when I was studying for the Ph.D. in German libraries and archives in 1968-69. At the University of Heidelberg where I was based, I discovered that the central library's card catalog was only 10 or 20 years old. Most of the earlier books were listed by author in elephant folios with a distinct cigar-box aroma, each page consisting of handwritten slips of paper held in niches by elastic bands with no subject or title cross-references. The primitive arrangement was a nuisance but also a blessing, forcing me to learn to use other bibliographic aids – and not to take cards for granted.

As I studied the history of card files, I realized that they were not just a convenience but the embodiment of a new mentality of storing and accessing information. The result was my essay "From Slips to Chips," in turn the basis of an undergraduate course I taught on the history of information, one of the first of its kind. Years later I followed up with an essay on the origins of a humble but indispensable invention, the paper card file tab, which persists as a screen metaphor. I also reviewed the rise of xerography, another paper-based analog innovation that inspired early digital culture. I reviewed an excellent museum exhibition on the transition. It reminded us, I noted, of how much our ancestors achieved without electronic data processing, of how much more beautiful and durable their instruments were than ours, and of how men and women have always complained about how time-consuming new labor-saving technology can be.

In other essays I underscored how the digital age promoted the use of paper more than it replaced it; the paperless office had already become an ironic phrase. In fact, the very convenience of electronic messages continues to make paper cards and notes demonstrations of sincerity by their very inconvenience. I also ex-

plored the downsides of information abundance. The "information implosion" I foresaw in a 1991 essay did not occur as I had predicted, but with the rise of Large Language Models (LLMs), robotically created mediocrity is flooding the web and in turn may be degrading the quality of writing. Search engine result quality has deteriorated. Plagiarism detection software, as I suggested elsewhere, has reminded us of how many other people thought of our clever ideas first; more recently it has been a cudgel to expose the citation misdemeanors of political enemies while artificial intelligence corporations train models on what copyright holders charge are illegally downloaded books. (I am a board member of a not-for-profit that is one of the plaintiffs, and a member of another, so cannot claim neutrality.) I have also speculated on the consequences of electronic publication for authorship, finding transformations less radical than once predicted, and examined the feedback of reader engagement studies on journalism, questioning the assumption that measurement always leads to long-term improvement. In fact, it may be partly to blame for the present epidemic of tribal partisanship. Finally, the noted design historian Steven Heller gave me an opportunity to discuss my views on the ethics of information design.

Theme 6. Artificial Intelligence.

My first encounter with artificial intelligence (AI) was indirect and negative. In 1985, ten years after I joined Princeton University Press as science editor, I recruited a future Turing Award winner as series editor. He wanted nothing to do with AI, at the time a speculative if brilliant stepchild of his discipline, because computational power fell so far short of its goals of duplicating and even surpassing human intelligence. The most powerful hardware of the day, the Cray-2 supercomputer, was rated at 1.9 GFLOPS;

the iPhone 15, released in 2023, is rated at 1789.4 GFLOPS, about a thousand times faster, and without the need for 150 to 200 kilowatts of power and a liquid cooling system. Princeton had a birthplace of the field in the 1950s, with the Ph.D. dissertations of John McCarthy and Marvin Minsky, but these were breakthroughs in mathematical theory rather than in industrial application before the rise of networked personal computers and the web as we know it.

As an editor and then as an independent historian of technology, I followed the ups and downs of the field but wrote little about it because so much of the controversy of the field was about what it might do in the future. Only in the first decade of this century, with the rise of mobile computing, did that future seem to be arriving. One early landmark was Ray Kurzweil's *The Singularity Is Near*, published in 2005 two years before the appearance of the iPhone in 2007.

The next year I revisited the impact of powerful chess software and the web on elite chess ten years after IBM's Deep Blue computer defeated the world champion Garry Kasparov under tournament conditions. Contrary to some predictions that the game would lose its magic once machines could dominate it, interest had grown as aspiring players all over the world could hone their skills online without having to seek out chess clubs. The real threat to professional chess masters was not computer power itself but the entry of so many other skilled competitors and the reduction of perks like expense-paid trips to tournaments. And chess engines themselves are of course partly human, the embodied work of chess masters, programmers, and hardware engineers.

I revisited chess and artificial intelligence in 2022, when a friend won an international correspondence chess tournament under new rules in effect since about 2000. After the honor system of correspondence (now email) chess proved impossible to enforce,

contestants are now free to use unlimited computer resources, including the most powerful chess engines and the most powerful computers they can afford. The result is that nearly all games end in draws, and the champion may have only a single victory. And despite the opportunities for low-cost education and practice on the web, the cost of competitive hardware for can be prohibitive for some aspiring correspondence players.

In over-the-board play all electronics remain banned, but artificial intelligence has affected preparation profoundly, as top masters develop strategies against opponents based on analyses of their previous games, aided by artificial intelligence experts on their teams. Yet despite all these changes, and in part because they have raised the bar, the excitement of face-to-face chess as a partly physical test of intimidation and stamina may be greater than ever.

Chess thus shows how the results of artificial intelligence may be unexpectedly positive and negative, sometimes leveling and sometimes tilting playing fields, as new technology so often does.

Theme 7. Animals.

One of my formative experiences in publishing was editing a book by one of Princeton University Press's advisors, John T. Bonner, *The Evolution of Culture in Animals* (1980), which joined *Big Fierce Animals* a few years later in the Princeton Science Library. John Bonner was a giant of evolutionary biology, an indispensable faculty guru with wide knowledge and discerning scientific tastes. A specialist in the weird life forms known as cellular slime molds, he was equally fascinated by the range of behaviors that animals transmitted by imitation and teaching – and by the ability of many species not only to use tools but to invent them.

Bonner's book, along with Colinvaux's, prepared me to consider the extent of non-human rationality in my essay for the

personal finance magazine *Money*, "What Wall Street Can Learn from the Dung Beetle." Citing other scientists, including the entomologist E.O. Wilson, the psychologists John Staddon and Howard Rachlin, and the behavioral biologist Robert Trivers, I suggested that during natural selection many species had developed highly rational life strategies that resemble prudent human use of resources. Colinvaux, for example, distinguished between what he called the small-egg gambit (fish and spiders) on one side, and the large-young gambit (elephants) on the other. Should we diversify by scattering investments widely or buy and pay attention to a small number?

I did not want to push the analogy too far. Some impressive animal skills appear to be hard-wired; in experiments, some beavers began to build dams when they heard a recording of rushing water from loudspeakers.

The essay also underscored the importance of humans and their modification of the environment for the evolution of other species. Dogs are the classic case and the subject of three other essays. Despite my background in German social history, I was surprised to discover – originally in an aside in a 1970s book review on a different topic that I had clipped and saved – that the German Shepherd Dog is a relatively recent breed, developed around 1900 by German nationalists seeking an alternative to the fashionable British collie. My essay in the breed's social construction was first delivered in a Shelby Cullom Davis Center at Princeton. I had spent many hours over the previous summer in the library of the American Kennel Club with its priceless runs of breed journals. Paradoxically it was German loss of the First World War that indirectly led to the international fashion for the breed thanks to the popularity of Rin Tin Tin films. (The breed may or may not be more intelligent than others, but it is among the most trainable.)

In another essay I considered similar breeds that have become national brands, such as the Japanese Akita and the Turkish Anatolian Shepherd Dog, an illustration of how human societies coopt and even shape nature for the sake of cultural identity.

When the editor and publisher of the yearbook *Oxymoron* invited me to contribute to its second volume, on the theme of the fringe, it occurred to me that dogs and bears were once both dwellers on the edges of human settlements. I imagined that their ancestors had made a conscious choice – a metaphor not a fact, of course. It was as though the earliest dogs had decided to draw closer to people and dine on the remnants of their meals, in effect joining human packs, while bears remained solitary fringe dwellers. I imagined that this had led to a kind of hereditary enmity reflected in the existence of breeds like Karelian Bear Dogs and Caucasian Shepherd Dogs and in the former barbarous custom of bear baiting. One of the happiest evenings of my writing life was a costume evening at the National Arts Club in New York. I wore a bear mask.

Theme 8. The Future.

Because my new life as an independent writer began in 1991, it was associated with the optimism and technological utopianism of the decade. In the same year, the publishing entrepreneur Louis Rossetto and his partner Jane Metcalfe issued a manifesto for a new magazine devoted to an emerging cyberculture triggered by the launch of the World Wide Web by Tim Berners-Lee, who announced the first public URL, hosted by the European particle accelerator CERN, on August 6, 1991. There had never been a more promising time to begin writing about the future of technology.

My strategy – my sincere belief – was to reject both the cornucopians and the pessimists, and to suggest that the real benefits might not be those anticipated by the first and the real dangers not those foretold by the second – and above all, that the chaotic nature of human affairs was bound to confound all would-be futurists, including me.

My first study of futurism was published the year before, already made that point. The French illustrator and publisher Albert Robida, whose work I had encountered at a dinner in the flat of a British science journalist and bibliophile, had an uncanny vision of twentieth century technology – especially the horrors of heavy artillery and chemical warfare – yet the artist had received almost no scientific or technological education and shared conventional French family values. Bemused alarm, and a prodigious imagination, made him a prophet.

As the decade approached a new millennium (which technically did not arrive until January 1, 2001), conference organizers and editors were eager for essays on the future, and I stuck to the idea that history can suggest possibilities but can never tell us which proposed innovations will transform life and which will flop – often because of the competition of other innovations. I wrote one such essay for the new-millennial issue of *U.S. News* – looking back at an 1897 Sears catalog – and another for the 2000 edition of *Britannica Yearbook of Science and the Future*. (It was an intelligently edited, beautifully produced series that sadly, thanks in part to science, turned out to have no future.)

A few years into the new century I reconsidered futurism after visiting Albert Einstein's house in Princeton, then home to a faculty couple of the Institute for Advanced Study. Einstein and relativity theory have always been associated with twentieth-century modernism. In the 1920s he collaborated with a noted architect on a solar observatory in that spirit in Potsdam near Berlin. It

bears his name to this day and is still operating. Einstein's home life was a different matter: heavy German bourgeois furniture, not Bauhaus design. I used this contrast to explore two visions of the future, one in which tastes and values are reshaped in harmony with new technology, and another in which culture becomes a traditional counterweight to change. Years after I published that piece, both tendencies are still visible. Good evidence for the persistence of tradition was the British military historian David Edgerton's book, *Shock of the Old*, which I reviewed for the *London Review of Books*. Agreeing with Edgerton's point, I still insisted that precisely because so many innovations fail, irrational optimism and hype are indispensable.

I carried this logic a step further in an essay review based on an exhibition of the industrial photography of Lewis Hine. Many of the jobs depicted, skilled and unskilled, have since been rendered obsolete by innovations, and yet the mass technological unemployment feared by some distinguished Depression-era economists did not come to pass. At the same time, the exhibition revealed how difficult for us to foresee which of the dozens of breakthroughs appearing each year in popular science magazines and newspaper sections will turn out to be viable.

This collection concludes with one of my favorite essays, originally delivered in German as part of a lecture series on shadows of the former Basel Design Museum. Its publication illustrated the persistence of the past, appearing in the original language in a volume issued by the world's oldest publisher, Schwabe Verlag in Basel, founded in 1488. And it also suggested that shadows, despite or because of their want of definition, have for millennia been the earliest representations of new scientific knowledge. The newly revealed shadow of a black hole thus seems both an appropriate end for this book and a sign of a new beginning.

1. Risk

2 | WHY THE HINDENBURG HAD A SMOKING LOUNGE

Why the Hindenburg Had a Smoking Lounge

ORIGINAL TITLE:

Markets, Risk, and Fashion:
The Hindenburg's Smoking Lounge

American Enterprise Institute – AEI, May 4, 2012

The historian of science Thomas Kuhn used to advise his students to read the books and papers of the past not for their insights into present-day science but, to the contrary, to notice what was strange about them. Those puzzling ideas, he believed, could reveal the hidden and deep assumptions of their age.

The same may apply to the technology and commerce of the past. And few of its innovations seem odder today than the smoking lounge on the airship Hindenburg, which caught fire upon landing at Lakehurst Naval Air Station in New Jersey on May 6, 1937.

Wikipedia has an excellent summary of the facts of, and theories surrounding, the disaster. A ball of flame appeared as the great ship was docking at the mooring mast. It sank to earth, killing 35 of the 97 passengers and crew members, plus one worker on the landing field. Almost exactly 25 years earlier, when the Titanic struck an iceberg and sank at night, there were no photographs

or outside witnesses. The Hindenburg's crash, on the other hand, was broadcast the next day on network radio and memorialized in countless newsreels, television programs, and (more recently) Internet videos. (In a strange inversion of the Titanic tragedy, at least one crew member of the Hindenburg survived thanks to the bursting of a water ballast tank, saving him from the flames.)

Even after the nuclear meltdowns at Chernobyl and Fukushima, the Hindenburg remains the most spectacular technological tragedy captured on film, outside military and terrorist attacks.

Despite revisionist theories, such as one claiming that the paint on the airship's surface both sparked and fed the explosion, most experts still blame hydrogen. The Zeppelin company originally preferred the cheaper and more readily obtainable hydrogen, but after 48 of 56 passengers on a British airship were killed in a storm in 1930, Zeppelin's engineers planned the new design for the safer, nonflammable helium. Unfortunately for Zeppelin, Congress had passed a law in 1927 banning the export of helium because it was a strategic gas with military aviation potential. There was thus no alternative to hydrogen, despite its risks. (Interestingly, the United States lifted the ban on helium after the Hindenburg disaster, although it was reinstated in 1938 after Nazi Germany annexed Austria.)

None of the half-dozen or more hypotheses and conspiracy theories on the cause of the fatal explosion and fire involves tobacco.

So how could the Zeppelin company have allowed smoking, even with the safeguards of negative air pressure to keep hydrogen out of the airlocked space? It's true that matches and lighters were confiscated upon boarding; the smoking room was equipped with an electric lighter, like the kind of glowing coil that was once standard issue in automobiles. The bar steward was supposed to pre-

vent guests from leaving absentmindedly with a lit smoke, since any fire could be catastrophic.

Still, hadn't the Titanic's sinking taught that a series of unlikely contingencies could defeat even multi-level defenses (in the Titanic's case, those included watertight compartments, radio signaling, and sharp-eyed lookouts)? What could they have been thinking?

The Hindenburg episode teaches a lot about risk, markets, and fashion. Among Victorian men, high-wheel bicycles were notoriously prone to throwing riders into potentially lethal "headers," yet it took decades for safer alternatives to replace them in the 1890s. The Dutch sociologist Wiebe Bijker has argued that for well-off young men—penny-farthings weren't cheap—the hazard was less a bug than a macho feature.

In the 1920s and '30s, cigarettes were the height of style. On the pre-war Titanic, affluent men in first class retired to a lounge filled with cigar smoke after dinner, while ladies had little choice but a writing room. By the 1930s, the luxury cigarette—machine-made, unlike hand-rolled Havanas—had become an icon of modernity in advertisements designed by leading artists and photographers. Smoking allegedly promoted creative thinking and helped keep weight down; aesthetic sophistication and slenderness had become the norms of the post-corset, post-Victorian wealthy.

The Hindenburg's smoking room was thus a necessary concession to global travelers who could book a first-class cabin on the greatest ocean liner ever built (even to this day), the Normandie, at no more than half the price. Guillaume de Syon, author of a standard book on the zeppelins, points out that the room was extremely popular, and travelers would otherwise have been oppressively bored, at least when no land was in sight. An open pack of premium cigarettes was thus a centerpiece of Hindenburg advertisements.

Should the passengers have been worried? The hydrogen-buoyed airship had already covered over 190,000 miles without a serious mishap, just as the Titanic's sister ship, the Olympic, had survived being rammed by a British cruiser in 1911. Edward Smith, the Olympic's master at the time and the future captain of the Titanic, declared that the new vessel would also be "unsinkable." Both estimates of safety were tragically wrong, but widely shared by customers before tragedy struck. In the Hindenburg's case, none of the half-dozen or more hypotheses and conspiracy theories on the cause of the fatal explosion and fire involves tobacco.

So essential was the smoking room to the Hindenburg's commercial success that even Nazi authorities, who had no love for the still-liberally oriented company, did not attempt to suppress it in the interest of their anti-cancer war on smoking. De Syon points out that the campaign against tobacco was still in its early stages— the first major smoking bans, in the air force and post office, were proclaimed in 1938—and that the Zeppelin archives he used for his research were incompletely indexed, so he could not locate the files related to smoking policy and the technical features of the lounge's design.

The very idea of a smoking lounge immediately under 7 million cubic feet of flammable gas, advanced precautions or no, seems ludicrous to generations familiar with the horrifying imagery of the airship's end. In the 1980s, the satirist of past futurism, Bruce McCall, once drew a parody Hindenburg prospectus featuring a skeleton in an officer's uniform asking elegant dining passengers, "Zigarette?" and more recently he punctured the ship's dignity anew in a TED talk.

For all the often-melodramatic reporting of the catastrophe—in which, incidentally, a far smaller proportion of passengers perished than on the Titanic—it was not the event that killed interest

in zeppelins, but the transportation market and the global economic crisis. The coming of the Douglas DC-3, with improved ventilation and soundproofing, in 1936 (hundreds are still flying!) was beginning to make scheduled flights profitable without airmail subsidies. The zeppelins have been compared by de Syon and others to the Concorde—fast, elegant, and exclusive, but also comparatively cramped. Despite the Hindenburg disaster, zeppelins remained popular icons in Germany until the eve of World War Two. But the Nazi leadership saw no military future in the craft and even destroyed the sister ship, Graf Zeppelin II, in 1940.

Is a smoking renaissance ahead? I doubt it, because sometime in the 1980s, the social profile of the cigarette changed profoundly. As early as the 1970s, confidential tobacco company studies began to reveal that smokers were disproportionately lower class. It's now rare in the West for any advertisement to depict smokers as an elite group. Health and "wellness" consciousness, once the province of crusaders like John Harvey Kellogg, is now in the bourgeois mainstream. That's why, contrary to dire predictions by some restaurant and bar owners, legislated smoking bans haven't damaged their business. The laws—propelled in part by reformed elite smokers like New York's Mayor Michael Bloomberg—are just ratifying a new consensus. That's a far cry from the day when, as the historian Robert Proctor has put it, even Hitler was not able to defeat the German tobacco companies.

Airship lovers, on the other hand, may have the last laugh against detractors. Bruce McCall may have ridiculed the concept as carrying "56 people at the speed of a Buick at an altitude you could hear dogs bark," but that was the very charm of it—an angel's-eye cruise near the earth's surface, a visual embrace of the landscape.

The present global economic crisis may have retarded the zeppelin's revival, but it has hardly defeated it. The successor of Count

Ferdinand von Zeppelin's company, now called Zeppelin Luftschifftechnik GmbH (ZLT) in Friedrichshafen, Germany, is building a "New Technology" (NT) series of airships using modern covering materials, engines, and electronically activated controls.

While limited passenger capacity is still a challenge, the Zeppelin NT's low noise and emissions are environmentally appealing. In the United States, Goodyear is planning to buy Zeppelin NTs in place of its blimps. The zeppelin has a bright future as what it really was even in the 1930s: a sublime transportation niche.

A Model Disaster

Popular Science, March 2012

Published April 17, 2012

The hundredth anniversary of the wreck of the *Titanic* on April 15 provides a welcome moment to celebrate the many great strides made by engineers. In 2012, people move around the world more quickly and more safely than ever before. But the fate of the *Costa Concordia,* the cruise ship that ran aground off the coast of western Italy in January [2012], reminds us that no matter how much progress we make, disasters still happen. It also presents a question: After a century of advances in naval engineering, why are we still unable to prevent deadly wrecks?

My graduate-school teacher, William H. McNeill, explored a similar question in a 1989 essay, "Control and Catastrophe in Human Affairs." McNeill had economic wrecks, not shipwrecks, in mind. At the time he was writing, regulators were confronting the savings and loan crisis, which itself was just the latest in a long series of financial and monetary debacles dating back to at least the Panic of 1873. Why were regulators unable to better manage the system? After each panic or crash, they would step in with reforms, yet no matter how careful the design, at some point those reforms would fail, and catastrophe would return anew. McNeill proposed that the problem was not poorly designed reforms, but rather reforms that worked all too well. They achieved their in-

tended purpose, but they did so by shifting risk to less-organized places. "It certainly seems as though every gain in precision in the coordination of human activity and every heightening of efficiency in production were matched by a new vulnerability to breakdown," McNeill concluded. "If this is really the case, then the conservation of catastrophe may indeed be a law of nature like the conservation of energy."

We can observe another variation of the conservation of catastrophe in the construction of medieval cathedrals. When builders discovered clever ways to construct larger and airier, more light-filled testaments to the glory of God, they incorporated them enthusiastically. Those new levels of achievement, though, also exposed the structures to previously unknown hazards. For instance, when the architects of the Cathedral of Saint Peter in Beauvais, France, set out to build the tallest church in history, they deployed the then cutting-edge technology of flying buttresses. The lightweight buttresses were a brilliant innovation, but the soaring design they enabled also revealed previously irrelevant structural flaws, still under scholarly investigation, that led to a partial collapse of the choir in a windstorm in 1284, a dozen years after construction was complete. (High winds also doomed another landmark, the Tacoma Narrows Bridge in Washington, six centuries later.)

Disaster may also reassert itself when engineers are so successful that they actually transform the environment. In attempting to control flooding on the Mississippi River, for instance, engineers built levees close to the riverbanks. Floodwaters that were once dispersed across a wide plain were now confined to a high, narrow channel. It worked well for the most part—but narrow waters run faster, so when the levees were breached or overtopped, as was inevitable, the same volume now spread more quickly, causing greater damage. Similarly, forest managers' increasing ability to

suppress wildfires can lead to the buildup of brush—which turns out to be a far more powerful fuel for the fires that do eventually rage out of control.

We can see the same three trends at work in marine disasters: First, genuinely safer systems can sometimes cause the crew to miscalculate risk. Second, genuinely better engineering can expose previously unrealized weak points. And third, the size and complexity that make new ships so impressive may exacerbate trouble when disaster does strike.

The *Titanic* demonstrated all three effects spectacularly, and precisely because its designers and officers were some of the most capable and experienced men of their professions. Captain Edward Smith's declaration in 1907 that "I cannot imagine any condition which could cause a ship to founder" might sound tragically foolhardy today, but he had reason to be confident. Big iron and steel ships really had held their own against icebergs—that same year, the *Kronprinz Wilhelm,* a German superliner, had survived such a collision with only minor damage. But the new transatlantic steamers were no more stable than their weakest points. The *Titanic*'s rivets and steel plating, analysis of samples from late-twentieth-century dives has suggested, may have failed in the collision. Furthermore, the scale of the ship, far from being protective as the designers and captain believed, made the hazard even greater. Forensic naval architect Philip Sims noted recently that the *Titanic* was three times as large as the iceberg-surviving *Kronprinz Wilhelm* and was "moving 30 percent faster, so it had five times the impact energy pushing in her side plates." And in the event of the disaster, that size only made matters worse. The length of passageways delayed some passengers in reaching the lifeboats, many of which were launched half-empty.

Engineers should remain aware that new designs can bring about new disasters. The disaster of the *Titanic* led to reforms.

Congress began requiring ships to monitor the airwaves at all times. The International Convention for the Safety of Life at Sea in 1913 called for ships to carry enough lifeboats to hold every passenger, and for the creation of an International Ice Patrol, to monitor icebergs. Yet disaster just as surely reasserted itself. The addition of lifeboats made some vessels less stable; the excursion ship *Eastland,* already relatively top-heavy before the installation of additional post-*Titanic* lifeboats, capsized in Chicago Harbor in 1915, killing 844 passengers. The ship was overloaded, and the alarmed crowd rushed from side to side until it listed fatally.

Passengers on the *Costa Concordia,* which ran aground off the coast of Italy in January, learned an old lesson: Disasters will strike despite (or perhaps because of) the best efforts of engineers.

The operators of the *Costa Concordia* appear to have repeated some of the same errors. The cruise-ship industry trumpeted the safety record of its shallow-draft megaships, originating in the 1980s. They became as iconic in the age of mass tourism as the transatlantic liners had been in the heyday of American immigration. With 4,200 passengers and crew, the *Costa Concordia* was far from the largest of its kind. Its captain was also experienced and well regarded by his peers. But as with the *Titanic,* the long period of success may have been misinterpreted. Some witnesses claim that the captain was distracted by conversations with passengers on the bridge at the moment of impact. He may have been overly confident because he had navigated the ship successfully on a similar maneuver only months earlier. Like Captain Smith, he has been criticized for delaying evacuation, too—possibly overly confident in the ship's resilience—thereby losing an hour before the ship began to list, which rendered half the lifeboats useless.

We don't yet have evidence regarding the *Costa Concordia*'s hull and whether the construction may have had weaknesses revealed only under unusual stress, as at Beauvais and on the *Ti-*

tanic. But it's very possible that construction of the hull did not assume that rocks could inflict a gash 160 feet long. We'll know more when the designers and builders testify.

Finally, the *Costa Concordia*'s scale, like the *Titanic*'s, created unforeseen problems. Now as then, the ship's evacuation routes confused many passengers. The *Costa Concordia*'s designers may have thought that by using advanced evacuation dynamics software to plan the interior, they could assure an orderly exit even from the most remote quarters. But Dracos Vassalos, a professor of maritime safety at the University of Strathclyde in Scotland, recently noted in *USA Today* that "the internal architecture of cruise ships is so complex that even with the same effects being accounted for in . . . experiments, computer simulations or, indeed, in real-life accidents, we could potentially see a different outcome every time we simulate the accident."

Engineers should, of course, continue to develop measures to prevent disasters. Collision-resistant construction, however imperfect, has helped save thousands of lives. On the *Titanic*, it bought hours of precious time; if evacuation had been ordered earlier and the nearby *Californian* had responded to distress calls promptly, the death toll might have been much lower. And the great majority of *Costa Concordia* passengers were rescued without serious injury.

Engineers should remain aware, though, that new designs can bring about new disasters—or, as McNeill concluded, "Both intelligence and catastrophe appear to move in a world of unlimited permutation and combination, provoking an open-ended sequence of challenge and response." Debates about the *Titanic*'s end continue, and hearings and legal proceedings regarding the *Costa Concordia* will probably also take years. But wherever the fault lies, we have already been reminded that there is no substitute for vigilance, imagination and enlightened paranoia. In the

words of Lewis Carroll's Red Queen, we need to run as fast as we can to stay where we are.

The Wreck After the Titanic

George, July 1998

In the aftermath of the *Titanic* catastrophe in 1912, lifeboats for all became a national priority. But the deadly sinking of a Chicago steamship three years later showed how our best efforts at combating disaster can come back to haunt us.

Devotees of technological disasters fall into two clashing schools: the managers and the moralists. Managers argue that accidents offer long-term benefits to human health, longevity, and well-being. Painful though disasters are, managers insist, we learn from them and we progress. The injuries occasionally caused by first-generation automotive air bags led to even better crash protection, for example.

But moralists aren't so sure. The engineer and historian Henry Petroski once pointed out that when a new generation of professionals begins to explore the possibilities of a new technology, they start to forget the lessons of the last disaster or create entirely new kinds of misfortune: People who feel safer behind an air bag may take greater risks on the road. The historian William H. McNeill coined a phrase to describe a new disaster that stems from the very features designed to prevent repetition of an old one: *the conservation of catastrophe.*

We consumers act like managers. We balance risks and rewards and put our confidence in hospital administrators, pilots, air-traffic controllers, ships' captains, even our fellow motorists. But we also worry like moralists. What if our children's vaccina-

tion for one disease gives them another? What if next winter's flu turns into a killer epidemic like the one that devastated the world in 1918?

The *Titanic* sparked one of the most vigorous debates between managers and moralists. For the managers, the *Titanic* tragedy in 1912 showed a positive side of catastrophe: the implementation of safety measures such as international iceberg patrols, 24-hour radio operators, and sufficient numbers of lifeboats. But for the moralists, every safety measure is a potential source of danger. And their most moving evidence is a tragedy half forgotten even in its own surroundings: the capsizing of the excursion steamship *Eastland* in the Chicago River on July 24, 1915.

Eight hundred and forty-one passengers perished when the *Eastland* flipped, but Hollywood found no glamour to evoke, no myths to transform into celluloid visions. The victims were employees of the Western Electric Company in suburban Chicago, mostly blue-collar workers and their families—they would have been steerage passengers on the *Titanic*—looking forward to a day trip to Michigan City, Indiana. But as the *Eastland* was leaving its moorings in water no more than 20 feet deep, it slid over onto its side, still tied to the dock between Clark and La Salle streets. In the ensuing panic, terrified passengers were trapped belowdecks, where hundreds drowned or were trampled just yards from horrified onlookers at the river's edge. Their tight-knit community was devastated; the passengers' descendants still recall that their relatives described a full week

of funerals. Paradoxically, the fact that the tragedy befell such a small community limited the impact of the event, and especially its memory, among other Chicagoans and the outside world.

For a while, experts blamed the capsizing of the *Eastland* on the passengers themselves, who supposedly shifted to one side to see a passing launch and tipped the vessel. But George W. Hilton,

an economist skilled in both the managerial and the moralistic side of disaster studies, has shown in his recent book, *Eastland: Legacy of the Titanic,* that the problem lay elsewhere.

The immediate technical cause was almost certainly the captain's procedures for loading passengers onto the ship, according to Hilton. Yet the underlying source of the *Eastland* calamity was deeper. As originally designed in 1903, the ship was stable. Yet, in that same year, it was modified for greater speed and comfort. Though it still rode well on the open lakes, it became "tender" (to use Hilton's expression) during loading and unloading. Once, in 1904, it nearly capsized. Even so, more changes followed. When wood in the dining room rotted, it was replaced with concrete—cheaper but heavier. To adhere to the La Follette Seamen's Act of 191, a piece of Progressive legislation intended to boost nautical safety, the owners added equipment that would qualify the *Eastland* to carry 2,500 passengers, up from the 2,183 previously allowed on board. Hilton calculates that the three additional boats and six rafts, weighing between eight and 15 tons, dangerously boosted the weight of the ship, as did the 317 new passengers and their baggage, which added up to 24 tons. The tragic cruise would have been the first at the *Eastland*'s new capacity.

One lesson of the *Titanic* had been that ships must carry lifeboats for all their passengers. The *Eastland* disaster showed that lifeboats themselves could contribute to calamity. Safety depends not just on single safeguards but on the entire design and management of a technology, and the *Eastland* had a history of pushing the limits of its design.

If the *Titanic* inspired life-threatening as well as life-saving technological change, today's libertarians and conservatives might expect the same of well-meaning safety legislation now. Consumer advocates, on the other hand, might argue that technology requires regulation. But legislation can contribute to a false sense of

well-being. In a global economy, for instance, strict laws in one country have a way of exposing a nation's citizens to unexpected risks: To skirt tough laws, ships may be registered where rules are looser, or produce may be imported from countries more tolerant of pesticides and herbicides.

The lessons of the *Eastland* still apply. At the moment, cruise ships are growing ever bigger and more elaborate. Entrepreneurs are dreaming of floating resorts too large for any harbor, seaborne clusters of condominiums beyond the reach of tax collectors and flying the flag of the most accommodating nation. Of course, there will be lifeboats for all, perhaps even evacuation helicopters. Confident that their ship could never capsize or hit an iceberg, residents will be thrilled by high-definition television screenings of disaster films such as *The Towering Inferno* and *Titanic*. And the crew will be so highly trained that disasters will no longer be possible—at least, the disasters they know. It's the disasters they may invent that they should really worry about.

Heroic Capitalism

Elon Musk, Meet... Stockton Rush?

Milken Institute Review

The implosion of the submersible *Titan* and death of its five passengers in June [2023] during its descent to the *Titanic* has made the pilot and CEO of its operating company, Stockton Rush, one of the most controversial figures in the history of exploration. To countless op-ed moralists, his adoption of an untested design for *Titan*—with its cylindrical carbon-fiber body, plexiglass window, and videogame-like Bluetooth controller—was a foolhardy defiance of engineering best practices in the service of aquatic empire-building.

But to diehard libertarians, his rejection of the nanny state and what he called "obscenely safe" corporate policies was a glorious throwback to the strenuous life advocated by likes of Theodore Roosevelt, who nearly perished in a Brazilian adventure of his own. Besides, Rush's paying passengers signed releases that acknowledged his craft's experimental design and the risks of tagging along.

Lines are thus already drawn for the international hearings and years of litigation to follow. Assigning legal responsibility for loss of life and for the costs of the search and recovery operations may not get us any closer to understanding Stockton Rush's courtship with destruction or his passengers' blithe risk-taking.

But looking back 200 years into the history of American business, we can find clues.

Once Upon a Time

It seems a stretch to link *Titanic* tourism to nineteenth-century coal mining, but the two enterprises have many links. Before the rise of surface strip mining, extracting coal was a hazardous exploration of a little-known subterranean world. While it is true that nobody descended into a mine shaft for fun in those days, many tourists and daredevil explorers do so today. Indeed, the website of the National Mining Association lists over a dozen coal mines open to tours.

While Rush established a charitable foundation to promote ocean exploration and marine research, he was not necessarily a coral-reef-hugger. *The Independent* of London cited a 2017 interview in which he acknowledged that the pool of wealthy *Titanic* explorers was limited. His goal for OceanGate was to metamorphose from adventure tourism into exploration, contracting for fossil fuel corporations seeking petroleum and natural gas deposits.

The origins of this quest stretch back to the early American republic. The opening of the anthracite fields of eastern Pennsylvania to national markets by means of a rapidly expanding canal system radically changed the economy beginning in the 1820s. Anthracite burns cleaner than bituminous coal and thus was preferred for household stoves and advertised as traveler-friendly by the railroads that powered locomotives with it. By the early 20th century, the Lackawanna Railroad could introduce a fictional heroine, Phoebe Snow, who arrived in Buffalo without a smudge on her fashionable white outfits — a meme that endured long after railroads had converted to electric and diesel power.

Demand for the relatively precious commodity drew speculators and workers into Pennsylvania's Schuylkill and Lucerne

counties. This coal rush, as it might be called, preceded the California Gold Rush by decades. But its fortune seekers shared the irrational exuberance of the next generation's argonauts.

Irrational Exuberance

The twentieth-century anthropologist Anthony F.C. Wallace wrote a series of studies of the anthracite communities and discovered that their entrepreneurs were not following classical models of rational risk-taking. The frequency of mine disasters was not due to misinformation about the geology of the mines, or even I'm-too-young-to-die optimism. The mine operators were seeking profits, of course, but were even more concerned about their reputations. They sought a role beyond wealth: recognition as heroes of industry.

Wallace's case-in-point was a man named Enoch W. McGinnis, a self-made manufacturer of steam engines who had begun his career as a machinist. McGinnis left an extensive correspondence with his financial backer, a Philadelphia publisher named Matthew Carey. McGinnis wanted to be known not as a rational capitalist but as one of the "daring men . . . the men who make things move." He aspired to be one of the leading operators, admired by "the faithful and true."

McGinnis and others like him, Wallace concluded, were taking irrational risks not only with the health and lives of the miners, but also with their own fortunes and those of their patrons. Paradoxically, it was only once mine risks were regulated by law that mining became profitable.

Stockton Rush, unlike Enoch McGinnis and his fellow coal operators, led perilous descents himself. (And ascents, too: After graduating from Princeton he became a flight test engineer for McDonnell Douglas's F-15 fighter plane development.)

But Rush shared McGinnis's passion for prestige as a risk-taker founding an industry. In an interview with *Smithsonian Magazine* in 2019, Rush declared, "There hasn't been an injury in the commercial sub industry in over 35 years. It's obscenely safe because they have all these regulations. But it also hasn't innovated or grown—because they have all these regulations."

In a November 2022 podcast with the journalist David Pogue, he went further: "At some point, safety just is pure waste. I mean, if you just want to be safe, don't get out of bed. . . . At some point, you're going to take some risk. . . . I think I can do this just as safely by breaking the rules."

Rush seems to have regarded competitors in undersea tourism as a cabal determined to thwart innovation. And by launching its submersibles in international waters, he eluded the cabal because it made OceanGate legally exempt from certification. Good thing, too. Following the rules like the one requiring an all-titanium hull would probably have been so costly that the charge to "mission specialists" (as Rush called paying passengers) would have led many to think twice. (For similar reasons, the *Hindenburg* needed a smoking lounge because half of its target elite market were smokers who could buy a first-class transatlantic liner ticket for half the fare.)

For early-nineteenth-century mine operators like McGinness [*sic*], reputation meant recognition for building the foundation of a new coal-powered society. For the post-industrial ideology of two centuries later, the peak of technological heroism is space. Excluded from NASA's astronaut program by its strict eyesight test, Rush saw the oceans as an alternative frontier—and one that more reliably promised the discovery of unknown life forms, consciously aspiring to be the Captain Kirk of the deep.

Obscene Safety

It is hard to imagine that OceanQuest will emerge from its legal (and PR) troubles as a viable corporation. In this, it is like the mining operations that Enoch McGinnis organized, enduring one fire, explosion and flood after another with frequent bankruptcies until in the late nineteenth century the mines were consolidated (and then closed) by the Philadelphia and Reading Coal and Iron Company.

In an appendix to his book *St. Clair: A Nineteenth-Century Coal Town's Experience with a Disaster-Prone Industry,* Wallace outlined what he called the "disaster-prone organization," two points of which are especially relevant:

It endorses a prevailing mythology that praises daring and productive persons more than cautious and protective ones.

It endorses a prevailing mythology that blames the industry's problems on conspiratorial outsiders and on disaffected, dishonest, or careless workers.

Two of OceanQuest's four paying "mission specialists" were sophisticated and experienced adventure travelers apparently charmed by Stockton's enthusiasm—and no doubt by his willingness to risk his own life. The third and fourth were an Anglo-Pakistani billionaire (or, at least, centimillionaire) fascinated by the *Titanic* and his college-age son; it is less certain whether they fully understood the risks of the descent.

The tragedy of the *Titan* won't end adventure travel. But just as ill-fated coal entrepreneurs like McGinnis saw their unprofitable holdings swallowed by giant corporations, the outcome is likely to leave OceanGate's "obscenely safe" competitors in the driver's seat. The expeditions of the future are likely to be more cautious, more regulated and even more expensive. Stockton Rush will have achieved his goal of historical recognition—for implod-

ing the mythology of the technological hero and advancing all the institutions he scorned.

Chronologically Incorrect

Wilson Quarterly, Autumn 1998

Seventy years ago, W.I. Thomas and Dorothy Swaine Thomas proclaimed one of sociology's most influential ideas: "If men define situations as real, they are real in their consequences."

Their case in point was a prisoner who attacked people he heard mumbling absent-mindedly to themselves. To the deranged inmate, these lip movements were curses or insults. No matter that they weren't; the results were the same.

The Thomas Theorem, as it is called, now has a corollary. In a microprocessor-controlled society, if machines register a disordered state, they are likely to create it. For example, if an automatic railroad switching system mistakenly detects another train stalled on the tracks ahead and halts the engine, there really will be a train stalled on the tracks.

Today, the corollary threatens billions of lines of computer code and millions of pieces of hardware. Because they were written with years encoded as two digits (treating 1998 as 98), many of world's software programs and microchips will treat January 1, 2000, as the first day of the year 1900. Like the insane convict, they will act on an absurd inference. For purposes of payment, a person with a negative age may cease to exist. An elevator or an automobile engine judged by an embedded microprocessor to be overdue for inspection may be shut down. All of our vital tech-

nological and social systems are vulnerable to crippling errors. Correcting programs requires time-consuming close inspection by skilled programmers, custom-crafted solutions for virtually every computer system, and arduous testing—and time is running out.

Nobody denies the hazards. And as we will see, if only because of the original Thomas Theorem, the Year 2000 Problem is already upon us. The unsettling question is just how serious it will remain after more billions of dollars are spent between now and then correcting and testing affected systems—fully 1,898 in the U.S. Department of Defense alone, and hundreds of thousands of smaller computer networks if those of small businesses are included. Will the first days of the year 2000 be just a spike in the already-substantial baseline of system failures recorded in professional forums such as the Risks site on the Internet? That might be called the fine mess scenario. Or will it be a chain reaction of self-amplifying failures—the deluge scenario?

Warning, diagnosing, correcting, testing, certifying, and testifying about the Year 2000 Problem, increasingly abbreviated as y2k, is the mission of a new computer specialty that might be called y2kology. Few of today's y2kologists were familiar to readers of the consumer computer press even five years ago, though Edward Yourdon had written influential books on programming and Capers Jones was a leading network management consultant. Few teach in the largest and oldest academic computer science departments or business schools. The hardware and software establishments regarded the problem as tedious housekeeping in the emerging frictionless networked economy. All that is changing as y2kologists begin to make headlines. Because y2kology mixes evangelism, prophecy, and entrepreneurship, its message has not won easy acceptance. The financial news magnate Michael Bloomberg called the Year 2000 Problem "one of the greatest frauds of all time" at a meeting of securities traders last year. As

late as last spring, the Bank of Montreal predicted only a "mild blip," and a mid-1998 survey of chief financial officers of companies with more than 20 employees revealed that only 17 percent were very concerned, and 48 percent were unconcerned. Read closely, y2kologists share no consensus on how severe the y2k dislocations are likely to be. Edward Yardeni, chief economist of the Deutsche Morgan Grenfell investment bank, now estimates that the odds are strongly in favor of an economic recession as serious as the one triggered by the 1973–74 oil shock. But an acknowledged aim of alarming predictions, as in George Orwell's *1984,* is to galvanize people into action that will prevent the worst. As of mid-1998, many leading y2kologists, including the Canadian consultant Peter de Jager and the American academic Leon Kappelman, were arguing that if organizations concentrated on their essential systems and deferred other work, massive failure could still be averted. Edward Yourdon and his daughter Jennifer Yourdon have written a guide for coping with a variety of plausible scenarios, which in their view range from a two-to-three-day disruption to a 10-year depression. And a few panicky y2k programmers are retreating to the western deserts—the very area most dependent on electronically controlled federal water distribution systems.

One thing is certain: The apprehension is real, and will have real consequences. Just as the fear of nuclear war and terrorism has transformed the world over the last two generations so the mere possibility of massive system failure will cast a shadow over its political, military, business, and scientific rulers for years to come. Year 2000 is less a crisis of technology than a crisis of authority.

For at least a century the West has expected, and received, orderly technological transitions. Our vital systems have grown faster, safer, and more flexible. Boiler explosions, for example, killed as many as 30,000 Americans a year around 1900; today, only a handful die in such accidents. The reduction was the result of co-

operation among engineers, state legislators, and industries to establish uniform codes and inspection procedures in place of patchwork regulations and spotty supervision. Well before the sinking of the *Titanic* in 1912, national and international bodies had made transatlantic travel much safer than it had been in the age of sail. Railroads long ago arrived at standards for compatible air brake systems that allowed passenger and freight cars to be safely interchanged. And evolving engineering standards have helped reduce accident levels on the nation's interstate highways. But no comparable effort has been made to cope with the y2k problem.

Most consumers pay little attention to the hundreds of national and international standards-setting bodies. Only when major commercial interests are at stake, as when specifications are established for high-definition television or for sound and video recording, do the news media report on debates. Laypeople are rarely present at standards-setting deliberations. Before the early 1980s, many conventions were handled mainly as internal corporate matters. AT&T established exchange numbers and area codes, and IBM and a handful of other manufacturers upgraded operating systems of their mainframe computers. And why should people worry? The record of these organizations was unmatched in the world. A Henry Dreyfuss–designed, Western Electric–manufactured rotary telephone could work for a generation without repair. The future seemed to be in good hands.

The breakup of AT&T, the explosion of utilities competition, the globalization of manufacturing, and the rise of personal computing have all helped diffuse authority over standards. And freedom from regulatory entanglement has brought immense benefits to manufacturers, consumers, and the economy. But it has had an unintended consequence. The diversity of systems and the fierceness of business rivalries discourage public and private technological authorities—from the Defense Department to Mic-

rosoft—from taking firm and early action to cope with emerging problems. (A fear of antitrust prosecutions has also inhibited Year 2000 cooperation among corporations, enough so that President Bill Clinton felt compelled in July [1998] to propose special legislation to clear the way.) Governments have avoided interference in commercial decisions, and businesses have succeeded more by following market shifts than by staking out ambitious new standards. As the Thomas Theorem implies, if people do not believe they can exert power or influence, then they cannot. Which brings us to "the millennium bug," which is no bug at all.

Over the last four decades, the Year 2000 Problem has passed through three phases, each bringing its own challenges for authorities. The first age, the Time of Constraint, lasted from the origins of electronic computing to the early 1980s. The managers and programmers of the time knew that programs using only two-digit years had limits. Many must have been aware of the master programmer Robert Bemer's early-1970s article in the industry journal *Datamation,* describing the Year 2000 Problem in the COBOL programming language he had codeveloped. These electronic pioneers could have used four-digit dates, but there was a strong economic case for two. In fact, the U.S. Air Force used single-digit dates in some 1970s programs and had to have them rewritten in 1979.

Leon Kappelman and the consultant Phil Scott have pointed out that the high price of memory in the decades before personal computing made early compliance a poor choice. In the early days of computing, memory was luxury real estate. A megabyte of mainframe hard disk storage (usually rented) cost $36 a month in 1972, as compared with 10 cents in 1996. For typical business applications, using four digits for dates would have raised storage costs by only one percent, but the cumulative costs would have been enormous. Kappelman and Scott calculate that the two-digit

approach saved business at least $16–$24 million (in 1995 dollars) for every 1,000 megabytes of storage it used between 1973 and '92. The total savings are impossible to calculate, but they surely dwarf most estimated costs of correcting the Year 2000 Problem. (One leading research group, the International Data Corporation, estimates a correction cost of $122 billion out of more than $2 trillion in total information technology spending in the six years from 1995 through 2000.)

Even where Year 2000 compliance was feasible and economical, it wasn't always in demand. In the 1980s, a number of applications programs were available with four-digit dates, such as the statistical programs and other software systems produced by the SAS Institute, one of computing's most respected corporations. SAS does not appear to have promoted it competitively as a major feature. The UNIX operating system, originally developed at Bell Laboratories, does not face a rollover problem until 2038, yet this too did not seem to be a selling point. Even Apple Computer did not promote its delayed rollover date of 2019. The year 2000 still seemed too far away.

By the mid-1980s, the Time of Choice was beginning. The economic balance—initially higher storage and processing costs versus long-term savings in possible century-end conversion costs—would have still been an open question, had it been openly raised. The great majority of crucial government and business applications were still running on mainframe computers and facing memory shortages. But the trend to cheaper memory was unmistakable. The introduction of the IBM PC XT in 1983, with up to 640 kilobytes of random access memory (RAM) and its then-vast fixed hard drive of 10 megabytes, was already signaling a new age in information processing.

Yet the possibilities presented by the new age remained an abstraction to most computer systems managers and corporate

and government executives. Then as now, most of their software expenses went not to create new code but to repair, enhance, and expand existing custom programs—what are now called "legacy systems." A date change standard would initially increase errors, delay vital projects, and above all inflate budgets. And it was not a propitious time to face this kind of long-term problem. The American industrial and commercial landscape during the 1980s was in the midst of a painful transformation, and investors appeared to regard most management teams as only as good as their last quarter's results. Only the mortgage industry, working as it did on 30-year cycles, had recognized the problem (in the 1970s) and begun to work on it.

In 1983, a Detroit COBOL programmer named William Schoen tried to market a Year 2000 conversion program he had created. A sympathetic column about his warnings in a leading trade weekly, *Computer World,* went unheeded. Schoen went out of business after selling two copies.

Not that government was much more prescient. The Federal Information Processing Standard of the National Institute of Standards and Technology (NIST) for interchange of information among units of the federal government specified a six-digit (YYMMDD) format in 1968 and did not fully change to an eight-digit (YYYYMMDD) format until 1996. The Social Security Administration was the first major agency to begin Year 2000 conversion, in 1990. Despite the impressive military budget increases of the 1980s and the Pentagon's tradition of meticulous technical specifications for hardware, many vital Defense Department systems still require extensive work today.

The computing world of the 1990s recalls a multimedia trade show display decorated at great expense and stocked with the best equipment money can buy, yet still dependent on a hideous, half-concealed tangle of cables and powerlines, with chunky

transformer blocks jutting awkwardly from maxed-out surge protectors. Our apparently seamless electronic systems turn out to be patched together from old and new code in a variety of programming languages of different vintages. The original source code has not always survived. Year 2000 projects can turn into organizational archaeology.

The German philosopher Ernst Bloch popularized the phrase *Gleichzeitigkeit des Ungleichzeitigen,* literally "simultaneity of the nonsimultaneous," to express the coexistence of old and new values. Far from being dead, the past (in William Faulkner's even more celebrated words) sometimes is not even past. Indeed, in Faulkner's native South, much of the cotton trade is said to rely on ancient IBM punch card systems now maintained by arcane specialty vendors. In the United Kingdom, the Royal Air Force's supersonic Tornado fighters, costing £20 million each, are still equipped with 256 kilobytes of core memory, with processing data recorded on standard audiocassettes. This seemingly obsolete system not only performed magnificently in the Persian Gulf War but is considered impervious to conventional electronic jamming techniques. Year 2000 repair confronts us with many such examples of coexistence.

The Time of Choice ended in the early 1990s, when leading computer industry publications prominently recognized Year 2000 conversion as a problem and warned of the consequences of neglecting it. Peter de Jager's September 1993 *Computerworld* article, "Doomsday 2000," may not have been the Silent Spring of y2kology, but it was fair warning. Writing in *Forbes* in July 1996, Caspar W. Weinberger, chairman of Forbes, was probably the first prominent business figure to underscore the seriousness of the problem (though, curiously, the former secretary of defense said nothing about the y2k dilemmas confronting the public sector).

The Time of Trial began in the mid-1990s, as conversion programs began in earnest and y2k issues were increasingly aired in the computer press. It will probably last until around 2005.

A few annoyances are already apparent. Credit cards with 2000 expiration dates, for example, have been rejected by some authorization systems. Many critical points will arrive in 1999, with the need to reset some older Global Positioning System (GPS) equipment, for example, and especially with the beginning of fiscal year 2000 for many governments and private-sector organizations.

During the Time of Choice, the problem was recognized but deferred for two reasons. First, there was the chance that entire computer systems would be replaced before 2000. Second, future software tools might reduce conversion costs sharply. In 1988, a senior Defense Department computer systems official told the *Chicago Tribune*: "Our projections for the development of artificial intelligence systems suggest that by 1994 and 1995, they may be able to handle most of this relatively easily." Yet 10 years later, a congressional committee heard one expert give the Pentagon an "F" for its Year 2000 readiness. In the civilian sector, too, older hardware and software is far more pervasive than many experts anticipated. It may also be too late for most businesses to replace their vulnerable systems; programmers are scarce and expensive, and conversion can take years to complete.

Speaker of the House Newt Gingrich (R.–Georgia), publisher and likely Republican presidential contender Steve Forbes, and other prominent Republicans are exploiting the Clinton administration's failure to address the problem earlier. How could self-styled technology advocates such as Vice President Al Gore have turned a blind eye to a threat of such magnitude? Embarrassed as Gore might turn out to be by a series of government computer failures in early 2000, and shy of the Year 2000 issue as he has lately appeared, congressional Republicans have no better track record.

For example, during hearings about the Internal Revenue Service's computer system woes in 1996, Senator Ted Stevens (R.–Alaska) cited "advice from a very distinguished thinker" to the effect that problematic computer systems would be replaced by 2000. Only in early 1997 did the Republican-controlled Congress's own auditing arm, the General Accounting Office, upgrade Year 2000 to its most serious category of issues. The other organization that might have dealt with the issue, the Office of Technology Assessment, was abolished by Congress in 1995. In fact, the legislators with an interest in the problem are a small group that includes members of both parties, among them senators Robert Bennett (R.–Utah) and Daniel Patrick Moynihan (D.–New York).

Computer industry executives, from Microsoft's William Gates on down, also missed opportunities. When Microsoft introduced Windows 95—a two-digit name—in the summer of that year, it required developers to meet a variety of compatibility standards before they could display the Win95 logo. (For example, the procedures for removing a program and its associated files from a hard drive had to be simplified.) Continued functionality after four and a half years was not one of these requirements. Even in mid-1998, some of Microsoft's own software products may have at least minor problems associated with the date change. Microsoft has been at least as responsible as most other companies, probably more so. Yet Gates published his book *The Road Ahead* (1996) without a discussion of the Year 2000 Problem; in a July 1996 column, he appeared unaware that a number of popular current personal computer programs were affected. (Most problems with programs on non-networked personal computers can be solved relatively easily, often with a simple upgrade.)

If the coexistence of past, present, and future was the discovery of the Time of Choice, *triage* is becoming the watchword of the Time of Trial. Fortunately, information technologies are not

created equal. Some organizations have hundreds or even thousands of computer systems, but only a minority are vital and only a few may be critical. In 1998 it is too late to fix everything, even with emergency budgets and the mobilization of computer-skilled employees from other departments. As the project management guru Frederick P. Brooks pointed out in his classic *Mythical Man Month* (1982), adding programmers to a late project can actually delay it further. In a complex interconnected system, more things can go wrong.

In the Time of Trial, triage will not be the only military metaphor. Many other information technology projects will be suspended or canceled as programmers are called up for the front. Careers will be damaged and entire organizations will be set back. Well-prepared companies will gain strategic advantages. Yet so far, financial markets have not been able to identify Year 2000 winners and losers. A study by Triaxys Research showed that as of June 1998 many companies had not completed Year 2000 assessments, much less undertaken efforts to correct their problems. Investors still do not have adequate information.

Despite these gaps, there is reason to hope for a fine mess rather than a deluge. Some banks and investment houses have reported making good progress on their systems. A Wall Street dry run of Year 2000 trading last July seemed to go well. Improvements of Year 2000 software tools may shorten the time needed to make repairs. Indeed, the military metaphor provides a measure of reassurance. For all the shortcomings of British and American policy and planning during the years between the world wars, for example, Allied scientists and engineers performed miracles once war broke out.

Some dangers will persist despite the efforts of even the most resourceful managers. Realization of any one of the five most ominous threats could validate the doomsayers' predictions.

These risks might be abbreviated as SMILE: second-order effects, malicious code, interdependencies, litigation, and embedded processors.

Thomas's Theorem suggests that the expectation of a Year 2000 crisis may be enough to create a real one no matter how effective the efforts to repair the underlying code. Our social and technological systems are more efficient than ever, but because, for example, information technologies now allow vendors and manufacturers to maintain lean warehouse inventories, slight disruptions can have more serious repercussions. Running the gamut from shifts of investment funds based on Internet-transmitted rumors about the Year 2000 readiness of particular companies, to depletion of bank and automatic teller machine currency supplies, to runs on bread and toilet paper, a late-1999 panic might be comical but also potentially deadly.

Add potential sabotage to the equation. The Pentagon already worries about information warfare and terrorism. Hostile states, criminal organizations, and domestic and foreign radical movements can already attack vital networks. The beginning of the year 2000 is a perfect cover. Do not forget embezzlers and vengeful staff. An apparently Year 2000–related incident could mask electronic robbery, and a continuing shortage of skilled personnel could delay diagnoses for priceless months. Computer security experts also fear fly-by-night y2k consultants who may collude with corrupt managers to offer bogus certification, or plant Trojan horse programs in the systems of honest but desperate ones.

Thanks to decades of global thinking, North America and Europe are also linked to nations whose Year 2000 readiness makes many Western nations look like paragons. The Asian financial crisis that began last year has surely delayed the compliance programs of some major trading partners of the United States and Europe. International interchange of data may send a failure in one

country rippling through the most rigorously Year 2000–ready systems: the sociologist Charles Perrow calls this "tight coupling." Major corporations are already pressing their trading partners for certification of their Year 2000 compliance. Domestically, this may make or break some firms, but it will not bring down the economy. Internationally, it may trigger local crises that might lead to mass migrations or insurrections.

The courts have only begun to consider legal liability for Year 2000 failures. The cases already on the docket will test one of the law's principles: to decree retroactively but to create predictability. Because Year 2000 cases will raise new questions and provoke immense claims, the litigation will be prolonged and sometimes ruinous.

The most serious wild card of all, though, is a hardware issue. Most discussions of the Year 2000 Problem focus on the difficulty of repairing and testing software, but that is a cinch compared to dealing with the thousands of embedded microchips that control critical systems. The Gartner Group estimates that 50 million embedded devices may malfunction. Traffic signals and freeway entrance metering lights will fail. Elevators will shut down if their electronic hardware tells them they have not been inspected for nearly a hundred years. (The largest elevator manufacturers deny their products are vulnerable to y2k failure.) Electric power distribution switches and pipeline controls will interrupt energy flow. Medical x-ray machines will not turn on—or far worse, off—at the proper times.

(There is an alternative final E in SMILE: the euro, the new European currency scheduled for introduction in 1999. Conversion of existing financial programs and historical data for euro compatibility competes for scarce programming time with Year 2000 conversion projects, and bugs in new and revised financial software may compound Year 2000 errors.)

No matter what its outcome, the Year 2000 Problem will stamp a cohort of managers, private and public, as it will put some of their predecessors on trial. Generation X will become Generation YY. Like other powerful events, Year 2000 will alter culture. But we don't know how, because it will have many surprises, positive and negative, for even today's most informed analysts.

The Year 2000 Problem shows that neither military nor civilian authority, neither social democracies nor authoritarian regimes nor market economies, neither big business nor small business, took fully adequate steps in planning for the future. And now, those seeking to discredit all established elites are coming into their own. Gary North, a PhD historian and founder of the Institute for Christian Economics, not long ago was a prolific but obscure lay theologian criticized by some mainstream evangelical conservatives for his mix of radical theocracy and financial doomsaying. Now enjoying the survivalist good life on an Arkansas property with a private natural-gas well, he runs the Internet's scariest y2k Web site, deftly collating the most frightening speculation available from establishment sources.

The future prestige of technological leaders is as problematic as the fate of political elites. Bill Gates apparently has never responded publicly to Peter de Jager's impassioned plea in the August 1997 issue of *Datamation* for a formal declaration of the urgency of action on Year 2000. A surprising number of nontechnical people still expect that Gates will find a way to fix the problem. Paradoxically, surveys of public opinion, independent of the millennium issue, have shown least public confidence in the insurance industry and greatest confidence in executives in the technology industries, yet insurers may well emerge less damaged in the early 2000s than some of the software producers. Prudential is often cited as an exemplary pioneer of conversion management.

Supposedly insulated from market pressures and encouraged to take the long view, universities seem to be as badly exposed to Year 2000 troubles as other organizations. Nor did any of the leading engineering, scientific, or business associations, or the best-funded think tanks, sound any early warning that I have been able to find. A few journalists did bring the issue to their readers' attention as early as the 1980s.

If centralized technological planning is discredited, if the discipline of markets (such as securities analysts' reports and insurance underwriters' risk assessments) has failed to give timely warning that cannot be ignored, what is left? Perhaps it is the realization that technology is not just a radiant future but a messy present, that the age of transition never ends, and that rapid novelty and massive legacy can interact to create lethal assumptions. The first of January 2000 will not be the first danger point, and it will be far from the last. Nobody can predict just what lessons will be learned, what concepts introduced, which individuals acclaimed. The outcome of y2k will change everything, but if we already knew what will be changed, there would have been no Year 2000 crisis, only a problem.

The Dark Side
of Tinkering

U.S. News & World Report, Vol. 131 Issue 26

Crime once took skill, but now it often relies on clever misuse of everyday objects. Until September 11 the humble box cutter was the Yankee counterpart of the Swiss Army knife: rugged, versatile, curved for a powerful grip, the master key to our corrugated-clad cornucopia.

We may never know just how this little device became a lever of mass murder. Details of the investigation are still secret, but the utility knives that Mohamed Atta and his accomplices wielded that Tuesday were not necessarily concealed from airport screeners; the blades were well under the four-inch limit prescribed at the time by the Federal Aviation Administration. Hundreds of law-abiding American technicians and hobbyists probably carried one on board in an attaché case or overnighter that morning. Yet the box cutter has taught us the power of criminal redefinition of legitimate technology—what might be called deviant ingenuity.

Once we start to look, we see it everywhere. The box cutter itself had a troubled history before September 11. Unlike proudly sinister switchblades and gravity knives, it could be carried legitimately, as a bona fide tool. Yet some cities banned sales to juveniles in the 1990s after outbreaks of gang mayhem.

The honest screwdriver is a basic part of the criminal repertory, standard in burglary and, in the view of the 1980s New

York subway vigilante Bernhard Goetz, even armed robbery. (After shooting the young men he claimed were threatening him with screwdrivers, Goetz in turn disposed of his pistol by breaking it up with one.) A ring of keys can serve as brass knuckles. Even the sports of American childhood have been abused. The baseball bat, long a domestic gangster weapon, has been selling vigorously in lands where bases, balls, and gloves are still rare. In the United States, antisocial kids prime the Super Soaker, a steroidal squirt gun that would otherwise be the height of youthful hilarity, with bleach solution instead of water.

The war on terrorism has turned these annoyances into matters of life and death. It has brought many formerly mundane objects—down to hair spray and nail clippers—under new scrutiny lest they be exploited by public enemies. The conventional view is that advanced technology will save us. Next-generation passenger screeners, for example, may be able to signal even the lethal plastic and ceramic knives that are already available. (And it's about time. Obsidian, a volcanic glass used in Aztec sacrifices, can be flaked sharper than any scalpel.)

Arms race. If only deviant ingenuity were so easy to apprehend. Criminal skills can flourish in societies of ostensibly total surveillance and control, as surprise prison inspections regularly show. Convicts fashion lethal "shanks" from hairbrushes and turn shoelaces into garrotes. And technological trends may be promoting deviant ingenuity faster than they are arming society against it.

To understand why, go back to the 19th century. Serious crime still demanded traditional skills rather than improvisation, and many criminals were gifted enough to have prospered honestly. The nineteenth-century German goldsmith Reinhold Vasters, who may or may not have intended forgery, was so masterly that some of his pseudo-Renaissance jewelry is still displayed in ma-

jor museums. Bank-note counterfeiters might be adept engravers. Safecrackers could have locksmithing skills.

Now technology can replace artisanship, inside and outside the law. Software can help mimic hard currency and divert electronic funds. Today's safes defeat fingertip manipulation, but their attackers use new types of explosives borrowed from the construction industry.

While some skills may have declined, it's easier than ever to learn others. Knowledge once seeped slowly from one culture or craft to another. Centuries passed before the secrets of silk and porcelain were smuggled from China. Now guild barriers have broken down, and technology helps knowledge spread almost uncontrollably, as the nuclear and chemical manuals found in al Qaeda safe houses in Afghanistan show. The Internet is only one of many channels; technological changes from dry-process photocopying to inexpensive fax and long-distance telephone service have also sped the flow of knowledge.

A would-be arsonist or bomber can easily summon a world of expertise. Ever since a Molotov cocktail appeared on the cover of a leading literary review, information on far more destructive homemade explosives has filled bookshelves and Web pages with titles like The Anarchist Cookbook. Timothy McVeigh's Oklahoma City fertilizer bomb was just the most horrific of these. Entire publishing companies specialize in taboo knowledge.

Many other criminal methods are simply passed along by word of mouth. The art of grinding up time-release tablets of the prescription painkiller OxyContin has transformed it into the scourge of rural America, "hillbilly heroin," spread rapidly from one abuser to another, producing a chain reaction of addicts who become suppliers.

Or consider auto break-ins. The old method used a special tool called a slim jim that had to be expertly manipulated. The

new style required cunning to develop but takes little skill to execute. Small jagged ceramic fragments, for example from broken spark plugs, can shatter side window glass silently when thrown correctly. On the street they're called ninja rocks. Unlike the slim jim, the ninja rock looks like a bit of junk. Only with a string tied to it—as possessed by one unwisely frugal thief in a Southeastern state not long ago—does it become a prosecutable burglary tool.

Such inventiveness also spreads in developing countries. In Borneo, the telephone company was baffled by the theft of 3,500 pay phones. The culprits were fishermen who attached the handsets to powerful batteries; feedback from the microphone to the speaker emitted a tone irresistible to tilapia.

Because deviant ingenuity is so flexible, it is hard to fight without creating new kinds of criminality. Making drivers' licenses secure against photocopying has discouraged casual forgery but stimulated sales of "genuine" documents by a few corrupt license bureau employees. Limiting purchases of spray paint to thwart graffiti writers not only has inconvenienced legitimate shoppers but has helped turn vandals toward the even more damaging tactic of etching subway glass and shop windows with sharp objects and acid.

And banning things because of their potential for terror may also defeat pro-social ingenuity. Consider the total absence of blades on an airplane. In the few cases of throat blockage that cannot be cleared by the Heimlich maneuver, a well-known emergency procedure is to take a sharp knife—a box cutter will do—make a cut an inch below the Adam's apple, and insert a straw or the shell of a ballpoint pen, then breathe. The inventor of this technique was displaying the same talent for improvisation in the service of life that the terrorists were using to spread death. Deviant ingenuity is the dark side of human resourcefulness.

While armed force can deter some threats and electronics may help reduce others, deviant ingenuity remains a moving target. We foresaw many elements of the September 11 attacks, including sleeper cells and the use of aircraft as bombs against landmarks, yet we lacked the wit to see how they could be put together. We have to anticipate the sinister creativity of terrorism. As Milton Glaser, designer of the original World Trade Center graphics and observation deck (as well as the "I Love New York" heart logo), put it, the attack was "a work of the imagination." Only superior imagination can defeat it.

When Systems Fracture
On the Tendency of Advanced Technology to Promote Self-Deception

A REVIEW OF

Inviting Disaster: Lessons from the Edge of Technology
by James R Chiles

Harvard Magazine, November–December 2001

As the enormity of September 11 sank in, a fertilizer factory near Toulouse, France, exploded, killing 29 people and hospitalizing at least 780. The first event was terrorism; French authorities say the other was almost certainly an accident. But think of the technological vulnerabilities the assailants exploited: hundred-story towers with single exits, jumbo jets loaded with fuel. Like potentially explosive chemical plants, these engineering landmarks have become part of the fabric of advanced industrial society.

The independent writer James R. Chiles completed *Inviting Disaster: Lessons from the Edge of Technology* after the happy outcome of the Year 2000 Crisis had calmed technological anxiety. Security against attack is not his major concern. But his book reminds us that even without lethal fanaticism, the hu-

man-made world is more dangerous than ever. Technological risk has not vanished, and indeed the number of disasters and fatalities has multiplied.

There are more potentially hostile states with intercontinental ballistic missiles—meaning more risk of rapid launches and false warnings like those that indicated Soviet attacks in 1979 and 1980. Chemical plants and electric-generating systems operate with unprecedented pressures and temperatures. Superjumbo aircraft and 10,000-container tankers are on the way. Freak accidents can cripple the most sophisticated technology. Last year, an 18-inch strip of titanium on a Paris runway triggered a chain reaction of failures in an Air France Concorde, leading to flames, loss of control, and 113 deaths. Chiles sees these catastrophes as "system fractures," comparing technical defects to the tiny cracks that appear in newly milled aluminum. Harmless initially, they can grow and propagate, especially if the surface is allowed to corrode or if it is cut the wrong way: as was demonstrated when square windows, originally a stunning design innovation, inadvertently promoted a series of tragic breakups of the de Havilland Comet, and with it the British lead in commercial jet aviation. The safety of complex systems demands a series of technical and human measures to keep the cracks from spreading. *Inviting Disaster* is not just an anatomy of failure but a study of successful "crackstopping." Thus, while acknowledging the contributions of the sociologist Charles Perrow, who has argued that some technologies make disasters almost inevitable, Chiles turns more to the classic study of an aircraft carrier as a "self-designing high-reliability organization" by the political scientists Gene Rochlin and Todd La- Porte and the psychologist K.H. Roberts.

Inviting Disaster takes a fresh approach to familiar tragedy. We think we know all about the *Challenger* disaster, but Chiles shows how many of the same problems, especially the cost and

deadline pressures that prevented the solution of technical problems, helped doom a British airship, the *R101,* more than 40 years earlier: pathologies of national prestige technology.

Even without political demands for results, failure also awaits organizations that neglect testing. Chiles tells the stunning story of the Newport Torpedo Station in Rhode Island and its miracle weapon, a proximity fuse triggered for maximum damage by an enemy ship's interaction with the earth's magnetic field. Never tested under battle conditions during the low-budget interwar years, the Mark 14 torpedo failed to explode when finally used in World War II. Its contact detonator, too, failed on impact. As the Hubble Space Telescope later showed, only rigorous testing can check the tendency of advanced technology to promote self-deception. Nor can we count on even highly trained men and women to react correctly under stress; hypervigilance and fixation on assumed solutions can easily defeat common sense. And both machine performance and human judgment can degrade disastrously and suddenly when certain thresholds—in the machines' case, marked by red lines on gauges—are exceeded.

Some organizations have been more able than others to deal with perils like these. Chiles calls them "crack-stopper companies." They encourage employees to admit errors and report their mistakes without fear of reprisals. They assign teams of specialists to comb assembled aircraft for loose parts, debris, and tools that could later prove fatal. In case of doubt, they assume the worst, tearing down and reconstructing systems as Admiral Hyman Rickover, one of the author's heroes, did when nuclear submarines were under construction and compliance of tubing with a specification could not be verified.

We are living on a machine frontier, this book concludes, but we need not be fearful because resourceful men and women can implement proven techniques and concepts such as uniform con-

trol systems for aircraft that reduce the likelihood of operator confusion. Technicians and managers can attain a state "like the satori of Zen Buddhism," following "the Way of the Machine."

Inviting Disaster is absorbing reading, going beyond official reports and bringing readers vividly into some of the scariest places on earth. It presents striking but neglected data: for example, that the Chernobyl meltdown released 200 times as much radioactivity into the atmosphere as the U.S. atomic bombs dropped on Hiroshima and Nagasaki. It also introduces us to concepts of reliability engineering that may not solve our everyday technological woes but at least make them more comprehensible: The refusal of my Honda Civic to start in hot weather (which it never repeats when left with a mechanic) is an example of what NASA engineers call a sneak.

Chiles makes his intended case solidly. *Inviting Disaster* is essential reading for anyone grappling with technological risk. Still, his evidence at times seems to question his own prescriptions. In the 19th century, the explosives manufacturer Lammot du Pont made his employees slosh through water to foil clandestine smoking, but still died in an explosion. During the Cuban missile crisis in 1962, the staff of Malmstrom Air Force Base secretly circumvented safeguards to make it possible to launch their Minuteman ICBMs without presidential authorization. The problem is that they thought they were being flexible and improving the reliability of the system, as were the Chernobyl engineers determined to proceed with tests for upgrading their safety technology. When, if ever, should an automated safety system let operators override it? Never, if they're panicked and in a cognitive lock. Always, if the software or hardware has hidden flaws and the human beings are courageous, resourceful paragons. But how can the machine tell when it's a better or worse risk than the people?

Why can't everybody be like Admiral Rickover and Captain Bryce McCormick, who saved American Airlines flight 96 in 1972 partly because he had requested extra simulator time that gave him vital skills? Why can't all high-risk organizations have the élan and morale of aircraft-carrier crews? Yet Chiles also points out that some of the same can-do enthusiasm may be fatal when other outstanding personalities cut corners in forcing prestigious projects to completion. He does not claim that disasters can be eliminated, only that the principles of high-reliability organizations can reduce their incidence to a level that is acceptable to you and me. But what is an "acceptable" level of risk for thermonuclear war? And is it possible to design effective safety systems for entirely new technologies without having to learn through a cycle of catastrophes like those of the explosives industries and steamship lines?

Inviting Disaster focuses on organizational style, operator behavior, and machine design. It has less to say about danger and the law, beyond recommending full disclosure of incidents. If design and training for high reliability are imperative, do current international standards and laws suffice? Do existing regulations need better enforcement? Or do we need new standards and laws to make all organizations meet the records of the top performers? Who—government or private certification authorities—should police these? Should they act like Admiral Rickover? Safety-conscious firms keep meticulous internal logs of design failures, but how would executives in the fierce global marketplace feel about putting development blunders on the Web?

What about costs? Tragically, a young boy in an MRI machine in a New York hospital was killed recently after being struck by a stainless-steel oxygen tank magnetized and attracted by the device. Is the answer better training alone, or use of aluminum oxygen containers? Could not the safer but costly nonferrous

tanks indirectly pose other risks to health by raising the price of medical services?

The most serious question of all is how long a culture of ultra-reliability can be sustained. Organizations and states decay, even if not always as spectacularly as the former Soviet Union. Market economies, too, are sometimes stressed severely. Standard-setting companies periodically founder. They can forget as well as learn. Will security programs enhance reliability? Antiterrorism initiatives might reawaken interest in innovations like more crash-resistant aircraft design and tighter standards for hazardous facilities. But reliability tends to be about people controlling machines, and security about machines surveilling people. A one-sided concentration on thwarting attacks could drain resources from reducing other and sometimes greater risks. The goal of a high-reliability world seems more distant than ever.

If Technology's Beyond Us, We Can Pretend It's Not There

Washington Post, August 24, 2003

Riding into New York one day last week, not long after power had been restored to the city, I began mentally to inventory the technological systems around me. I recognized the rough stages of roadwork on the New Jersey Turnpike. Near Newark airport, I saw the new rail link and had some idea how the tracks had been laid and how the trains were controlled. But many of the vital systems I saw were opaque to me. I didn't know what products were flowing from the nearby refineries. And I couldn't name the power stations visible from the road and certainly couldn't tell how they were connected. The electrical network that, as we were recently reminded, crisscrosses North America, remains a mystery to most outsiders. It is an example of what scientists and engineers call a black box, meaning a system that is not directly observable.

Scientifically trained people regard the black box as a challenge to be pried open and analyzed. The trouble is that fewer and fewer machines can be taken apart and understood without special skills and tools. The result is a black-box mentality, a disconnection (voluntary or not) from the way things work, a passive approach to technological systems. I'm beginning to believe that black-box thinking has contributed to America's failure to modernize its electrical grid.

The black box originally referred to a top-secret device on World War II Flying Fortresses—a gun sight with hidden components that automatically corrected for such factors as velocity and wind speed, and provided a relatively untrained gunner with deadly accuracy. The phrase later came to mean any kind of complex equipment not normally maintained or modified by its operators yet often vital to their existence.

In the case of the electrical grid, men and women sitting in control centers throughout North America had been keeping the lights on without any of us being terribly interested in how they did it. Only when a large part of the system crumbled, and 50 million Americans and Canadians were in the dark, did we become curious about the contents of the box.

Lack of curiosity starts early. For decades now, children have made their first contacts with science and mathematics through black boxes. In a 1986 essay, James Blackaby, who was then a curator at the Mercer Museum in Doylestown, Pa., described the difference between the slide rule and the pocket calculator as the shift from tool use—an active style of working with a machine—to tool management. The calculator is orders of magnitude more accurate, and substantially more convenient. But, he wrote, while our hands and eyes participated actively in getting a reading from a slide rule, and while we see all of its parts in operation, the calculator is sealed. The numbers displayed on the upper and lower parts of the slide rule, and the ratios that resulted from the sliding, were themselves a representation of the underlying math—you could see the result taking shape. Calculators eliminated that. We could tell if a slide rule was chipped or warped; we must accept on faith that there is no bug in the calculator's circuits.

Around the same time, the microbiologist and science writer Bernard Dixon wrote a classic essay, "Black Box Blues," on the rise of devices opaque to the users: transistor radios, microwave

ovens, electronic fuel-injection systems, even microprocessor-controlled domestic carving knives. Dixon ended on an optimistic note about the new skills that these complex systems made possible. Like him, I wouldn't turn back the clock even if I could—though I find it interesting that the wristwatch industry is once again favoring the familiar analog dial, which provides a direct connection to the passage of time that the digital display never can. It hardly matters that a battery and quartz crystal—rather than a mainspring and escapement—turn the analog hands.

And yet, I'm no longer sure that the shift toward complex systems is as benign as Dixon suggested. America's technophilia is a love of consumption, not necessarily of understanding. We were not always so.

Ironically, while our daily lives have never been more imbued with technology, we may have reached the height of our technological engagement as long ago as the 1920s with its generation of hands-on tinkerers. Machines were cruder then, but more open. Kids built crystal radio receivers and learned Morse code. Typists developed a touch and rhythm to match their machines. Driving meant grappling with clutches and chokes, and the curious took their cars apart to understand how they worked.

The farm and factory youth of the 1920s and '30s were master improvisers who could work wonders with lathes, sewing machines and drill presses. Even classical music audiences were more open to innovation than they are now. The electronic music wizard (and possible Soviet spy) Leon Theremin, who had an electronic music laboratory near Carnegie Hall, was once the talk of New York. No wonder Ronald Reagan loved to recount his reply to a student who had observed smugly that Reagan's generation had not known space travel or computing: "It's true . . . we didn't grow up, my generation, with those things," Reagan said. "We invented them."

My own generation, the baby boomers, were raised in the twilight of that transparency. In the 1950s, there were still factory tours in my native Chicago, but it was getting harder to find the "scrap" that Cub Scout manuals assumed would be abundant. As the plants closed, beginning in the 1970s, the city and nation lost not only well-paying jobs but the skills and the understanding of how things work and how they're constructed. Many things still made in America are true black boxes: classified military components, for example, and high-end chemicals.

Near Princeton, tourists on U.S. Route 1 once stopped to see the cows of the ultra-hygienic Walker-Gordon Dairy being milked on a slowly rotating turntable called the Rotolactor. The cows departed in 1971, and some of the land is now occupied by a factory in the highly competitive business of flavors and fragrances. With so much at stake, it's not surprising that I have never seen an open house announced. Even the relatively low-tech Kellogg cereal complex discontinued its nationally famous factory tour in 1986. In its place, there is a museum and visitor center called Cereal City USA.

At least the new attractions try to give a sense of what happens inside their plants. The situation at home is much less transparent. Today we can't repair a radio by taking tubes to a local store and testing them; instead, we just get a new radio. The needle wiggling in the groove of a recording has been replaced by the concealed laser beam (not healthy to look at anyway) and mysterious circuitry that decodes a CD. Nor do lay people understand what happens inside the digital home thermometers that have replaced glass and mercury—and which may not be as accurate.

Mechanics can't adjust carburetors anymore; they must run diagnostic checks with expensive instruments. I recently spent $90 (plus tax) to have my local garage troubleshoot a yellow "check engine" light—with no results. If it lights up again, the mechanic

said, further investigation could cost significantly more. Irritated as I am with the vehicle's apparent false alarm, I must acknowledge the positive side of the inscrutable circuitry that caused it. My car's black-box-enhanced technology helps deliver far better fuel economy and zippier performance than the more straightforward controls of earlier models. Like the power grid, our cars can run longer without breakdowns, but the complexity of all black boxes makes the economic consequences of occasional failures more serious.

I am happy enough to cast my ballot using a new-style electronic voting machine rather than one of the former mechanical monoliths. I am also aware, though, that the clunky old equipment could be inspected for tampering, while the proprietary software of high-tech voting equipment remains a black box because its source code is a trade secret.

Ultimately, the power grid is the supreme black box, the one that makes all those other hard-to-understand technologies, from fuel injectors to plasma TVs, possible. It reduced the cost of power and doubled the time between major shutdowns in New York: from 12 years between 1965 and 1977, to 26 years until 2003. But the outage this year [2003] has been proportionately wider, as though following the Law of the Conservation of Catastrophe coined by my teacher, the historian William H. McNeill. By this, McNeill meant that the solutions to one crisis pave the way for some equal or greater disaster in the future.

There are still too many questions about the recent blackout to draw conclusions from the event. On the one hand, the sequence that triggered it took only nine seconds, apparently too short an interval for human reaction to have done much good. On the other, there had been warnings and anomalies for hours, and power managers in New England and the Middle Atlantic states were able to avoid being drawn into the outage.

Whatever investigators will reveal, the events of Aug. 14 show that the technical is too important to be left solely to the technologists and technicians. The more ordinary people understand about their infrastructure and its hazards, the more accountability there will be from utilities, public agencies, and legislators.

In Switzerland, among other places, citizens passionately discuss the aesthetics and economics of public works projects. I once had lunch in Zurich with a semi-retired lawyer, a man apparently in his seventies and not the American picture of a technophile. The dial telephone in his wood-paneled office had decades-old buttons and switches, and yet he was so enthusiastic about the construction of a new tunnel level in the main rail station and the rerouting of the train lines that I regretted I could not accept his invitation to see the work in progress with him. (I've since used the Zurich station, and I understand from its efficiency why he was so excited.)

Few of us will want to return to the slide rule or abacus, but the more we know about vital systems, the less black the box and the more secure we will be. Real technophilia is a national asset. Concealing information, even for security's sake, reminds me of Moscow under the Soviets. The official maps of the city were deliberately distorted for national security reasons. U.S. diplomats and journalists in the capital knew how to get around the problem. They used accurate maps—prepared by the CIA.

The Shock of the Old

Technology Review, December 1, 2001

On September 11, a nation primed for a futuristic attack failed to foresee a low-tech assault. Why?

On September 11, a nation primed for a futuristic attack failed to foresee a low-tech assault. Why?

September 11, when terrorists forcibly diverted two airline flights into the Twin Towers of the World Trade Center and a third plowed into the Pentagon, stunned surprise and inconsolable grief could be our only initial response. Then came an apprehension that will long be with us: How many other terrorist cells are still out there, and will we be able to find them in time?

But to many of those who have followed the scientific and technical side of warfare and terrorism, there was yet another jolt. It was comparable to the horror of the military analysts in December 1941 who had been expecting a Japanese preemptive strike in the Philippines or elsewhere in Asia, but not at Pearl Harbor. Assumptions were fatally wrong. Things were not supposed to be this way. We faced an old nightmare, not the futuristic dystopia of information warfare and massive chemical or biological attack that we had dreaded.

In the 1990s, as advanced systems triumphed in the Gulf War and the Nasdaq index began to soar, conflict was supposed to be

going high tech. In December 1995, for example, a dozen Marine Corps generals and colonels, including the commandant, General Charles Krulak, visited the World Trade Center. They were studying how to master information overload by observing some of the top traders of the New York Mercantile Exchange practicing simulated commodity activity. Later, they conducted simulated combat exercises with 15 traders at advanced workstations on Governor's Island off the southern tip of Manhattan. How could the images on those 69-centimeter monitors have warned them that, less than six years later, the Twin Towers would become the battleground of a domestically launched air war?

Of course we feared attacks from the Middle East and elsewhere in the late 1990s. But the bad guys, we thought, were getting online, just like us. As the year 2000 approached, military and civilian authorities were on high alert, not only for accidental failures of vital systems but for cyberattacks using the date change as a smoke screen. Yet the nation's pipelines and electrical grids survived the new year without incident. Even the powerful anti–U.S. emotions of the Kosovo war produced no serious assault on the U.S. infrastructure. Only too late did we realize what a cataclysm had been in preparation.

Our tragic mistake was not that we pursued the new. It was that we neglected the old. And it's a pattern that could have troubling implications if we don't recognize its applicability to other key parts of our technological culture.

In the case of the September 11 attacks, as journalists soon realized, the terrorists' methods were surprisingly low tech. In fact, the technologies involved had been established for a generation—30 years, plus or minus five.

While the building design was tested to withstand a hit from a 707 jet, the Boeing 747, with its immense fuel loads, was already in service by 1969. The terrorists also apparently needed no so-

phisticated knowledge of automatic pilots and global positioning satellites. They had simply, and all too well, learned the classic principles of flying.

The immediate goal of the hijackers was also a 1970s concept: stunning the world with photogenic violence, as at the 1972 Munich Olympics. Thanks to satellite feeds, cheap color televisions, and the Internet, these images could now have a more rapid and vivid impact, but the principle was old hat. So was the idea, dating at least from the time of the Ho Chi Minh sandal—carved by resourceful Viet Cong soldiers from rubber tire segments—that the improvised technologies of poor countries and peoples might humiliate the West. The terrorists understood all too well this neglected feature of technology: With enough determination, practice, and time, mature and even seemingly outdated tactics and devices can be reborn.

What can halt future attacks? The events showed the limits of communications monitoring and satellite surveillance. The question remains whether more ambitious programs like the FBI's troubled Carnivore email-sniffing technology or facial recognition software will unearth new data on terrorist activity, or simply compound the familiar problem of information overload and produce an illusion of control. The frequent false alarms from even the simplest home security systems are already a plague for the police.

We obviously need to think more about protection from both newer and older forms of attack. One common feature of both is reliance on personal networks. The terrorist cells' apparent methods of recruiting from the same regions, clans and families, and moving frequently from base to base, make them difficult to infiltrate conventionally—but they also reveal patterns to experienced analysts, making more targeted technical surveillance possible. We don't need another decimal place of accuracy from computa-

tional social-science studies but a better intuitive understanding of the terrorists and their civilian neighbors. At the same time, the tacit knowledge possessed by the most effective police officers and detectives deserves more respect. One of our great challenges will be to formalize and teach these elusive skills to security screeners at airports and elsewhere.

But the shock of the old is not limited to breaches of national security. The civil engineer and historian Henry Petroski, in his book *Engineers of Dreams: Great Bridge Builders and the Spanning of America,* points to a 30-year cycle in which a new generation of professionals forgets the hard-won lessons of its predecessors' errors. Indeed, there are signs that many professions have started to lose their technological balance. Many U.S. medical residents, for example, are no longer highly skilled in using a stethoscope to interpret body sounds. The demands of training physicians for tomorrow's biotechnology may be in conflict with the best preparation for hands-on contact with today's patients. Doctors obviously need to know the latest science, but both educational trends and the pressures of managed care make it harder for them to read facial expressions alongside lab reports.

What makes a good lawyer, too, is not just access to databases of legislation and decisions but intuitive knowledge of clients and clients' environments. That's why most lawyers still avoid representing themselves despite all the new tools at their disposal. They're paying not for formal information but for tacit knowledge.

Librarians tell me that students often spend much more time finding certain information on the Web than they would have needed using standard printed reference books. Internet skills are indispensable—in fact, they too are not taught enough—but so is the ability to access the vast body of essential knowledge that has not been and may never be available in an electronic format. The high cost of both electronic and paper information, not to

mention terminals and printers, challenges librarians, but most of them recognize that each mode has irreplaceable advantages.

In fact, engineering itself is not just the application of mathematical equations but a subtle balance of aesthetics, economics, and science in which culture counts as much as calculation. Computer-assisted design can accelerate execution of ideas but can never replace the insight that comes from immersion in the traditions of building. It was the cultural resonance of towers and polygons, used by brilliant designers, that made the targets of September 11 such powerful icons, not simply their acres of usable space.

Just as the Nasdaq's collapse well before September 11 was a symptom of an economy out of balance, so this infinitely greater catastrophe reminds us to seek a new equilibrium between virtual reality and the real kind, between pixels and iron and concrete, flesh and blood. As Dan Rather told his viewers during the ordeal, "This is not a graphic."

The Virus and the Volcano... and Don't Forget the Fugu

Milken Institute Review, July 30, 2020

The Covid-19 pandemic is a reminder of some striking ironies about risk and our tolerance for it in contemporary life. First, in seeking and embracing safety, we have become so confident in our capacity to manage risk that we have inadvertently exposed ourselves to new perils. And second, even as we insist on levels of safety in most circumstances that our grandparents never dreamed of, enthusiasm for risk taking in activities ranging from extreme sports to adventure travel implies that many of us feel most alive at the edge of the precipice.

Traffic Jams on Everest

At the end of February, even as Covid-19 was breaking out of Asia, *The New York Times* reported predictions of a 40-percent increase in Antarctic cruises during the next Southern Hemisphere summer from November to March. It noted that the maiden Antarctic voyage of the *Coral Princess* (yes, sibling to the coronavirus-stricken *Diamond Princess* and *Grand Princess*) will offer relatively affordable rates to 2,000 passengers.

This, despite a warning from the State Department on the growing hazards of extreme weather. Indeed, the cruise companies themselves are not ignorant of this new reality; many are requiring proof of coverage for emergency airlift and treatment in

the nearest hospital for passengers on their adventurous routes. Evacuation and repatriation from ships hundreds or even thousands of miles from civilization, by the way, can cost hundreds of thousands of dollars.

Nor was Antarctica the most extreme form of adventure travel still flourishing in the early weeks of the pandemic. *The New York Times* reported "a growing crowd of Instagram conscious adrenaline junkies planning to try Mt. Everest, many of them with little to no climbing experience"—and all this despite 2019's nightmarish traffic jams of climbers at high altitude and, by no coincidence, multiple deaths.

Capitalism, it seems, has led us in into a perilous place: the marketing of perceived safety that lowers our guard to risk and invites our indulgence in dangerous activities, on the assumption that technology will always be there to save us. Cruise ships are a case in point. The Centers for Disease Control and Prevention reported that from 2008 to 2014, years in which all international cruise ships stopping at U.S. ports were regulated under the CDC's Vessel Sanitation Program, just one in 600 passengers suffered from what was long the bane of ocean travel, acute gastroenteritis. There is still sickness and death on cruises, but not more than on land.

Indeed, patrons had reason to believe that a cruise was safer than air or surface transportation (combined with a stay abroad). Vessels like the *Diamond Princess* are triumphs of computer-enhanced design, making them among the largest and most technologically complex machines that have ever existed. The latest generation are longer than 1,092-foot Nimitz-class aircraft carriers and can transport more people.

Whatever their environmental impact, the cruise lines otherwise seemed a model of operational competence until the pandemic struck. Last year the U.S. Navy asked Carnival Cruises, the

Diamond Princess's owner, for help in improving the maintenance of its carriers. Statistics show why: In 2019, ship related deaths on cruises amounted to just one in 6.25 million passengers, nearly equal to the airlines' gold standard of one in 7 million.

Coronavirus demonstrated the Achilles heel of risk management—the difficulty in planning for risk where experience can be misleading. The cruise industry was familiar with management of another pathogen, norovirus, which attacks the digestive system ("food poisoning") rather than the lungs and is responsible for 400,000 annual emergency room visits in the United States. The far more lethal Covid-19 behaves differently.

In February [2020], the *Telegraph* of London featured a piece on Carnival Lines' Center for Simulator Maritime Training Academy near Amsterdam, where the company's bridge and engineering officers learn to cope with emergencies from fire to collision to terrorism. Keeping an upbeat tone, the writer declared that such realistic training "should also have helped manage" the quarantine of the *Diamond Princess* after Japanese authorities refused to allow it to dock during the coronavirus epidemic. But it turned out that computer simulation had its limits.

Densely populated crew quarters let the virus spread rapidly, yet the ship would cease essential functions if staff were locked down. Japanese authorities' refusal to let the ship dock for two weeks made it inevitable that the virus would infect more passengers as asymptomatic crew members continued to deliver meals. During the quarantine, over 700 passengers and crew were infected, and four died.

But the failure to contain Covid-19 on an otherwise well-managed cruise ship revealed a second weakness: dependence on the safety of interconnected systems. In March another Carnival cruise ship, the *Grand Princess,* was held in quarantine off the port of Oakland after returning from Hawaii. One passenger on a previ-

ous cruise to Mexico was thought to have spread the infection to crew members, nineteen of whom as well as two passengers tested positive for the virus.

Meanwhile it was discovered that a smaller cruise ship on the Nile had spread the virus to its passengers from around the world, including six who returned to Maryland and 12 to Texas. A retired couple from Pennsylvania chose Egypt in part because it had reported no Covid-19 cases and seemed as far as possible from the epidemic's origins in China. By March 17, dozens of other ships around the world with tens of thousands of passengers were reported stranded, and Carnival had voluntarily suspended Princess cruises for two months.

The pandemic affected adventure travel, too. Nepal shut down access to Everest, and the near-paralysis of global air travel alone ruled out similar expeditions. Yet the epidemic helps us see why dangerous activities have been so attractive in the first place. While passengers on vessels like the *Diamond Princess* and the *Grand Princess* seek safety and comfort, other travelers crave adventure—which entails uncertainty and just the right amount of danger.

Technology has enabled a greater range of people to engage in adventure sports and adventure tourism. Most obviously, it has sharply cut the time and cost to reach the desired venue, and it has improved on-site communication. But technology has yielded subtler improvements, too. In the 1960s, improved parachute designs enabled gentler landings and plastic astronaut-style helmets afforded additional protection, opening sport jumping to civilians. And in the more established sport of mountaineering, a host of apparently modest technological advances have attracted a mass following. Nylon and polyester rope have virtually banished the nightmare of breakage, while the elasticity of these materials has usually reduced damage from minor missteps to bruises. New ma-

terials also make possible more extreme sports like wingsuit flying and base jumping.

The Fiery Domain of Hephaestus

The most striking counterpoint to the *Diamond Princess* ordeal is not climbing but another growing adventure activity: volcano tourism, which has become popular enough to warrant an entire textbook for nature tourism planners, *Volcano and Geothermal Tourism*. If a luxury cruise between port excursions is an experience of abstraction from terra firma, volcano tourism is the most intense form of engagement.

Nobody embarks on a megaship like the *Diamond Princess* primarily for spiritual or intellectual insight, but one of the main attractions of volcano tourism is direct exposure to some of the most primal processes at work in a dynamic planet. It reveals that the blue marble seen by space tourists—the one percent of the one percent of adventure travelers—is an illusion. The fiery domain of Hephaestus is closer to reality than the arc of Apollo.

And yes, volcano tourism provides the treasured experience: the perception of well-managed danger. The question is whether the perception can be delivered without the risk.

White Island is a privately owned nature reserve off the coast of New Zealand's North Island. It is a conical volcano (like Vesuvius) located in the Ring of Fire, where the oceanic plate slips. On December 9, 2019, 47 tourists were visiting the uninhabited island, where the volcano had been dormant for a hundred years. The official threat level was at its second lowest (a "2"), and the tour organizers had an excellent safety record. But with hot magma near the surface, and with a sea-level crater that could be seen without climbing, there was always a small but real chance that a change in the level of sea water, or some other small disturbance, could trigger an eruption.

Whatever the cause, in the early afternoon, superheated steam, caustic ash, and boulders the size of beachballs were suddenly ejected some two miles into the air. Twenty-one of the visitors perished. The New Zealand military was able to rescue the other 26, many of whom suffered horrific burns, including lung injuries from aspirating ash and gases.

The White Island eruption followed a pattern all too common in our search for safe adventure. The greatest menace to steamships 100 years ago was fog, not sea ice, and the *Titanic* sank on an unusually clear night. The *Hindenburg* had flown nearly 200,000 miles, some during thunderstorms and lightning at sea, without a mishap. And as we have seen, the safety record of cruise lines in the decade before the arrival of the coronavirus had been impressive. Thus, it is not surprising that some of the casualties of the volcano were passengers of Royal Caribbean's *Ovation of the Seas*, who had chosen the $320 excursion rather than a visit to the *Lord of the Rings* film set.

Together, cruising and volcano tourism—ironically, sometimes by the same people—embody the complexity of our attitudes toward safety and danger. Before the 2008 financial crisis and the Covid-19 outbreak, we perceived ourselves as living in a world of managed hazards, our lives guided by professionals in medicine, engineering, and finance.

We could not eliminate danger. But we could optimize the trade-off between risk and expected reward by spreading its costs through insurance and reducing risk through regulation when consumers cannot obtain adequate information. Yet there is no collective memory that ties disparate risky events such as the mass viral illness on the *Diamond Princess* and the White Island catastrophe to a centuries-long process. It is time for a survey.

King George II Goes to War

Risk culture can be divided into three ages: heroism, rationalization and precaution. Recent research suggests that it would be wrong to call medieval society fatalistic. The era saw great successes in managing the environment, especially the control of flooding in the Netherlands. While theories of the plague and most proposed remedies seem bizarre to us now, we are still relying mainly on an innovation from fourteenth-century Venice, the quarantine, to manage poorly understood pathogens.

Yet there are differences, too. For one thing, there was little understanding of occupational safety and health for the great majority of subsistence farmers and urban artisans. More surprising to 21st-century people is the embrace of danger by the upper classes as a source of prestige, which offers a faint precursor to adventure tourism.

A recent Metropolitan Museum exhibition highlighted the importance of physical danger for the renown of Emperor Maximilian I of Austria (who reigned from 1508 to 1519). Maximilian invited challenges from the most feared professional soldiers of his time, sometimes fighting in tournaments with sharp lances, clad in full body armor while struggling with opponents on foot with swords and axes—and then celebrating his triumphs with works by some of the leading artists of his time despite the ruinous drain on his treasury.

Aristocratic women also participated in the culture of risk. Maximilian's first wife, the immensely wealthy heiress Mary of Burgundy, was an enthusiastic hunter who succumbed after her horse tripped and fell on her.

The knightly ideal of risk never died in the world's militaries, but by the eighteenth century it had faded away among rulers. George II was the last king of England to lead troops personally into battle (in 1743 at Dettingen, now part of Bavaria).

In the same age, what might be called risk management took hold. The Lisbon Earthquake of 1755 shocked Europeans, who believed in a well-ordered universe. Was it literally an act of God? If so, why were so many churches destroyed?

The Marquis de Pombal, Portugal's prime minister at the time, acted more like a technocrat than a theologian. Pombal may or may not have literally ordered, "Bury the dead and feed the living," but his book of principles for disaster relief is still cited today. Employing what amounted to dictatorial powers, he supervised the rebuilding of the city as a model of health and earthquake resistance. (One economic historian even argues that the earthquake was, on balance, a net benefit to the Portuguese economy.)

Pombal, and contemporaries like Benjamin Franklin with his lightning rod, introduced the idea that rational planning could prevent, mitigate, and speed recovery from natural hazards. Enlarged cadres of bureaucrats began to inspect and manage every detail of life. And private insurance companies—also pioneered by Franklin—began to make danger more tolerable by spreading its costs among subscribers. Vaccination, a technological breakthrough of the highest order, began to control the universally feared smallpox.

Some remnants of an older fatalistic culture persisted. In Redditch, England, a town that long dominated European manufacture of sewing needles, the final stage of polishing filled the air with deadly metal dust and abrasives. The young men who had mastered this art typically died in their twenties, accepting the danger that made them some of England's best-paid workers. Indeed, they seemed to glory in it, refusing to wear uncomfortable masks intended to protect their lungs from the dust.

The fatalistic, fast-living Redditch pointers eventually had to accept improved ventilation—and reduced pay as the price of longevity. The new workshop fans were just a start. Beginning in

the mid-19th century, a wave of patents bore "safety" in their titles: matches, pins, razors, lamps for miners, brakes for trains. Lifeboats and life preservers became standard equipment for both ship's crews and passengers.

Some of these innovations introduced new perils—what economists call examples of "moral hazard." At first mine owners seized on safety lamps as an excuse for deeper and more dangerous shafts. Surgeons had to develop special instruments and techniques to extract open safety pins from children's throats. Even so, few doubted that ingenuity could, on balance, save lives.

Unsafe at Any Speed?

This age of risk management lasted well into the 20th century, when critics warned that safer design was needed to prevent, rather than just mitigate, danger. Governments, it was argued, were responsible for ensuring the health of all members of society through preventive medicine. The rational era evolved into a preventive age, perhaps symbolized by Ralph Nader's campaign against the Chevrolet Corvair in the United States, which gave us the ideal of a society that could anticipate future tragedies.

Some social scientists have written about a "risk society" as a new form of modernity in which all forms of danger are managed. Many Europeans embraced the idea in the form of the precautionary principle, which placed a burden of proving safety more squarely on manufacturers than American regulation has done. And the transformation of HIV infection from a death sentence to a manageable chronic illness suggested that technology could master the gravest natural risk.

The Covid-19 pandemic may well follow a parallel course—never has so much technological expertise been mobilized so quickly to solve a biomedical problem. But it has shown how myopic we have been to depend so heavily on science to come to the

rescue. The coronavirus pandemic promises to introduce a new era, one we cannot name yet because we know too little about the epidemic's origins and about how social institutions enabled its spread.

Virus and Volcano, Redux

The virus and the volcano now appear as the two faces of danger in the 21st century. The virus is uncanny—a threat that eludes conventional perception. It is neither a living thing like a bacterium nor an inanimate structure like a mineral. Viruses are so small that all but the freakishly large ones could be photographed only after the invention of the electron microscope. The virus is a vampire depending on living cells to reproduce and harvest energy. Yet natural selection has made some successful viruses alarmingly cunning, staying their effects for weeks as though they had planned a stealth campaign of conquest.

The volcano, by contrast, is sublime—a defiant force of nature sometimes literally in your face. Philosophers, at the dawn of the romantic age, defined the sublime as the awe inspiring, terrifying, mysterious features of the world that remind us of our mortality, but thereby paradoxically affirm the power of our reason in their presence. This seems prescient in explaining the growing popularity not only of volcano tourism but of tornado chasing.

The rationalists of the eighteenth century saw the volcano as a symbol of the secularization of the world view. No longer was lava evidence of the nearness of hell, as many medieval churchmen considered it. It was a natural process, and demonstrating a lack of fear of it could signify faith in the Enlightenment and the age of reason. In 1767, the archaeologist and art historian Johann Joachim Winckelmann and two aristocratic friends defied the fears of their pious Neapolitan guide and servants by organizing a picnic on Mount Vesuvius during an eruption, stripping off

their own clothing in the heat before their perilous meal. It wasn't the first naked lunch, but it was one of the first recorded episodes of adventure tourism.

Put another way, there may be a paradoxical relationship between the precautionary society and the quest for risk. Science and technology sometimes seem to make the sublime safe—a danger, but in manageable form. Tourists in the Chernobyl exclusion zone, reopened by the Ukrainian government for limited tourism, can hear the click of Geiger counters with only a frisson of peril.

... And the Fugu

The most telling example of the market for controlled danger is blowfish gastronomy. There are many species of poisonous fish of the family *Tetraodontidae*, slow swimmers that discourage predators by inflating themselves with air—and harbor a deadly poison as further insurance.

Daring fate by eating fugu (one of the *Tetraodontidae*) is not an ancient Japanese tradition. It is more a product of the modernization of the Meiji era of the late 19th century, when Japan's first prime minister, himself an aficionado, lifted a centuries-old ban. (It remained illegal to serve it to the Emperor.)

The species favored by Japanese gourmets ever since contains a neurotoxin 1,200 times more deadly per milligram than cyanide, and many Japanese, mainly fisherman unaware of the danger, have died from consuming them. But victims have also included risk-seeking celebrities like the kabuki actor Bandō Mitsugorō VIII, a "living national treasure" who ate one blowfish liver too many times and succumbed in 1975.

What makes fugu such a perfect study in the appetite for risk is that, according to those who have tried it at restaurants offering carefully regulated preparations, the flesh of the fish is not exceptionally tasty. Fugu chefs have many ways to enhance the appear-

ance by the most delicate slicing, and the taste by exquisite sauces. But the point, as with tourism to active volcanoes, is a controlled sublime experience in sidling up to the edge of death.

Farmed non-toxic blowfish have long been available, but purists dismiss the concept. What diners are buying is the knowledge that the chef has spent years in training to safely remove the poisonous parts of the fish, a triumph of human mastery over nature and death. While in principle all traces of the neurotoxin should be removed, chefs sometimes leave a very slight amount on their special knives by accident or design. A buzz to the diner's lips signifies the real deal.

The fugu tingle, as it might be called, is evidence of our ambivalence toward danger. The caustic ash near the White Island volcano is another form of tingle.

Conservation of Catastrophe?

Going back to the *Diamond Princess* and White Island, both tragedies remind us of the limits of our knowledge. Epidemiologists and microbiologists cannot anticipate the full range of viral and bacterial threats and are constantly surprised: the *Legionella* bacterium, for example, was unknown until the Legionnaires' disease outbreak of 1976.

Likewise, volcanoes are sometimes predictable, and the CDC was prepared for the Kilauea eruption on Hawaii in 2019 (yes, the CDC does volcanoes, too). But often, they are not, and volcanologists and experienced tour guides are killed, as during the Mount St. Helens eruption in 1980 and on White Island.

As in bridge design (and emergency medicine), technology sometimes advances one disaster at a time.

Volcano tourism displays both a desire for a brief break with the safe world that experts have promised for us on the giant cruise ships as well as a reliance on experts from volcano guides

to fugu chefs in giving us a prickle of danger. It may be that the precautionary society was a mirage all along, that humanity must advance by going through wrenching cycles. As the University of Chicago historian William H. McNeill wrote after the 1987 Wall Street crisis: "It certainly seems as though every gain in precision in the coordination of human activity and every heightening of efficiency in production were matched by a new vulnerability to breakdown. If this really is the case, then the conservation of catastrophe may indeed be a law of nature like the conservation of energy."

In Conversation with... Edward Tenner, PhD

Patient Safety Network, June 1, 2011

INTERVIEW WITH DR. ROBERT WACHTER

Editor's note: *Edward Tenner is an independent writer, speaker, and consultant on technology and culture. He received his PhD from the University of Chicago and has held visiting positions at Chicago, Princeton, Rutgers, the Smithsonian, and the Institute for Advanced Study, as well as a Guggenheim Fellowship. His book* Why Things Bite Back: Technology and the Revenge of Unintended Consequences *is a seminal work in patient safety and is generally credited with introducing the concept of unintended consequences, including those surrounding "safety fixes," to a general audience. His most recent book is* Our Own Devices: The Past and Future of Body Technology. *He is completing a new book on positive unintended consequences.*

Dr. Robert Wachter, Editor, AHRQ WebM&M: What do you mean by the term *unintended consequences*?

Dr. Edward Tenner: I mean consequences that are not just disadvantageous but are actually inimical to the purpose that one originally had. A revenge effect goes beyond a side effect. It isn't only an unfortunate result of a therapy with benefits that outweigh it. It's a result that cancels out the reason for doing something.

RW: Can you give us your favorite example or two from outside of health care?

ET: One typical one that bridges health care and consumer behavior is the filter cigarette. Smoking one is really just as unhealthy as smoking an unfiltered cigarette because of the way the smoker compensates for lower nicotine by inhaling more deeply. That is a frequent theme: People tend to offset the benefits of some safety measures by behaving more dangerously. I don't agree with a few risk analysts who see this behavior as a universal law: Automobile seat belts actually do reduce deaths and injuries, although the record of, for example, antilock brakes is less clear. But it's common for safety technology to backfire.

RW: So when you've written about "revenge effects"—that seatbelts or airbags cause people to go faster. First of all, are they so anticipatable that we should just now expect them? Second, how do you decide then whether the intervention is going to have a net positive effect?

ET: Trying to prevent all revenge effects has revenge effects of its own, so I don't subscribe to the strong form of the precautionary principle, that you shouldn't try anything new unless you're sure it's harmless. This can mean locking in existing revenge effects. In the case of seatbelts and other road technology, I just read in *The New York Times* about how the latest airbags may be more dangerous for drivers who are using their seatbelts. Airbag inflation sufficient for an unbelted person or a large person may seriously injure a person wearing a seatbelt, a child, or a smaller person.

RW: We're going to segue into health care; let me do it via aviation, which is a common theme in patient safety. You have undoubtedly seen discussions that say that the modern cockpit has become so automated that pilots are lulled into a sense of security and no one's on the till anymore. What do you think about

that general philosophy—that although automation may be good, one of the unintended consequences will be that people stop paying attention?

ET: I think that risk has always been there. In fact that risk was used in the nineteenth century to oppose safety signals on railroads. People said that if you had these red and green lights, the engine drivers would just pay attention to the lights and they would neglect their senses. There is a problem that arguments like that have been used against all kinds of really beneficial systems that we take for granted today. I think that it's really a matter of constant training and practice to be able to work in an unsupported or semi-supported mode. It's an organizational problem more than a technological one. I don't think the existence of something that's automated necessarily leads to the abandonment of skills, although the tendency is clearly there.

RW: I'm told that TSA airport screeners are periodically shown an image of a weapon in a suitcase just to be sure that they're awake. Can you envision technological fixes built in to health care to create some almost artificial vigilance?

ET: I don't think it's necessarily a bad idea. The big problem is how far you are willing to go financially in continuing to train people and have people practice to be able to work if the system fails. We saw that in the landing in the Hudson, here was a pilot who was widely considered to be "old school," so the question was raised whether younger pilots who are coming on now would have the same ability to work with the system. Of course some people have also disputed how skilled Captain Sullenberger really was; some people are second-guessing him, saying it might have been safe to go back and land, etc. But it's clear that the public wants heroes, people who can improvise when the automated systems fail, who can somehow pull off a miracle and get the job done.

RW: Checklists are a very hot issue in health care, the idea that things that we've relied on human memory for, we're now trying to encode in a series of manageable steps. What unintended consequences should we be on the lookout for as we think about that as a new strategy?

ET: I like the idea of checklists up to a point. But I'm worried about checklists because they make the assumption that all cases are basically very similar, and that's a normal assumption for professionals. A professional really needs to work to some kind of list of best practices, but on the other hand, when people look at the very best professionals, they're the people who very often have the ability to see something that's different in this case and to investigate it further. I know that in the current medical system that is very hard to do given the workloads and systems of reimbursement, so I'm not blaming people for not being full-time problem solvers. What makes me uneasy about the checklists is the assumption that there is a body of best practices and you just follow that and then you're going to be okay. I don't doubt that in preventing surgical errors, operating on the wrong limb, and that kind of thing, that checklists are very useful. But my real question is to what level? How far should that go?

RW: In computerizing health care, we've seen that alerts designed to cue people to remember that the patient was allergic to medicine, or to do thing x in situation y, are getting ignored because the volume of alerts are such that people feel like they cannot get their work done. Are you familiar with this issue from other lines of work, and what cautions or solutions should we think of around the computerization of patient care?

ET: The false positive problem is one that I hardly have to mention to people interested in patient safety and health care issues, and it's one that also appears in many other safety contexts, for

example, the frequency of alarms. One of the issues in fire alarms is that if they go off too often, then it's very hard to get residents of a campus apartment complex to take them seriously. I was in a building like that, and there were so many false alarms that I'm not sure how many people followed what Public Safety tried to get everybody to do, which was to evacuate every time. So an automated system like that does run the same risks, and I don't have a recommendation for dealing with that. But when you look at accounts of many other kinds of accidents, it often turns out that there was a signal; there was a sign warning of something, but people were used to disregarding it. There is another sociological element, and I hope it isn't widespread in medicine but it is in some other areas, that Harvard Business School professor Scott Snook calls "practical drift"—that is that organizations can start to deviate from established procedures and bend them if in their culture they feel this is really necessary to get things done. Snook was himself a victim of a friendly fire episode, and his experience made him really interested in how organizations go wrong when they are supposed to be as accurate and precise as humanly possible, and his theory emerged from his experience. So I think the combination of a high frequency of alarms and pressure for productivity is potentially dangerous.

RW: Let me turn to solutions, because it does strike me that your work is extraordinarily relevant to what we are doing in health care over the past 10 years, as we've thought about safety and quality problems. The epiphany was to approach these issues as system problems rather than manifestations of individual carelessness or sloppiness—most are good people trying hard and the systems have to be improved. As we think about improving and changing systems, are we always going to be empirically measuring these unanticipated consequences and revenge effects after we're done? Or are there ways to prospectively anticipate that

something is likely to fall off the back of the truck and mitigate it before you've created the harm?

ET: It's possible to imagine the categories of problems that can arise through new technologies or new regulations. I was reading about the controversy over a robotic surgery system that requires a certain number of hours for proficiency and that can produce significantly better results if the surgeon is really experienced and adept, but also might have a greater potential for adverse outcomes if they're not fully practiced and careful. There's enough evidence from that kind of system that when it is implemented people can focus on, first of all, whom do you practice on, how do you get that experience, and then second, how much continuing education a doctor should have to use it. Many of these things can be foreseen. Some of them involve interaction between the technological system and organizational systems and the organizational ethic. There is a concept called the "high reliability organization" that you might have encountered, and that has as its exemplar the flight deck of an aircraft carrier, which turns out to be a surprisingly manageable environment despite the unbelievable apparent physical risk of it, because people have been trained and drilled so well, and are also able to interrupt regardless of rank. That's something that medicine has learned and could continue to learn from, that any member of the team, even the lowest rank, can interrupt something that the commanding officer has ordered if they see a potentially unsafe situation. The worst aviation disaster in history, at the Tenerife airport in the Canary Islands in 1987, occurred in part because the pilot was such a respected authority figure in European aviation that his subordinates didn't warn him. So there are various bodies of work, both about organizations and about particular technologies, that would let people stretch their imaginations in thinking of the possible risks of innovations, and then they could be alert to watch for them and to take ac-

tion earlier rather than to wait until a larger number of events have occurred.

RW: For the physicians, nurses, quality managers who do this kind of work, who are in charge of building new systems, do they need additional training to know about these effects? Is this human factors? Is this engineering? Or do we need an extra person sitting at the table who does this for a living to raise these concerns that we might not think of? We may be too much in the middle of the soup.

ET: I'm not sure if adding another category of professional might not have some revenge effect of its own; that's one of the real problems of the field—when you think you're preventing some unintended consequence, you're actually unleashing another one that could be even worse. In the Gulf oil spill cleanup, we were aware of the damage done by some of the chemicals used against the effects of the Exxon Valdez spill. The analysis of possible unintended consequences is really dependent not on a single body of doctrine or a textbook but on experience in many examples of things going wrong in many domains. It's a form of tacit knowledge. It's something that I have to learn for myself reading into the literature of many different fields, but one of the things that I discovered is when you start following this systematically, you start developing intuitions of the kinds of things that can go wrong. To me it's a little disappointing that the advocates of new technologies under discussion aren't more sophisticated in dealing with these possible unintended consequences. I'm not saying that I think that people should just pull back and not do something new and be paralyzed because there might be some harm, but people could use their imagination more in dealing with the world's complexity.

RW: Do you worry about groupthink? As someone sitting around the table hearing the plan, you can imagine that there probably is

someone thinking, "But what about this," or "Isn't this bad thing likely to happen," but then feeling like they're going to be the skunk at the party?

ET: That really depends on the leadership of the group. If there is somebody in charge of the group who really wants to push something through, they might pay lip service to possibilities, but in practice they're going to find ways around them. This seems to have been the case, for example, in the federal Minerals Management Service. In studying some of the recent mine accidents, I found there was an institutional pressure there to have the most optimistic assessment of just about everything. I don't think that they necessarily thought that they were really creating some danger. I think that it's possible for people to believe that a lot of requirements are really just paperwork—that it doesn't matter whether the systems are really adequate. The culture created at the top is more important than any number of experts that you have there. I spoke at a conference of professional safety engineers a few years ago, and these were executives who were responsible for the whole programs of companies. Their role though was really quite limited—they were not really able to say, "I don't think we should do this." Or they could say that, but they did not have the total professional autonomy to stop something in the way that the lowest ranking sailor on a flight deck can stop something.

RW: And so was their role to raise flags?

ET: Their role was to raise flags and make recommendations, and they took it seriously. My sense was that, although none of them complained about senior management or suggested to me that they were denied the ability to get things done, everything depended on the attitudes and the values of the people at the top. Everybody else in an organization will tend to follow the lead of the CEO. This is true in government, and it would be true in

industry, and I suspect it would also be true in a medical setting. Hospital managers have to be especially aware of the risks of hierarchic organizations. Tokyo Electric Power Co. engineers warned of a tsunami risk several years ago, but TEPCO executives ignored their recommendations. Japan's culture made it harder to discuss the risk. So it might take a certain kind of consistent courage in all parts of organizations to face potential problems rather than to make a series of optimistic assumptions. I think the problems usually come not because people are greedy or selfish or that they don't care, but that their bias and the pressures on them induce them to take an optimistic view of everything.

RW: I think the socio-cultural phenomenon that you've observed in other industries is what we're going through in health care, and we're trying to figure out how to change it. It's a heavy lift.

ET: I can understand that, and I think there's another dimension in health care. One is patient expectations, which can cut both ways. In some cases, the patients themselves might be interested in procedures or medications that might increase the risk for them. On the other side, there is the widely discussed ability of medical professionals, much more than other professionals, to create demand for their services, and those two interact. I'm not saying that that is necessarily a bad thing; sometimes it's a good thing. It can risk life, but it can also help enhance its quality. Either way, though, it sets medicine apart.

Closing disclaimer: *This project was funded under contract number 75Q80119C00004 from the Agency for Healthcare Research and Quality (AHRQ), U.S. Department of Health and Human Services. The authors are solely responsible for this report's contents, findings, and conclusions, which do not necessarily represent the views of AHRQ. Readers should not interpret any statement in this report as an official position of AHRQ or of the U.S. Department of Health and Human Services. None of the authors has any affiliation or financial involvement that conflicts with the material presented in this report.*

COVID-19 and the Swiss Cheese Effect

Milken Institute Review, August 18, 2020

After culture-altering catastrophes, the search for underlying errors that make sense of the improbable seems both natural and necessary. But there's more to gaining insight than identifying who flubbed what. We need to understand the mechanisms by which systemic problems become crises—and these often depend on bewilderingly complex sequences of events.

A Pandemic Like No Other

The Covid-19 pandemic, many would say, was widely foretold. The journalist Laurie Garrett was already warning the world about the risk of a global infection on the scale of the 1918 influenza outbreak in her 1994 book, *The Coming Plague: Newly Emerging Diseases in a World Out of Balance,* and sounded an alarm about the fragile state of global public health in Betrayal of Trust. In September 2019, when Covid-19 may have already leapt from beast to man in China, she wrote an online column for the journal *Foreign Policy* on the approach of "an apocalyptic pandemic."

Between 2011 and 2018, the World Health Organization had fought against some 1,500 separate epidemics. Yet the report of the independent Global Preparedness Monitoring Board cited by Garrett missed an essential feature of Covid-19. It foresaw that a new pandemic would devastate developing countries' economies,

but it predicted that advanced industrial nations like the United States and Germany would lose only half a percentage point of GDP. In fact, while the toll in human life has been mercifully far smaller than the benchmark 1918 pandemic (caused by the H1N1 flu virus), the purely material price has been orders of magnitude greater. The Congressional Budget Office has conservatively estimated an inflation-adjusted toll of $7.9 trillion for the U.S. over the next decade, a 3 percent loss in GDP.

Why did the experts miss the economic threat of the new pandemic? One reason was a confluence of circumstances that synergistically magnified the impact. Like SARS and swine flu, Covid-19 almost certainly originated in China. But Covid-19 had one unexpected, and by now notorious, characteristic: a high degree of contagion during a long asymptomatic period, which made traditional contact tracing inadequate for quarantining carriers. (China was incredibly fortunate that the virus was detected before the mass travel of the Lunar New Year and acted decisively to shut it down.)

It took months for U.S. public health authorities, who had been monitoring travelers from China, to realize the extent to which the virus had been spreading in Europe. Some of the "super-spreaders" never experienced symptoms of their own yet managed to infect dozens. As late as March 8, Anthony Fauci was discouraging citizen use of face masks—a position shared at the time by the U.S. Surgeon General and the WHO. Even as late as May 21, a distinguished group of frontline physicians wrote in the *New England Journal of Medicine* that "we know that wearing a mask outside health care facilities offers little, if any, protection from infection."

Once the value of wearing masks to protect against asymptomatic transmission was understood, a bizarre new obstacle to containment emerged: the transformation of reluctance to wear

masks into a sign of political solidarity with Donald Trump. With hindsight, then, it has not been the virulence of the infection—the 1918 flu and both SARS and MERS were more lethal—but a confluence of obstacles to decisive action that has made the pandemic so grave.

A Slice to Remember

The pandemic illustrates how chains of improbable independent factors can turn unfortunate events into catastrophic ones. Risk analysts call this the Swiss cheese effect (or Swiss cheese model). Imagine slicing a block of Emmenthal that contains randomly placed hollow spaces—the latest thinking, by the way, is that they are caused by tiny particles of hay in the milk, not gas bubbles—and then randomly rearranging and stacking the slices. Every so often the holes will align so light is visible through the stack. If we think of each slice as a potential barrier to some unwanted event, it may be only a matter of time before a new way to stack creates a fateful tunnel.

The destiny of the *Titanic* offers the best-known example. Count the "slices" that had to align:
- the limited maneuverability of the new great liners
- the odd but universal custom (as a parade of captains testified) of maintaining speed through ice fields
- the fairly unusual dark color of the fateful iceberg
- the rare atmospheric conditions that concealed the iceberg's presence
- the smoldering coal fire (the indirect result of a mining strike) that may have weakened the steel used in the hull
- the angle of the collision
- miscommunication with the nearest potential rescue ship, the *Californian*
- the absence of lifeboat drills

Likewise, the severity of the 1918 pandemic was related to eccentricities of timing and vulnerabilities. As the epidemic specialist Dr. Jonathan D. Quick has pointed out, President Woodrow Wilson was so concerned about maintaining wartime morale that he—like leaders of the other belligerent nations—suppressed news of the outbreak until it was too late, resulting in the loss of at least 675,000 lives in the U.S. alone. (Fun fact: The pandemic was called the Spanish flu because only in neutral Spain were newspapers allowed to publicize it in its early days.)

Over a quarter of the U.S. Army contracted the flu—in contrast to Covid-19 and most flus, H1N1 proved especially lethal to the otherwise young and fit—and nearly 30,000 died before reaching France.

The most vivid illustration of the Swiss cheese effect deserves to be remembered alongside the *Titanic* and the pandemic. On March 27, 1977, two Boeing 747s (flown by KLM and Pan Am, respectively) collided on the runway of Los Rodeos airport in the Canary Islands, resulting in a loss of 583 lives.

The pilot of the KLM plane, Jacob Van Zanten, was one of the most respected in Europe—as, indeed, Captain Edward Smith of the *Titanic* had been in transatlantic shipping. Van Zanten trained junior pilots and had been featured in KLM advertising. If the KLM 747 had not required additional fuel, it would have taken off while the weather was clear. But a thick fog rolled in shortly before the plane was due to leave. The terrain was also relatively unfamiliar to both pilots: Because of a terrorist bomb attack on the islands' main airport, the two charters had been diverted to this secondary airport. And because of ground congestion, the two giant planes had to make an unusual maneuver, putting both on the runway at the same time—at an airport with no ground radar and with the planes invisible (thanks to the fog) to the control tower.

Meanwhile, the pilots were communicating with the tower over two-way VHF radios like walkie-talkies, which could render simultaneous speech unintelligible. Van Zanten, impatient to take off, failed to understand that the other plane was in his path. When he did discover it, he desperately accelerated to gain altitude and nearly cleared the Pan Am 747—but instead sheared off its top, killing all passengers in his own plane and sparing only a small number of Pan Am crew and passengers in the nose.

Think of all the cheese holes that had to line up:
- the diversion of the planes due to a terrorist bombing
- the fog that obscured vision
- the added weight of a fresh load of fuel that prevented the KLM plane from clearing the Pan Am plane

Van Zanten's hurry, ironically caused by his need to return to Amsterdam before he exceeded his maximum allowed flying hours

Van Zenten's [sic] vast experience, which made other crew members hesitant to interfere

Tenerife catalyzed a very successful new approach to flying called Crew Resource Management, training that prioritized communication and early identification of potential problems. Crew Resource Management effectively demonstrated that messing with the cheese slices by analyzing social processes can interrupt the accumulation of small failures that lead to very, very big ones.

Could similar approaches prevent epidemics or help reduce their impact? The Swiss cheese metaphor certainly makes it clearer that we really do need to understand the social processes that allow those holes to align catastrophically.

2.
Technology: Leaving It *and Loving It*

The Meaning of Quality

Quality, pilot issue, April 1986

To see it, hear it or taste it is to discover something that has been fashioned with love.

Quality, or the absence of, can pierce like a knife. When this happened to me, the knife was real. It belonged to a cobbler. As a student in Heidelberg in the late '60s, I took my shoes for repair in the picturesque but decaying old town where I lodged. I had bought the American-made shoes from an American retailer that had (and has) a prestigious image, but the heels had worn more quickly than I had expected. Through a courtyard where smudgy blonde children played, I reached an ill-lit shop run by a small, gray-skinned middle-aged man, an apparition from the Weimar-era photography of August Sander, smoking a cheap Rhine-Ruhr cigar. He pried off the offending heel, uncovering a wooden inset presumably used to save rubber, and cackled triumphantly. *"Ami! Ami."* In Heidelberg the word was not French for *friend*; it was German for Yankee, and about as chummy as jerry or kraut.

Unlike his fictional countryman, in John Galsworthy's short story "Quality," set in Edwardian London, he was not standing to death as he finished his last order of superlative boots. But

he knew his shoemaking: His knife had probed other American footgear, and his suspicions were confirmed. A civilization, *my* civilization, had been tried and convicted of contempt for quality.

Long after the shoes were discarded, the feelings remained: wounded national pride, yes, but also interest in how complex and even paradoxical an idea quality can be. I watched as America (and the rest of the world) began to deal with quality more seriously in everything from urban design to consumer safety. Quality is now a goal of civilized life. But trying to measure quality too exactly can be useless and even harmful in the absence of an inner will to strive for it, to make things better than they have to be.

Quality has become an American issue since the Second World War, as we have lost confidence in our products and services. The critique of quality began with a persnickety few and spread over decades to Middle America. When the writer Bernard DeVoto announced in *Fortune* in 1951 that business regularly forces on the consumer products of lower quality than it knows how to make, he still spoke self-consciously for the academic and professional. In the 1950s and early 1960s, liberals pointed to deteriorating product quality in attacking business for hucksterism and planned obsolescence. Meanwhile, cultural conservatives argued that Johnny couldn't read because the public-school establishment put buildings and attendance ahead of academic standards.

In the late '60s and '70s, inflation, the rusting snow belt, the new environmental consciousness, and the triumph of well-made imports all helped to make quality an issue for most of us. *Schlock* passed from garment-district argot to mainstream slang by the mid-'60s. Robert Pirsig's autobiographical *Zen and the Art of Motorcycle Maintenance* (1974) brought a philosopher's search for the meaning of quality, metaphysical and mechanical, to the best-seller lists. By 1980, Barbara Tuchman's essay "The Decline

of Quality" needed to make no excuses for affirming traditional high culture against mass tastes.

Quality can be a sensory experience. To see, hear, or taste quality is to discover something that has been fashioned with love. Quality can be felt in the balance of a fine chef's knife made in Oregon and the silky focusing of a pair of German binoculars. It can be heard in the two-stage click of an Italian sports car door latching shut after a gentle push and in pianist Alfred Brendel playing Liszt. It can be seen in the mellow glow of a pair of bench-made English brogues after five years of professional shining or the sharply visible impression, the "bite," of the letterpress printing and the creamy paper of a volume of the *Oxford English Dictionary* in perfect condition after five decades of use. It can be sensed even in the elegance of a mathematical proof as it is demonstrated by a gifted teacher.

But since we value quality so much, *why isn't there more of it?*

One reply to this question is that we don't always know how to look for it. We take the appearance of some part for the quality of the whole, judging not only the book by its cover and the wine by its label, but the delicious apple by its knobby bottom and waxed surface. Ever since Eberhard Faber coated its Mongol pencils yellow in the 1890s to proclaim the Asian source of their premium Siberian graphite, yellow has been the color of most American pencils; to this day, whenever some intrepid pencil-maker paints an identical product green, complaints pour in about defects.

Another reply is that there is more quality around than we think. Nostalgia clouds our judgment. While many people believe in a golden age of pre-industrial artisanship, in fact our ancestors complained of poor quality too. A few fastidious Renaissance scholars shunned early printed books as crude imitations of genuine calligraphy. Nineteenth-century English critics doubted that the great railroad stations of their day, now regarded as master-

pieces of design and construction, could be considered architecture at all.

Prophets of deterioration often ignore past mediocrity and present achievement. Lamenting the Checker taxi, no longer in production, they remember the legroom but forget the rattles. Deploring the thinner steel of today's cars, they overlook the tougher paint and lesser need for maintenance. And they disregard the large number of people still willing to pay more for the durability of American classics like Kirby vacuum cleaners, Snap-on tools, and Fuller brushes.

Yet we can't take American quality for granted, even in something as simple as a children's cartoon. The crude animation of today's Saturday morning fare makes *Daffy Duck* and *Roadrunner* look like *Fantasia*. Even some of America's most respected hardback publishers use bindings that will fall apart on the nation's bookshelves. If, that is, the nation's bookshelves will hold them. A Los Angeles magazine recently published a bitter article by two Soviet emigres, once worshipers of the label MADE IN THE U.S.A., whose newly ordered bookshelves "rejected Euclidean geometry...so that parallel lines intersected and generally did whatever they felt like doing."

In international trade, problems with quality have hurt us at least as much as high wages and a strong dollar. As recently as 1983, a Harvard Business School study of the U.S. and Japanese room-air-conditioner industries show that the worst Japanese maker had a failure rate that was half that of the best American maker. Our oil tanker fleet is 32nd out of 65 countries ranked for reliability by a New York–based research group.

If the reality of quality is close to the perception, then America has some catching up to do. Most U.S. workers polled in 1985 believed their Japanese counterparts worked harder, more attentively, and with higher standards. Evidently, they think the same

about many Europeans. Are German automotive engineers really the lab-coated *Übermenschen* in the TV commercials? Millions of American viewers seem to think so.

The public sector has been even more depressing. America's space program, once the symbol of technological excellence, is in shambles. Two major satellite-launching failures have followed the explosion of the *Challenger* space shuttle in January 1986. Five percent of young adults are illiterate and 80% of 17-year-old students cannot write an "adequate persuasive letter," according to reports of the U.S. Department of Education and the National Assessment of Educational Progress. The once esteemed Tennessee Valley Authority has not been allowed to operate any of its nuclear reactors for more than a year because of safety violations.

Having put our trust in professionalization and specialization, we have made it harder for any single individual to take responsibility for the quality of a project. Before two suspended walkways in the Kansas City Hyatt Regency Hotel collapsed in 1981, neither the general contractor, the construction manager, the testing and inspection laboratory, the architect's resident inspector, [n]or city inspectors noticed a faulty connection between a threaded rod and a beam, according to Forrest Wilson, a professor of architecture at Catholic University who has studied the accident. Apparently, no one regarded it as his job to notice such a flaw.

If even testers and inspectors have no system for assuring quality, is it any wonder that it puzzles the rest of us? We think we know quality when we encounter it, but when we try to analyze it, we find not a unified concept but a series of paradoxes.

Paradox No. 1. Opposing quality and quantity seems logical, but it is just as natural to link them. The historian F.W. Maitland wrote that there are some thoughts which will not come to men who are not tightly packed. In higher education, "critical mass" is shorthand for the size an academic department must reach to

attract the best faculty and students. Busy parents like to plan what they call "quality time" with children. But research by Dante Stem, a psychiatrist at Cornell Medical College, has shown that the moments most important to a child's development often come unexpectedly. Thus, quality time can depend on appearance simply being around a lot.

Quality is sometimes real to us only after we have assigned a quantitative grade, score, or rank to it. The ancient Olympic Games recognized no second- or third-place winners. There were no time or distance records. The Greeks regarded equality qualitatively. According to Stanford historian Amos Funkenstein, it was during the Middle Ages that people first believed that quality could be made a science. The circles of Dante's Inferno are carefully graded. Ranking the pupils in a class was a medieval innovation that led to our present grade-point averages and percentiles.

In the U.S., as quality became a public concern, we began to hand out stars and merit badges as never before. People eagerly sought out ratings of the best: not only hotels and restaurants, but films, colleges, hardware, software, and corporations as employers. Research began to weigh the quality of life (a phrase first used in the U.S. in 1955) of communities and whole countries; a recent survey at the University of Pennsylvania, for example, ranks Denmark first and the U.S. 27th.

Necessary as quantification of quality seems, it has a price. It makes us magnify insignificant differences in performance. The pressure of standardized test scores brings a cram-school mentality into the classroom. The importance of quarterly earnings reports discourages companies from long-term investment in product improvement. Yet how can we be fair without measurement?

Paradox No. 2. We want quality to be both priceless and purchasable, to be above mere ostentation yet to be available to the highest bidder. Once this was no paradox at all. Quality was what

upper-class patrons said it was. Many of the old masters had to sign contracts specifying their paintings' dimensions and content in detail. Until well into the 18th century, there was no profession of music criticism and no set of musical classics, as the music historian William Weber has shown: Patrons did not quite call the tune, but their tastes mattered. One musical patron of the late 15th and early 16th centuries, Isabella d'Este, Marchesa of Mantua, had instruments constructed to measure, as we might have a suit or dress tailored. The composers she supported wrote pieces expressly for her voice and even developed new musical forms at her direction. According to the *Oxford English Dictionary*, a quality horse in the eighteenth century simply meant one suitable for a **person** of quality. It is only since the nineteenth century that quality has meant an inherent degree of excellence in a product or service.

In the last hundred years, we have loosened the connections between buying habits and social position. Anybody with a job paying above the minimum wage can buy a diamond or rent a limousine at least occasionally. A recent advertising agency study shows many heavy buyers of premium goods to be younger middle-class people who can't always afford more basic items like a house. Meanwhile, upper-class taste now often tends to the folk arts—weathervanes, Navajo blankets, Shaker chairs, and decoy ducks, all made superb. But (originally, at least) for everyday use and not for display or prestige.

Still, the concept of quality has an aristocratic heritage that makes it divisive. "I am too disdainful of shoddy goods," humorist Russell Baker wrote recently. "The word for this condition is 'elitist.' It is a bad word which is meant to make the person to whom it is applied seem despicable." In fact, fastidiousness and ostentation are not easy to separate from the drive for quality. The rarity of a fish may make it desirable as much as its taste;

when salmon was still abundant, medieval London apprentices are said to have protested being fed so much of it. Adam Smith, in his *Theory of Moral Sentiments* (1759), smiled at the connoisseur of watches willing to pay a premium for a useless minute or two of accuracy.

Before the invention of electrolytic extraction in the 1890s, aluminum was so difficult to produce that it had the cachet of present-day platinum; Emperor Napoleon III of France and Empress Eugenie set the places of their most illustrious guests with knives, forks, and spoons of the precious metal. In the past few years, as Japan has lowered restrictions on some food imports and prices have fallen, the once-costly box of grapefruit has disappeared as a prestigious business gift there, though the flavor of the produce has surely not changed. No wonder so many social scientists, since Thorstein Veblen's, if not since Smith's, day, have seen quality as a doctrine for defending privilege.

Paradox No. 3. Quality usually depends on *many* qualities and increasing one may reduce another. Thus, traditional all-cotton American men's blue chambray shirts, which are comfortable because they are absorbent, are now shunned by their original industrial clientele. Reason: One quality (comfort) conflicts with another (practicality). Today's working man prefers the easy care of polyester-blend shirts, which were first introduced in 1953 by Brooks Brothers as a specialty item for the traveling executive. Work shirts, meanwhile, have become upscale leisure wear, selling for $36 and more. Our class metaphor should not be blue collar and white collar, but natural collar and synthetic collar.

Paradox No. 4. Quality can also imply the *limitation* of excellence. Within a market economy and a democratic society, compromises are inevitable. When U.S. industry developed quality control, as the historians Eugene S. Ferguson and Daniel J. Boorstin have shown, it was to maintain predictable—not necessarily

the highest possible—quality at low cost. This statistical approach does not always support what Veblen called "the instinct of workmanship." The marketplace is just as likely to demand low price with so-so quality as high price with high quality.

Likewise, quality control in education is ambiguous. The scientific study of children's reading levels, begun with the commendable goal of systematic progress for all pupils, has helped reduce the vocabulary of textbooks so drastically that it is hard to find the word "because" in elementary-school readers. The apple on the teacher's desk and the text on the pupil's were both meant to be of high quality in a certain way: bland, inoffensive, standardized, tested, nationally transportable. Quality as uniform goodness drives out quality as peak performance—or rather it drives some of us from supermarkets and public schools to farmers' stands and private academies.

In fact, a shift to premium goods and services does not necessarily show the prevalence of quality in a society; rather, it can be a warning sign. The political economist Albert O. Hinchman has suggested that the middle range of quality is unstable. Once it worsens, those who can afford to defect pay more for better things. Most upwardly mobile people leave a sinking neighborhood, for example, rather than fight for improvement. Their pursuit of quality reduces further the quality of life of those who can't leave.

Quality, then, is not completely rational. We cannot increase it in our lives merely by making it into a science. Efforts to measure quality and regulate its creation do not, we have seen, always succeed. No, we have to grant quality its moral dimension. Too often we expect excellence to result from something else: the pursuit of money, say, or fame. But instead it should be recognized as a virtue—something to be sought for its own sake—not just a profitable strategy. To the Swiss, with their passion for grace and

precision in everything from pocket knives to highway bridges, quality is second nature. Can we import not just Swiss products but the attitudes behind them?

Whatever Swiss clockwork or Danish furniture or Swedish automobiles have to teach us, we still must follow our own path to quality. We must not restrict our idea of it to a museum-store, anodized-steel designer grail for a discerning few. Our definition of quality has instead to recapture the idea of mass-produced excellence that we gave the Japanese and others.

Certainly there is plenty of evidence that we can do just that. Our aircraft, business and professional schools, industrial research laboratories, computers, steaks, and ready-made suits are still the world standard. Black marketeers the world over covet our blue jeans, cigarettes, and videos. Humble American baked beans line the shelves of Piccadilly's specialty grocers. In Detroit iron still cruises the streets of Havana. Furthermore, we can excel at traditional crafts. The violins handmade by a 33-year-old Michigan artisan lead in international prizes. And young apprentices keep the medieval stonemason's skills alive as they work on New York City's Cathedral of St. John the Divine.

Years after my visit to the Heidelberg Shoemaker, I took one of the last runs of the old Southern Crescent, the train carrying passengers between New York and New Orleans before the Southern Railway turned the route over to Amtrak. The meals were among the finest I had ever enjoyed on any train. Then a few months later I read a newspaper report about a cook on the Crescent killed in a derailment. He was described as having been a perfectionist, bringing his own mixing bowls and pans when the railroad's did not meet his standards. Of course there must have been several cooks on the Crescent, but somehow I was sure he had been mine. Here was America's answer to the shoemaker, a man who spent his life doing something better than it had to be done, for passen-

gers whom he might never see. Some will still think that quality is a mask for privilege, others that it takes a patience and pride of place that are beyond the capacity of the vain and lazy *Amis*. Yet the example of that cook on the Southern Crescent remains. I think we will find ourselves returning to something strong in our own past, best expressed by the critic who described an individual who embodies the ideals of Ralph Waldo Emerson as someone who likes "a good barn as well as a great tragedy."

Digital Dandies

From Function as Fashion to Fashion as Function

MIT Technology Review, January 2005

Some technologies are tools, others are toys, and still others are attitudes. A case in point is the 7280 cell phone just introduced by Nokia. The 7280 is the size and shape of a candy bar. It's unusual not so much for what it has—a built in 640-by-480-pixel camera and voice recognition—but for what's missing. The work of Nokia's Mobile Phones Business Group, the 7280 has no keypad at all. Numbers and names are entered by voice only and are displayed on-screen at a fraction of the size of those on conventional instruments. If less is more, the price is nice, too: about $600 retail.

Unhappy with this design philosophy? A separate Nokia division, Vertu, has just the instrument for you—a personal project of Nokia's design vice president Frank Nuovo. The top-of-the-line Signature has a keypad. It also has eighteen jeweled bearings, spring-loaded with microscopic rubber bands for what Vertu's website calls "the perfect click." The display is made of what Vertu says is the largest sapphire crystal ever offered on the market. The earpiece is made of aerospace ceramic for a warm touch, while the logo is deposited in a vacuum chamber for permanence.

The Signature bezel is offered in platinum and gold; the platinum version sells for an eyebrow-raising $32,000.

But despite all the refinements of the Signature, the 7280 is the more radical technology. Transcending functionality, it is the instrument of the digital dandy. The Vertu is visibly luxurious, but conventionally so. Its buyer is the clockwork connoisseur, the admirer of solidity and complexity. Clockwork connoisseurship first flourished in the 18th century, when the artisans of London and Paris produced not only clocks and scientific instruments of the greatest refinement but also home furnishings with hidden drawers and compartments—more for aristocratic one-upmanship than for security.

In nineteenth- and twentieth-century watchmaking, dandyism diverged from connoisseurship, giving us wafer-thin Patek Philippes on one hand and, on the other hand, self-winding Rolex GMTs carved from solid stainless steel, which told the time in two zones. Connoisseurship is masculine, favoring ruggedization and echoing the battlefield in its love of sandblasted and matte finishes. All-black cameras historically sold at a premium over brushed stainless steel, reflecting the obsession of professional combat and candid photographers alike with avoiding telltale glare.

In the early 21st century, most technological objects may be hybrids, but the connoisseur taste tends to favor the analog, the dandy aesthetic, the digital. Most high-end audio equipment, for example, reflects clockwork connoisseurship. Black finishes, dials with flywheels, glowing meters, big switches, massive cables—all glory in overengineering. Connoisseurship revels in the triumph of solidity over domesticity. The dandy, on the other hand, is a flâneur, a jaded, narcissistic observer well-suited to the 7280, whose screen becomes a mirror when not in use. The dandy's car is a near-silent hybrid, the connoisseur's a Hummer.

The industrial world of the nineteenth century and most of the 20th belonged to the connoisseurs. The baby boomers, far from being culturally revolutionary, may have been the last connoisseur generation, closer to their parents than to their children, who have replaced the floor-standing speakers of the 1960s with the earbuds of MP3 players.

And to connoisseurs' chagrin, the market has rewarded dandyism. Consider the Sony Vaio 505 notebook computer, introduced in 1997. Teiyu Goto, its designer, reportedly insisted on a profile of less than an inch and a magnesium-alloy case at a time when the competition was still using plastic. After some concessions to Sony engineers, Goto held the line at 22 millimeters in thickness, even though an imperceptible additional millimeter could have doubled the hard drive's storage capacity. Despite or even because of this, the 505 was an outstanding success.

At Apple computer, Steve Jobs spent hundreds of thousands of dollars making the sides of his impractically cubic NeXT machine precisely perpendicular. While the NeXT's hardware could barely support its sophisticated operating system, and the platform subsequently vanished, it ultimately gave Jobs the tools to restore Apple's finances and éclat (the Mac OS X was built from the NextSte OS). Apple's current icon, the iPod, is a dandy technology with the solidity, storage capacity, and ergonomics that make it appealing to all but the most diehard connoisseurs.

The 7280 is within the reach of the affluent young; the Signature is for the prosperous and perhaps socially anxious middle-aged. The 7280 reflects the glories of rapid electronic obsolescence; the Vertu denies death—its own, and its owner's.

I'd love to have it both ways. I'd love to think that a solid key click builds character. But dandies don't mind what they're losing. They can always discard the current model when engineers catch up to designers' visions. "Stand out like a flame in the darkness,"

urges the Nokia website. Dandies may sometimes burn good money, but they light the way for the rest of us.

There's the Rub

Convenience Comes with Baggage

MIT Technology Review, September 1, 2005

We know resistance when we feel it. And we're well aware that reducing physical or social inefficiencies can produce big benefits; Jacqueline Krim of North Carolina State University is a pioneering physicist who studies friction and says the U.S. could save $110 billion a year by limiting it. Yet large-scale improvements in efficiency bring out unexpected collective behavior that may introduce new sources of social, if not of physical, friction.

Consider luggage. In the late 1980s, a pilot named Robert Plath borrowed the idea of the in-line skate to develop the first commercially successful wheeled suitcase. Today, most new luggage can roll. For soft cases, the conversion was simple. Not so for some premium models. Halliburton aluminum luggage, which was invented by the oil well-cementing pioneer Earle Halliburton (but is now produced by an independent company, Zero Halliburton), is an incomparable made-in-the-U.S.A. suit of pressed aircraft-grade aluminum armor. It defies the ravages of human and mechanical abuse and is sealed with a neoprene gasket.

At last, the makers of my 50-year-old Zero Halliburton two-suiter have produced a replacement model, the Zeroller, with an elegantly recessed handle and polyurethane wheels. The price

is still steep, $755 and up, but with the convenience of the Web I found excellent mail-order prices. And besides, the latches of my case were starting to wobble.

The problem with this convenience is social, not technical. The airlines, as the *Baltimore Sun* recently reported, have found that wheeled cases, which have grown in popularity since the early 1990s, have encouraged people to pack heavier bags. Facing higher fuel costs, most carriers have begun to impose a charge of at least $50 for bags weighing more than 50 pounds. Whether reasonable cost recovery or stealthy rip-off, the charges mean that the more durable—and thus heavier—the bag, the smaller the free payload. At 15 pounds, a 24-inch wheeled Zero Halliburton Zeroller uses more than a quarter of the domestic allowance; a 26-inch model, closer in capacity to my old two-suiter, weighs 16 pounds, nearly a third. And thus the convenience of wheeled luggage begins to break down. At airports, it is common to see travelers hastily removing heavy items from their luggage and dragging them onto planes in plastic bags.

The transfer of information is not so different from the movement of personal effects. Neither in principle requires nearly as much work as was once believed. In the case of data, the Web has trivialized the effort of searching for knowledge that was theoretically public but too tedious in practice to discover. The New York University communication scholar Siva Vaidhyanathan has even proclaimed "the collapse of inconvenience" to a *Boston Globe* writer, referring to the millions of Web users who employ the pitiless eye of search engines to hunt for awkward personal data, from youthful indiscretions to middle-aged eccentricities and worse.

In popular culture, too, the extension of efficiency to the masses has changed behavior unexpectedly. The CEO who did the most to encourage early television remote control, E.F. McDonald Jr. of Zenith, hated commercials and expected newly empowered, re-

mote-armed viewers to force the replacement of advertising with subscription-based television. They of course did no such thing; even most premium cable channels now feature advertising. But restless viewers did change programming in other ways.

For decades, programmers have been increasing the pacing of their shows. This makes it less likely that viewers will change programs at any instant, but for many observers, the jumpier action makes the shows less effective. Our ability to avoid commercials by fast-forwarding effortlessly through our TiVo-cached and similarly stored programs is making product placement more pervasive.

Finally, the spread of easy electronic fixes to knotty problems can postpone fundamental solutions. The ease of crafting new legislative districts with mapping software has invigorated the ancient art of gerrymandering. And a taxation expert, Joseph J. Thorndike, recently argued in the *New York Times* that electronic income-tax preparation software has removed an important incentive for tax reform: the annoyance of calculating certain taxes. If citizens had to fill out their forms manually to comply with the alternative minimum tax, originally directed at the wealthy but expected to soon snare a third of taxpayers, the tedium of the calculation (by many who turned out not to owe any tax) might have tipped the scales for reform.

I'm not about to do next year's form 1040 on an abacus, but sometimes a bit of inconvenience is just what I need; having a manual transmission discourages me from answering the cell phone while driving. As Vaidhyanathan observed, "It turns out inconvenience was a really important part of our lives, and we didn't realize it."

Plain Technology

MIT *Technology Review*, July 1, 2005

With their creative uses for hydraulic-powered machines, 12-volt conversion technology, fiberglass, and even herbicides, the Amish have a lot to teach the rest of America.

Of all of America's religious communities, few seem less likely to thrive in the 21st century than the Old Order Amish. They are forbidden not only to drive tractors and automobiles but also to install electrical wiring in their homes and businesses. Yet their numbers are doubling every 20 years, and there are 1,600 Amish-owned businesses in Lancaster County, PA, alone, according to Donald Kraybill, author of *The Riddle of Amish Culture* and co-author of *Amish Enterprise*. He notes that more than 90 percent of Amish youth accept baptism and its obligations.

As Kraybill and others have shown, the Amish are so resilient in part because their society tempers discipline with flexibility. Within the decentralized leadership, each bishop allows experimentation before deciding whether an innovation will be sanctioned by the community's *Ordnung*—its oral body of customs and rules. For example, the bishops have generally permitted the use of electrical inverters in Amish shops so they can operate standard 110-volt AC machines like cash registers and typewriters with 12-volt batteries. The Amish receive modern medical care and encourage scientific study of their genetic diseases. Many of their famous black buggies are made of fiberglass. And some un-

baptized youths experiment with automobiles and computers for a few years of *rumspringa* (running around) before they decide whether to join the church.

But although the Amish make certain technological concessions, their way of life, of course, imposes limits, which stem from their core value: *Gelassenheit,* which means yielding to God's will as manifested in the community's leadership. This principle informs their view of formal education: To reduce pride and competitiveness, the Amish do not educate children past the eighth grade.

Self-imposed limitations promote a basic, but valuable, form of innovation. Amish metalworkers have been at the forefront of a revival of horse-drawn agriculture in the United States; the number of horses on U.S. farms increased by 20 percent between 1997 and 2002. Amish shops are leading suppliers of innovative implements—for example, a horse-drawn plow with an external wheel that charges a hydraulic cylinder, which lets a farmer raise and lower the plow with little effort. (Models sold to non-Amish farmers may use rubber tires, forbidden in Amish agriculture.) Amish inventions are of special interest in developing countries, where draft-animal farming is still common.

Amish bishops set limits on the size of companies, so Amish shops tend to have 10 or fewer employees, who are generally Amish themselves. Labor relations are usually excellent, based on teamwork and shared values. When an Amish business grows beyond the prescribed size, the bishops often make the owner sell it, but this can be to the owner's advantage. He is spared the pains of the middle-sized company that needs professional managers and heavy outside financing. His workers learn a few technologies thoroughly. And Amish profits are often reinvested as low-cost loans within the community.

The ban on connecting to the power grid fosters great ingenuity in hydraulic and compressed-air technology, resulting in devices that are often more energy efficient than conventional electric motors. Since stationary diesel engines are permitted, Amish mechanics also gain valuable experience adapting off-the-shelf machinery to run on diesel-powered hydraulic pumps, air compressors, and battery chargers. Power outages have become more frequent in North America but leave Amish farms and businesses largely undisturbed: The freezing rain that shut down the electrical grid in Quebec in winter 1998 had little effect on the Amish farmers who had established themselves in neighboring northern New York state.

The Amish do not all think alike. Many Amish farmers are enthusiastic users of pesticides, herbicides, and genetically modified seeds, which they regard as the God-given means of sustaining their farms and communities. Other Amish (Kraybill estimates 10 to 15 percent) are allied with the Green movement; the Yale University environmental historian Steven Stoll applauds organic Amish farmer David Kline,

whose way of life Stoll calls postmodern: "traditional without being nostalgic, practical without nodding to technology."

Amish life might not be utopian, but it remains one of America's oldest and most robust technological experiments, with something to teach the rest of us. When all else fails, try a little *Gelassenheit*.

Technophilia's Big Tent

A REVIEW OF

What Technology Wants
New York: Viking, 2010, 416 pp.

Issues in Science & Technology, Fall 2010

As the effects of climate change and other environmental stresses become more apparent, some technological prophets are alarmed, while others are more sanguine than ever. Jared Diamond has gone from *Guns, Germs, and Steel* (1997) to *Collapse* (2005). James Lovelock's original *Gaia*, a light of hope in the gloomy late 1970s, has been succeeded by *The Revenge of Gaia: Why the Earth Is Fighting Back—and How We Can Still Save Humanity* (2007) and *The Vanishing Face of Gaia: A Final Warning* (2009). In 2010 Lovelock even told a newspaper interviewer that "democracy may have to be put on hold" to deal with "global heating." An opposing Singularity movement, led by Ray Kurzweil, sees instead a millennial convergence of innovation potentially leading to a new golden age and even the conquest of death itself.

Kevin Kelly's *What Technology Wants* (available October 14 [2010]) is a plea for nuanced optimism. Kelly rejects submission to inexorable trends. To the contrary, while acknowledging the inevitability of change, he recognizes its risks and seeks to promote better choices. He admires advocates of social control of technology such as Langdon Winner and David Nye, and the more radi-

cally skeptical educator and philosopher Ivan Illich, finding value even in the Unabomber Manifesto. Conversely, he lauds Kurzweil's utopian vision only as a myth, "like Superman." A former editor of the *Whole Earth Catalogue,* Kelly the technology critic just wants to know the best tool for the job, whether it's the latest electronic device or the result of 3,000 years of refinement.

Throughout the book, Kelly makes a strong case against nostalgia and for technology's benefits to the welfare of ordinary men and women around the world. He cites studies of the high rate of violent death in early human societies—which could be deadlier than the twentieth century with its horrific wars. Human longevity continues to increase. The world's increasingly urban population is far better nourished and healthier than its peasant forebears.

These improvements flow from the spread of information. The culture we create, Kelly argues, is not so much a collection of things as an ever-multiplying realm of ideas—patents, blueprints, drawings, poems, music—that interact in unpredictable but ever more complex ways, just as the DNA and other information of living creatures has been changing for billions of years, creating an ever richer web of life, evolving into enhanced "evolvability." The technium is the term Kelly gives to this dynamic order, influenced by evolutionary thinkers such as the Russian biogeochemist Vladimir Vernadskii and the French philosopher Pierre Teilhard de Chardin. It's not a spiritual principle for Kelly, though; it's an inevitable consequence of a small number of physical and chemical principles. Beside the pragmatic Kelly there is a cosmic Kelly who forthrightly sees progress as a consequence of the evolution of the universe.

Despite his rejection of vulgar determinism, Kelly urges us to embrace and help accelerate long-term change. Unlike some other enthusiasts, he denies that the new necessarily replaces and obliterates the old. The technium, like life on Earth, is a reservoir of

concepts that often endure even after they go out of favor. Selecting a two-page spread of apparently obsolete farm tools from an 1894–1895 Montgomery Ward catalogue, he discovered in a few hours online that every one was still available in some form because the old designs still served their purpose—as the historian of technology David Edgerton reminded us in The Shock of the Old. But where Edgerton cites such facts to question belief in progress, Kelly redefines progress as the optimal combination of old and new.

Kelly also does not slight the technium's messes: "Hiding behind the 10,000 shiny high-tech items in my house are remote, dangerous mines dug to obtain rare earth elements emitting toxic traces of heavy metals. Vast dams are needed to power my computer." This grimy underside may comprise nearly half the technium. Yet the technium sincerely wants to clean up its act. It offers tools such as satellite photography for making its own environmental costs more transparent and thus influencing consumer and producer behavior. And in the long run the technium is moving to ever-lighter and even intangible objects, from a stack of 78-rpm records to music download with only a minute carbon footprint. Technology analysts have been studying this "dematerialization" of consumption since the late 1980s, but Kelly makes it a foundation of his world view. Technology wants to be lighter. For this reason, Kelly does not subscribe to the view of the economist Nicholas Georgescu-Roegen that entropy is an implacable constraint on the human standard of living. In fact, he believes that the long-term history of the universe reflects a trend from energy to mass to information, a process he calls exotropy, adopting a concept popularized by a radical futurist movement of the 1990s. There may still be no free lunch, but for Kelly it's more important that recipes now can be exchanged globally, virtually without cost.

No matter how bad the situation looks now, the technium has powerful built-in corrective mechanisms. Essential to Kelly's argument is that striving to avoid all adverse results in the future can create problems of its own, blocking solutions as well as disasters. To the Precautionary Principle now popular in Europe Kelly opposes an idea from the 1990s Extropian movement: the Proactionary Principle. Try as many innovations as possible, but monitor them closely for long-term indirect problems. The technium doesn't want prior constraints or advance orders.

The tension between Kelly's green *Whole Earth Quarterly* communitarianism and his *Wired* cornucopianism, between Illich's concept of conviviality and the Extropian Max More's transhumanism, makes *What Technology Wants* a dialectical wonder. Yet there are a few errors. Kelly quotes Carl Mitcham's statement that "[m]ass production would be unthinkable to the classical mind, and not just for technical reasons." But late-classical philosophers undoubtedly read and wrote by the light of mold-stamped clay oil lamps from industrial-scale workshops. One brand, Fortis, was coveted enough to have been counterfeited. Kelly also invokes the alleged dependence of U.S. railroad gauges (and thus of the size of space shuttle rocket engines shipped over them) on the distance between wheel ruts of ancient Roman war chariots—an oft-cited erroneous example of path dependence that has been laid to rest by the economic historian Douglas J. Puffert.

Kelly's assertion of long-term human progress is also hard to prove—or disprove. He sees democracy and equality as among the desires of the technium. And so they often have been. But when the Plains Indian tribes acquired horses from Mexico in the 18th and 19th centuries and expanded their technological capabilities, they became more likely to wage war on each other. More recently, nineteenth-century slaveholders and twentieth- and twenty-first-century tyrants have been enthusiasts and early adopters

of many technological innovations. Is it not possible that the technium, like its avatar Wernher von Braun, is really interested in whatever social order, free or unfree, will advance it most steadfastly at the moment? Was the humorist Mort Sahl closer to the truth when he observed about Braun's work that it aims at the stars but sometimes hits London?

Apart from electronic miniaturization and social networking, the technium's progress has slowed in the past decade. We seem to be losing ground against infectious disease. The threat of pandemic influenza still has no solution, and there is no vaccine or therapy against Alzheimer's disease. The number of new FDA-approved drugs declined by more than 50% between the 1996–1999 and 2006–2009 periods. Only 29 were approved last year. Some epidemiologists have been predicting a "post-antibiotic era" in which we cannot develop new therapies as quickly as resistant strains are evolving. We are also making slow progress in designing radically new energy systems such as nuclear fusion and thorium reactors, announced with great optimism in the later 20th century. The improved but venerable diesel engine is competitive in fuel economy with the latest hybrids. Battery capacity is advancing slowly. Dematerialization is failing to create skilled jobs and investment opportunities comparable to more massive 1950s and 1960s innovations such as the Xerox 914 photocopier. We may yet be able to overcome these challenges, but Kelly does not confront them directly.

In particular, he puts too much trust in the number of patents as a measure of innovation. It isn't necessarily true that each patent is "a species of idea"; it's really a way of disclosing and legally protecting one or more aspects of an idea. A patent, by blocking competitors from pursuing certain paths of innovation, may actually reduce product diversity. The 2008 Berkeley Patent Survey of technology company executives found that patents offer "mixed

to relatively weak incentives for core innovative activities, such as invention, development, and commercialization." Increasing patent applications might indeed signify more creativity, but they might also reflect "salami slicing" of the same work into smaller units, to use a phrase applied to some scientific papers.

Kelly believes that our ability to accelerate cultural evolution is opening a new stage of human consciousness; that we are evolving a growing ability to evolve. He writes that we should "see more of God in a cell phone than in a tree frog," but he is surely also aware that the frog is a miracle of biochemical complexity beside which the phone is primitive and anything but divine. Our real risk is not global catastrophe—I'm with Kelly against the doom-sayers—but banalization, the loss of the variety of the biological species and human languages and cultures that we have only begun to understand. It's the pathos of the technium that no sooner does it start to reveal the wonder of the world to us (through, among other things, images and sound recordings of amphibians and other wildlife) than it threatens to remove them. *What Technology Wants* is a brilliant book, essential reading for all debates on the human future. But despite Kelly's formidable learning and generous open-mindedness, the state of the world economy and environment will leave many readers with the question: What has the technium done for us lately?

Confessions of a Technophile

Raritan Quarterly Review, Summer 2002

The word *technophile* now refers to an avid buyer of complex new consumer electronics, or of other microchip-enhanced goods from refrigerators to amateur telescopes: an early adopter and often a debugger. By this definition I hardly qualify. Yet I still consider myself a technophile.

The meanings of technophilia have changed as much as technology itself. It seems to have begun as an unflattering word introduced by technophobes in the mid-1960s, just as technophobia was a diagnosis favored by technophiles of that era. Each camp sniffed an emerging pathology if the *Oxford English Dictionary* citations are representative. Jacques Ellul included technophiles among "technicians, technologists, technolasters, technophagi, [and] technocrats"; while across the Channel in Harold Wilson's England the New Statesman scolded "the incipient technophobe" for his "rage" against 20 daily motoring deaths "without considering that cars also carry 50 million people and their goods."

While technophobia still connotes only mild condescension—neo-Luddism is now the preferred fighting word on both sides—technophilia has not lost all its stigma. The website of one New England police department even applies the word to compulsive online activity like cybersex and child pornography in a paper by a detective entitled "Technophilia: A Modern Day Paraphilia."

I have my own definition. Technophilia is enthusiasm for the products of human ingenuity, for the craft, skill, and scientific knowledge that helped create them, for the economic and cultural influence that they reflect and exercise, and for their beauty—or sometimes for their inspired ugliness. A technophile does not necessarily love each new product, any more than a bibliophile or an oenophile applauds all books or wines equally. Training one's voice recognition software is a form of technophilia, but so is restoring a vintage typewriter.

The time and place where I spent my childhood and adolescence—Chicago of the Truman and Eisenhower years—made me a certain kind of technophile, neither an authentic tinkerer nor a voracious consumer, but a participant observer of what turned out to be a transitory efflorescence. And just as I still wonder just what kind of technophile I am, I reflect on what Chicago was and what it became. It was a city with a talent for making things but a genius for moving and selling them.

Astrologically I may be a Leo, but geographically I was born under Mars, arriving in a metropolis that had emerged from the Depression into a military-industrial renaissance. In December 1942, less than two years before my birth, Enrico Fermi had produced the first self-sustained nuclear reaction in a University of Chicago squash court. By June 1945, the federal government had poured $926 million into Chicago's industries. Without my realizing it, the outcome of the war would shape my early years.

For all of Chicago's elegant lakefront, its museums and concert halls, it was a tough city further hardened as well as enriched by the war effort. Neighborhoods once stylish or at least respectable had become segregated and blighted. In the better ones, too, countless houses, including the apartment building where I spent the first nine years of my life, were still heated with soft coal that soon left its sooty stippling on each layer of winter snow. Even

after we moved to a small co-op in a greener area when I was nine, there was a coal depot beside the elevated tracks at the station we used a few miles away. Chicago was nonetheless darkly enchanted. My building's coal bin was a grimy netherworld, granular quicksand threatening suffocation of curious children, or so we were warned. Ruling it from his basement apartment was a taciturn old-world janitor named Adam, no ogre, but a chthonic enigma. In the alleys on the way to school high wooden fences concealed cluttered backyards.

Yet the mild sense of menace was thrilling more than intimidating. We were one of the last generations allowed the full and innocent exploration of our surroundings. The capacious Green Hornet streetcars still glided along thoroughfares like Clark Street. And these roomy cruisers expressed a technological style: massively reassuring, windows barred against waving hands, staffed with a cashier collecting fares in the back with an authoritative mechanical chunk, a municipal ship of state clanging its way among lesser craft. Industrial modernism had also planted itself firmly in the home. Our dining room may have been conservative mahogany, but the indispensable kitchen table and chairs were tubular steel, a 1930s innovation delayed by the war and thereafter produced in vast quantities by manufacturers in Chicago and elsewhere.

Considering today's child safety standards, it is a wonder that my Chicago generation survived to adulthood. The swing seats in the playground at Le Moyne Elementary School a few blocks from my house were still hazardously solid wood, not the canvas straps later adopted. On the side there were steps to a vertiginous slide consisting only of two parallel bars, one fitting under each arm. Below, there was cushioning, but not much. We played, in other words, with steel industrial equipment a world apart from the womblike redwood-and-plexiglass zones that have prevailed since the 1970s. We sat unbelted on the front seats of automo-

biles. Family visitors filled our living room with clouds of smoke that lasted for hours after their departure. And there were the weekly sounds of air raid sirens.

Nevertheless, for all the later meditations of psychologists and scholars on the anxiety of growing up facing nuclear destruction, we—or at least I—still had an unshakable sense of safety deriving from a salutary ignorance. Whatever adults might have known, school air raid exercises meant little more than shipboard lifeboat drills. I never visited Commonwealth Edison's Dresden nuclear power plant, opened proudly in 1960, but the outline of my bones in the shoe store fluoroscope was a source of delight rather than alarm. (Even as a graduate student at the University of Chicago in the 1960s and user of the gym, I never wondered what had happened to the radioactivity from Fermi's nearby experiments.)

The military apparatus of the Cold War was almost entirely invisible to us. It was the family automobile, ultimately the nemesis of the Green Hornet, that represented patriotism, and not only because a car assembly plant could so readily produce tanks and vice versa. The car was an encyclopedia of American industries and skills, including Chicago's as well as Detroit's. I do not recall being aware of car assembly plants in the city, but their presence would hardly have surprised me. The odor of the refineries that powered our vehicles was apparent on the southeast margin of the metropolis. One of Chicago's largest factory complexes (and former war plants) was the Stewart-Warner speedometer works on Diversey. My family rarely traveled far enough into the countryside, say to northern Wisconsin or Michigan, to have a concept of wilderness. But the end of the war was starting to extend our horizons: On the site of a former Douglas Aviation plant, about 10 miles from my home, the future O'Hare Airport was being built. Flying was once more a civilian pursuit, benign and glam-

orous, yet also an industry buoyed by the orders and research programs of the Cold War.

Yet if the automobile summarized American achievements in the arts and sciences, there was one kind of car that stood apart: the Cadillac. There must have been Rolls Royces cruising in Lake Forest and Mercedes snug in their garages in Kenilworth, but the Cadillac was the vehicle of civic substance, the measure of automotive technology. As a schoolboy I never looked under the hood of one. But that seemed to be the ideal vantage point for contemplating the vehicle.

My young eye went unfailingly to the shield on the front of the hood. Other brands had their emblems—the Pontiac Indian head, the Oldsmobile rocket—but the Cadillac arms were different. They were proudly complex, a symmetrical array of stripes and wildlife (little heraldic birds called merlets, I now understand) hinting at mysteries like those in which high-ranking Freemasons like the fez-capped Nobles of the Mystic Shrine, the tricycle-pedaling Praetorian guard of Chicago conventioneers, had been initiated. (Chicago's own Zenith Radio, then the world's largest maker, had almost equally magnificent if less European-looking arms.) It was evident that the simpler shield with the bold, angular cross adorning the Chevrolet signified a more plebeian straightforwardness.

The tail fins of late 1940s and early 1950s Cadillacs were masterpieces of serene balance inspired by World War II aircraft. The cultural historian Bevis Hillier has observed that postwar design sought to absorb and neutralize military symbols like balloons, spotlights, and camouflage patterns, and so it was with rudders. But I did not perceive them that way at the time. What impressed me was the bold wrapping of the red plastic shells covering the taillights and the ingenious hinge that revealed the fuel cap when one of the enclosures was lifted. In all, the Cadillac was a majestic sea creature, riding softly on its great, white-walled tires.

If the Cadillac was the nobility of transportation, the Checker taxi—a Chicago brand, though manufactured in Michigan—was its labor aristocracy, proudly utilitarian and minimalist, with the exciting addition of the jump seats that we coveted. The taximeter, with its squarish numerals, the reflected glare of its tiny light, the authoritative [text missing] drop of its flag, its solemn lead seal and colored inspection stamps, was our earliest computer. For ourselves, there was the Schwinn bicycle. Already other brands were known, but hardly any self-respecting Chicago child seemed to have one. The sturdy frame with its curved lines, chrome-trimmed horn inset at knee level, the solid springs under the seat, the balloon tires gamely absorbing the insults of curbs and detritus, and the ubiquitous single-speed coaster brake (in the nearly level Chicago landscape, who needed more?) all made the Schwinn the exemplar of Chicago's forthright and rugged technological style. Even after English bikes with three-speed Sturmey-Archer hubs arrived in the late [F]ifties, Chicago kids still had no idea of Peugeot panniers or Campagnolo derailleurs. We were in love with a self-contained system that had its own idea of luxury: the black Phantom, the costly top of Schwinn's line, much coveted and seldom actually seen.

When we had our hair cut we were still invariably seated in the regal embrace of a Chicago-made Emil J. Pasdar barber chair, with its leather seat and padded arms, its gleaming hydraulic cylinder controlled by a handle that matched its porcelain base, and its adjustable ratcheting headrest. European critics, I later learned, had also marveled at this populist throne. The name embossed on the heavy reversible footplate pressed itself indelibly into my mind, as the company's founder had no doubt intended.

The older I grew, the more I could move around the city, the more its productivity astonished me. To young people of my place and generation, there seemed no opposition between industry and

information. To the contrary, Chicago with its satellites and suburbs was the heartland of an earlier age of calculation and communication. Here was the proud Victor Company, with its rugged manual Comptometers and costly electric adding machines. Beside the elevated tracks at the Fullerton stop the Dietzgen Company made some of the world's most precise slide rules, fitting the cursors with hairlines of spider's silk spun by resident arachnids. (I was not aware of it, but Chicago had once even made its own typewriter, the Oliver.) In neighboring Cicero was the Hawthorne complex of Western Electric, where 48,000 people had worked during the war. At one time it had supplied virtually all of America's telephone instruments. Here were the R.R. Donnelley & Sons Lakeside Press printing plants just south of the Loop, where many of the country's telephone books were printed, along with magazines like *Life* and *Time,* still at the height of their influence. Abutting the Illinois Central tracks was the flagship building, seen by few but railroad workers and rail commuters, its Tudor Gothic facade adorned with the colophons of historic publishers.

Chicago was a capital of the graphic arts as well as transportation, including some archaic skills. A few advertisements for Wrigley chewing gums, another classic Chicago company, were still set using the 150-year-old technique of wood engraving, practiced by a handful of shops in the city 50 years after the advent of the halftone. (Some of our school supply catalogues also had superbly detailed cuts of pen nibs, inkwells, and rare styles of paper clip, all cut in this way.) And in the northwestern suburbs the cartographers at Rand McNally were preparing the country's maps: some distributed gratis at filling stations, others bound in commercial atlases rented by the year at high fees.

Chicago no longer had feature film studios, though local companies like Coronet produced scores of didactic features for the classroom, the multimedia of the 1950s. I learned the magical whir

of sprockets from running my schools' projectors, at least some of which were made by the north suburban giant Bell and Howell. Before the first dry photocopiers arrived from Xerox in Rochester, New York, the mimeograph was the engine of self-publication. A Chicago lumber merchant named A.B. Dick had licensed the patent from Thomas Edison in the 1880s. I still recall the facade, football fields long, of his descendants' factory in Niles.

Before Wal-Mart and Amazon.com and eBay there was our own Sears Roebuck and its omnipresent catalogues and retail stores, not to mention its older rival Montgomery Ward, and Spiegel. It was Ward's and Sears that had urged American farm families to question their local merchants and to rely on their central purchasing and customer service staffs for quality assurance and fair pricing—in other words, that had helped establish the patterns reborn a century later as Internet marketing. Avidly since grade school days I pored through Sears catalogues, glorious summas of nearly all things adult, promising a future bounty that would be Good, Better, and Best—as it classified many of its lines. The locally produced *World Book Encyclopedia* abounded with stylized pictographs of human figures and objects displaying the increase of populations, products, and commodities. And Chicago's own *Encyclopaedia Britannica* adopted the motto of its major shareholder, and my mother's alma mater, the University of Chicago. It read *"Crescat scientia, vita excolatur"* with the poetic translation "Let knowledge grow from more to more, and thus be human life enriched."

If the *Britannica* was a monument to the theoretical and practical knowledge of humankind, accompanied by a guide for truly earnest purchasers who could build a whole reading program around it, the city itself was a reference book, one that distributed goods as well as knowledge. Everywhere there were railroad tracks, not just of the Chicago and Northwestern and the Illinois

Central, the most Chicagoan of the lines, but of most of the glamorous northeastern and western companies: the Pennsylvania with its magisterial keystone, the Chesapeake and Ohio with its homey sleeping kitten, the Santa Fe with its white cross—and the less picturesque but equally distinctive insignia of the New York Central, Rock Island, Burlington, Southern Pacific, Union Pacific, and gritty midwestern lines like Grand Trunk and Nickel Plate. A young Chicagoan felt instantly linked to the entire nation's geography. Each company emblazoned its viaducts as on their rolling stock According to legend, the city received a tax or advertising fee for each of these little signs. Sprayed graffiti on railroad property, as opposed to discretely scratched hobos' marks (which I never saw), would have been sacrilegious even to the coarsest delinquents of the age. Chicago had the awesome responsibility of shifting and coordinating the nation's goods and passengers. Just as true New Yorkers of the day gloried most of all in the global connections of their port (about which Jan Morris has written so powerfully), Chicagoans were constantly reminded of their continental, inland centrality.

Model railroads thus had a special magic for us; they miniaturized part of our own landscape. And they also taught an emerging generation how technical dreams could exceed any budget. A simple oval track layout was supremely boring, and the whole point of the hobby seemed to be to increase the number of switches and the power and complexity of transformers and controllers with their throttles and little glowing red and green lamps, not to mention accessories like loading stations with tiny, magnetized milk cans.

Even the representation of railroads could be engrossing. My father was often absent on business trips, but he brought home the thick timetables of the lines he traveled. The European Cook timetables with their spidery lines are pallid, bureaucratic exercises by

comparison. As the maps that my father brought home unfolded, the lines of the tracks pushed across state borders and time zones as bold black ribbons punctuated by white dots, claiming sovereign control of the landscape, as the rail barons themselves once had. From descriptions of Pullman accommodations—then still run by Chicago's intact Pullman Company—I learned how the industry compressed space as miraculously as its overnight service shrank time, making sinks and beds and sofas vanish and reappear with nickel-plated, spring-loaded fittings that clicked and snapped a little world into order. Railroad accommodations, like the Cadillacs and Buicks, followed hierarchies: from the berths that had been the wonder of European visitors in the nineteenth century but had become the stuff of film comedy, through snug roomettes and compartments, to lordly drawing rooms. As I ventured downtown, I could peer in the Santa Fe ticket office, with its panoramic mural of the Grand Canyon—I recall its gorgeous purple accents, and the chromed steel armchairs provided for customers—in the gleaming terra-cotta-faced Railway Exchange Building on Michigan Avenue.

Not all Chicago businesses were industrial or transportation giants. All through the city I could see evidence of small plants. And I could share supposed insider talk of industrial realities. One of my father's colleagues in public administration, a PhD and attorney, had become an executive with a manufacturer of steel strapping. The family of my brother's best friend ran chemical factories that supplied products packaged under well-known labels. (Industry even had its own ecology; his operations nested in former telephone equipment plants.) The father of one of my own high school friends was an inventor with a factory that made plastic bathtub enclosures. My friend told chilling tales of the mayhem caused by falling through the elegant glass products of the competition. He also enlightened me about the impressive profits of the

hula hoop business and of the alleged multiplier effects of small changes in the cost of plastic bottles on pharmaceutical prices.

Countering these revelations were the patriotic broadcasts of the National Association of Manufacturers (NAM) whose weekly short feature, Industry on Parade, remains one of the finest documentary series ever to appear on television. Each program consisted of three segments of five minutes or so on some factory or research program, quite a few in the Chicago area, introduced with the image of an enormous and slowly rotating gear, as though from a Lewis Hine photograph. The metamorphosis of raw materials into finished products on assembly lines and the mechanical ballets of canning and packaging operations were enthralling spectacles. The intellect and discipline required to synchronize so many moving parts and to make substances amenable to such rapid and uniform handling took my breath away. All these scenes were presented as evidence of the superiority of American free enterprise. Only later did I learn that Communist states had shown similar scenes to show their own young the fruits of "scientific socialism."

We dreaded the Reds as little as we feared traffic accidents. War was, for us, a producer of surplus, a cornucopia of bargains engineered to ferocious Army and Navy specifications: not just clothing and tents but beautifully milled gear trains, impeccable mirrors, little switches like shiny metal bats, and even whole bombsight assemblies released to the taxpayers and their offspring for cents on the dollar. My younger brother was the great enthusiast of such bins, but even for those who did not disassemble and rebuild, there was something inspiring in having the building blocks of hegemony spread out before us. It had to be the grandest of all societies that could virtually give away such riches.

Chicago even had a temple of industry, the Fine Arts Building of the 1893 World's Fair, reconstructed in stone and marble during the Depression with a $6 million bequest from the philanthropist

and Sears Roebuck founder Julius Rosenwald. As a collection the Museum of Science and Industry may not have been in the same league as the Science Museum in London or the Deutsches Museum in Munich, but it was and remains the most visited museum in the city, with a vast model railroad layout, a chick hatchery, a captured German submarine, and a convincing replica of a southern Illinois coal mine, with a scary elevator ride into darkness. One display case offered dozens of beautiful combinations of gears. It had no indication of what each was good for, but it was still my favorite.

In fact, just about all my knowledge of industry had come not from a shop floor but from a window: of a Green Hornet or bus, of an elevated train, [of] an automobile. The mid-twentieth century was a grand time for the American tradition of watching such things work through windows—the operational aesthetic, as the historian Neil Harris called it in his study of P.T. Barnum. After my father's death one of my uncles taught me bowling, and I admired the graceful precision of the new pin setting machinery, boldly sweeping and faultlessly replacing the clattering hardwood with a single dip. Bowling may have been codified in New York in the 1890s, but it had become the great Chicago sport, combining participation with spectatorship, exercise with beer. Somewhere between athleticism and vice, too, was pinball, of which Chicago's Bally Manufacturing was a paragon. On one side it was the most abstracted of physical sports, played through a window; on the other, it was the most kinesthetic of mental games, operated with an interface not of logical circuits but of electromagnets, mercury-based motion detectors, rubber bumpers, and chrome-plated steel balls.

Despite the ubiquity of the window, technology could still be directly tactile. On Wabash Avenue, in the El tracks' shadow, there was still a white-tablecloth family restaurant, Harding's, to which

my mother sometimes took me, and I marveled at the Electric Pen that transmitted the waitresses' orders to the kitchen. I could see the orders written in a lit opening on a continuous roll of paper and imagine them reappearing instantaneously to the cooks. Across the street, Marshall Field had its own pneumatic tube system, a kind of subway for information. I can't remember seeing it used, but I could not help wondering about the journeys that papers might take. In my father's downtown office, I was allowed to play occasionally with the plugs and switches of the receptionist's old-style "private branch exchange" system. Even the elevators were almost a thrill ride; like many in Chicago of the day, they had no interior gate between the passengers and the door but the operator's outstretched arm. And it was perfectly legal: early instruction in what was literally machine politics.

My high school taught other lessons. There was the typing class, which I embraced as a shortcut to speed writing, and in which I discovered that each model typewriter had its own touch: A machine could have a personality. And there was mechanical drawing, with its rigorous conventions. I had no idea what I would ever do with my knowledge, yet it fascinated me as an initiation into a graphic community. The course conveyed not just an appreciation for the beautiful drafting instruments we used and the superiority of center-wheel over side-wheel compasses, but a heady sense of power. We were learning a visual language that could be translated into immense three-dimensional objects. I still can't get over the chaste elegance of a properly drawn dimensional arrow. And the instructor had an admirable pride of place; when we learned how to construct an organization chart he quietly but firmly cautioned us about its limits. It was only a structure of reporting, not of skill or responsibility. Drawing objects was one thing, building them another. For all the precision equipment pouring from the surplus stores, it was not so easy to find parts for

Scouting projects. The handbooks assured us that we could find many parts in scrap, but we no longer knew where to look for a scrap heap. The 1920s cohort had built crystal radios; the 1950s generation tested tubes (though the first transistor radios were arriving); and the children of the 1970s and beyond discarded whole systems when circuit boards failed. World War II had been won with chokes and clutches like those in our day camp vans. The counselors, who seemed to be veterans, pushed and pumped and shifted. But like most of my contemporaries before the Volkswagen and Honda waves, I learned automatic.

Our technophilia was becoming passive. After visiting the Museum of Science and Industry, I recall complaining to high school friends that the Bell Telephone exhibit never really conveyed how the system worked. As a high school senior, I learned why. At a party I met a blind young man with a blue box with a dozen buttons that could make free long-distance telephone calls. He was a phone phreak, spiritual ancestor of today's hackers, the Orpheus of the network, demon lover of the electromechanical.

In fact, what we considered the beginnings of a new information age were really the climax of a century-old one. The Harding Restaurant's amazing Electric Pen, really a descendant of the telegraph, was invented by an associate of Thomas Edison in 1875; Edison had invented the technology of the shoe store fluoroscope, too. When the new, electronic information age arrived, it would come from outside Chicago. The hundred-dollar pocket calculators that appeared at Marshall Field in the 1970s were made by Texas Instruments, not Victor or Dietzgen. Today's home video games are more likely to be from Sony, Nintendo, or Microsoft than from Bally, which found more money in hotels and resorts. Meanwhile the remaining major manufacturing, like Motorola's cellular telephone plants, generally shifted to places like Harvard, Illinois, 75 miles from the city (a facility scheduled to close in

2003), or to plants dispersed even further in the rural Midwest, where an older work ethic was said to survive.

The Pullman complex is now a burned-out ruin, the A.B. Dick site a shopping mall. The Stewart-Warner speedometer plant survives only as a tower in a residential development. And the Santa Fe murals vanished under Amtrak management. The imposing five-story Cadillac dealership/garage near my childhood elevated station was demolished a few years ago to make a parking lot. The marque that once so bedazzled me has left the new generation of Cadillac buyers unimpressed by heraldry of merlets; it survives only in an abstracted form that would have mortified the original so-called Sieur de Cadillac, a resourceful and educated soldier-administrator named Laumet who assembled his crest adroitly from other families' arms, and who also founded Detroit in the process of extending France's empire in the Great Lakes region. Unintentionally Laumet had created the insignia of a now almost-vanished species: the self-made midwestern industrialist.

It is true that Chicago has reshaped itself from the crises and plant closings of the 1970s. Among metropolitan areas it actually ranks higher than New York as a hub of Internet business and an advanced technology center. Bell and Howell no longer makes photographic equipment but does sell information (including most of the nation's doctoral dissertations) online. Emil J. Paidar, battered by imports, turned to medical equipment. A.B. Dick manufactures advanced offset printing equipment in new factories, and Dietzgen remains a leading name in drafting. The former Donnelley headquarters, an official landmark, now houses banks of Internet servers. And the city has worked to retain manufacturing, for example by encouraging A. Finkl & Sons, a leading producer of specialty steels, to maintain its showcase plant along Clybourn Avenue in one of the few remaining, but attenuated, industrial corridors. A rail spur still delivers, across city streets, carloads of

sugar to a remaining candy manufacturer, even if Field's no longer has its signature Frango mints made locally. Both Junkunc Brothers American Locks and Chicago Faucets continue the modernism of Paidar and Checker. Schwinn's new outside owners are reviving cycles with 1950s lines, and a descendant of the founder has his own company, building premium cycles under a new trademark in a small plant in southern Wisconsin. Ford still assembles cars within the city.

Still, factory demolitions remain common, and Chicagoans hardly seem to mourn their lost industrial world. There was little apparent outcry as the Hawthorne [W]orks was torn down in the late 1980s and early 1990s after the Bell System breakup. At the Chicago Historical Society in fall 2001, I found not a single book on the industrial landscapes of the city, such as exist for Philadelphia and Buffalo, among others. I asked a man at the cash register whether it was because none had been published or because there was no demand. He replied, "Both."

Why such indifference when Chicagoans do rally around their historic commercial and residential landmarks? Is it nothing more than forward-looking pragmatism? Perhaps the war and its aftermath were detours from an earlier role as the nation's greatest hub of trade. Chicago had once been a technological miracle. In the previous century its river had to be reversed to assure its shipping, sanitation, and water supply, and the grade level of its downtown raised, at immense cost. But as these projects were accomplished and the railroads built out, the city became a link between the world's greatest farming region and its markets, the classic host of the trade show and convention, the association headquarters of the nation's doctors and lawyers. Already in 1893, the Columbian World Exposition had revealed not so much manufacturing prowess as the city's aspirations to European cultural standards.

Mighty as its factories were, Chicago's true genius was not in production (like Manchester and Birmingham, Pittsburgh and Detroit). It was in distribution. This steel center had neither coal nor iron ore. It was not renowned for training in crafts, except for lettering and typography, with their roots in commercial display. Despite the distinction of the Northwestern and Champaign-Urbana engineering schools, the University of Chicago never established one, unlike nearly all its Ivy League counterparts—even though it was founded during a surge of technological optimism. William Rainey Harper would have liked one, but he could neither persuade the Rockefeller family's advisors nor local philanthropists. The U. of C.'s collegiate Gothic architecture, like the Beaux Arts temporary buildings of the Exposition, were invocations of past glory, in contrast to the bold commercial structures of Louis Sullivan and others that had risen in and near the Loop.

Much of Chicago's manufacturing was tied to its superlative transportation and distribution networks. When Henry Ward Beecher called the post-Fire city "a merchant's beau ideal of paradise," he said nothing about the manufacturer. Its passion was "buying and selling, buying and selling, buying and selling"—evidently not making. Even the city's original Promethean industrialist, Cyrus McCormick, probably owed as much to aggressive marketing as inventive genius and had to fight patent infringement suits for decades. In the late nineteenth century, the city's greatest wonder (and horror) for visitors was the Stockyards, a place of organized disassembly rather than fabrication. In the 20th its most notable monument was the Merchandise Mart wholesale showroom center, with 28 stories on two city blocks, and still the world's largest civilian office building. Even Chicago's steel plants served the railroads more than the automobile industry.

Chicago's vocation was partly in stamping things out, but even more in moving them, literally and metaphorically. There the Tex-

as-born journalist Albert Lasker defined the modem advertising agency and became a multimillionaire with his unforgettable print and later radio campaigns. His successors refined commercial populism to create a Chicago low-falutin' style, which even had a locally designed signature font: Cooper Black. There Leo Burnett created the Marlboro Man, and Joe Sedlmaier filmed the former manicurist Clara Peller ad-libbing "Where's the Beef?" It was to Chicago that Alvin Eicoff brought the nation's finest pitchmen to develop the late-night television commercial in the 1950s. The Popeil family came to Chicago from New York City to demonstrate gadgets on Maxwell Street and later on television, in the famed slicing, dicing Vegematic series of the 1970s. In Chicago John MacArthur and W. Clement Stone built fortunes by making insurance affordable for the poorest families. Even the city's innkeepers were apostles of leveling upward. In 1946, S.J. Perelman recounted a hotel managers' convention in which a Philadelphia proprietor argued for appealing to the "prestige guest"; only to be reminded by a Palmer House representative that today's unimportant customer may be tomorrow's big spender, as indeed many turned out to be.

And in the end what doomed the old Chicago plants was not so much the competition of imports as the very prosperity of the wartime and postwar boom. Behind the humming workplaces of the NAM films, weariness and resentment were emerging that even the best of hours and wages could not allay. Chicago technology was often masterly, but one Cicero steelworker interviewed by Studs Terkel in the early 1970s asked readers to imagine what it must be like if Michelangelo had to paint the Sistine Chapel ceiling time after time, or if Leonardo had to produce the same anatomical drawings over and over. He wanted his son to be college educated, an effete snob (as he put it) who would call

him a dummy. And I doubt that many of the small manufacturers expected their own children to continue their companies.

For the children of the owners and managers, as for those of the workers, the future was in sales and marketing, the professions, and academia. As far as I know, none of my friends from Amundsen High School, at the edge of a still-vibrant manufacturing zone and offering strong science instruction, entered an engineering program. Most of those classmates whose careers I can trace are professors in the Northeast and California.

How can I blame my fellow Chicagoans for losing an industrial vocation they never fully embraced—and one that I certainly did not? But I can't help thinking how many marvelous things, and people, I took for granted. And when I study the history of technology I am always surprised by the vividness and frequently by the pathos of the stories behind artifacts and structures. In the end the love of technology is born of the fascination with humanity.

3.
Organizations, Politics, and Technology

The 737 MAX and the Perils of the Flexible Corporation

Milken Institute Review, October 28, 2019

Sometimes a crisis reveals long-term structural changes in organizations that are otherwise hard to discern. Technical complexity and issues of responsibility when critical systems fail often serve to obscure the weaknesses of the organizational machinery. But thanks to ongoing revelations from a pair of recent airline catastrophes, we can get some insight into a long-developing tension between two iconic corporate models: the flexible organization and the deep organization.

The airline disasters, of course, both involved Boeing's mid-range 737 MAX, the aircraft that was expected to be the company's bread and butter for a decade to come. But by summer 2019, Boeing was widely seen as one of America's most troubled mega-corporations, with its historic pre-eminence over its European rival, Airbus, in play.

Two brand-new 737 MAXs, one operated by Lion Air of Indonesia and the other by Ethiopian Airlines, crashed in a span of less than five months, killing a total of almost 350 passengers and crew. The plane was subsequently grounded worldwide, disrupting global airline schedules and leading to a slew of canceled orders. Yet, even as Boeing engineers scrambled to fix the software and sensor issues thought to have been responsible for the aircraft's runaway behavior, they discovered other problems

that threatened to further delay the planes' return to service until 2020. Airlines that had bet heavily on the 737 MAX because its similarity to older models of the plane would simplify the training of pilots who were already certified to fly 737s were forced to pare flights and in some cases discontinue routes.

Litigation is likely to continue for years after the jets return to service. Some analysts have suggested that using a baked-in software module to prevent stalls—the 737 MAX's Maneuvering Characteristics Augmentation System (MCAS)—is no substitute for an inherently robust design that is more forgiving of pilot error. Others have faulted Boeing's failure to insist on simulator training for pilots already familiar with older 737 models.

Boeing's attorneys, for their part, are likely to probe for lapses in training by the airlines that would allow the company to share the blame. It's worth noting, for example, that co-pilots for some foreign carriers got only 240 hours of training time in the 737 MAX rather than 1,500, as pilots in the United States do. Meanwhile, critics of Washington's new anti-regulatory regime question the wisdom—or even common sense—of delegating some of the FAA's certification procedures to airlines' own technical staffs.

There is still a gap between the short-term damage to Boeing's reputation among pilots and travelers and the market's judgment of the company's long-term prospects. In June 2019, America's most revered pilot, Chesley "Sully" Sullenberger (who had landed a disabled USAir Airbus 320-214 in the Hudson River a decade earlier), testified before the House Aviation Subcommittee that the MCAS of the 737 Max is a "fatally flawed" system that "should never have been approved." And at least one next of kin of the Ethiopian crash, who lost his wife, three children, and mother-in-law in the accident, has been calling for a criminal investigation of Boeing executives.

Yet Boeing's share price has been remarkably resilient. After the Lion Air crash, it fell below $300, but rebounded to an all-time high of $440 just before the March crash. It was trading above $330—close to its precrash 2018 levels—in early August 2019 despite canceled orders and the prospect of delayed 737 MAX certification.

Boeing stock's strength in the face of humiliation reflects policies going back nearly two decades, to the company's decision to relocate its headquarters from its historic home in Seattle to Chicago. In March 2001, *The New York Times* quoted Boeing's chairman and chief executive, Philip M. Condit, calling for a "leaner corporate center" providing more "flexibility to move capital and talent to the opportunities that maximize shareholder value."

Flexibility meant, among other things, the freedom to establish new plants under labor rules and tax regimes more generous than those of the State of Washington. In 2009, Boeing illustrated this flexibility by departing from the conventional high-technology wisdom of choosing manufacturing locations with the deepest pools of skilled labor. Instead, attracted by generous tax breaks from the state of South Carolina and a relatively inexperienced (and largely nonunion) work force, it built a factory to assemble 787 Dreamliners in North Charleston.

This decision compounded the company's embarrassment in the wake of the 737 Max crashes after an investigation by *The New York Times* revealed many cases of shoddy work in the South Carolina plant—including manufacturing debris left in finished aircraft. Within weeks of the *Times* report, the executive in charge of the plant had resigned and was relocating back to his native Australia. And in June, *Bloomberg* revealed that some key software of the Boeing 737 MAX had been developed by $9-an-hour programmers outsourced abroad, the rationale being that

aircraft design was now a "mature" industry in which the skills of elite engineers were no longer necessary.

Meanwhile, a report in *The New York Times* of July 28, 2019, focused on the FAA's delegation of some essential monitoring tasks to Boeing employees—a policy originally praised 15 years ago by the Government Accountability Office for its flexibility as well as questioned for its risks.

Run Silent, Run Deep

Before Boeing became a flexible organization, it was a deep organization. Depth is not just a matter of corporate size or scale. It is an attitude of public responsibility. Executives of a deep organization may strive for the highest possible profits —but only in the context of a perceived essential role in the social order.

The gospel of flexibility, rooted in business-school doctrines of the primacy of shareholder value (as expressed by Condit in Boeing's headquarters move to Chicago), seeks to preserve freedom of short-term optimization and cost reduction. By contrast, the gospel of depth has been mainly a tacit one, based on the idea that a dominant organization has a distinct role in the social order. It seeks to serve multiple stakeholders, to provide safety and security to consumers even if it raises costs and to plan for its long-term future.

Deep organizations have often subscribed to what has been called welfare capitalism, providing impressive health, educational, and recreation services for employees, expecting exceptional loyalty and higher productivity in return. Many, though not all, deep organizations have government ties and semi-official roles. John D. Rockefeller's Standard Oil was not a deep organization in this sense; AT&T before the breakup of Ma Bell was.

The best way to understand the relative shift from depth to flexibility is to compare the launch of the 737 MAX with Boeing's

iconic 747—completed in February 1969 almost exactly 50 years before the crash of the Ethiopian Airlines 737 MAX. Boeing had a rare opportunity. A key customer, Juan Trippe of Pan American World Airways, envisioned an aircraft with two and a half times the passenger capacity and more than double the range of Boeing's workhorse 707, hoping to spark a new era of inexpensive global travel.

Now, in 2019, the post-crashes modification of the aircraft design is requiring months of software fixes and retesting. In 1968, construction of the first 747 from scratch, a plane that was radically different than any existing aircraft, was completed in only 29 months.

Boeing had to build an entirely new factory (the world's largest) to produce it. But the company already had the asset on hand that mattered most, a staff of some 50,000 experienced engineers, technicians, and managers known within the company as "the Incredibles." In contrast to the trial and error of many engineering projects, the 747 was completed with such remarkable precision that the head of the project, Joe Sutter, could predict exactly where on the runway the plane would take off—and test pilots lauded its handling from Day 1.

A deep organization, like Boeing in the 1960s and 1970s, has not only a reservoir of professional skills, but also an esprit de corps that can resist policies that threaten the mission. At one point in the project, Boeing senior management wanted to cut 1,000 of the 4,500 engineers assigned to the 747. But at the risk of his own job, Sutter walked out of the meeting at which the proposal was made; Sutter prevailed.

We should not necessarily blame Boeing's current problems on management shortsightedness. The 747 was a masterpiece, but it was designed to fly efficiently on very long, densely traveled

routes. At first, it solidified Pan Am's position as the flagship global airline. Later, it became a burden.

Pan Am survived for decades by selling its government-protected right to fly intercontinental routes, yet it could not establish profitable new domestic ones. The 747 proved a magnificent flying machine—but an inflexible one, ill-suited to the evolving mission of serving less dense routes.

No Business Like Show Business

As commercial air travel spread beyond the elites in the developing world, a greater proportion of orders came from newer, rapidly growing, cost-conscious airlines in Asia. As noted earlier, the 737 MAX promised not only economy but also greater flexibility because it did not require pilot retraining on simulators. This was especially important because Boeing faced competition from new models offered by its only global rival, the European Airbus consortium. Indeed, it was the announcement of a fuel-saving variant of Airbus's A320 that galvanized Boeing into modifying the 737 rather than investing billions in a true next-generation replacement.

This raises an institutional issue—the first of several that have challenged deep organizations: antitrust. In the 1920s and 1930s, the large Hollywood film studios were classic deep organizations. The vertical integration of most of the giants with theater chains (Columbia was the exception) ensured distribution of a steady supply of films, a mix of ambitious wannabe hits and B movies to fill voracious public demand. In his 1989 book *The Genius of the System*, the film scholar Thomas Schatz celebrated the masterful hierarchies of the studios at their best—their ability to organize thousands of the most diverse talents from script evaluation to scandal suppression. Like other deep organizations, the studios were not just factories but ecosystems.

But independent exhibitors, unable to freely choose what they played, argued that the integration of production with theatrical distribution was a restraint of trade, and the courts ultimately agreed. Paramount set a pattern in 1948 in signing consent decrees separating production studios from theater chains and limiting studios' rights to withhold the films the theaters wanted unless they agreed to show the dogs and cats, too.

While studios managed to retain some of their market power, they increasingly embraced the flexibility of assembling a new team for each project, substituting mixed-and-matched groups of smaller firms and individual specialists for in-house depth. By 1995, the business writer Joel Kotkin and the environmental lawyer David Friedman would write an article in the small-business magazine *Inc.*, "Why Every Business Will Be Like Show Business," celebrating "the network of flexible small businesses that make up Hollywood's entertainment industry." The new flexibility had spawned entrepreneurial specialist companies working together to achieve higher quality films in a more competitive global environment.

A more critical historian, Ronny Regev, in her 2018 book on the industry's labor relations, *Working in Hollywood,* acknowledged that the highly integrated studio system could stifle originality and that the rise of independent production sparked the film renaissance of the 1970s. But she argued that it also magnified the winner-take-all quality of Hollywood culture.

More recently, other drawbacks to the new flexibility have appeared. The major talent agencies, which were once focused on advocacy on behalf of actors and writers, have begun to take the place of the imperious studio moguls. With the rise of Netflix and proliferation of new productions, the Writers Guild has argued, agencies have been profiting at the expense of many of their clients.

What is clear is that antitrust litigation against deep organizations may only substitute new bosses for old. The Paramount decree unintentionally became a harbinger of the future gig economy.

Other deep organizations were almost forced to dissolve by technology. AT&T was for decades a comfortably regulated monopoly, subsidizing local consumer telephone service (especially rural lines) with profitable business and long-distance charges. Arrogant as it could be—it notoriously dubbed handsets made by unauthorized third parties and other consumer-installed equipment as "foreign"—the company had a strong commitment to continuity of service.

In the 1930s, its own vacuum tubes lasted 10 times as long as generic radio tubes of the era. And, in the 1950s, handsets designed by the renowned Henry Dreyfuss and manufactured by its own Western Electric subsidiary, were rated to stand decades of punishing use. One result was the Bell System's astonishing reliability rate of 99.999 percent call completion. In 2011, a senior Google executive acknowledged that the web had yet to achieve reliability even remotely as high.

The emergence of personal computers, satellite transmission and mobile telephones—not to mention the rising tensions created by the price distortions inherent in cross-subsidies among phone customers—made it increasingly difficult in both political and economic terms to sustain the Bell System's hegemony. The regulated monopoly was broken up in 1984.

Without the financial support of the broader company, Bell Labs, a remarkable fount of science and technology, never found a new sustainable role. Its confidence in a rising star, Jan Henrik Schön, to regain its prestige backfired when the German physicist was discovered to have fabricated data. By 2008, having become part of a new entity called Alcatel-Lucent, it discontinued its

flagship fundamental physics program, which had won six Nobel Prizes before the Schön affair.

AT&T was not the only near-monopoly to feel the winds of change. It became increasingly difficult in the late twentieth century for deep organizations to be sufficiently nimble to use their R&D programs to sustain their dominance. An Eastman Kodak researcher created the first digital camera in 1975, and the company continued to invest in the technology. Yet it never led in design or marketing digital photography, as it had in film. Kodak had earlier declined to invest in the dry-photocopying process that its much smaller Rochester neighbor, Haloid, developed into the Xerox 914 machine in 1959.

Xerox, ironically, was soon on its way to becoming a deep organization as well; its Stanford-area laboratory, the Palo Alto Research Center (Xerox PARC) developed the graphic user interface and mouse control that transformed personal computing in the 1980s. Yet the company proved unable to look beyond its base of lucrative corporate, government, and academic clients.

Like other deep organizations, it was so attuned to the needs of its core customers that it was deeply reluctant to take the next step of developing innovations to succeed commercially at much lower price points. It took a radically different culture, that of Steve Jobs' Apple, to transform Xerox's innovations into successful products.

By the late 1990s and early 2000s, the weaknesses of the flagship corporate research centers like PARC had become apparent. A new doctrine of "flexible specialization" developed in the 1980s proclaimed a "post-Fordist" age in which the giant organization and its mass production and distribution systems were yielding to a greater variety of niche products and a greater reliance on networks of suppliers—just as Hollywood was shifting craft work from in-house studio resources to independent specialists.

Looking back at the history of American industrial research in 1996, the historian of technology David Hounshell saw in the end of the Cold War a new era in which ideas were no longer developed internally by the former military-industrial complex. In 2001, two other historians of technology, Scott G. Knowles and Stuart W. Leslie, took a skeptical look at the "Industrial Versailles" of Eero Saarinen's corporate research campuses, observing that these laboratories were often too disengaged with corporations' product development.

All five of IBM's Nobel Prizes were won by research in the company's smaller laboratories closer to its manufacturing plants, they noted; the staff of IBM's flagship Watson Research Center, originally headed by the physicist and champion of basic research Emanuel Piore, won none.

From the perspective of 2020, the state of deep organization in American industry is not as discouraging as it appeared a generation earlier. Google, still an obscure academic startup in the late 1990s, is the old AT&T's successor as a deep organization, hegemonic in the new field of online search as the Bell System had been in telecommunications. In 2017, fully 16 percent of Google employees held PhD degrees, over three times the proportion at Microsoft, Apple, and Amazon. If a measure of a deep organization is its efforts to plan the future privately, it is hard to think of any twentieth-century corporation's plans as ambitious (and controversial) as those of a Google subsidiary for creating a network-controlled smart city in Toronto.

General Motors, once berated for trailing innovations of European and Japanese carmakers, has been rejuvenating its historic research center, founded in 1920, to prepare for a new generation of electric and autonomous (or semiautonomous) vehicles in the 2020s.

To be sure, another twentieth-century titan, General Electric, the direct descendant of Thomas Edison's Menlo Park invention factory, has followed a reverse trajectory, from one of the most admired U.S. corporations to a case study in failure. An original component of the Dow Jones industrial average since 1896, it was removed in 2018.

Jack Welch, the late twentieth-century CEO, seemed a managerial wizard who was able to take GE to new heights of profitability while cutting the company's renowned laboratories to focus on finance. Welch's successor, Jeffrey Immelt, rebuilt research and made new industrial acquisitions, but the wrong ones, like a $15 billion coal-fired turbine business. In summer 2019, GE was trading for only about 20 percent of its peak share price in 1999. No amount of research could offset bad strategic decisions. General Motors, in its relatively strong concentration on its historic roots, seems to have been more successful than the supposedly more flexible GE.

Despite GE's woes, the deep organization appears to be alive and well in what is supposed to be the age of radical flexibility and the gig economy. In fact, a study published by the Bureau of Labor Statistics in 2018 revealed a small decline in the proportion of workers relying primarily on contract employment, from 7.4 percent to 6.9 percent. Whether or not Boeing's outsourcing of software work had anything to do with the fatalities of the 737 MAX, the company remains a deep organization that spends $3 billion in research a year.

Safe at Air Speeds

Organizational depth may not be endangered, but it still needs defense in the age of the flexibility gospel. It may seem wasteful, but it has three great virtues that are more important than ever.

The first is safety. The steadily declining rate of aviation disasters is due to the cooperation of three kinds of deep organizations: the laboratories of manufacturers, notably Boeing; those of research universities with strong aeronautical and mechanical engineering programs; and the resources of the FAA. Understaffed, the FAA delegated 96 percent of approvals on new aircraft to Boeing staff engineers nominated by the company, and those engineers—according to a *New York Times* analysis—failed to brief the FAA adequately about the software of the 737 MAX's antistall system that has been implicated in the crashes. Self-certification is certainly more flexible than duplication of oversight by government engineers. But social institutions sometimes need redundancy.

The second is expertise. In 1989, the information scientist Michael J. Prietula and the Nobel economist Herbert A. Simon published an article in the *Harvard Business Review*, "The Experts in Your Midst," on the wealth of knowledge and capabilities that underappreciated specialists in an organization possess. Theoretically, a lean, agile company might try to substitute outside consultants and temporary workers for in-house talent. Yet because in-house professionals bring years of tacit knowledge to problems, they paradoxically may be better equipped to find solutions than experts unfamiliar with the organization's workings. The sociologist Chandra Mukerji has even argued that the government sponsors academic oceanography generously not because its findings are directly applicable to, say, Navy operations, but because its support creates a reserve army of scientific experts for urgent needs.

The third is externalities. Independent inventors are essential to technological improvements, and their conflicts with big corporations periodically make business headlines. But there has been a positive side to hegemony: spinoffs that eventually enrich and even help launch other companies.

The most famous is the transistor, developed by Bell Labs and licensed for virtually a token fee. AT&T's Unix operating system, widely licensed, inspired a series of open-source programs, including Linux. The IBM theorist Edgar F. Codd published an idea for a relational database in a company journal. It was never patented, probably because of IBM executives' initial skepticism, and it became the foundation of the Silicon Valley giant Oracle. And public benefits were much more widespread. As IBM's own website puts it, "most routine data transactions—accessing bank accounts, using credit cards, trading stocks, making travel reservations, buying things online—all use structures based on relational database theory."

Consider, too, that thousands of inventions were developed by NASA, including GPS, memory foam and the CMOS active pixel sensors used by today's digital cameras. At least five NASA inventions were incorporated in the Boeing 777.

Flexibility is a double-edged idea. It began as a progressive critique of the manufacturing behemoths of the 1960s and 1970s. It helped spawn entrepreneurial companies and entire industries. Outsourcing, grants and contracts helped universities become the deep organizations of last resort, refuges for curiosity-based research, "the usefulness of useless knowledge," as Abraham Flexner, founding director of the Institute for Advanced Study, put it. It also helped shift more research support to government agencies.

The troubles of the Boeing 737 MAX show the dark side of flexibility: overriding the checks and balances of strict government supervision. Boeing will struggle to regain the prestige of a time when loyal pilots' watchword was "If it's not Boeing, I'm not going." Yet deep organizations can be remarkably resilient in the long run, as General Motors has been after Ralph Nader's attack on the Chevrolet Corvair in 1965, learning to live with increased government scrutiny.

In the end, runaway flexibility, like stagnant depth, can impede both corporate and social goals. Disastrous in the short run, the 737 MAX episode gives Boeing a chance to reclaim the legacy of its depth—and its Incredibles.

Digging Across Panama

The Americans triumphed over yellow fever, landslides, and worker strikes to change the earth's landscape.

NEH Humanities, Volume 32, Number 1,
January–February 2011

The Panama Canal marked a transition: from the great public works of classical Egypt, Rome, and China, built by backbreaking labor, to the far more mechanized triumphs of the 20th century. And as a monument to optimism and national pride, only the U.S. space program of the 1960s has been its true successor. Both the canal and the moon landing were assertions of American military power and engineering prowess. Both mobilized outstanding international talent to overcome obstacles that could not be gauged fully at the outset. Each was launched by a charismatic new president in the wake of a crisis: by Theodore Roosevelt shortly after assuming office following President William McKinley's assassination, by John F. Kennedy not long after the Bay of Pigs fiasco. Each project subordinated economic calculation to political and military logic and was a bonanza for suppliers of state-of-the-art equipment. Each pushed the endurance of the human body to its limits, enlisting physicians alongside engineers. They aimed, respectively, at control of the sea and of space, but each also changed global consciousness: one by linking the

two great oceans, the other by creating iconic images of an astronaut planting the American flag on the moon and of the earth as a fragile blue island.

Though the program does not mention the Apollo missions, the evidence of the PBS documentary *Panama Canal* suggests that for all these similarities, there were equally striking differences. In the 1960s, America was the dominant superpower, challenged in space by the Soviets and Sputnik; in the early 1900s, America was just emerging as a global force after defeating Spain. In the canal's case, though, the impetus was not the threat of a European power's success but the consequences of what was deemed the century's most spectacular technological and financial failure, the French sea-level canal project in Panama.

France had been America's scientific inspiration. Thomas Jefferson eagerly noted its eighteenth-century standardization of military parts, which sparked American mass production after its introduction in our own arsenals. Our first academic engineering program was created at the U.S. Military Academy at West Point by its superintendent, Sylvanus Thayer, a civil engineer who revered French technical education and reformed the curriculum on the model of his other alma mater, the École Polytechnique (still under the French Ministry of Defense today) with compulsory French instruction. Ferdinand de Lesseps, who had become a world hero of civil engineering as well as a national icon as the builder of the Suez Canal, believed he could repeat his success with a sea-level canal across the Isthmus of Panama. He discovered too late the exceptional difficulties of the site: unstable soil, overpowering vegetation, virulent diseases, and especially the turbulent Chagres River. Over eight years, 20,000 lives were lost to work hazards, malaria, and yellow fever. There was little to show for an investment of more than a billion francs, the equivalent of $280 million today. By the time the project collapsed, the 800,000

shareholders had lost their savings, the greatest crash of the 19th century, according to Matthew Parker's *Panama Fever*.

While de Lesseps never recovered professionally or psychologically, his chief engineer, Philippe Bunau-Varilla, who had a personal fortune at stake, refused to abandon the project, even after a new Panama Canal company was ready to give up and American politicians and strategic planners were leaning toward a canal through Nicaragua instead. He allied himself with the original superlobbyist and master fixer, the attorney William Nelson Cromwell. Then, as sole representative of the newly independent nation of Panama (freed from Colombia by a revolution protected by American warships), Bunau-Varilla signed a treaty that gave the United States virtual sovereignty in the Zone and a free hand to build the canal.

The Hay–Bunau–Varilla treaty was one-sided, even by the standards of its time. But it reflected a widespread western belief in benevolent imperialism. Theodore Roosevelt wrote to a friend at the British Foreign Office that just as British rule in Egypt and India benefited those countries and the world, so American hegemony would be good for the Panamanians. Woodrow Wilson later declared that his own military interventions would "teach the South American Republics to elect good men." Among early twentieth-century great powers, and some smaller ones, despite voices of dissent, arrogance was ecumenical.

The open projection of power would not be enough to build a canal where the French had failed. Another attitude was needed: promethean self-confidence. When the treaty was signed, nobody knew how to solve problems that had defeated the French. The majority of the Board of Consulting Engineers, an expert international committee, recommended a sea-level canal like the one de Lesseps had attempted. While the force of the Chagres River would have overwhelmed it and doomed the project, proponents

of lock construction realized their own solution also had disastrous precedents, including the failure of the Johnstown, Pennsylvania, dam and a vessel's collision with a lock on Britain's Manchester Ship Canal.

Perhaps only a state enterprise backed by military methods could have solved such open-ended problems of building the canal. America's experience in building transcontinental railroads across inhospitable terrain certainly helped. The first head of canal construction, John Wallace, was a railroad engineer attracted by a salary second only to the president's on the federal payroll. It was John Stevens, an even more notable railroad builder, whose observations of the realities of the site's greatest challenge, the Culebra Cut, led him to convince Roosevelt to back the lock idea, a minority viewpoint. But the ultimate direction of the project fell to a career engineering officer, George Goethals. Construction was a paramilitary operation: Although paternalistic, the venture was enlightened by the standards of the day.

How did the United States succeed where perhaps the most admired engineer of the nineteenth century had failed? Timing was part of the answer. France was a world leader in medicine, but it was Walter Reed, a U.S. Army physician, who recently had eradicated yellow fever in occupied Havana by preventing mosquito breeding, applying decades of studies by the brilliant Cuban physician and epidemiologist Dr. Carlos Finlay. Another army doctor, William Gorgas, relentlessly used the same method to suppress mosquitoes in the Canal Zone, eliminating a major source of the French project's high mortality rate. Bucyrus steam shovels, recently developed, moved earth three times as fast as French equipment. Advances in electrical engineering by the 1890s made possible hydroelectric-powered, motorized lock systems with controls that performed superbly for decades. The mass-circulation

newspapers and magazines that began to flourish in the mid-1890s stoked popular enthusiasm.

The project benefited from more troubling changes too, especially from the drop in world sugar prices that put pressure on wages in Barbados, a preferred source of labor. The canal was staffed according to blatant racial and ethnic stereotypes. Chinese laborers, initially favored for their heroic work in railroad building, were considered too ambitious. Once they arrived, they might leave digging for shop keeping. American laborers, white and black, as well as Europeans, were thought too likely to agitate and strike. West Indians were favored for the most arduous and dangerous jobs; the 10 cents an hour the canal offered surpassed the dwindling wages of Caribbean plantations. White managers and skilled workers were paid in gold, the West Indian laborers in silver, specie that was also a euphemistic metaphor for the color line.

For many viewers of the *American Experience* program, one of the great surprises may be the extent of high-handed management by Goethals. Unlike some later "czars," he actually could rule autocratically, dominating Canal Zone life as well as the actual construction work. He set his tone early by refusing to negotiate with some of the most skilled and apparently indispensable workers, the steam shovel operators, effectively shutting down the project until strikebreakers arrived to replace them. His ruthless drive was most apparent in the nonstop excavation of the canal's most daunting section, the Culebra Cut, where landslides constantly imperiled all workers on the site, but especially the West Indians, whose living conditions remained miserable. But the men of the "Gold Roll" who did not challenge his authority or the wage scale enjoyed increasingly comfortable accommodations, reversing the initially high turnover and persuading families to join their men. For them, the military strongman created a tropical welfare state that persisted well into the new century.

The Panama Canal illustrates the principle that the economist Albert O. Hirschman has called the Hiding Hand. People begin many enterprises because they don't realize how difficult they actually are, yet respond with ingenuity that lets them overcome the unexpected, as the Apollo program's engineers and astronauts were later to do. The testimony in *Panama Canal* also shows the power of the heroic image of technology in the early 20th century. It was felt even by the exploited laborers, who still shared the 19th century's stoic approach to industrial risk. Three percent of white American workers and nearly 14 percent of West Indians died. Despite improvements in sanitation, it was "a harsh nightmare," the grandson of one of those workers declares in the program, but he also recalls the pride of his grandfather in participating in one of the world's great wonders. In fact, many returnees were inspired by their achievement to join movements for greater economic and political equalitiy in the 1920s and 1930s, the roots of the decolonization movement.

No change to the world's landscape since the Panama Canal—the Interstate Highway System, the Channel Tunnel, or China's Three Gorges Dam—has come close to its acclaim. It has kept its magic even as the other great technological breakthrough of its time, aviation, has passed from inspiration to regimented mass routine.

It was conceived without today's cost-benefit analysis. The historian Walter LaFeber acknowledged in 1978, during often emotional controversies over new U.S.–Panama treaties, that "[w]hether the investment [of $400 million in the Canal] has been amortized is an unanswerable question. . . . like a thousand-piece jigsaw puzzle which has important pieces missing." Members of Congress, he continued, had really wanted to subsidize shippers and never thought about recovering construction costs.

A sea-level alternative through Nicaragua might well have made more economic sense, but overcoming the landslides, the flooding, the heat, and the mosquitoes that threatened to doom completion, as documented by print mass media at their height, made construction in Panama uniquely audacious. Perhaps our aspirations both on earth and in space are more modest now because we are more rational in our ability to foresee costs, especially environmental ones.

Planners of any future grand ventures should bear in mind the words of Joseph Gavin, in charge of the original lunar module of the space program, applicable to all the canal's builders from de Lesseps to Goethals: "If a project is truly innovative, you cannot possibly know its exact cost and exact schedule at the beginning. And if you do know the exact cost and the exact schedule, chances are that the technology is obsolete." Or as global student graffiti was proclaiming in 1969, year of *Apollo 11*: "Be realistic. Demand the impossible."

Steel into Gold

A Steel Town in New Jersey Made the Golden Gate Bridge Possible

NEH Humanities, Volume 33, Number 5,
September–October 2012

The Golden Gate Bridge ceased long ago to have the world's longest span. Its towers are far from the tallest among bridges. Its volume of traffic is not the highest. Its cost of about $35 million—raised by local bonds, not federal grants—ranks well behind that of its contemporary, the Hoover Dam, at $49 million. But it has a unique relationship with its city and its landscape, marking them as even the Statue of Liberty and the Empire State Building don't define New York, or the Eiffel Tower Paris. It was not universally acclaimed at first; some local artists were convinced the structure would mar a magnificent landscape. Yet on its 50th anniversary in 1987, 250,000 people crowded onto its deck to celebrate.

One of the reasons for the Golden Gate's enduring fame can be found not in California but in Roebling, a century-old former company town near Trenton, New Jersey, named for the maker of the bridge's cables, John A. Roebling's Sons. An exhibition at the Roebling Museum supported by the New Jersey Council for the Humanities, "Spinning Gold," shows how the principles of the cable suspension bridge, developed by a German immigrant

engineer in the 1840s and applied in the Brooklyn and George Washington bridges, met even greater challenges in 1937.

Roebling company engineers did not design the Golden Gate. The project was sparked by a brilliant but technically limited engineer, Joseph Strauss, who had made his name designing bascule river bridges in Chicago. His own original design was clumsy, but with the technical gifts of his academic associate, Charles Ellis, and of world-renowned consultants like Leon Moisseiff and O.H. Ammann, engineer of the George Washington Bridge, the result has been as strong as it is beautiful. Yet the success of the design depended on cables of unprecedented size.

John A. Roebling's Sons, the successful bidders for making the bridge's suspension cables, was a survivor of the consolidation of the steel industry around 1900. The Roebling mill had been built so the company would not depend on competitors for its raw material; steel smelted there was made into products from elevator ropes to window screens. Bidding on the Golden Gate, Roebling defeated U.S. Steel with a proposal of $5.9 million, which the exhibit estimates at about $97 million in today's prices. For this it would have to deliver 80,000 miles of wire weighing 24,500 tons.

It was in the spinning of massive cable from strands of wire about a fifth of an inch thick that the Roebling family had become world famous. Two of the ideas of the founder, the immigrant German engineer John A. Roebling, incorporated in U.S. patents granted in 1846 and 1847, respectively, were the basis of suspension bridge construction. Giant cables could not be manufactured in sections at a factory and then spliced. They had to be made on the spot, spun by wheels traveling between bridge towers. This system, in turn, depended on creating an unbreakable bond between the cables and the earth. Roebling's idea was to pass each strand of wire through steel loops in a structure of huge concrete weights called the anchorage, locking the already spun part of the

cable down while the live end was passed in the other direction, to the opposing anchorage. At the Golden Gate, each anchorage was secured by 60,000 tons of concrete.

The contract was a godsend for the Roebling company. By 1932, it had laid off half its workers; with Golden Gate wire production in New Jersey, it had regained 2,000 jobs, plus 500 in California. But there was a risk. If the company missed contractual deadlines, it could lose money on the project. Under this pressure, Roebling engineers improved the traveling-wheel system. In a "split tram" system, two wheels approached each other from each side of the bridge, the wires were exchanged between them, and each wheel returned to its own side, doubling productivity. Ultimately, as many as six wheels with color-coded strands were deployed at once. Cable spinning took from October 1935 to May 1936, finishing months ahead of schedule.

Spinning was only the start. Workers on the spot had to compress the wires first into strands. The 27,572 wires were wrapped into 61 bundles. Dimensions of the bundles varied so that the cable would rest as compactly as possible in the saddles atop the towers. Workers used jacks exerting a pressure of 4,000 pounds per square inch to compress the finished cable into its final diameter of 36-3/8 inches, still the world's thickest. A highlight of the exhibition is a section of this cable, still a marvel of the union of design, craftsmanship, and sheer force.

The Roebling family, unable to finance needed modernization after the Second World War, sold the company in 1953, and in 1973–1974 the new owners closed the plants. But the bridge's legacy survived the corporation. A young engineer, Blair Birdsall, who worked for Roebling on the bridge's construction, became a managing partner of one of the world's leading civil engineering firms. At the time of his death, 60 years after completion of the Golden Gate, he was a consultant for the $5.8 billion Great Belt

bridge and tunnel complex in Denmark, which has a main span 1,100 feet longer than the Golden Gate's.

Why is the Golden Gate still more beloved than any other bridge in the world, according to surveys? It's because, contrary to critics' fears, it enhanced rather than defaced a magical site. Gifts from descendants of the owners and workers in the exhibition and museum show a pride that is undiminished after three-quarters of a century.

Lasting Impressions

An Ancient Craft's Surprising Legacy in Harvard's Museums—and Laboratories

Harvard Magazine, September 2000

Harvard does not care about shoes. Once it did. Male footwear, at least, had an almost military propriety and ritual. While a Norton Lecturer in 1932, T.S. Eliot '10 had his shoes not shined but boned, polished with the downy side of the femur of an elk or deer, a tool of atavistic refinement. As late as the 1970s, President Nathan M. Pusey wore gleaming black wingtips to a Society of Fellows dinner, their crisp laces tied in impeccably symmetrical bows.

Only a remnant of that culture survives around the Yard. The repairman at Felix's Shoe Repair reports that business has declined by 85 percent over the years. He still has a professional clientele, including Harvard faculty members and administrators, but undergraduates take their shoes far less seriously. Caille Millner '01 recently reported here that the footwear of the unofficial Harvard uniform alternates between sneakers and outdoor boots. Harvard students do buy expensive "technical" shoes at the local Adidas outlet, another undergraduate reports, but the staff insists it's a matter of athletic performance, not fashion. Memorabilia don't extend to footwear: Harvard University did license a Japanese line

of men's shoes in the 1990s, but the name was visible in the lining only, and the brand seems to have vanished in the crash of 1998.

Harvard's indifference reflects not just style, but values. In the American academic tension between theory and practical instruction, the Ivy way is abstraction. Everyday shoes are irredeemably concrete, empirical, and earthbound; Martin Heidegger once rhapsodized over what he took to be a peasant woman's shoes in a Van Gogh painting. The old-time shoemaker's bench combines a seat and a work surface, rather than separating the body analytically from the task like the chest-level benches of most other skilled artisans, or of laboratory scientists. The dressing, the buffing, is but a brief victory for order amid decay—as vegetarians remind us, leather shoes are dead-animal parts—unlike the cabinetmaker's work that can last with care for a thousand years. While good shoes are vital for health, few MDs have paid much attention to their design. Even Harvard's leading biomechanics specialist didn't. The late Thomas McMahon, professor of engineering and applied science and probably the world's leading expert on the design of running tracks, once replied to an e-mail query that he didn't think much about athletic shoes; he just liked to go barefoot.

High-fashion shoes challenge the Puritan strain that remains part of Harvard's heritage. Women's high heels are expensive, failure-prone, defiantly unhealthy, often hazardous to foot and flooring alike. Industry promotion celebrates their links with the sensuality and theatrical extravagance of baroque southern and east-central Europe. The heritage of the Ferragamos, Guccis, Pradas, and Manolo Blahniks remains exotic even in the more cosmopolitan Boston, and Harvard, of today. For the Harvard community, New Balance and Timberland are the happy medium. The platform shoes now worn by many undergraduate women, a chunky interpretation of the genre, are as high as shoe fash-

ion goes. As for Third World traditions, don't look for Harvard's splendid ethnographic specimens on public display at the Peabody Museum; they're in the reserve collection.

The industry of shoemaking puzzles academics. Although some companies prospered for generations, even at its height the U.S. shoe manufacturing business had an exceptionally high failure rate. In 1940, the leftist economist Horace B. Davis '20 declared it "irrational and contradictory." During the postwar boom, Harry L. Hansen, MBA '35, a professor in the Graduate School of Business Administration, observed in a 1959 study sponsored by the National Shoe Manufacturers Association that the prevalence of intuitive entrepreneur-managers made the industry "wasteful of its energies." Yet Hansen had to acknowledge a self-sufficient mastery in the all-around shoe entrepreneur that was missing in the academically trained corporate footwear executive. Shoemaking was a way of life, not a science.

The fabrication of shoes, however, is of even less interest to Harvard (and other universities) than their style. Although there are a few remaining academic programs in shoemaking and an advanced technology consortium (SATRA), shoe manufacture has always been a realm of tacit, imperfectly documented knowledge. The most recent edition of the standard English-language textbook of shoe production was published in 1964. Machinery continues to evolve, but shoe-industry skills and lore pass mainly by apprenticeship, rather than classroom instruction. In the global world of shoemaking, the lingua franca is not the published manual but the lucid sketch made by an industry veteran for a neophyte operative. And the higher the technology of footwear— for example, the gases and gels used in high-performance sneaker midsoles—the less information is published about it.

No, Harvard is not interested in shoes. But shoes, to paraphrase Leon Trotsky's reported quip about war, have been inter-

ested in Harvard. Footwear and higher education were two New England specialties. They could not avoid each other. While Harvard was becoming a national and international university after the Civil War, the Boston shoe industry was flourishing as a technological showpiece of American industry. Independently, they rose together. Even in 1865, before widespread mechanization, Brockton alone was producing more than a million pairs of shoes annually; by 1900, Boston shipped more than 100 million pairs. Although Cambridge itself never became one of the major shoe towns, some of Harvard's administrators and faculty members inevitably came to know the executives of the footwear industry.

One of these Harvard men, Nathaniel Southgate Shaler, dean of the Lawrence School of Science, was a close friend of the industrialist Gordon McKay (1821–1903), a Pittsfield, Massachusetts, native who had become one of America's most successful technical entrepreneurs. McKay, a self-taught specialist in the maintenance of mill equipment, learned of an invention for sewing the uppers of shoes to the soles, bought it for only $8,000 in cash and a $62,000 share of future profits, and developed it with the help of the master mechanic and original inventor, Lyman Reed Blake. He received his own patent for the improved version in 1862. During the Civil War he set up a company to produce his machines, helping meet the great demand of Union footwear contracts.

McKay's most original idea was to lease the machinery rather than sell it outright, collecting a small royalty on each pair of shoes made with his equipment. Leases encouraged would-be manufacturers and reassured customers afraid of obsolescence, making it in McKay's interest to maximize customers' output. His company made constant improvements, and Blake sold the machinery and taught workers how to use it. McKay was earning $500,000 a year by 1876, and had collected royalties on more than 177 million pairs of shoes. By 1895, 120 million pairs of

shoes a year were produced on McKay machines, more than half of U.S. production. Meanwhile a forceful businessman named Sidney Winslow had bought the rights to the lasting machine developed by the Suriname-born, African-American inventor (and former McKay machine operator) Jan Matzeliger, which brilliantly complemented the McKay process, and refined McKay's leasing and training strategy. It was Winslow who combined McKay's interests with those of Charles Goodyear Jr. (son of the inventor of vulcanized rubber), whose company produced equipment for sewing higher-grade welted shoes, and with dozens of large and small vendors of equipment and supplies and their patent portfolios. The resulting United Shoe Machinery Company, incorporated in 1899, had a virtual monopoly of the technology for the leading types of American shoe production. Winslow ran the company, and the retired McKay's interest in it was one of America's great fortunes.

Reformers soon assailed the Shoe Trust. A shoe manufacturer might still, with some difficulty, get every necessary machine from some other supplier, but few independent domestic makers were left. United's leases forbade the use of most competitors' equipment and mandated the use of high-priced United supplies like wire and eyelets. The monopoly's only serious rival, a self-made French-Canadian shoe manufacturer named Tom Plant, introduced a competing line of machines, only to sell out to United in the end. To its supporters, including most New England shoe manufacturers, United earned its high profits with excellent equipment and service. To its foes, especially the Western shoe industry that was growing as producers sought lower costs outside New England, United suppressed innovation as well as competition, discontinuing superior machines after absorbing their makers and sitting on patents that could have lowered costs. The muckraking journalist Judson Welliver even attacked Winslow and United for

virtually forcing the use of inferior materials that endangered the health of working-class shoe consumers. When McKay died in 1903 and the decades-long transfer of his bequest to Harvard began with a million dollars in 1909, Harvard thus almost certainly became a part owner of one of the most controversial companies in America, and definitely was a beneficiary. (Life trusts delayed the full transfer of the principal of the estate to Harvard until 1949. By then the total amounted to $16 million, the largest single gift received by the University until then and still one of the most generous so far when adjusted for inflation.)

McKay and Shaler wanted to revive Harvard's flagging Lawrence School of Science. McKay, who lived a block from Harvard Yard, had given most of his fortune to Harvard rather than to the Massachusetts Institute of Technology because he hoped not only to improve engineering education, but to increase its appeal to the New England elite. MIT officials did not give up; they persuaded Harvard to accept a form of merger in which a new science and engineering campus would rise across the Charles River, where the business school is today. The plan, opposed vociferously by MIT alumni, was rejected by the Massachusetts Supreme Judicial Court in 1905, leading Harvard to establish a Graduate School of Applied Science—forerunner of today's Division of Engineering and Applied Sciences—in 1906.

While the Corporation and faculty were studying uses for McKay's bounty, a number of Harvard alumni were busy engineering the hegemony of United, also called The Shoe. Through directorships they helped connect it with the First National Bank of Boston and with Lee, Higginson and Co., two of New England's greatest financial powers, and at least indirectly with J.P. Morgan, A.B. 1889, LL.D. '23. Some of the University's cleverest sons helped rivet its redoubtable boilerplate. Before Louis D. Brandeis, LL.B. 1877, brought an antitrust lawsuit on behalf of

a group of Western shoe manufacturers against United, he had helped draft its leases. Among its directors were both shoe men and leading Harvard-educated attorneys like Robert Treat Paine, A.B. 1882, and James J. Storrow, A.B. 1885, LL.B. '88. Robert F. Herrick, A.B. 1890, was chief legal adviser. United's treasurer from 1909 to1924, the former journalist and political publicist Louis Coolidge, A.B. 1883, helped to make the vast United plant such a model of enlightened safety, health, and recreation programs that Horace D. Arnold, A.B. 1885, M.D. '89, dean of Harvard Medical School, proclaimed that it provided the best industrial working conditions he had ever seen. Sidney Winslow Jr. '05 succeeded his father as head of United. Under his presidency, in 1930, the company built the 24-story art deco downtown headquarters, its lobby adorned with sumptuous tableaux of shoemaking, that for decades was Boston's tallest building.

United affected Harvard's building, too. As a young architect, Walter Gropius was impressed with a postcard of Ernest L. Ransome's extensively glazed United factory in Beverly, Massachusetts, possibly the world's most advanced industrial plant on its completion in 1906. The building influenced the design Gropius completed for the Fagus shoe-last company in Alfeld, Germany, in 1913, a progressive firm coincidentally backed by United. This celebrated commission helped him become director of the state architecture and design school reorganized as the Bauhaus, and, after emigration, chairman of the architecture department at Harvard's Graduate School of Design. The lineage of Gropius's Graduate Center (1948–50) thus goes back to the quest for more efficient shoe-machinery plants.

After profiting from the rise of the American shoe industry before the first world war, Harvard people helped shape its course after the second. As a Junior Fellow, Carl Kaysen, Ph.D. '54, acted as law clerk to U.S. District Court Judge Charles E. Wyzanski Jr.

'28, LL.B. '30, writing an incisive economic analysis of the federal government's antitrust suit against United. Kaysen's dissertation helped persuade Wyzanski to reject a breakup and impose a more limited reform of the leasing system in 1952, initially upheld by the Supreme Court in 1954. The stellar reviews of the version published by Harvard University Press helped launch Kaysen's career—and the lucrative industry of economic antitrust-litigation consulting—but the academic purists had their revenge on the empiricism of footwear. During Kaysen's later directorship of the Institute for Advanced Study, restive members of the School of Mathematics opposing his plans joked that he had written his thesis about a shoe factory.

Kaysen, who had honed his knowledge of manufacturing technology as a wartime intelligence officer helping to choose German bombing targets, toured the Beverly plant with Wyzanski and found the staff there technically impressive yet (as he recently recalled) "unimaginative." In the 1950s and 1960s the European machinery industry was beginning to nibble at United's markets. Meanwhile, most of the established New England shoe factories, as the 1959 Hansen study had underscored, could not compete with more efficient single-floor layouts. With the fitness boom of the 1960s, sneakers—increasingly marketed from Europe and the Pacific Northwest—began to replace leather shoes, devastating the remaining makers. When the Supreme Court in 1968 accepted the government's assertion that the conduct remedies prescribed by Wyzanski had not worked and ordered the breakup of United, it was the worst possible time to tear the company apart: Electronics were starting to displace mechanical control. United, led by a 1959 graduate of Harvard's Advanced Management Program, William S. Brewster, responded by diversifying into other machine-tool systems, but became a takeover target and was ultimately absorbed by a British machinery company. United is still

a world-famous brand and has been technologically rejuvenated, but it is no longer a Boston institution.

In the 1970s and 1980s, American shoe production moved rapidly offshore. Between 1965 and 1987, the production of men's welted shoes dropped from 600 million pairs to 1.5 million. As U.S. costs grew, the economies of production in Asia made New England competitive only for higher-priced footwear. By the 1990s even Stride Rite, then run by Arnold Hiatt '48, began closing the Boston-area plants that had been models of paid day care and other progressive policies just as United's Beverly plant had been. Hiatt is still a celebrated philanthropist, but welfare capitalism is largely a memory in American manufacturing. United headquarters is now an office condominium called the Landmark, and the rehabilitated main Beverly plant has a new life as the Cummings Center, an office complex with 32 acres of space. Just as scrappy footwear entrepreneurs once set up shop in mills that the textile industry had closed in its move south, a new generation of businesses has occupied United's abandoned nests.

Harvard Business School may no longer produce guides to retail shoe-stocking systems, but the industry has still left its footprint on the University. In the 1999–2000 academic year, 45 of 63 faculty members of the Division of Engineering and Applied Sciences, including the computer science department, held positions named for Gordon McKay. (So did the barefooting Thomas McMahon, a delightful polymath who even conjured up a new, improved Gordon McKay in his 1979 novel, *McKay's Bees*.) The McKay bequest—a model of legal prose, rigorous yet literate—stipulated that the salaries he endowed "be kept liberal, generation after generation, according to the standards of each successive generation." What more can a professor ask from a benefactor?

And Harvard has repaid the shoe industry's largesse. The Boston shoe wholesaler Joseph Goldstein '18, once the University's

oldest alumnus, who died at 101 in 1997, put his college chemistry degree to good use. He invented Nite-Glow slippers, with luminescent patches—homely, practical, and supremely transitory, as even the best of shoes must be.

Mother of Invention

A REVIEW OF

The Idea Factory: Bell Labs and the Great Age of American Innovation
by Jon Gertner
New York: Penguin Press, 2012, 422 pp.

Issues in Science & Technology, Summer 2012

High-handed corporate monopoly and high-minded national treasure, the American Telephone and Telegraph Company (AT&T) was a unique project of this country's pragmatism and for decades the envy of the world in extending low-cost local telephone service.

At the heart of AT&T was its R&D unit, Bell Laboratories, the world's greatest entity of its kind, and a giant manufacturing arm, Western Electric. Jon Gertner's *The Idea Factory* is hardly the first book about AT&T history or the first about Bell Labs research. The company published a massive survey near its peak in 1977 (a second edition appeared in 1983), *Engineering and Operations in the Bell System.* On the topic of its pure science research, the physicist Jeremy Bernstein's *Three Degrees above Zero* (1984) told the story of the discovery of the cosmic background radiation at the Holmdel branch. In 1997, Michael Riordan and Lillian Hoddeson published *Crystal Fire: The Birth of the Information Age,* an award-winning history of the lab's greatest technological triumph, the transistor.

The Idea Factory is still welcome. It is the first study of Bell Labs that puts its history in its full organizational, political, and administrative context. AT&T was a company striving to expand and maintain a privileged empire under a government that saw it alternatively as a trusted military/industrial partner and an anticompetitive threat. This ambiguous embrace, Gertner suggests, inadvertently encouraged a culture that combined a gifted and diverse workforce with a long-term outlook, creating the foundations of a new information economy, which in turn made radical changes in the charter of the parent company inevitable.

Gertner's story is the interaction between three leaders of Bell Labs in its critical years—Mervin Kelly, Jim Fisk, and William Oliver Baker—and three of its greatest scientific minds: William Shockley, Claude Shannon, and John Pierce. Of all these men, Kelly may have been the most influential. When Bell Labs was established in 1925, many vital components of the telephone system needed radical upgrading if the network was to continue growing. Bell Labs had to develop and constantly improve its own equipment, such as the manufacture and sheathing of cables and wires. It had to invent and build its own testing apparatus. Even the leather belts of telephone line workers were rigorously studied and specified. The integration of R&D with Western Electric manufacturing ensured that challenges in supply chains and industrial processes could be met at early stages.

For an ultimately revolutionary organization, Bell Labs had remarkably conservative values: Equipment was designed, manufactured, and tested to last for 40 years. By today's Wall Street and Silicon Valley standards, it was also remarkably egalitarian. The best-paid staff members earned no more than 10 times the annual wages of the lowest paid. Yet it was also far from a civil service culture. Kelly's crucial move after the end of World War II was a virtual coup, demoting experienced managers so that new groups

led by younger researchers such as William Shockley could take charge, reducing at least one of the veterans to tears. Many of the materials needed did not exist yet. Shockley's fixation on taking personal credit, so contrary to the collegial norms of the Labs, was also tolerated because of his ability to catalyze ideas developed by others.

The transistor also illustrated how the Bell system's sensitive political position encouraged rapid diffusion of its inventions. In the midst of today's patent wars, it's striking to see how AT&T managers licensed what Gertner and others have considered the greatest invention of the 20th century. Ceremoniously distributing samples around the world, they made the technology available to all manufacturers for a license fee of $25,000, almost a token amount considering the development expenses and the profits to be made. It was the Bell system's monopoly status that encouraged such generosity, justifying their view of their own company as a public resource rather than a selfish old-style trust.

The Bell system could not deploy the transistor without another revolutionary innovation that the Labs were developing at around the same time: the theory of information, which enabled engineers to ensure the highest volume and quality of transmission possible. It was one of the Labs' most gifted researchers, Claude Shannon, who in 1948 published one of the most influential mathematical papers of all time, "A Mathematical Theory of Communication." It was Shannon who coined the word and concept of a bit and who showed not only how ordinary communication was full of redundancy that could be suppressed for the sake of speed, but also how the addition of redundant information in the form of error-correcting codes could overcome glitches in transmission. Shannon's work, theoretical as it was, also owed much to the Labs' military contracts. He had been a major figure in the devel-

opment of cryptography and in the automation of counterattacks against German missiles attacking London during World War II.

The Cold War was also a strategic boon for Bell Labs, helping deflect planned antitrust actions against the Western Electric monopoly on AT&T equipment supply. By performing vital work on the Distant Early Warning missile detection system and Nike missile systems and by managing Sandia Laboratories, the Bell system could continue arguing for a privileged legal position as a national strategic asset. One of Mervin Kelly's main challenges, as he saw it, was to balance the expansion of civilian telecommunication service, and its role in prosperity and economic growth, with the company's military role.

Not all of Bell Labs' investments paid off. Although managed by one of the most brilliant members of the Labs, John Pierce, the satellite communication program was doomed when the federal government decided to create COMSAT in 1962, excluding AT&T. The Picturephone seemed to be the future of business and ultimately residential service, after Bell Labs' success in reducing the costs of what were originally elite services, but the service never reached a critical mass of users. And AT&T was slow to recognize the value of fiber optics, originally developed in Europe, partly because AT&T was focused on long-distance and Picturephone transmissions, for which it believed hollow pipes (waveguides) were more practical. Gertner shows how the Labs, for all their maverick genius, were not immune to corporate inertia and the tyranny of sunk costs in older systems.

Still, Gertner may be too harsh in judging the Picturephone only as a fiasco. The historian Kenneth Lipartito has suggested that the fate of major inventions is subject not to an all-knowing market but to many contingencies. The Picturephone initiative might be regarded as a kind of proto-Web, designed for sharing images and documents as much as for face-to-face electronic con-

versations. Although the Picturephone may not have had a chance to become more than a niche product, the project was like many other failures in creating the conditions for ultimate successes. The real point is not that the Picturephone was a folly, but that even by the 1960s, the acceptance of technological innovation had become so complex that it could no longer be planned reliably, even by the best minds.

The paradox of Bell Labs in its original form was that its very success upset the sensitive equilibrium of its charter. The greater the scope of its products and services, the more would-be competitors could cry foul. As early as 1943, Kelly wrote to his colleagues that despite the Bell system's conservative philosophy, "our basic technology is becoming increasingly similar to that of a high-value, annual model, highly competitive, young, vigorous and growing industry." As the management guru Peter Drucker wrote in 1984, the applications of the Labs' innovations were beyond the ability of any one company to realize. One scenario Drucker imagined beyond the breakup—an independent, self-supporting laboratory licensing patents to all companies—seemed too visionary even to Drucker. As Gertner notes, some of the Labs' greatest breakthroughs were responses to challenges of telephone service, not developments of pure science. In fact, Bell Labs survived through repeated reorganization, retaining its ties to AT&T and the operating companies and enjoying spectacular prosperity as Lucent in the 1990s, before the collapse of the dotcom boom destroyed most of its market value.

KEY OMISSIONS

As a history of some of Bell Labs' greatest ideas and an analysis of the company's strengths and shortcomings, *The Idea Factory* is the best all-around account yet. Yet it slights some individuals and innovations that today's software industry considers among the

Labs' greatest contributions: the UNIX operating system and the C programming language, both credited in part to the late computer scientist Dennis Ritchie. Nor does it describe the remarkable work of the Labs in human factors, such as the remarkable succession of handsets designed in consultation with Henry Dreyfuss, which were so robust and comfortable to use that many are still in service. Dreyfuss's designs for the Bell System, realized in collaboration with the Labs and Western Electric, remain a foundation of today's human/electronic interfaces.

On balance, Gertner sees Bell Labs as part of a bygone business model that cannot and should not be revived in an age of rapid, consumer-oriented electronic product development and global supply chains. He cites a 1995 paper by a Bell Labs mathematician, Andrew Odlyzko, suggesting that dominating narrow market segments, not pursuing breakthrough inventions, was now the main way to corporate profits. Incremental improvements rather than giant steps were the way to go.

That remains an accurate description of the current research environment. But is this situation entirely inevitable? Breakthrough industrial research continues. IBM's Watson Research Center's artificial intelligence program, for example, is on a par with the tradition of the old Bell Labs. Even Toyota, then considered a conservative "fast follower" company, created the radically new Prius hybrid car in only four years in the mid-1990s. Gertner might have also considered the vigorous academic debate on whether markets promote underinvestment in research, dating from Kenneth Arrow's paper "Economic Welfare and the Allocation of Resources for Invention" 50 years ago. If government rules and constraints stimulated creativity at Bell Labs, isn't it possible that changes in the tax code to shift rewards to long-term investment might benefit not only shareholders of individual companies but the broader world economy?

Yet in one respect, Gertner is right: The Labs were a unique creature of their times. As he points out, they concentrated a generation of brilliant, ambitious, often eccentric young men from the ranks of 1920s Midwestern rural and small-town tinkerers. During the Depression, the Labs were able to assemble a critical mass of sheer talent, especially because they paid up to twice academic salaries at a time when few universities were hiring. Hard times may even have accelerated researchers' ideas. Gertner observes that when hours were reduced to save money, staff members used their extra time to audit courses taught by famous physicists at Columbia University, a subway ride from the Labs' original location in lower Manhattan. Mervin Kelly and his successors also understood how to manage this diverse cohort and above all how to promote an ethic of generally unstinting cooperation, open doors, and what is now called mentoring. Its only parallel in academia was the Massachusetts Institute of Technology's Building 20 after World War II. As Gertner observes, the design of the Holmdel laboratory, with its vast atrium and exterior corridors with views of the countryside taking the place of the more spontaneous interactions of the Murray Hill campus, was already beginning to undermine the ethos of the Labs. Universities, for all their vaunted interdisciplinary initiatives, are still organized around proudly independent departments.

The wonder of Bell Labs is that it could be so focused on carefully specified corporate goals in expanding its network, yet so open to chance encounters (in hiring, too) and fortunate accidents. The study of the organization's past will thus remain an indispensable resource for thinking about the future of serendipity.

The French Connections

U.S. News & World Report, Vol. 136 Issue 6
February 16, 2004

A hundred years after the Wright brothers' triumph at Kitty Hawk, the European consortium Airbus announced a milestone of its own—surpassing the American aviation giant Boeing in the number of airliners delivered in 2003. Airbus, based in Toulouse, France, is now beating its U.S. rival at its own game of size and distance: The 555-passenger, long-range A380, bigger than any Boeing, is already in production.

Airbus's success should be no surprise. America and France may be sparring diplomatically, but technologically the two nations have had a long love affair. Each has developed outstanding innovations, and each has assiduously exploited the other's ideas.

Even the current U.S. military-industrial hegemony has some decidedly French roots. Sylvanus Thayer graduated from West Point in 1808, spent two years in Europe, and was utterly taken with French military thought and training. When he became superintendent in 1817, Thayer modeled the academy's demanding technical curriculum and ethic of honor and service after France's Ecole Polytechnique. Classics on sieges and fortifications by Louis XIV's engineering genius, Marshal Sebastien Le Prestre de Vauban, were standard texts; studying French was de rigueur.

Silver bullet. The French connection persisted into the Civil War. The Minie bullet that made that conflict's rifle-muskets three times as deadly as earlier weapons was originally developed by

French officers. In 1885, the French ordnance engineer Paul Vieille introduced smokeless powder. French artillerymen invented the revolutionary hydropneumatic recoil that allows cannons to remain murderously locked on target for shot after shot. And where would the Navy SEALs be without scuba gear, developed in 1943 on the French Riviera by Emile Gagnan and a soon-to-be famous French officer, Jacques Cousteau?

Even interchangeable parts, the foundation of America's mass production, have French roots. The historian of science Ken Alder has shown that a French gunsmith was using such a system as early as the 1720s. By the 1780s, French military officials were introducing uniform jigs and fixtures at arms factories to enforce strict tolerances and ensure deadlier firearms and ordnance. Thomas Jefferson praised the system, and while it fell into disuse in France in the 19th century, U.S. armories embraced it. Related methods became known in Europe as the American System and, in the early 20th century, as Fordism.

Speaking of Ford, what could be more American than the automobile? Yet a Frenchman built the first self-propelled vehicle, powered by steam, more than 200 years ago. A hundred years later the French company Panhard introduced the basic architecture that automobiles have followed ever since. Henry Ford's triumphs depended not just on standardization but on use of strong, rust-resistant vanadium steel, which had impressed him in the wreck of a French racing car.

Long before Airbus, the French produced superlative aeronautical engineers. They were the first Europeans to acclaim the Wrights' breakthroughs in aircraft control, and they made key improvements. French inventors, especially Louis Bleriot and Robert Esnault-Pelterie, created the monoplane as we know it, which is why we still speak of fuselages and ailerons. Esnault-Pelterie was also the father of the joystick.

Flag-waving Americans may reply that many of France's own technological triumphs rely on ideas born here. French high-speed trains lead the world today, but as the railroad historian Mark Reutter has shown, the Budd Co. of Philadelphia was already building lightweight, articulated streamliners in the 1930s. And France now gets 75 percent of its electricity from America's great hope of 50 years ago, nuclear power. Social legislation also helps make France a showplace of other U.S. innovations: vending machines (limited retailing hours) and mass-produced antibiotics (generous health benefits).

In fact, the French have so often jettisoned their heritage in favor of novel technology that it sometimes takes Americans to defend it. The Cornell University scholar Steven Kaplan has revived the art of French bread making, and Mother Noella Marcellino, an American Benedictine nun with a PhD in microbiology, has been saving the classic cheese of France from pasteurization—a process invented by the Frenchman Louis Pasteur.

It's pointless to debate who owes more to whom, and far more interesting to rejoice in cross-appropriation. Airbus has many U.S. suppliers, and Boeing will jump ahead sooner or later in the endless technological leapfrog. The last word may belong to the sage—perhaps Oscar Wilde—who said, "Talents imitate; geniuses steal."

The Importance of Being Unimportant

Milken Institute Review, January 24, 2021

Some of the deepest ideas seem obvious in hindsight. Alfred Russel Wallace and Charles Darwin were not the first biologists to investigate the idea of evolution. But the mechanism of variation and natural selection (later expanded with genetics) was so intuitively powerful that Darwin's most zealous advocate, Thomas Henry Huxley, is said to have reflected after reading *The Origin of Species,* "How extremely stupid of me not to have thought of that."

In Sir Hubert Henderson's short textbook, *Supply and Demand* (1922), with a foreword by John Maynard Keynes himself, there is a less momentous but deeply intriguing section titled "The Importance of Being Unimportant." It expresses the unintuitive idea that, under the right conditions, it is desirable to be a very small part of something big.

A good example in Henderson's book is the dynamics of setting wages for workers at different stages of production. In the manufacture of steel, coal miners were extremely important—coal, once converted to a purer form of carbon, is needed to remove the oxygen from iron ore—and their strikes could inflict severe economic damage. (Indeed, a coal strike may have played an indirect role in the sinking of the *Titanic.*) But the miners' leverage was limited because a big wage increase would have severely damaged the

British steel industry in the near term, and because steelmakers could have eventually switched to American or European coal. Smelting workers, by contrast, were also indispensable, but they managed to extract high wages because the cost of their labor had a much smaller impact on the steelmakers' bottom line.

Actually, Henderson was standing on the shoulder of a giant, Alfred Marshall, who had made parallel observations on the building trades three decades earlier. In the late 19th century, masons and carpenters were much more important than plasterers to housing construction, a reality reflected in the fact that their wages accounted for a substantial part of building costs. But the plasterers had the upper hand in wage bargaining because builders could more readily absorb the cost of plasterers' demands to keep construction on schedule.

Marshall also presciently noted that markets have a way of foiling such gatekeepers. The bells tolled for those well-heeled plasterers once the U.S. Gypsum Company introduced drywall, which all but replaced lath-and-plaster construction.

Even today, some unimportant (in terms of value added) but essential trades remain—notably, the job of the stationary engineer, a skilled blue-collar worker who watches over potentially lethal boilers and elevators. If stationary engineers' wages were a larger part of the cost of building maintenance, they probably would not be able to enjoy princely wages (sometimes six figures)—or more would be spent to automate safety.

Make Way for the Threadocracy

Henderson's chief example of the unimportance principle was not in the labor market, but in the clothing industries—in particular, a deceptively humble commodity, sewing thread. Historians of technology have taken thread for granted at their peril.

While thread hardly seemed to merit a footnote in treatises on textile making, it was essential to the integrity of finished garments. Paisley, Scotland (near Glasgow), was the center of one of Britain's nascent luxury crafts, the weaving of shawls in silk and fine wool with designs imitating traditional floral patterns of India. ("Paisley goes with nothing," the title of one recent men's fashion guide sneered, but the characteristic pine motif was the height of ladies' fashion around 1800 and has periodically experienced faddish revivals since.)

The weavers of Paisley were not the oppressed home workers of other crafts but a labor aristocracy of independent artisans who wove in the morning and spent afternoons promenading and gossiping in town. Not surprisingly, though, market power can be a fleeting phenomenon in a competitive economy. When power looms were designed to produce lower-price knockoffs of similar patterns, the original lost its cachet among the 1 percent, and the town looked to a new industrial basis that began at the height of the handloom era.

Among the "unimportant" but essential parts of their looms were the heddles, the loops through which the warp threads ran. The best heddles were made of silk imported from continental Europe. When the Napoleonic wars disrupted the supply, one of the weaving suppliers, Patrick Clark, developed a cotton thread that proved so durable it supplanted silk even after the supply resumed. Clark also had the brilliant idea of selling the thread as a substitute for linen, not in the customary skeins but wound on now-familiar wooden spools.

Of course, the Clark family's innovation does not account for the family's rise to become a dominant supplier among cotton spinning firms in Paisley. They were known for high standards of quality. But they also were pioneers of branding and their anchor trademark was jealously (if not always successfully) guarded.

The Clark firm had global ambitions and was a pioneer in turning American trade protectionism to its advantage by establishing plants in the United States. Even today, Newark, NJ, boasts a Clark Thread Company Historic District, a registered National Historic Site now redeveloped as an industrial park.

Coats, another family firm, developed a following of its own. And soon giant mills appeared in the Paisley landscape, along with churches and other public buildings endowed by the reigning families of what became known as the threadocracy.

By mid-nineteenth century it was the sewing machine that propelled the fortunes of the threadocracy, along with their relentless improvement of spinning technology and quality control. The rise of ready-made clothing manufacture gave sewing thread an enviable unimportant-but-essential status. It was a small part of the cost of a finished garment, but breakage of weak thread meant costly interruption of the production line. As was later said about IBM, nobody was ever fired for specifying Coats or Clark thread.

The threadocracy pioneered not only brand-name marketing but global management. Their star salesman was a German national named Otto Ernst Philippi, who embodied his nation's prized *gründlichkeit*—thoroughness. A schoolmaster's son, fluent in four languages, he won the family's confidence in part through his impeccable English correspondence.

More important, he proved a brilliant business strategist and architect not only of the firm's market expansion but of its manufacturing strategy, focusing its identity on the production of premium six-cord thread, the highest common grade.

With the age of trusts and combinations—market concentration works even better than branding in fattening the bottom line—Philippi also guided the merger of the Coats and Clark empires with other British thread firms to create J&P Coats in 1890. By then the merged family firms controlled two-thirds of U.S.

cotton thread production. By 1905, it was third in capitalization among all British corporations (after Imperial Tobacco and Watneys, the brewer) and larger than DuPont (dynamite, anyone?) in America.

A digression (which, as must be plain by now, I cannot resist): Patrick Clark's descendant, Kenneth Clark, the art historian and *Civilization* television series star, grew up on an estate with a 14-hole golf course and a resident pro. His profligate father's share of the proceeds of the Coats public offering was worth $650 million in today's money. His parents may not have been the richest of the idle rich, Kenneth Clark wryly recalled in his autobiography, but there were few who were more idle.

The unimportant but essential industry of sewing thread created a disproportionate number of luminaries. Friedrich Engels was the scion of an old textile family in the town of Barmen, part of today's Wuppertal, Germany. His father had combined with the inventor of a patented method for polishing thread (yes, that's a thing), creating another internationally branded product. The younger Engels was able to lead a double life as respectable merchant and amateur revolutionary, ultimately turning pro with his friend Karl Marx.

The French counterparts of the Coats and Clark families were the Cartier-Bressons, whose spools still show up on auction sites, their colors too beautiful for actual sewing. There is no evidence that Henri Cartier-Bresson, the great photographer and scion, was interested in the family business. But it did give him, like Engels, a considerable cushion to pursue his passion. Meanwhile, the multinational Coats Group Ltd. remains the world's largest manufacturer of industrial sewing threads, exceeding its Asian rivals in sales.

Unimportant but essential sewing thread has been more important than we imagine. The University of Pennsylvania econo-

mist Edwin Mansfield and his colleagues found that stronger sewing thread had contributed more to productivity and well-being than any other innovation, including information technology.

The Not-So-Humble Valve

What sewing thread is to garments, valves are to pressurized devices—small parts that hold larger ones together. Consider the humble tire valve. While automotive journalists periodically remind readers of the perils of underinflation, what is impressive is how little air is lost from a tire inflated at 30 pounds or more per square inch. The most common (and best) variety is the Schrader valve, still manufactured according to principles worked out in the 1890s by the German immigrant August Schrader and his son George.

The Schraders had prospered as suppliers to the thriving maritime industries of New York and had worked with valves of diving apparatus and life preservers when the safety bicycle (the kind with the now-familiar diamond frame and equal-size pneumatic-tired wheels), and then the automobile, brought a demand for reliable fittings. Schrader's genius was not only to perfect a durable valve but to standardize sizing, making it possible for millions of Schrader-compatible pumps—from slender ones mounted on bicycle frames to massive pressurized systems in repair shops—to connect with every Schrader-type valve on anything inflatable.

None of the early Schrader patents looks much like today's Schrader valve, but the principle is unchanged. A tire valve is a small part of the cost of the vehicle. Yet failure can be disastrous, so a high-quality product can command a premium price. In proportion to their size and weight, Schrader valves were some of the most expensive manufactured objects in America. The Schrader company's successor, Sensata Technologies, is now a leading

producer of high-tech valves for tire pressure monitoring systems mandated in every new car.

Other valves, intended for industry, were massive. One of the most influential was created by an Austrian-born inventor named Hanns Hörbiger in the early 1890s. Just as Schrader learned from his father's innovations in diving, Hörbiger applied lessons from his family trade of organ building and its management of compressed air.

A new generation of blast furnaces and other industrial equipment was operating at intense pressures that challenged existing valve designs, risking catastrophic explosions. Hörbiger's solution resists verbal description. Even published patent drawings and photographs reveal little about how it works—but work it does.

Unlike the Schrader valve, Hörbiger's became the anchor of a family dynasty and a multinational corporation like today's Coats industrial sewing thread empire. According to its website, Hörbiger products are used in everything from reciprocating compressors to vehicle transmissions. They are a small part of the cost of the final product—but essential, and thus highly profitable.

Yet another digression: Hörbiger's interests were not limited to engineering. Even as he was inventing his valves, he developed an unorthodox cosmology that he called the Cosmic Ice Theory, according to which the universe formed from the transformation of ice into the moon and planets. He thus joined a throng of outspoken mystical scientific amateurs of the Central European antimodernist fringe—proof that technological wizardry and scientific insight can diverge.

While scientists rejected his ideas, he did attract a ragtag bunch of admirers equally eager to challenge scientific authority. Indeed, after Hörbiger's death in 1931, these superfans found a new patron in Heinrich Himmler, the head of the Nazi SS and a man who never met a fringe doctrine he did not like.

There was a brighter side to the family legacy. Paul, one of Hörbiger's sons, became a celebrated stage actor who had a minor but memorable part in Carol Reed's 1949 film masterpiece, *The Third Man*. The most recent representative of the theatrical dynasty is Mavie Hörbiger, Paul's granddaughter, a familiar figure in German-language cinema. While the family members succeeded through their own talents—as did Engels and Kenneth Clark—a family fortune did not hurt.

Buckle Up

After the triumph of the valve in the annals of important unimportance came the age of the fastener, the ultimate little thing. Some successful fastener inventors have faded from memory. Who has heard of the Ukrainian-American William Dzus, who invented a self-locking fastener that could be installed rapidly yet could withstand the intense vibration and stresses of combat aircraft? But other fastener innovators were some of the most colorful twentieth-century industrialists.

Across the street from the Ukrainian Center's Gilded Age chateau donated by Dzus, the Metropolitan Museum of Art houses one of the finest collections of eighteenth-century French furniture masterpieces, given by Jack and Belle Linsky, the founders of the Swingline Corporation. Virtually no manufactured object costs less than a staple. Yet this humble device so enriched the Linskys that they were able to compete successfully with the Queen of England in auctions for decorative arts. You are certain to be able to see the Linskys' treasure trove when the Met reopens because the Linskys included a clause in their deed of gift requiring transfer of the collection to another museum if a single piece was disturbed.

Jack Linsky was not like most founders of industrial companies; he had neither an engineering nor a manufacturing background. He was a stationery salesman who represented a German

company that made staplers. The state of the art at the time was ungainly and expensive—with some, the staples were sold loose and often ended up on the floor.

Linsky found specialists to invent for them. Little is known about these tinkerers and chemists, but they made two brilliant innovations, both now taken for granted. One was the cohered strip, in which staples were connected with just the right amount of glue to be handled easily, yet could separate cleanly when struck. A complementary innovation, reflected in Swingline's name, was a springloaded cover that opened to allow the strip to be dropped in, and then applied pressure to the back of the strip once closed. Incidentally, the technology for making those cohered strips was long a closely guarded trade secret.

These Depression-era inventions came into their own in the postwar era, and especially in the 1960s thanks to a far more intricate innovation, the Xerox photocopier. A deluge of office paper ensued, along with (before the advent of copiers with built-in collators and stapling mechanisms) more stacks of paper needing to be stapled. What began as one cumbersome machine typically used by everybody in an office became an inexpensive fixture of each employee's desk. The more staplers were sold, the more staples were needed.

While Germans missed out on the global stapler market, they more than compensated in structural fasteners. Consider an object familiar to nearly all Europeans, a plastic expanding screw anchor with notched sides designed to anchor wallboard and other building elements. Like William Dzus's device, it was ingeniously designed to set securely without adhesives or complex manipulation. There is relatively little use for it in the United States, where frame houses (as opposed to masonry construction) are the norm. But it has become essential in European construction—a tiny but indispensable component.

Unlike the other important-unimportant inventors and entrepreneurs, Artur Fischer, the originator of the expanding screw anchor (aka the Dübel), was an all-around inventive genius. A locksmith and master mechanic in the artisanal tradition of Southwest Germany and Switzerland, he made his reputation and first fortune after World War II with the synchronized photo flash. Before then, photographers either had to use dangerous powder or independently activated bulbs.

Fischer claimed more patents than Thomas Edison, but many of them were for variations on the design of the Dübel. Of course, they gave some protection against would-be competitors as the original patents expired, but Fischer was also seeking bragging rights as a champion of German industry. In that spirit he devised a modeling kit, Fischer Technik, used as a teaching tool not only by students and hobbyists but by professional engineers to this day. At the time of his death (2016 at age 96), the company he founded, the Fischer Group, had 4,000 employees and sold 14,000 products worldwide.

The Future of Unimportance

I can offer no great insights into the next, important unimportant innovation. But that won't stop me from guessing.

One likely growth field for important unimportance may be microdevices that combine proprietary hardware manufacturing techniques with software controlling them. Switzerland is an ideal location, with superb science education (including Einstein's alma mater, the Swiss Federal Technical Institute) and high labor costs that encourage the development of niche manufacturing. My favorite little-known champion is Maxon Motor, with about 3,000 employees worldwide.

It manufactures virtually no consumer goods but supplies the miniature drives (with their own gears and software) that make

so much possible in everything from tattoo machines to humanoid robots. There are tiny motors everywhere around us—for example, in digital photography they control autofocus, zoom, and picture stabilization. The motors are small but critical parts of the total cost of these systems, so (as with Coats and Clark thread) it is risky to purchase imitations that cost less. Giant corporations could perhaps work around the patents, but the savings would not be worth it as they might be without components that largely determine the cost of the final product.

* * *

In these stories, David doesn't defeat Goliath with a slingshot. For a hefty but bearable fee, he supplies a secret miracle ingredient for the alloy used to forge the giant's sword.

The Trouble with the Meter

Why the Metric System May Never Completely Rule

Technology Review, May 1, 2005

Amid the ideological and religious upheavals of the last 200 years, the metric system has spread around the world as an exemplar of science and rationality. But in both its champions and detractors, it has evoked as much passion as reason.

Created beginning in 1790 by the French Academy of Sciences at the behest of the revolutionary National Assembly, the metric system reflected a century of measurement reform proposals. The meter was defined by a law of the National Convention in 1793 as one ten-millionth of a quarter-meridian, the distance from the earth's equator to one of its poles. Ken Alder of Northwestern University, studying records in Paris, found that the attempt to measure the meridian mixed painstaking detail with high adventure. It took two French astronomers seven years to measure the distance between Dunkirk, France, and Barcelona, Spain, and Alder's memorable account, *The Measure of All Things,* reveals that one of the men covered up for the other's fudged work. The astronomers knew the earth was slightly flat at the poles—Pierre-Louis Moreau de Maupertuis had proved Newton's prediction in 1736—but thought it otherwise uniform. Survey one

meridian, they thought, and you've surveyed them all. They soon learned the lumpiness of reality.

Not only was the earth-based metric system difficult to devise, and flawed: It was also unnecessary. Two Italian scientists, Paolo Agnoli and Giulio D'Agostini, recently noted in a paper that well before the French Revolution, scientists proposed a new unit that was less than a half-centimeter shorter than the current meter. They defined it not by measuring the earth, but by timing a pendulum. The Italian polymath Tito Livio Burattini proposed such a "catholic [i.e., universal] meter" as early as 1675. Burattini noted that a weight swinging on a string the length of his proposed meter returned to its original position in two seconds. The amount of time the weight took to travel from one maximum elevation to the other was one second: a unit that corresponded with the approximate duration of a human heartbeat. Timing a pendulum, even in a vacuum at a controlled temperature, was easier than surveying a meridian, and its deeply human rhythm was satisfying.

Why did the Academy of Sciences take the more difficult course? Because time itself was in play. The Academy was considering the establishment of a decimal-based 10-hour day, with 100 seconds to a minute and 100 minutes to an hour. Besides, France's scientists believed the project would unite humanity in the thrill of common proprietorship of the newly measured globe. After the shortcomings of the meridian-based meter became apparent, a platinum meter bar was presented to the French legislature in June 1799 as an arbitrary basis for the new measurement.

Since 1983, to establish greater precision than any material object allows even in controlled conditions, the 51-nation General Conference on Weights and Measures has defined the meter as the distance traveled by light in a vacuum during a time interval of 1/299,792,458 of a second. The Système International d'Unités (SI) starts with seven basic units—the meter, kilogram, second,

ampere, kelvin, mole, and candela—and defines 22 others that include every unit science, technology, and commerce need but money (and even that is now universally decimal).

Elegant as it is, the metric system has provoked spirited resistance. Some countries, including France in the nineteenth century and the U.K. today, have imposed draconian penalties on recalcitrant vendors; a northeast English grocer was sentenced to probation in 2001 for selling bananas by the pound rather than the kilogram. In the U.S., the government has yielded to opposition even to dual systems of measurement. In 1978, the Federal Highway Administration's policy of adding distances in kilometers to highway signs was reversed following protests of antimetric folk who saw the thin edge of a wedge.

The conflicts over metrication tell a messy truth: No single system of measurements is ideal for all uses. Like any object of human design, a measurement system trades one advantage for another. In its avoidance of thirds, for example, the metric system has no colloquial equivalent of the foot. Decimeters are seldom used; the system skips an order of magnitude from the centimeter to the meter. And liters exceed normal individual human thirst.

On the other hand, the millimeter has its own advantages. Around the thickness of two fingernails, it's the smallest unit we find useful for measuring common objects; a dime is 1.35 mm thick. It avoids the contortions of arithmetic involving sixteenths and thirty-seconds of an inch. Only where objects are regularly divided in half, as in carpentry and the building trades, does the inch come into its own. *What* is being measured dictates the appeal of the system used to measure it. The metric system has become the world's lingua franca, but traditional measures, rooted in the body and its crafts, are its tenacious vernacular.

Engineers and Political Power

Some Have It. Some Don't.

Technology Review, April 2005

In the United States, engineers don't rule. According to a *Congressional Quarterly* survey of the 109th Congress, there are just four engineers in the House and one in the Senate. When the engineering specialties in the 2004–2005 Statistical Abstract of the United States are combined, there are 2.12 million engineers in the U.S. versus 952,000 lawyers and 819,000 doctors; yet 10 physicians now sit in the House and two in the Senate, and CQ lists 160 representatives and 58 senators with legal backgrounds.$

One explanation for those discrepancies is that rapid technological change makes it hard for engineers to return from political office to professional life. In a 1992 interview with *Technology Review,* John H. Sununu, President George H.W. Bush's chief of staff, acknowledged that as a consulting mechanical engineer, he was lagging 10 years behind the field. Physicians, however, face equally great problems keeping up with the latest research, and by entering public service, they often forgo even greater potential income.

Another theory is that engineers are self-selected for social distance. Sylvia Kraemer is an intellectual historian who became a

senior NASA official and interviewed 51 colleagues for her insightful study *NASA Engineers and the Age of Apollo.* She found that lab engineers and those promoted into management endorsed the reputation of awkwardness. A manager declared that most engineers "wouldn't recognize an emotion if it hit them in the face." One rocket engineer flatly acknowledged, "I related to things."

This is an old American stereotype. In *The Engineers and the Price System,* the maverick economist Thorstein Veblen, championing what was later called technocracy, wrote that the public considered engineers a "somewhat fantastic brotherhood of overspecialized cranks, not to be trusted out of sight except under the restraining hand of safe and sane businessmen." He added, "Nor are the technicians themselves in the habit of taking a greatly different view of their own case."

But in many other cultures, especially in Eastern Europe, Asia, and the Middle East, engineers have been in the thick of power. The[y]'ve been prominent in Marxist movements, such as the brief Hungarian Communist revolution of 1919. They became influential enough in the early Soviet Union that Stalin directed one of his first purges against them. Later, scientists and engineers were put to work in the gulags' special research prisons, the sharashkas. After Stalin's death, engineering degrees became desirable credentials for the politically ambitious. As the historian Kendall Bailes wrote in 1974, "What lawyers and businessmen are in the American political system—the major professional groups from which most politicians and policymakers are recruited—men with engineering backgrounds have become to a large extent in the Soviet Union."

In 2004, almost all two dozen members of China's ruling Politburo had engineering degrees, including all nine members of the Politburo's Standing Committee. In the Middle East, prominent engineers fill the political spectrum, from former president Süleyman Demirel of Turkey to the members of the Society of Muslim

Engineers, pillars of the ayatollahs' Iran, to the late secular nationalist Yasser Arafat. In many countries, engineering appeals—to the civic minded. On the other hand, disaffected young men recruited in European engineering schools were prominent among the September 11 hijackers. As R. Scott Appleby and Martin E. Marty observe in *Foreign Affairs,* "fundamentalists tend to read scriptures [as] engineers read blueprints—as a prosaic set of instructions and specifications." Civil engineer Osama bin Laden surely did.

Globally, then, the unpolitical Anglo-American nerd is the exception. The argument that gained credence in nineteenth-century France and was echoed in other regimes is that a state must be guided by a scientific and technological elite. Two forces kept that notion from taking hold in the United States. The first was American suspicion of central government. The second was industry's appetite for engineers; at the turn of the 20th century, U.S. companies fearing manpower shortages resisted attempts to make elite postgraduate degrees the norm for engineers, as they were becoming for lawyers, doctors, and executives. So engineers in this country continue to design and implement everything but our laws.

When Big Data Bites Back

Milken Institute Review, July 6, 2020

Could Donald Trump be right about deliberate bias in political polling—a charge he recently raised about a CNN poll showing him 14 percentage points behind Joe Biden? Steven Shapiro, writing for *Politico,* rejects Trump's charge that the numbers were cooked. But he raises a question that goes beyond politics to the heart of a data-driven economy and society: Can assumptions lead even the best qualified experts to misleading conclusions when interpreting statistics?

A Twice-Told Tale

The public opinion industry had its *Titanic* moment in 1948, when the arch-Republican *Chicago Tribune* called the presidential election based on polls, leading to the iconic photograph of a beaming Harry Truman displaying the premature headline, "DEWEY DEFEATS TRUMAN." (Like the *Titanic* shipwreck itself, the headline was the consequence of multiple unlikely circumstances—in this case, a newspaper typesetter strike that pressured editors to set headlines hours earlier than usual.)

A forthcoming book, *Lost in a Gallup,* by W. Joseph Campbell, shows how the 1948 polling catastrophe echoed the distortions in sampling that sank the almost-as-famous *Literary Digest* mail-in poll, which had been accurate in elections since 1920 but missed by a mile in the 1936 presidential contest between the incumbent Franklin Roosevelt and Alfred W. Landon. Camp-

bell shows how other errors have bedeviled the polling industry since 1936 despite decades of advances in computer power and statistical sophistication.

It is difficult to read Campbell's book without empathizing with the pollsters and (crucially, as Campbell observes) the journalists and pundits interpreting and amplifying their conclusions. Every means of sampling, whether by telephone or internet, introduces biases. Response rates unexpectedly decline. Predictions of who will actually vote become more complex—and are likely to be even more so in 2020, with the future of mail-in ballots and the safety of voting at polling stations uncertain. It may be a great accomplishment that polls do not fail more often.

2016 and All That

But the 2016 and possibly the 2020 elections are different. As Shapiro observes in its postmortem of the 2016 failure, the Association for Public Opinion Research identified an Achilles heel of the polls. In hindsight, the blunder seems obvious: polls in decisive battleground states did not weight their samples for education levels, probably because until this campaign, education was not considered an important variable. White voters without college degrees were thus undercounted.

It is unknown how many pollsters and the journalists who interpreted their results had watched Donald Trump's reality TV show, *The Apprentice,* which elevated Trump from vulgar New York eccentric to national brand. While ratings dropped steadily after the first season, the NBC program was still must-see TV for some 10 million Americans.

If the political gurus had watched *The Apprentice* faithfully, they might have noticed a favorite theme of the host: the rivalry of college-educated professionals against self-made high school grads. The third season's teams represented book smarts (Team

Magna) against street smarts (Team Net Worth). The winner, Kendra Todd, was a Magna member with an undergraduate degree in linguistics. But Trump still had made his point that the losers were higher earners as a group than the winners and that there was more than one path to success. The season was the only one nominated for an Emmy.

Donald Trump has alternated between celebrating his undergraduate degree from the University of Pennsylvania's Wharton School and questioning the value of the business curriculum when weighed against his "genius." What detractors consider vainglory has seemed to Trump's partisans the power of positive thinking in the self-help tradition of Norman Vincent Peale in which Trump was raised—a creed scorned by academia but still followed by millions.

Thus, there were clues in plain sight of what might influence voters with Trump on the ballot. It was also common knowledge that the outcome in the Electoral College could turn on a handful of states, as it had in 2000 when a Supreme Court decision on Florida's near dead heat decided the election.

The most serious error of all may have been to assume that the statistical errors in state polls were uncorrelated. In retrospect it seems obvious that the failure to factor in educational background meant that as goes Wisconsin, so goes Michigan and Pennsylvania.

Devil's in the Details

The lessons of the 2016 polling debacle go well beyond politics. They fall into three categories. The first is what statisticians call Simpson's paradox. If we ignore certain variables—not necessarily clear in advance—we can draw false conclusions.

One of the most famous examples is a study of graduate school admissions at the University of California Berkeley. Women seem to have been at a great disadvantage; 35 percent of female versus

44 percent of male applicants were selected. But when results were analyzed by department, they revealed a striking distortion. Women applied disproportionately to humanities and social science programs, which had relatively low acceptance rates for men as well as for women. In natural science programs, with acceptance rates over 50 percent, women actually were admitted at a higher rate than men, but the departments were much smaller than those in the humanities and social sciences. Education appears to have been a neglected variable in key state polls.

The second data distortion was the bandwagon effect. This was the fault not only of the pollsters but perhaps even more of the journalists and opinion writers who interpreted the polls. As one pundit after another forecast a Clinton victory, it became more daring to call the contest close, let alone predict that Trump would squeak by in the Electoral College.

London bookie websites, with no emotional ties to either campaign, were giving odds strongly favoring Hillary Clinton; they lost tens of millions of pounds. An international conference of astrologers fared no better. Even the positive-thinking Trump, as he later acknowledged to an audience in Wisconsin, seemed ready to throw in the towel.

The third challenge to polls is the difficulty of framing questions to capture robust attitudes. A data analyst at the University of California at Berkeley has found that when asked about immigration in general, opinion is favorable, yet the same respondents may feel threatened by immigration in their immediate surroundings.

It should not be entirely surprising, then, that the losing side in the 2016 election had the more sophisticated and better funded data analysis operation, despite the supposed prowess of Donald Trump's creepy social media experts at Cambridge Analytica. *Politico* ran an admiring story on Hillary Clinton's guru and his

formidable "data-based" campaign that some Republicans feared could set them back for multiple election cycles.

Where Angels Fear to Tread

The failure of 2016 and concerns about 2020 do not mean that we should reject data science. They do suggest, though, that with eh proliferation of data—the rise of proprietary data, largely unavailable for study, in the hands of social media oligarchs—we need both more technical sophistication than ever and analysis that probes for variables hidden in plain sight.

As the Harvard statistician Xiao-Li Meng has written in the abstract of an otherwise highly technical paper, "without taking data quality into account, population inferences with Big Data are subject to a Big Data Paradox: the more the data, the surer we fool ourselves."

4.
Design

How the Chair Conquered the World

It was not inevitable that the chair would become the world's most widely used tool for sitting.

Wilson Quarterly, Spring 1997

Pull up a chair. And take a good look at it. It forms our bodies. It shapes our thinking. It's one of the first technologies an American or European child encounters. No sooner has a child been weaned than it learns to eat in an elevated model. And even before, it is (by law) strapped into a special molded minichair for automobile transportation, and indeed is sometimes carried by hand in the same little seat. At school, the chair is one of the most common objects in the classroom and among the first words a child learns to read and write. Despite all its variations, the chair could almost stand for the whole "domain of middle-size dry goods," to use the philosopher Charles Taylor's phrase.

In the West, we prefer to contemplate nature without too many chairs obtruding. We picnic on the grass and spread blankets on the beach. But in artificial settings, there is something disconcerting about the absence of chairs. The "festival seating"—that is, none at all—introduced by post-Woodstock concert promoters soon connoted not celebration but chaos and violence. (The arrange-

ment, though widely banned in the 1980s, is still common, even if the euphemism has long worn thin.) The standing-room-only arrangements of many British football stadiums in the same period amplified hooliganism and turned small perturbations into fatal stampedes. Chairlessness as dehumanization was carried to a nightmarish extreme by the infamous mass transports of the prewar Reichsbahn and the Soviet gulag.

Chairs go a long way toward filling a vacuum. They act as our proxies, claim space for us. The New Jersey Transit rail line between Princeton Junction and New York passes a large, new, nondescript condominium near the station in downtown Linden; almost half of the apartments have plastic chairs on their balconies, yet I have never seen a [soul] sitting in them at any hour I passed by. The chairs seemingly are no for human use but rather for filling otherwise empty niches in the building's exterior.

Yes, chairs are in every sense fundamental to us. With their humbler cousins, the stools and benches, they have been with us for millennia. Curiously, though, they are neither essential nor especially healthful even in industrial and postindustrial societies—even if a few activities probably do demand them. Until recently, the majority of the world's people rarely used chairs, and many still do not. Yet chairs have spread inexorably around the world, occasionally promoted deliberately by Western rule or influence but more often spontaneously adopted. The change has been one of the most thoroughgoing and apparently irreversible in the history of material culture. Essential parts of this spontaneous technology transfer are still obscure. But in every sense, the fortunes of the chair illustrate human malleability—and society's construction, reconstruction, and misconstruction of the human body. Once people [began] to spend most of their lives in chairs, they are removed as though by ratcheting from their original ground-level ways; individual return may be hazardous, and social reversal has

been unknown. Whole civilizations, in adopting chairs, literally change not only their posture but their point of view.

The chair's history is made up of several stories. The first is a functional and a negative one: Chair seating was not predestined to dominate modernized humanity. Western specialists themselves branded it a health hazard, but only after it had become such a standard that radical change became almost impossible, as would later be the case with computer keyboard layouts. The use of chairs spread partly because technological systems were built around them before alternatives were available. The second story is a symbolic one: Physical elevation appears to be a mark of prestige and power in nearly all societies, yet for centuries raised seating (including objects similar to Western chairs) never went beyond its ritual boundaries in nonchair societies. The third story is a material story: the chair as a European cultural good adopted less for economic than for social reasons, a slow but relentless change. And the fourth is functional again: The chair finally makes itself indispensable by inducing changes in the bodies of its users. Yet those users have second thoughts, and begin their own experiments in ground-level living.

* * *

Europeans and Americans occasionally are disconcerted to see Asians, individually or in families, sitting in airports or even at urban bus stops, preferring squatting or other ground-level positions to standing or raised seating. They may be feeling envy because chairs in most Western public spaces are so appalling. (The *Newark Star-Ledger* reported in 1989 that the Port Authority was installing "specially designed, uncomfortable seats" in its New York bus terminal. They remain.) But the feeling may also be wonder at seeing a remnant of an allegedly preindustrial, agrarian way of living. Western technology, with its operatives seated at everything from farm tractors to computer terminals, seems a func-

tionally chair-borne way of life. In the West, the closest we come to a floor-sitting worker is the cross-legged hand tailor, laboring in the shadow of sewing machines designed for chair operation. (The British columnist Bernard Levin once gloated good-naturedly to his readers that, having grown up in an East End needle-trade family, he could sit cross-legged and they couldn't.)

But floor- or mat-level seating could have been and could still be perfectly functional. The same technologies that let paraplegics operate machinery of all kinds without the use of foot pedals (seated in chairs, but only because the rest of Western society is) could also allow design of lower-profile automobiles, truck cabs, and even aircraft controls. Computer monitors and keyboards could be used at precisely the heights at which scribes and scholars composed masterpieces of science and literature in ancient civilizations from Egypt and the Americas to Asia. John T. Bonner, professor emeritus of biology at Princeton University, recalls his World War II days in aviation research at the Army Air Force's Wright Field, when pilots complained of intense pain after extended missions using conventional seats and praised the first alternative design, a simple cloth sling that put users in a position closer to reclining. In fact, recumbent bicycles, with the rider leaning back rather than perched on a saddle, are potentially more efficient and generally speedier (and less hazardous to operate) than the "safety" frame that has prevailed for the last hundred years. Perhaps cultural prejudice against reclining as much as sheer conservatism prompted bicycling officials to reject the design for competition.

Chairs themselves are surprisingly hazardous. According to the U.S. Consumer Product Safety Commission, 410,000 injuries serious enough to disable someone for at least a day occur every year in connection with chairs, sofas, and sofa beds, most as a result of falling. Another 400,000 injuries involve beds; the number would be far lower if we used floor-level bedding like the origi-

nal Japanese futon. (Just as missionaries brought some of the first chairs to China, they later introduced Western beds to Japan.) John Pierson has written in the *Wall Street Journal* that sitting in chairs causes most of the lower-back pain that costs the American economy $70 billion a year.

We don't often consider mat-level alternatives, partly because our upbringing hastens us in childhood from the positions that the very young find so natural. The French anthropologist Marcel Mauss considered the loss of childhood squatting "an absurdity and an inferiority of our races, civilizations, and societies." Depriving the child of this capacity is "a very stupid mistake....All mankind, excepting only our societies, has so preserved it." In *Growth and Culture: A Photographic Study of Balinese Childhood* (1951), Margaret Mead and Frances Cooke MacGregor observe that Balinese children "retain the flexibility that is characteristically seen in the human fetus, moving with a fluidity that suggests suspension in amniotic fluid.["]

* * *

It is a challenge to reconstruct how part of humanity began sitting in chairs while the rest (including some of the most culturally complex) lived near ground level. The historian Bernard Lewis has remarked that during their seventh- and eighth-century expansion, the Arab conquerors, a desert people without a steady wood supply, replaced the chair-level ways of the pre-Islamic Middle East with softer seating closer to the floor, only to return to the chair in today's urban society. But why did the Egyptians and other Mediterranean peoples begin to use chairs in the first place? Skeletons can sometimes reveal something about seating habits, but the answer remains mysterious.

What is clear is that chairs are keys to a distinctively Western system of things and symbols. Many other cultures have had elevated seating for rulers and other authority figures. It is almost

a cultural universal that higher is better. In folk culture and trade union caricature, the rich are portrayed as sitting on top of the poor. Even other animals attach importance to keeping the high ground; when a pet parrot sits on a human shoulder, it asserts possession as much as it claims protection, and owners of some aggressive dogs must prove their dominance to reclaim their favorite chair or sofa.

All this does not suffice to promote the chair as we know it. Hierarchy can exist very close to the ground. In pre-Columbian Mexico, even Aztec rulers slept on the same kinds of mats as their subjects, and the same mats on low platforms were standard seating even in law courts and government offices. It is true that the wood or wicker seat (icpalli) of emperors and notables had backrests that provided much of the allure of power seating attributed to today's high-backed "executive" or judge's chair, but the sitters were still cross-legged. In fact, in pre-Columbian Mexico rulers were often called "He of the Mat." Most of the thrones of South Asia, including Iran's original golden Peacock Throne (actually removed as booty from Delhi in 1739), were designed for cross-legged sitting, though Western-style chairs were also known; the current replacement of the lost Peacock Throne follows Western throne models. And even in the contemporary United Arab Emirates, according to the cultural historian Margaret Visser, guests must lower their bodies immediately to floor level and never rise while their host is seated.

In the absence of heavy furniture, the mat and the carpet have rich symbolic worlds of their own. The Japanese tatami is a module still used as a basic measurement of space. Among Japanese artisans, "mat learning" had the same connotations that "armchair knowledge" does in the West. The Chinese title translated as "chairman," *chu hsi,* means literally "mat master."

In the West, the chair diverted attention from the floor covering and helped determine every aspect of life and belief from the sublime to the material. Jewish and Roman sources both acknowledged chair sitting as central to kingship. Solomon's throne in 2 Chronicles 9:17–19 sets the pattern of a ruler elevated with legs suspending from the body and resting on a small stool; Greeks and Romans represented their deities on the high-backed *thronos*. The Holy See, the bishop's cathedra, and other chairs of state also followed this pattern. In the European High Middle Ages, high-status men and women worked the finest gradations of power and prestige in the public arrangement of their chairs. The physical occupation of a seat of office not only stood for office, it constituted office, and in one 12th-century succession dispute in the Holy Roman Empire, three ranking bishops physically removed Henry IV from his throne and thereby deposed him. (This mentality does not require a Western-style throne. Even in the 20th century, one Indian prince recalled for the anthropologist Adrian C. Mayer: "So long as I ascend the gaddi [a cushionlike throne for crosslegged sitting] I am ruler, otherwise I am not. I am just nobody.") Even today, cartoonists depict Saint Peter in a heavenly chair, not sprawled on a cloud.

From such exalted seats of power the chair has extended throughout Western society, even into its rudest outposts. The archeologist James Deetz has argued that until around 1600, the chair in most households was a single seat for the male head: "As the ruler was enthroned before his court and kingdom, so was the husbandman enthroned within his household. Others sat on stools, chests, settles, benches, cushions, or rush-covered floor." In our own popular culture, Archie Bunker's easy chair in *All in the Family*, higher than his wife Edith's, echoes ancient patriarchy.

For men and women of all stations, sitting Western-style affects more than the spine. While the water closet as we know it

dates only from the 19th century, the contrast between the Western seated position for defecation and the Asian and African squatting posture has long been familiar to travelers. In this century, Western physicians and designers have subjected the commode to the same scrutiny as the office chair, and most agree that it promotes straining and constipation. (Along with diet, squatting seems to have kept the common Western inflammation of the bowel, diverticulitis, out of Africa.) The architect Alexander Kira's definitive 1976 monograph, *The Bathroom,* cites overwhelming medical opinion against the throne-toilet as we know it; yet so accustomed are we to the sedentary life that no significant market has ever developed for redesigned fixtures.

With so little to recommend them, chairs and related objects—raised beds, desks, worktables, commodes—nevertheless dominate the world. And at first glance this is not surprising. Were not chairs part of the baggage of empire, instruments of hegemony? And sometimes the symbolism of sitting positions is apparent. Press photographs of Ayatollah Khomeini and his circle always showed them seated at carpet level in robes and turbans, in contrast to the Westernized shah and his officials—a contrast that must have been powerful to Iran's traditionalists.

But there is far more to the adoption of chairs than conquest or modernization. More than 30 years ago, the remarkable self-taught Sinologist C. P. Fitzgerald investigated one of the mysteries of material culture: why, of all the peoples of Asia, the Chinese should have changed from ground-level to chair seating before modern times, within a half century of the year 1000, to be exact. There were several types of chair seating documented in China as early as the second century [AD]. One involved a military folding chair not so different in function and design from goods available today through L.L. Bean and originally intended for use in often-muddy fields where mat and carpet living were impractical.

Over the centuries, it became a common furnishing indoors, and as such gradually ceased to be noticed by writers. By around AD 750, another form began to appear: a fixed frame chair closer in appearance and use to Greco-Roman and Byzantine counterparts. (Fitzgerald observes that the Chinese were sitting in chairs for centuries while most Europeans contented themselves with stools.)

Fitzgerald believes that Greek- or Syrian-born Nestorian missionaries brought chair sitting from Constantinople to China, but there was another source closer to home: the peoples of the north, some of whose rulers surprised Han Chinese diplomats by holding formal audiences while sitting on chairs with their legs hanging down. This practice also is seen in the imagery of one of the five Living Buddhas, the Maitreya, whose cult was popular in the north. Why was this sitting position popular there? It may have reflected the influence of northern peoples who spent much of their time on horseback and found it more natural than cross-legged positions. The Chinese characters for "chair" in any case attests to its foreign origin: "barbarian bed."

The Chinese appear to have modified a raised platform or k'ang (a wooden adaptation of an oven-platform popular in the cold winters of the north), adding a back and shortening the seat. But the precise process is less important than the result: a cultural revolution of sorts in which clothing and furnishings were modified for men and women whose bodies were now several feet higher off the ground. Chinese joiners over the centuries created some of the most beautiful and comfortable chairs on earth, and even introduced the S-curved splat, the earliest antecedent of today's domestic designs.

If China shows how powerful historical accident can be in the diffusion of a concept as basic as the chair, Japan illustrates how mat-level ways can persist. Had the Chinese adopted the chair before the beginning of the Heian age (794–1185), Japan might

have made the same transition. But though examples of chairs were known to the Japanese, they had little lasting influence. The art historian Kazuko Koizumi has identified a number of periods after the 12th century, when groups of Japanese took to chair living. In the Kamakura period (1185–1333), the chairs of Zen abbots—who usually sat cross-legged rather than in the Maitreya position—were copied for a time by wealthy samurai, the same group who emulated the furniture that arrived with Spanish and Portuguese missionaries and merchants during the brief Momoyama period (1573–1600). Except for the emperor and high-ranking Buddhist clerics, Japan remained almost entirely mat based until the Meiji Restoration in 1868. And for the dignitaries who used chairs, they may have been as much conveniences of age as emblems of exalted status. Colder Chinese winters cannot account for such a sharp difference; neither can Japan's island geography. (Chairs were even less common in Korea.) There may be no better answer than contingent events at crucial junctures.

It was European conquest, diplomacy, trade, and warfare beginning in the sixteenth century that finally secured the worldwide dominance of the chair, at least among most elites. The lines of influence become easier to draw, if not to explain in detail. We have seen that chair sitting is not inherently more comfortable to those who have grown up with one of the dozens of other resting positions that the anthropologist Gordon Hewes documented in a masterly article more than 40 years ago. Those who tried it in middle age often reported intense discomfort, he noted. The most influential channel of change may have been the Western-style schoolroom, which accustoms children to chairs in their formative years.

Consciously or not, Europeans began to maneuver non-Westerners into the chair as a precondition of bringing them to the bargaining table. The universal privileging of elevation probably

guaranteed that the higher seating technology would prevail. European lore told the story of an African queen whose courtier bent over to make a living chair of his own back when her European hosts tried to humiliate her by not offering one. More likely, the West offered its furniture as instruments of co-optation or coercion.

Aztec manuscripts of the Spanish conquest of Mexico depict Cortés and Montezuma sitting in massive chairs that the former had brought—obviously as valuable political instruments—to their initial meeting. Even after the destruction of temples and palaces, the Christianized Aztec nobles integrated into the Spanish order, adopting the huge, Spanish-style chairs. The Aztec nobility thus became the first of the non-Western elites to change its seating posture as a result of European expansion. But this was a cultural and not a functional change; bureaucracy as such can work perfectly well in mat-level societies without chairs or tables.

In Africa, the result was similar but the forms and motivation radically different. In many traditional African societies, stools were not the stark, utilitarian seats of medieval Europeans, but superbly carved objects almost inseparable from the owner and carried with him on trips. The Ashanti and some other groups believed the owner's soul dwelt in the stool. Royal seats had political potency even beyond their European counterparts; like European thrones and unlike Asian ones, they were occupied with sitters' legs resting on the ground. Whereas the chair remained a practical item of furniture for the Chinese, it entered Africa with a different aura. It was a kind of superstool. Africans had long made backrests for ground-level use, and some kings had already used seats and backrests together.

When Europeans arrived with furniture that integrated seat and back—and the first of these came with the Portuguese in 1481—these well-chosen gifts soon won the admiration of elites.

African rulers received them not as alien impositions but as potent elaborations of their own ways. While there had been indigenous highbacked seats in some regions, artisans now developed the European idea with complex narrative and cosmological decorative programs. Some of these magnificent objects in turn made their way to European collectors and museums. What would the original chair makers have thought had they been informed that, in 1921, a Bauhaus student named Marcel Breuer (later celebrated for the tubular-steel sled-base Cesca chair) would in turn appropriate their work, now considered naive, as inspiration for a five-legged "African" chair? It is as though world culture had become not an array of vitrines but a house of mirrors.

* * *

In the rest of the modernizing world, chairs spread with less aesthetic panache. The European embassy and diplomat's home was usually the point of entry. The Akasaka Detached Palace in Tokyo, built under Western direction in the early Meiji era (1868–1912), was modeled after Versailles. Once the local upper classes began to entertain with Western furnishings, social emulation began a process—later accelerated by the customs of the office, the railroad car, the airplane seat, and the automobile—that did the rest. Sometimes, as in Turkey, the old elites remained conservative and it was members of the newer middle classes who took to Western decor, but diplomats were still the chief agents of change.

For their part, affluent Europeans and Americans were drawn to what they considered sensual alternatives to the sprung and overstuffed parlors of the 19th century. The canvases of Jean Auguste Dominique Ingres, Eugène Delacroix, and a host of academic Orientalists later in the 1800s evoked an unbooted, uncorseted, and uninhibited Middle East, duly re-created in three dimensions in the world exhibitions that were the Internet of the age. Later in the century, some Westerners even built "Turkish corners" in

their homes with low divans, about as close as they were willing to approach the carpet.

Of course, chairs are not used universally and almost certainly never will be. Many people still cannot afford even simple ones; others, especially peasants, may simply prefer ground-level ways. Richard Eaton, a historian who visits India often, reports that while offices, schools, and factories in the South have chair seating, homes generally do not—another argument against technological determinism.

Still, there are signs that the world's commitment to the chair may be difficult to arrest, let alone reverse. In Japan, where many households have maintained both tatami and Western rooms, younger people are finding it increasingly difficult to maintain traditional ground-level seating positions. The less time is spent in them, especially in the kneeling meditation posture of *seiza*, the less comfortable they become. Worldwide lumber scarcity has discouraged traditional Japanese building methods, and many families now choose American materials and plans inspired by the sets of Hollywood films. Meanwhile, children as young as two and three sit on tiny chairs at cram-school desks preparing for the kindergarten entrance examinations.

It is not clear whether (as some Japanese and foreign officials have claimed) the decline of kneeling has supplemented diet in increasing the stature of Japanese youth, or whether different proportions have contributed to the preference for chairs. Sitting habits affect tendons, ligaments, and joints in ways that medical research has hardly studied; prolonged kneeling can induce bursitis, and extended cross-legged sitting by Western novices may damage knee joints permanently. In our posture, cultural choices become biological facts. It is not clothing but seating that truly makes men and women. Even mature Japanese executives now routinely use

cushions with short backs in traditional restaurants to ease their discomfort. Most new toilets are of the Western sitting type.

Meanwhile Europeans and Americans continue to experiment fitfully with mat-level life. Shag carpets, conversation pits, beanbag chairs, and brightly patterned floor cushions are all period pieces, but the impulse is not dead. And behind it is not so much a quest for health or even novelty as the sense that the chair as a technology has raised us a bit too much from nature, from our nature. In the end, the chair may not be a matter of health or performance or power, but of values. The scholar of Zen D.T. Suzuki contrasted Rodin's chair-height *Thinker* with Sekkaku's Zen master in meditation: "To raise oneself from the ground even by one foot means a detachment, a separation, an abstraction, a going away in the realm of analysis and discrimination. The Oriental way of sitting is to strike the roots down to the center of earth and to be conscious of the Great Source whence we have our 'whence' and 'whither.'" Has humanity lost something in attitude as it has gained in altitude?

The Life of Chairs

How *Homo Sapiens* Became *Homo Sedens* —and at What Cost

Harvard Magazine, January 1997

The Norwegian chair manufacturer T.M. Grimsrud, president and CEO of the prestigious company Hag A.S.A., once confessed in the journal *Ergonomics* that "humans were not created to sit; humans were created to walk, stand, jog, run, hunt, fish, and to be in motion; when they wanted to rest, they laid down on the ground." This statement is probably not valid anthropology; nearly 40 years ago, Gordon Hewes identified dozens of sitting positions around the world in a *Scientific American* article that unfortunately remains the main summary of its subject. But perhaps this variety only reinforces the first part of Grimsrud's statement. If there were a natural way to sit, we would not have so many chair designs with radically different principles, from kneeling to reclining. No wonder artists almost invariably portray Adam and Eve standing in paradise. Before the fall, we were indeed upright. Standing is in many ways a healthier position than sitting, especially sitting in chairs, which tend to rotate the pelvis forward and increase the load on the spinal column by about 30 percent. Prolonged sitting at work has been shown to shrink the spine and swell the feet temporarily. No matter. The more ills

Western-born science traces to the Western- (or more exactly Near Eastern- and Mediterranean-) born chair, the more ubiquitous it has become worldwide. In the German historian Hajo Eickhoff's expression, *Homo sapiens* has become *Homo sedens*.

Seating defies linear chronology. Materials and doctrines change, but the human body and certain basic forms remain. Reclining, for example, connects the ancient Athenian symposiast, the Viennese analysand, and the San Jose programmer. Even the ubiquitous folding director's chair echoes the field seating of Roman officers. Sometimes analysis must follow chairs as they move through time and space, for the chair itself sits at an often-dangerous intersection of the cultural and the biological. It can be seen from three sides: as a reflection of humanity; as one of humanity's self-imposed constraints; and, most recently, as the site of physical consequences of an information society.

Every few years a designer finds another way to give a chair the semblance of a human body, and the very lexicon of chair design suggests why designers should. Chairs are the solid shadows of humanity and indeed of all animal life. It is not just that they have legs. They have feet, or at least claws. At the Brooklyn Museum's recent *Converging Cultures* exhibit I saw a massive Peruvian 18th-century ecclesiastical armchair with spooky toe joints. And the jargon of furniture continues the metaphor. Chairs have knuckles. They have knees. They have elbows. Chairs have seats and backs, often reverse contours of our own. They have arms, often the size of ours. The protruding corners of Chippendale chairs are called ears. Some African chairs have human heads carved exactly where a sitter's head might be—literally sit-ins for deities and ancestors. In a recent contest for a chair for the megastar doll Barbie, one of the entries (according to an article by Diana Friedman in the sponsoring magazine, *Metropolis*) was "a chair made

from a naked version of her male counterpart, Ken, supporting her through various adjustable, submissive positions."

Chairs even have a social life. Many seem to travel in herds, like the curious little gilt ones that are toted from one society event to another, or they exist in stacks, like communally nesting swallows or purple martins. (Come to think of it, some chairs have paws or hooves, and others have wings.) A French designer, F.X. Lalanne, offers seating in the form of a herd of fleecy sheep, and the architectural historian Vincent Scully has described one of Robert Venturi's adaptations thus: "The flopping black Chippendales cluster like Labradors waiting to be fed around the table." The scattered folding chairs in a Paris park, the firmly bolted oak seats of the jury box in what we Americans appropriately call a county seat, the empty rows of writing chairs in an American classroom, are stage sets for a social order. Debates over the position of pupils' seating fill the educational journals, and even psychoanalysts discourse at length about the differences of interaction using couches and chairs. Indeed, a chair is a protean prop, able to help express almost any personal relationship.

Chairs are not only gregarious creations; they are even human surrogates. Like the prophet Elijah's reserved seat at the Passover Seder (in a few Avignonese synagogues it is even mounted in wall niches) or the "Vacant Chair" representing the faraway soldier in the American Civil War song, a chair turns the missing into the present. For millions of visitors to the National Museum of American History, Archie and Edith Bunker's chairs are Carroll O'Connor and Jean Stapleton. On a more sinister note, at the 1993 murder trial *in absentia* of the Philadelphia guru Ira Einhorn, an empty defendant's chair was retained. Above all, the chair is a memorial, a common gravestone image of the 19th century. The patriarchal Puget Sound industrialist John S. McMillan

even memorialized himself and his family as a set of chairs around a dinner table.

Yet chairs can stand for social disorder as well as order. A chair lying on its side in a painting or print like Hogarth's *Marriage à la Mode* is a convention for a disordered life. The familiar 18th-century English political ceremony of "chairing the member" was curiously followed by the violent dismemberment of the victorious candidate's temporary throne—mere animal spirits or an unsubtle reminder of the crowd's ability to unmake power? Indeed, in more recent popular culture the chair is a potent weapon that can at least plausibly keep a circus lion at bay, not to mention furnish the cast of a classic Hollywood Western with matériel for a photogenic brawl. And for contemporary artists it can be a sinister place in its own right: an installation by the video sculptor Tony Oursler features a man's face, delivering a recorded religious harangue, projected onto a doll lying beneath an overturned chair.

Chairs remain potent emblems both of human variety and of common fate in our own time. Photographs of a handful of chairs in the street have represented conflagration and survival in modern Lebanon and Bosnia. In 1989, the artist Alexis Smith and the poet Amy Gerstler presented an exhibition of five dozen children's chairs accompanied by enigmatic epitaphs: "a lesson in mortality," as the critic Richard Armstrong put it. And in the same year the staff of Harvard's Fogg Museum commemorated colleagues, family members, and friends who had died of AIDS (and those living with the disease) on the Day Without Art by assembling dozens of chairs and stools of every kind in a gentle spiral.

In our presence, as well as in our absence, we lend our character to our chairs. When we drape a jacket on a chair, or leave a hat on it, we even start to clothe it. As the historian Leora Auslander has written in her new book, *Taste and Power,* choosing a chair can mean reconciling conflicting values within one's own fami-

ly, and even negotiating a new self-definition: "[Guests] respond with their interpretations of my chair and me. I respond and am changed by their responses. I have been made by that chair and I have made the chair."

To return to the physical, as opposed to metaphorical, chair, it is equally a double agent. The chair arranges our bodies for presentation. In doing so, it promotes our public selves, but it often oppresses our bodies. In his book *Home,* the architect Witold Rybczynski has, correctly of course, deplored the dysfunctional consequences of the modernist aesthetic in furniture. And it does seem hypocritical that the Bauhaus school, which exalted industrial efficiency, should have produced structures like Mies van der Rohe's Barcelona Chair, with its concave back, thin cushions, and massive weight, or Marcel Breuer's Wassily Chair, a cubist exercise in chrome plated tubing and leather straps that provide even less support. (Its inspiration was reportedly the designer's bicycle handlebars.) Not that the deep cushions of Le Corbusier's misnamed Grand Comfort Armchair are a satisfactory alternative, however inviting its form might seem.

It is easy now to smile at the modernists. Some of their buildings, like their seating, proved remarkably dysfunctional. And as Rybczysnki recognizes, ease was secondary to image. The "friar's chair" shown at the Brooklyn Museum exhibit, which Spanish priests and officials brought to the New World, displays an uncompromising squareness that imposed itself on the mind of the conquered and was soon adopted by most of the elite among them. The high-backed chair of authority, like certain stiff hats and formal shoes, produces effects in the user no less than in the beholder.

Why is it so surprising that chairs should be valued for their external meanings just as neckties and high heels continue to be, despite a century of clothing-reform movements? The necktie is not based on ignorance of air circulation, nor the dress shoe of

podiatric health; instead, each expresses image and convention. Modernist furniture expresses a certain this-worldly asceticism that Max Weber ascribed to Protestantism, and a certain denial of comfort may even reinforce the idea of fitness to rule. According to the writer Philip Weiss, Spiro Agnew avoided leaning back in his chair to prevent creases in his suits. This consciousness of image he shared with his late-modernist foes. Indeed, as the architectural historian Joseph Rykwert observed, the very discomfort of the celebrated Hardoy (butterfly) Chair was a sacrifice the owners gladly made to underscore the antiauthoritarianism that its unstructured suspension system betokened. The chair allowed a new elite to display its superiority to tufted, overstuffed fogies, just as Agnew's immaculately pressed look confounded the rumpled and pointy-headed.

Of course this suffering to be beautiful or powerful or progressive has a sinister side. It is only a short step from the chair as self-discipline to the chair as control and correction. It is interesting that a popular Chinese adaptation of European chair design, imported into Europe in the 18th century, had its back in the form of a yoke. A chair is a kind of social yoke. Those who saw the play or film of Alan Bennett's *The Madness of King George* will recall the sinister debut of the Reverend Dr. Thomas Willis's specially built chair, in which the erratic king was clamped by Willis's strong-arm attendants when he resisted the doctor's regimen. In real life the king sardonically but tellingly called it his Coronation Chair, and it differed from the wooden armchairs of the day mainly in having a large, flat base that effectively anchored it to the floor. Not many years thereafter Dr. Benjamin Rush, the Philadelphia patriot-physician, introduced a similar chair for the insane, augmented by a hood. Much later, interwar Scandinavian functionalism could also be an almost sinister source of control; Grimsrud said of the Finnish architect Alvor Aalto's "sanatorium

chair" that "[i]f the patients were not already sick, then they certainly would be" after sitting in one of them. Even today, high-tech "violent prisoner restraining chairs," with due precautions against "positional asphyxia," appear at corrections trade shows.

A century after George III's treatment, New York State introduced the ultimate extension of Dr. Willis's clamp-fitted chair as the medium of its first electrocution. The philosopher Arthur C. Danto speculates that a chair, rather than a table or cross or noose or kneeling position, was chosen because of its dignity. A more likely answer, I think, was that it (and later the chair-equipped California gas chamber) built on the therapeutic chairs of Willis and Rush and others. Today's prevalent lethal injection is administered hospital-style to a prone "patient," but in *The Body in Pain* Harvard professor Elaine Scarry has documented the disturbing frequency of chairs as torture instruments in our own time. Is she right to say, though, that this practice inverts the true function of the chair, to provide comfort? Perhaps pain is instead the logical outcome of the search for ease. How pleasant, for example, is prolonged sitting in an overstuffed seat, with thick cushions that restrict circulation? The Inquisitor in the Monty Python skit may have had a point when he called for the Comfy Chair.

Is there a natural way to sit that avoids these alarming precedents? Most of the world's peoples sat at mat or carpet level before contact with Mediterranean chair sitters. There are reasons to believe their body techniques (in Marcel Mauss's phrase) may be healthier than those of chair sitters. A Sudanese professor of medicine compared the eating and defecating patterns of nomads with those of medical students in Khartoum and concluded that squatting, along with bulkier food, reduced the rate of hemorrhoids and varicose veins among the former. Some physical therapists have observed fewer complications in childbirth among women who have grown up in non-chair societies. (But then again,

squatting and kneeling may have pathologies of their own. The skeletons of some peoples reveal depressions in certain bones of women from prolonged kneeling in food preparation; one official of the Japanese health ministry believes that chair sitting as well as improved nutrition has made the postwar generation significantly taller than its parents.)

For better or worse, chairs have moved around the earth as though they had walked on their own legs, spread not only by the Spanish friars we have noted, but (for example) by medieval Nestorian missionaries in China, by early modern Portuguese traders in West Africa, and by French and other diplomats in the Ottoman Empire. The famous Golden Stool of the Ashanti, the embodiment of nationhood, was even enthroned on a chair of its own. Chairs carry us, and we carry chairs.

At first the chair coexists with ground-level customs. For years, many Japanese households maintained both tatami and Western rooms, with different proportions and décor as well as different seating. But this seating truce has proved unstable. In Japan at least, younger people report increasing discomfort in the floor-seated positions as they practice them less, a self-reinforcing cycle. Both Western reporters and at least one Japanese colleague note the decline of traditional seating. The kneeling position of *seiza,* familiar in Zen meditation and in school discipline, has become harder for the Japanese to sustain for any length of time. Nonwesterners have shifted to chair sitting not because it is a form of comfort they had been too hidebound to invent—the Japanese used chairs for centuries in a number of settings—but because of the chair's way of re-forming the physical as well as the social self. We make chairs and chairs make us.

We are still not quite happy with our chairs. Chairs for conversation and rest reached a high level more than 200 years ago, and the sprung furniture of the nineteenth century may even have been

a step backward. The quest for too much ease began to threaten well-being. As the designer Karl Lagerfeld put it, "It has been said that conversation died in France when chairs became too comfortable." The "elaborate padding of nineteenth-century upholsterers" made wit itself ponderous, whereas "in a bergère the mind can remain lively and alert."

Neither authority, nor conversation, nor wit is the object of today's chair; it is the manipulation of symbols on cathode ray tubes. And here the genius of the Rococo as celebrated by critics like Rybczynski is of little help. The computer has had some terrible unintended consequences in helping to multiply the reported rates of cumulative trauma disorders, but at Harvard and elsewhere these problems have also had a positive effect. They have accelerated serious thinking and research about seating.

In the nineteenth century, new quantities of padding and ingenious arrangements of springs attempted with varying success to assure new levels of comfort—a challenging enterprise considering the reinforced corsets of women and the many layers worn by both sexes. Most striking, though, is the casual attitude this progress-minded century took toward the improvement of executive and clerical sitting. Many 19th-century business chairs, even those of the wealthiest industrialists, look remarkably ordinary and uncomfortable today, especially side by side with the elaborate desks of the period. Adjustments arrived only slowly. Eighteenth-century society may have sprawled and leaned on its chairs, but 19th-century gentility—ever on guard against the parvenu—frowned on this form of animation. At the start of the century, Thomas Jefferson's political opponents, warning that "science and government are two different paths," scorned Jefferson's "whirligig" revolving armchair, and suspicion of novel work seating persisted, among bosses and workers alike. As the cultural historian Katherine C. Grier has written, truly adjustable furniture was largely reserved

for invalids. Springy seats were prized not for easy sitting but for their embodiment of the latest in "elastic" materials. (Were they enjoyed subconsciously as the repressed pleasure principle of the literally uptight?)

The paradox of the twentieth-century search for the healthy seat is that it probably began not with ruling adult males but with the perceived needs of schoolchildren and mass-transit users. The first studies of proper seating I have found are treatises from the middle to late nineteenth century on the proper desks and chairs for elementary-school classrooms. Transportation companies followed only a century later; the Harvard anthropologist Earnest Hooton conducted an extensive physical measurement program for the New Haven Railroad in the 1940s.

While today's commercial airlines seem to get their seating ideas from MBAs rather than either MFAs or PhDs, Rab Cross '67, MD, an occupational medicine specialist and certified professional ergonomist, believes that military studies of pilot seating were the first scientific treatments of the needs of machine operators as opposed to passengers or pupils. My own search of the papers of the pioneering industrial engineer Frank Gilbreth, at the National Museum of American History, reveals no attention to chair design, save an interesting concave footrest. Early textbooks of office practice are silent on such major topics as support for the lower back.

According to Cross, it was the computer that provoked the first extensive research and thinking about healthy seating in the office. Computers raised new questions about the proper height of seating in relation to work surface, about the optimum position of the body, and above all about activity. The physical dangers of the computer were unprecedented. With the computerization of the workplace, the old-style catastrophic industrial injury caused by a single traumatic event began to yield to a new and more insidi-

ous form of disability caused by the rapidly repeated performance of small motions and, indeed, sometimes by the absence of motion—by the fact that an operator could work for hours without even the throwing of a typewriter carriage or a trip to replenish paper supplies or change a ribbon. Cross reports that a number of the pioneers of computer science suffered serious disabilities from years of working in what now seem primitive conventional chairs. Nor does he consider the furniture of that golden age, the eighteenth century, much of a guide: He reacts to a 1995 *Martha Stewart Living* spread of antique French furniture supporting a personal computer system as C. Everett Koop would to a Marlboro landscape.

Today's ergonomic chairs are, from one point of view, worlds away from their origin in ceremonial role and constraint. Long vanished is the attempt to enforce a single optimum position. The chair is not so much a fixed object as a set of carefully formed and adjustable parts. A swiveling seat in Jefferson's day was a novelty. Even in the early nineteenth century, tilting chairs (like rockers) were domestic amenities, not commercial equipment. Now office chairs afford not only changes of seat height and back reclining angle—often with back- and seat-changing positions at carefully adjusted angles—but other degrees of freedom. The seat pan can tilt forward, as some ergonomists recommend for certain work. The position of the lumbar support, the height of and distance between the arms, the tension of the backrest, and sometimes the depth of the seatpan are all adjustable. A few chairs have split backs. Others, like the Equa II and the sculptural new Aeron, both lines designed by Bill Stumpf and Harry Chadwick for Herman Miller, are sized by body dimensions (small, average, and large) rather than by hierarchic and gender distinctions (secretarial, managerial, executive). The Steelcase Sensor, a favorite chair

at Harvard, has "highback" and "midback" styles. New flexible synthetics are taking some of the role of springs and padding.

Yet for all these innovations, the chair is still the object of unease. Some models, based on slim European bodies, lose their lumbar support when larger American bottoms push sitters up and away. The more adjustments and possible seating positions, the more time the sitter has to take to learn them. Some employees never do. And some designers have even concluded that chairs should not be contoured at all, that they should be designed to encourage constant shifting. The Rudd International Cyborg of the 1980s had a weight-activated hydraulic cylinder. As the Rudd brochure explained, "the chair itself moves, *making* the user move—virtually all of the time he or she is sitting in one," yet slowly enough that "[m]ost people will find it impossible even to detect." (The maker, now Rudd Incorporated, offers a lower-priced successor called the Cyncro.)

The horizon of chair design seems to be the horizontal, with ever bolder reclining angles. Theoretically, if the body does not slip, a wider angle means less pressure on the spinal column. The idea is not new. Jefferson wrote leaning back with his legs propped on a padded extension; Mark Twain and Winston Churchill also liked to stretch out with their heads supported. The ultimate laid-back executive seating, Nils Diffrient's Jefferson Chair, is a business lounge chair with its own table and computer monitor support. It is less a thing than a place—at $6,500 for chair plus ottoman it was the world's most expensive production chair; its original manufacturer went out of business after the stock market crash of 1987. It is now made by the Alma Group in Elkhart, Indiana, at the same widely discounted list price. In Middle American price brackets the La-Z-Boy and Barcalounger recliner chairs, once despised by aesthetes, now earn respect from ergonomists and designers, and may influence office chair design. (*Harper's*

Magazine's "Index" feature recently reported volume purchases by the CIA.) Meanwhile some chair designers report that Silicon Valley programmers, always in the sedentary vanguard, are looking for extra reclining room. At last the headrest, once a mere status-driven "nimbus" in the phrase of the designer Emilio Ambasz, may actually have a function.

Paradoxically, it is the very group that inspired some of the first anatomical studies of seating—students—who are now most at risk. Rab Cross's slides of Harvard students at work, taken with a House Master's permission, show (among other ergonomic problems) chairs utterly unsuited for computing. Cross, who with William A. Schaffer has published a book on personal workplace health called *ErgoWise,* warns that the true cost of universities' apparent indifference may appear only later, in workers' compensation costs to the graduates' ultimate employers. (Back pain is said to cost American business $6.5 billion annually.) Will Harvard, and students' parents, face yet another major investment? The chair, apparently so natural, turns out to be one of our most complex and least understood technologies, and in one way or another one of the costliest.

Talking Through Our Hats

Harvard Magazine, May–June 1989

Not so long ago hats were musts, and the language of headgear was universal. The old order has changed, but a revival may be in the making.

Once again a new chief executive took the oath of office and walked bareheaded and buoyant down Pennsylvania Avenue. But the breeze of freedom tossing President Bush's hair on that chilly January day brought cold comfort to sad hatters.

Their handiwork used to crown our new heads of state. The owner of the only unionized top hat factory in New York personally fitted Franklin Roosevelt. At his 1957 inaugural Dwight Eisenhower wore a black "international" homburg, its Italian body finished in nine countries in Western Europe, the Americas, and the Pacific. Even John Kennedy, chided by *Tailor and Cutter* for his allegedly hatless ways, became a hero to the standard historian of the high hat, the splendidly named Baron Eelking, for reviving the inaugural topper in 1961.

At our latest inaugural most other dignitaries seemed to follow the presidential line. Tradition-conscious Chief Justice William Rehnquist and Associate Justice Sandra Day O'Connor wore black woolen skullcaps like those used by Charles Evans Hughes at all three of Franklin Roosevelt's inaugurations, but they removed them while administering the oath. "Unflattering" was the *New York Times* fashion correspondent's harsh verdict on Marilyn Quayle's royal blue pillbox. And the new president did not

flaunt a Western hat at the festivities, perhaps having been advised that it would send an unwelcome message to non-Texans.

The swearing-in showed that hats, once worn almost by everybody, are returning only slowly. From the mid-sixties to the mid-seventies, the hat industry even seems to have lacked a trade association. According to the 1988 *Statistical Abstract,* there were 12,000 workers in 1985 producing $297 million in value added—hardly an after-inflation increase from $186 million in 1977. (There were at least 22,000 workers in 1941.) The John B. Stetson Company factory, once the pride of Philadelphia, closed in 1971; when Stetson turned from licensing back to manufacturing in 1984, it went into Chapter 11 by 1986.

Things are looking up. From Tom Wolfe's Panamas to Daniel Patrick Moynihan's tweeds to the Princess of Wales's wide brims, from the fedora of *Raiders of the Lost Ark* to the Aussie Western hat of *Crocodile Dundee,* headwear is again stylish. Franchised hat shops are appearing in malls.

Still, a trendy accessory is not necessarily an obligatory fixture. An "Anti-Hat Revolution" paragraph in the 1975 original edition of John T. Molloy's *Dress for Success* calls men's hats "completely unnecessary unless your head gets cold," and in the current version they are still tersely "optional." The German pictorial magazine *Stern* recently presented Giorgio Armani amid the elegant fedoras and overcoats of his Milan boutique. Yet in the same issue a south German hat factory manager, lamenting the lack of trained workers declared that "The occupation of hatmaker no longer exists," and the market for men's hats is declining in the Federal Republic.

Yet not so long ago hats were musts. In scenes of European and American cities before the Second World War the crowd appears as a collective mass of headgear, a hatscape. A man wearing no hat, or an inappropriate or out-of-season one, risked street

urchins' harassment. Photographs of Depression-era New York bread lines, like engravings of Victorian London homeless shelters, reveal barely an uncovered scalp among the poorest. In the Roaring Twenties, Barnard College women still needed the dean's permission to go hatless on campus. In 1940, editor David McCord '21 wrote in the *Harvard Alumni Bulletin* that a Harvard College sophomore had only a few years earlier solemnly advised a young visiting alumnus of this club that "you'd better put on your hat. Nobody goes without a hat in Cambridge nowadays" (see page 18). Even after the Second World War, a lidless associate in an old-line law firm hazarded partners' reprimands.

Headwear in Asia, the Near East, and the West alike used to be part of, and proxy for, the self. Some medieval Japanese noblemen would not remove their elaborate *kammuri* even when sleeping. Striking off a headcovering—whether a turban in the Islamic world or a felt hat in the American West—was the ultimate insult. And after death, the hat remained a poignant fragment of its owner. The only remaining trace of the Scots nobles in the "Ballad of Sir Patrick Spens" are their hats floating on the North Sea, and in Turkey headstones have long been constructed in the form of stylized turbans. In 1852, at the Duke of Wellington's funeral, a contemporary observed that a breeze in St. Paul's Cathedral "caused the feathers in the chieftain's hat that lay on his coffin to wave about, giving it a singular life-like appearance." As Milan Kundera has observed, the fur cap of the Slovak Communist leader Vladimir Clementis, which he had kindly placed on the head of party chief Klement Gottwald during Gottwald's historic 1948 speech in the Old Square of Prague, remains in official photographs years after Clementis was airbrushed from the scene. No wonder the *Oxford English Dictionary* lists "hats to be disposed of" as a phrase for "lives lost."

Making hats, like wearing them, has always been a serious matter. Two hundred years ago the Genevan Dr. Gosse won a prize from the French Academy of Sciences for showing that the erratic behavior we know as mad hatter syndrome was caused by the mercury compounds used to soften stiff hare fur. (Sergeant Boston Corbett, who shot John Wilkes Booth, may have been a sufferer [*Harvard Magazine,* March–April, page 30].) Incredibly, 40 percent of U.S. fur felt producers were still using mercury when it was finally banned in 1941. But a custom hatter's workshop can still be a steamy den of ancient machinery. In rural Ecuador, an aged master weaver of *fino* Panama bodies told the journalist Tom Miller that he could not afford eyeglasses, though his work ultimately retailed for as much $750 per hat. In the factory visited by *Stern,* a press operator had no time even to exchange glances with the reporter.

If they have borne down on people, hats have positively crushed wildlife. European male taste from 1650 to 1850 was unhealthy for beavers and other furry things. Having let European beavers be trapped to near-extinction, hatters declared open season on their American cousins with predictable results. In New Orleans alone, 96,000 beaver pelts were sold in 1833; the Detroit department of the American Fur Company "harvested" 727,000 furs of all kinds in 1840. Only the invention of the silk top hat and the popularity of the populist raccoon (think of Davy Crockett) ended the disaster of Astor versus *Castor.* Decades later came the ladies' turn. Conservationists estimated that before the protective legislation that followed the First World War, two or three hundred million birds were slaughtered worldwide annually for hat feathers, including (for example) 35,000 birds of paradise for the London market in 1898.

Wearing hats, like making them, has had its costs. A man's felt hat seems almost engineered to blow off in urban canyon

updrafts. "To avoid the indignity of chasing your hat down the street, which isn't very dapper," writes columnist Mike Royko, "you have to walk with one hand holding your hat on your head. . . . I see no point in keeping the top of my head warm if the price is a cold armpit." The eight-pointed hats of New York City police also tumble. "You lose them when you run after perps," one officer told a *New York Times* reporter. "This is my fourth hat." Washington's distinctive hazard, helicopter blade wake, dispatched Marilyn Quayle's hat after the inauguration.

Before professionals dared wear stocking caps and Irish tweeds against the cold, inconvenience was part of a hat's very being. Nineteenth-century travelers coped with cumbersome hatboxes and bought trunks and valises with ugly protuberances. All paid interminable ransom. The essayist Robert Coates Holliday wrote in 1918 of an acquaintance "who affirmed that a hat which had originally cost him three dollars had cost him eighteen dollars to be got back from hatchecking stands." Unattended they are easily mistaken or stolen. In 1946 a Michigan congressman even had a roll call vote taken in the House on a parliamentary ruse to compel the return of his new straw hat.

Class overrode climate and comfort. As Thorstein Veblen wrote in 1899, "[T]he more elegant styles of feminine bonnets go even farther towards making work impossible than does the man's high hat." In London around 1910, top hats still had to be worn until the end of July. In tropical Brazil, according to its great historian Gilberto Freyre, men "were in top hat from seven o'clock in the morning; and down to the beginning of the twentieth century the law students of São Paulo and Olinda, the medical students of Rio and Bahia, physicians, lawyers, professors, all went about in beaver and black cutaway."

Where a hat *could* aid in work, national pride reared its head. The Egyptian government never acted on a proposal reported in

the *New York Times* in 1952 "that the fez or tarboosh . . . be discarded in favor of the Mexican sombrero, the latter being considered better adapted to Egypt's warm climate." Of course it was, but there were things that a fellah didn't do.

Impractical as they may have been, hats were (in the great age that extended from George Washington's tricorn to Dwight Eisenhower's homburg) more than civilian uniforms. Out of the obligation to wear a headcovering and the subtleties of class relations emerged a lexicon and grammar of hattedness as an extension of the personality, just as the felt hat is the continuation of the head by other means.

Of course a sea of bowlers or toppers looks monotonous to us. And hats *were* easily confused. Flaubert's Bouvard and Pécuchet meet on a park bench after noticing each other's names written on their exposed sweatbands, an "original" idea to prevent exchange. All the more remarkable in manufacturers', wholesalers', and mail-order catalogues of the nineteenth century, then, is the number of variations not just in material and design but in small details of shape often imperceptible to today's casual reader.

This profusion did not arise only from the need to flatter as many body types and head shapes as possible. It appealed equally to customers' ideal selves, to the concern for the telling detail that Richard Sennett has identified as a nineteenth-century trait. Trade names often evoked settings and period male types like "the Swell," including some that have changed meaning ("the Masher") and others that remain cryptic ("the Go-on-the-Railroad Young Man"). One American maker, Knox-Dunlop, offered 9,280 styles of *soft* hat alone in 1922. Undergraduate group photographs from the nineteenth and early twentieth centuries reveal wild variations among chums.

Hats were ritual props as well as personal emblems. Even in the seventeenth and eighteenth centuries, they could display the

owner's grace and breeding in a courtly world. When one literally bowed and scraped, it was the precious hat that trailed on the floor. The eighteenth-century book *The Dancing Master* devotes a whole chapter to the proper ways to remove a hat, and in the heyday of wigs there was even the chapeau-bras, which was made to be folded and held under the arm when not being worn on top.

The hats of the next 150 years extended this language. By its pitch or yaw the hat could now signify probity, boredom, skepticism, aggressiveness. Honoré Daumier catalogued brilliantly the range of meanings that a hat salute, or failure to salute, could convey, depending on the actors' rank and mood. At least one American etiquette book recommended raising one's hat consistently to a hostile person as a means of reconciliation. Not surprisingly, Thomas Edison chose his era's symbol of esteem as the subject of the first voice-synchronized moving picture in 1889—"a man raising his hat as a speaker announces: 'Good morning, Mr. Edison, how do you like the cinematograph?'" By 1911, a writer in the *London Graphic* could declare, "There exists a language of hats as fraught with charm and interest as the language of flowers."

The hat not only expressed the person; it rooted him, and often her, in a place in life, a calling. Stéphane Mallarmé extolled the top hat as "the pot of that upside-down plant which is man. Let him implant his head underneath, and you will see him put out his trunk branched with arms and divide into the fork of his legs." The worker made his cloth cap a badge of class solidarity; in the 1911 Liverpool strike photographed for the *Graphic*, the helmets of the police and the forage caps of troops revealed the part each had in the hatscape.

Even those trying to transcend class nearly always spoke the language of headwear. One of the earliest bohemian cliques in Paris described by Jerrold Seigel, the Bousingots of the early 1830s, were known by the name of their waxed leather caps. The

poet and novelist Théophile Gautier recalled the artist Célestin Nanteuil as "an angel who had come down into the town, among the bustling bourgeois, still wearing his aureole ... in the guise of a hat, without the least suspicion that it was unusual to wear one's nimbus in the street." The same might be said of Gautier's own wide-brimmed hat as depicted in a contemporary caricature in *Le Charivari*. "The bowler of Mr. Jerome K. Jerome," Max Beerbohm wrote some fifty years later, "is a perfect preface to all his works. The silk hat of Mr. Whistler is a real *nocturne*...."

How could such a universal language be so nearly lost? Why have analogous, equally useless, and occasionally life-threatening articles like neckties and high heels survived it? The sociologist Michael Schudson has noted how sudden and puzzling the change was, and how impervious to advertising campaigns. Some of the most common suggestions are at best circular. There is the motorized suburb hypothesis, at least for the United States: As Americans moved out of cities and began to commute and shop by automobile, they no longer needed to keep their heads warm, and hats did not fit in cars. But top hats had been even more awkward in the crowded public transportation of the nineteenth century.

John Kennedy's frequent appearances without hats are also blamed. Yet Jacqueline Kennedy, celebrated by the nation's milliners, did not change the long-term trend among women. From Louis Kossuth to Winston Churchill, prominent hatwearers have had only temporary effects on fashion. In fact, the language of hats was suddenly mute in the mid-sixties, after waning for a half-century. Men and women of all stripes were ready for hatlessness. And trends had converged slowly to promote it.

There was renewed faith in the natural, and headwear proclaims the incompleteness of nature. Many animals wear fur coats; others welcome blankets and sweaters in cold weather; but only people, a few cart horses, and trained rhesus monkeys toler-

ate hats on their heads. The historian Sarah Levitt has pointed out the existence as early as 1904 of a "new hatless league," including the Manchester Physical Health Culture Society. Its motto: "Less Hat More Hair." By the 1960s, longer and fuller hair (as Schudson notes) diverted attention from hats and made it more difficult to wear them. Hair, the organic outgrowth of the human scalp, was authentic self-expression and, in the form of the Afro, ethnic pride.

To nature was joined youth. Hats signify the mysteries of adult roles, hence young children's fascination with them. But they also imply the responsibilities of maturity and old age. The heavy casualties among the young in the First World War provoked a reaction against the generation of brass hats many considered responsible for it. Among the first signs of youthful anti-hat sentiment may be the episode in F. Scott Fitzgerald's *This Side of Paradise* (1920) when freshman Amory Blaine leaves his bowler in his boarding house after observing that his friends are not wearing theirs.

Even after the trend toward long hair in the late sixties and early seventies had subsided, hats retained a geriatric stigma. Egon von Fürstenberg's *The Power Look* (1978) declares them very distinguished on "those men (usually older and quite conservative) who still wear them," recommending consultation with "one of the elder statesmen in a good men's store" and keeping to "fairly muted, fairly dark" colors. In 1986 Mike Royko was not entirely joking when he called hatless men "youthful, vigorous, impetuous," with a devil-may-care glint in their eyes," and continued that barehreaded JFK is remembered as "youthful and dashing" while hat-wearing Herbert Hoover "is dismissed by many historians as a dusty old coot." And the columnist Russell Baker wrote recently of "the old man, invariably in a hat, determined to hold his car to 35 miles an hour" on highways jammed with speed-obsessed truckers.

Hats also have suffered with the decline of authority. Even without insignia, certain hats were once badges of position. In Switzerland, the legendary William Tell was said to have refused homage to a Hapsburg official's cap set up publicly for the purpose. The early Quakers' denial of "hat honor" to magistrates brought ghastly punishments in colonial New England. I saw a British Rail official strutting in a black bowler in York during a wildcat strike as recently as ten years ago, a microphone on his lapel, at least looking supremely in control. Princeton's plainclothes proctors all wore fedoras until the late 1960s.

But the hat's strength is also its liability. Displays of authority now may disquiet more than reassure middle-class publics, and *Dress for Success* cautions against a threatening appearance. The softening of power, in the sociologist Robert Nisbet's phrase, has been reflected in the softening of hats. Harry Hopkins's banged-up hat embodied Yankee democracy in wartime London; after the war, Emperor Hirohito's crumpled pearl-gray fedora, waved to admiring crowds, signified his newly acknowledged humanity. Among today's leaders, only Mikhail Gorbachev, who needs to assert his power, is a prominent hat-wearer, and his triumphant visit to the United Nations in 1988 seems to have inspired remarkably few hat purchases, according to the *New Yorker*.

(In the Third World the hat once embodied the dominance and prestige of Western ways. When "barbarism" meets "civilization," the legal historian F.W. Maitland once innocently wrote, the "hitherto naked savage may at once assume some part of the raiment, perhaps the hat, of the white man." In campaigning against the fez and for the "civilized" brimmed hat, the political reformer Kemal Atatürk called for "shoes on the feet, trousers over the legs, shirts with neckties under the collar, jackets, and … a headcovering to protect you from the sun." African notables once bespoke their top hats and bowlers in London; perhaps a few

still do. But now that the West has lost much of its preeminence, it is the turbans of the Iranian mullahs and Afghan rebels that represent national pride.)

The old hatted order, with its strange production methods, its sea of covered heads, its gallant rituals, is forever gone. The $150 silk top hats of Harvard's Overseers, like those of magicians, lodge members, English undertakers, tap dancers, and chimney sweeps, are retained precisely for their anachronism, solemn or ironic. The costly Stetson and the handwoven Panama are now more likely to be the trophies of northeastern securities analysts than the working garb of ranchers and planters.

The well-made hat is now the property of the dapper few. And if more try to follow their example, how many department stores will be able to fit them properly when it is hard enough to find a clerk to ring up a few pairs of socks? To this dilemma the headwear industry of the 1980s has found its own answer.

It is called the baseball cap, football coach's cap, feed cap, or (most revealingly) gimme cap. The old-regime hat was costly, bulky, permanent; the gimme cap is cheap, portable, and relatively disposable. Hat connoisseurs disdain it. "It's nothing more than a duckbill visor attached to a skullcap," writes John Berendt in *Esquire*, "and it's not particularly flattering to the person who wears it. It throws the face into shadow and makes the head look proportionately small." Yet over 300 million are sold annually or give away as effective commercial promotions.

Among Old Boys and Good Old Boys (and Girls) alike, this uniclass headgear smashes the barriers of deference that divided the hatted order. But suppression of both class pride and individuality is the price. The nineteenth-century hat announced the wearer's place in a productive process at the same time it proclaimed a unique personality. The gimme hat usually marks instead participation in what Daniel J. Boorstin has called a consumption

community. At the Minnesota State Fair, the English writer Jonathan Raban saw hats promoting "farm machinery, Holsum Bread, chemical fertilisers, pesticides, corn oil, cement, and root beer." Under these corporation colours," he observed, "the owners of the hats looked queerly like feudal retainers riding round wearing the arms of their barons."

It is outside the Western mainstream that a language of hats still flourishes in tightly knit religious communities and in Latin America and Asia. The sociologist/anthropologist John Hostetler has described the subtle differences of crown and brim that set Amish bishops apart from rank and file, grandfathers from younger men, and strict from progressive communities. He recalls his own family cutting off some of his hat brim after moving from Pennsylvania to Iowa, to fit in with their more modernized new community. (The meticulously ironed pleats and seams of women's and girls' caps also identify the community.) Likewise among many Hasidim, the fur *Shtreimel* is a pledge of special commitment to Jewish observance.

The people of Bolivia have more than 300 regional hat styles, including the La Paz women's overwhelming favorite, the bowler. The Creole women of the former Dutch colony of Surinam have revived the printed cotton African headdress, called the *anjisa*, that can be tied to convey moods and messages. And the men of India's Rajasthan signify community, region, occupation, season, and attitude with their turbans.

But ours is the gimme cap, and it too has its cultural message. When George Bush was campaigning and distributing blue caps with "Bush-Quayle 88" written in gold letters, one reporter noticed that the manufacturer's labels had been removed. The boxes they came in read "Made in Taiwan."

Suiting Ourselves

Chronicle of Higher Education, March 30, 2007

America's classic suited-up zone is surely the two square miles or so north of the New York Public Library at Fifth Avenue and 42nd Street in New York, a district home not only to old-line men's retailers but also to many of the financial, legal, and media headquarters where coats and ties are still de rigueur.

The library now features a delightful exhibition, "A Rakish History of Men's Wear," on view until May 6. What unites it is an improbable story: the rise and persistence of the male suit, a garment that shows how cultural evolution can be as bizarre, yet weirdly logical, as biological selection.

Suits are, in fact, unnatural. The peoples of antiquity, the early Middle Ages, and traditional Asia, Africa, and the pre-Columbian Americas dressed beautifully with a minimum of cutting and sewing. Togas, kimonos, pre-Columbian mantles, dashikis—however luxurious or elegant—were not constructed as second skins.

The present male uniform began to emerge in the 14th century as an unintended consequence of military innovation. The body-fitting plate armor that we now admire in museums was replacing mail of the earlier Middle Ages. New craftsmen, the linen armorers, emerged to construct padding to cushion warriors' new exoskeletons, cutting and stitching pieces of cloth to fit the body. Those artisans, Anne Hollander declares in *Sex and Suits* (Knopf, 1994), "can really count as the first tailors of Europe."

Greater changes were to come. The French and American Revolutions discredited the elaborate waistcoats and knee breeches of the old regime's palaces. Male aristocratic finery never recovered from the Terror. Men from the middle and even upper classes copied the practical dress of country gentlemen and urban artisans. A colored etching of a gentleman's costume of 1792 reminds us that the new democratic spirit induced even wealthy men to adopt the pantaloons and trousers of the working class in place of the courtier's breeches (culottes) for political self-protection if not from conviction—hence the nickname "sans-culottes" for the revolution's militants.

Beau Brummell, an Etonian from an upstart middle-class family, established a new aesthetic. English pre-Revolutionary dandies like the Macaronis (best known now through "Yankee Doodle") had copied elaborate flourishes like the richly embroidered waistcoats of French aristocrats. In place of such overt luxury, Brummell introduced more subtle but equally painstaking and meticulous detail, admired by intellectuals like Baudelaire for turning the self into a work of art. Dark fabrics contrasted with immaculate white shirts and matching neckcloths that could take an hour to tie properly. And just as the medieval knight's silhouette in a pointed helmet resembled a Gothic arch, the late-18th- and 19th-century Western man in his top hat echoed the smokestacks and chimney pots of growing cities. (Visitors to the show will instantly recognize one of Brummell's greatest followers, the Count d'Orsay, as the inspiration of *The New Yorker* magazine's fictitious Eustace Tilley.)

Brummell was the last of the grand rebel-innovators in men's fashion. Machine sewing encouraged further democratic simplification. The price of business clothing was beginning a decline that has continued ever since. By the late 1800s, the present-day "sack

suit" of a single fabric had made the frock coat with contrasting trousers almost obsolete.

Would-be revolutionaries since then have failed, if only because their innovations have seldom improved appearance, comfort, or price. In one 1930s photograph at the library exhibit, a motley foursome of British dress reformers appear to be on their way to a mad tea party, not a progressive rally. The toga-wearing future citizens in the era's science-fiction film classic *Things to Come* are no more believable. More recent rebel styles—zoot suits, hip-hop gear, motorcycle leathers—have rarely made the jump out of their own subcultures. The most successful alternatives to the suit have been variants of work, military, or sports clothing: miners' blue jeans and pilots' bomber jackets, for example.

For 10 years or so in the late 1960s and early 1970s, the youthful rebels almost had their way. Mainstream manufacturers seemed to be capitulating. At a recent vintage film festival, I saw an unintentionally hilarious promotional short sponsored by the Arrow Shirt Company from 1970 in which grumpy, frumpy middle-aged people deplored the new styles of groovy youth; they were foils for a hip granny who found the kids refreshing.

But in the mid-70s, John T. Molloy's *Dress for Success* heralded the end of such polymeric exuberance. Molloy's meticulous research revealed clothing's signals of social class and education, confirming that conservative cuts and colors, and dressing like one's superiors, were the means of advancement. Science had developed brightly colored polyester double-knits to defy conformity; Molloy made conformity a science, helping consign the leisure suit to comic punch lines. Even the most celebrated breakthrough of 1960s fashion technology was a conspicuous failure. DuPont dropped production of its massively advertised plastic shoe material Corfam, the Edsel of footwear, within seven years of its introduction.

The informalization of the workplace in the 1990s also fizzled. It seemed either to devolve into T-shirts and flip-flops or to flower into a whole new wardrobe for "casual Fridays"—hardly more serviceable at a desk than shirt sleeves and tie, yet requiring new outlays for an ill-defined reincarnation of the competitive dressing it was supposed to replace.

Indeed, men's business clothing illustrates a paradox of design. The faster technology changes, the more people are reassured by the classics. Consider architecture. The Crystal Palace of the London Great Exhibition of 1851—which originated from the experience of its architect, the gardener Joseph Paxton, in building greenhouses for the aristocracy—became one of the world's most influential commercial structures. But the industrialists whose wares crammed such halls showed no interest in modeling their own homes on such glass-and-steel edifices.

For example, Sir William George Armstrong, a 19th-century inventor-engineer who became one of the world's largest makers of artillery and the armor plate to resist it, loved his era's new electrical lighting and devices. The home displaying them, however, was an immense neo-Tudor complex by Norman Shaw built high on a Northumberland hillside. Thomas Edison's plans for poured-concrete houses for American workers failed, and Edison himself remained in his New Jersey mansion with its 1880s Victorian furnishings (acquired with the house) until he died in 1931.

Even the most wired scholars today appreciate tradition. The renovated, century-old Beaux-Arts Carrere and Hastings building housing the library exhibition is more popular than ever with researchers, with its spacious and well-lit reading rooms in which the magnificent original tables have been discreetly rewired for laptop connections.

So, too, fashion resists technological advances. Our hottest high-tech innovation, nanotechnology, is found in apparel mainly

as an invisible protective coating for traditional materials. Luxury itself is disguised; platinum watches resemble stainless steel to all but a few cognoscenti.

Technology has also increased the value of protective coloration and "fitting in." The Renaissance pikeman could flaunt his shocking stripes and gaudy sleeves; the more visible he was, the more intimidating. Noblemen literally followed suit. Today even camouflage—originally based on natural forms—is now abstract and digitized, the better to mask the soldier's presence. The library exhibition features the ostentation of the hip nonconformists of revolutionary France, the incroyables, but the existentialist dissenters of 1950s Paris dressed in black, as many of the hip have done ever since. Belief in the color's slimming illusion, its psychological if not truly visual disguise, has helped.

In today's office, the rakish dresser is the tall poppy, standing out to be downsized—raked away. Even violators of the corporate dress code echo conservative stereotypes: Steve Jobs's blue jeans, black turtlenecks, and rimless glasses combine to mark him as the officiating worker-priest of design.

If there is a new rebellion in costume, it is the middle-class tattoo, recalling a plate of Pictish body art at the beginning of the library exhibition. Well-off businessmen are said to be wearing the most elaborate designs—discreetly. But men have largely given up using clothing as a means of expression in the workplace. Rather, suits are more useful than ever for shielding people's true selves.

Body Smarts

Wilson Quarterly, Spring 2003

In an age of pacemakers and microchip implants, the old nightmare vision of man melding into machine no longer seems completely far-fetched. Not to worry, says a noted observer of technology. Surprising things happen when the body interacts with technology.

For more than 50 years, enthusiasts have proclaimed the coming of a new age of technologically augmented humanity, a somewhat unsettling era of bar-coded convicts and chip-implanted children. But technology has been reshaping the body since the very dawn of civilization. The feet of shod people, for example, are physiologically different from those of people who have always walked barefoot. Technologies as various as the thong sandal and the computer mouse have affected how we use our bodies—the techniques we employ in our everyday lives—and this coevolution of technology and the body has not always followed the course engineers and other designers imagined. The question now is whether mind, body, and machine will fuse in some radical new way over the next generation.

The enthusiasts themselves are far from agreement on the mechanism that might achieve such a fusion. For some, the new intimacy between humans and machines will simply involve more portable and powerful versions of devices we already take with us—computers, for example, that might be carried as we now carry cell phones and personal digital assistants (PDAs), to be viewed

through special eyeglass displays. Spectacles might also transmit the emotional states of their wearers, so that a speaker, for example, could detect an audience's interest or boredom. There are already sneakers that can transmit or record information on a runner's performance, and civilian motorcycle helmets with intercoms and navigational aids built in.

Other enthusiasts scorn mere wearability. They're having sensors and transmitters surgically implanted in their bodies—as, for example, some deaf individuals have been fitted with cochlear implants that restore hearing. The cyborg, or human machine, is an especially powerful and persistent notion, perhaps because it seems a logical next step from technological symbiosis. (Politically, the cyborg idea—which for a few enthusiasts is a movement—spans a continuum from Paul Verhoeven's original *Robocop* film in 1987 to the work of cultural scholars such as Donna Haraway and Chris Hables Gray, who see the connection between human and machine as an emancipatory strategy against rigid economic and gender roles.)

But is the body really becoming more mechanized? Is the interaction of technology and human behavior all that new and frightening? Despite the legend, George Washington never wore wooden teeth, but his last pair of dentures, made of gold plates inset with hippopotamus teeth, human teeth, and elephant and hippo ivory, and hinged with a gold spring, were as good as the craftsmen of his time could produce. Still, he suffered great discomfort, and ate and spoke with difficulty (perhaps the enforced reserve enhanced his dignity). At any rate, if the nation's first president was a cyborg, it's not surprising that one in 10 Americans had some nondental implant—from pacemakers to artificial joints—by 2002. Nor was Washington an isolated case: Benjamin Franklin's bifocals and Thomas Jefferson's semireclining work chair were giant steps in human-mechanical hybridization. One might

even say that John F. Kennedy was continuing the cyborg tradition when he became one of the first politicians to adopt the robotic signature machine, a giant and distinctively American step in the cloning of gesture.

The many amputations wounded soldiers suffered during the U.S. Civil War led to the creation of an innovative artificial-limb industry. Today, responsive advanced prosthetics, wheelchairs, vision implants, and other assistive devices exceed the 19th-century's wildest dreams. (There has even been litigation in the United States over whether a teenage swimmer with an artificial leg was unfairly barred from wearing a flipper on it.) But the first choice of medicine is still the conservation of natural materials and abilities. Thus, the trend in eye care has been from spectacles to contact lenses to laser surgery, and dentistry has moved steadily from dentures to prophylaxis and the conservation of endangered natural teeth. Some dental researchers believe that adults may be able to grow replacement teeth naturally. Other forms of regeneration, including the recovery of function by paraplegics and quadriplegics, may follow.

The body remains surprisingly and reassuringly conservative, and humanity has stayed steadfastly loyal to objects that connect us with our environment. The traditional zori design—the sandal with a v-shaped thong separating the big toe from the others—is still used for some of the most stylish sandals. Athletic shoes with the most technically advanced uppers and soles still use a system of lacing at least 200 years old. For all their additional adjustments, most advanced new office chairs still rely on the 100-year-old principle of a spring-mounted lumbar support, and recliners still place the body in the same contours that library chairs did in the 19th century; according to industry sources, interest is fading in data ports built into recliners and in other technological enhancements. The QWERTY arrangement of the keyboard has

resisted all reform, and alternatives to the flat conventional keyboard are expensive niche products, partly because, in the absence of discomfort, so few users are willing to learn new typing techniques. A century after the piano began to lose prestige and markets, it remains the master instrument, with a familiar keyboard.

Computers now allow the production of advanced progressive eyeglasses without the visible seam of bifocals, but wearers still hold them on their heads with the folding temples introduced in the 18th century. The latest NATO helmet still reflects the outlines of the medieval sallet. But then, our skulls—like our foot bones, vertebrae, fingers, eyes, and ears—have not changed much. Even the automatic transmissions in our cars rely on a familiar tactile principle, a knob or handle and lever; the seemingly more efficient pushbutton shifter was largely abandoned after the Edsel. And the 21st century's automobiles are still directed and controlled by wheels and pedals—familiar from early modern sailing ships and wagons—rather than by the alternative interfaces that appear in patents and experimental cars. Meanwhile, many technological professionals study body techniques that need few or no external devices: yoga, martial arts, and the Alexander technique (a series of practices developed by a 19th-century Australian actor to promote more natural posture, motion, and speech).

Even Steve Mann, the Christopher Columbus of wearable computing, has misgivings about integrating himself with today's "smart" technology. Mann, who holds a PhD in computer science from the Massachusetts Institute of Technology, was photographed as early as 1980 wearing a helmet equipped with a video camera and a rabbit-ears antenna. But in his book *Cyborg* (2001), he acknowledges being "increasingly uncomfortable with the idea of a cyborg future," where privacy is sacrificed for pleasure and convenience to a degree he compares to drug addiction.

Today's advanced cyborg technology is a harbinger of neither a utopian nor an apocalyptic future. Virtual reality helmets, often featured in scare scenarios of the future, are still not playthings; they're professional tools demanding rigorous training in physical and mental techniques if wearers are to avoid disorientation and lapses in judgment. At the other extreme of complexity, the miniature keyboards of cell phones and other devices are exerting a surprising influence at the level of everyday life. They're shifting the balance of power of the human hand from the index finger to the thumb. C.P.E. Bach elevated the role of the thumb in musical keyboarding 250 years ago, but touch-typing pioneers of the 20th century rediscovered the fourth and fifth fingers and banished the thumb to space bar duty. Now the thumb is enjoying a renaissance. It has returned to computing with the introduction of pen- and pencil-like devices such as the styluses used with PDAs. The latest computer mouse, developed by the Swedish physician and ergonomist Johan Ullman, is gripped and moved around the desk with a pen-shaped stick that uses the precision muscles of the thumb and fingers and doesn't twist the hand and tire the forearm. Even thumb-dependent pencils are resurgent, their unit sales having increased by more than 50 percent in the United States in the 1990s.

The biggest surprise is the thumb's role in electronics. In Japan today, so many new data-entry devices rely on it that young people are called *oyayubi sedai,* the Thumb Generation. In Asia and Europe, users have turned technology on its head: Instead of using the voice recognition features of their phones, they're sending short text messages to friends, thumbs jumping around their cellular keyboards in a telegraphic imitation of casual speech. By spring 2002, there were more than 1.4 billion of these transmissions each month in the United Kingdom alone.

One British researcher, Sadie Plant, has found that thumbs all around the world are becoming stronger and more skillful. Some young Japanese are now even pointing and ringing doorbells with them. As Plant told *The Wall Street Journal*, "The relationship between technology and the users of technology is mutual. We are changing each other." Always attuned to social nuance, the "Style" section of *The Washington Post* also noted the ascent of the formerly humble digit. The major laboratories did not predestine the thumb to be the successor to the index finger, though they did help make the change possible; its full capacities were discovered through collaborative experimentation by users, designers, and manufacturers. The ascendancy of the thumb is an expression of the intimate relationship between head and hand described by the neurologist and hand injury specialist Frank Wilson, who speaks of the "24-karat thumb" in his book *The Hand* (1998): "The brain keeps giving the hand new things to do and new ways of doing what it already knows how to do. In turn, the hand affords the brain new ways of approaching old tasks and the possibility of understanding and mastering new tasks."

But change is not without cost. We learn new body skills to the neglect of others, and humanity has been losing not only languages but body techniques. Scores of resting positions known to anthropologists are being replaced by a single style of sitting. Countless variations of the infant-feeding bottle compete with the emotional and physiological rewards of nursing. The reclining chair, originally sold partly as a health device, has become an emblem of sedentary living. The piano's advanced development in the late 19th century prepared the way for the player piano, and ultimately for recorded music. Typewriter and computer keyboards eliminated much of the grind of learning penmanship, along with the pleasure of a personal hand (today's children may still grumble, but rarely must they learn the full, demanding systems of the

19th-century master penmen). The helmet wards off danger even as it encourages overconfident wearers to engage in new and dangerous activities. All these devices augment our powers, but in doing so they also gain a power over us.

The challenge within advanced industrial societies is to cope with a degree of standardization that threatens to choke off both new technologies and new techniques. We need a return to the collaboration between user and maker that marked so many of the great technological innovations, whether the shaping of the classic American fire helmet or the development of the touch method by expert typists and typing teachers. Research in even the most advanced technical processes confirms the importance of users. In the 1980s, for example, the economist Eric von Hippel studied change in high-technology industries such as those that manufacture scientific instruments, semiconductors, and printed circuit boards. Von Hippel found that up to 77 percent of the innovations in the industries were initiated by users. He therefore recommended that manufacturers identify and work with a vanguard of "lead users"—as was done in the past, for example, when 19th-century musicians worked with piano manufacturers, or when the typewriter entrepreneur James Densmore tested his ideas with the court reporter James O. Clephane in developing the QWERTY layout, an efficient arrangement for the four-finger typing technique that prevailed until the victory of the touch method in the 1890s. Today's cognitive psychologists of work are rejecting the older model of a single best set of procedures and learning from the experience of workers and rank-and-file operators how equipment and systems can be modified to promote greater safety and productivity. As one psychologist, Kim J. Vicente, has written, "Workers finish the design."

Design should be user friendly, of course, but it should also be user challenging. The piano keyboard is rightly celebrated as an

interface that's at once manageable for the novice and inexhaustible for the expert. Information interfaces should similarly invite the beginner even as they offer the experienced user an opportunity to develop new techniques; they should not attempt to anticipate a user's every desire or need. The practice of participatory design, introduced in the 1970s by the mathematician and computer scientist Kristen Nygaard, began with Norwegian workers who wanted a say in the development of technology in their industries and was ultimately embraced by corporations worldwide.

The keyboard that's negotiated with a thumb is a threat to handwriting traditions, whether Asian or Western, and that's regrettable. But adapting to its use is a mark of human resourcefulness and ingenuity. The thumb, a proletarian digit ennobled in the digital age, is an apt symbol for a new technological optimism based on the self-reliance of users. The index finger—locating regulations and warnings in texts, wagging, and lecturing in person—signifies authority, the rules. The thumb, by contrast, connotes the practical knowledge men and women have worked out for themselves, the "rules of thumb." It represents tacit knowledge, too, the skills we can't always explain, as with a "green thumb." And when extended during the almost lost art of hitchhiking, the thumb displays the right attitude toward the future: open and collaborative, but with a firm sense of direction.

Adam Smith and the Roomba®

Raritan Quarterly Review, Fall 2022

Every so often technology critics charge that despite the exponential growth of computer power, the postwar dreams of automated living have been stalled. It is true that jetpacks are unlikely to go mainstream, and that fully autonomous vehicles are more distant than they appear, at least on local roads. And the new materials that promised what the historian of technology Jeffrey L. Meikle has called "damp-cloth utopianism"—the vision of a future household where plastic-covered furnishings would allow carefree cleaning—have created dystopia in the world's oceans.

Yet a more innocent dream, the household robot, has come far closer to reality: not, it is true, the anthropomorphic mechanical butler of science-fiction films, but a humbler machine that is still impressive, the autonomous robotic vacuum cleaner. Consider, for example, the Roomba®. Twenty years after introducing the first model, the manufacturer, iRobot, sold itself to Amazon in August 2022 for approximately $1.7 billion in cash. Since 2013, a unit has been part of the permanent collection of the Smithsonian's National Museum of American History.

As the museum site notes, the first models found their way by bumping into furniture walls, and other obstacles. They could not be programmed to stay out of areas of the home; an infrared-emitting accessory was needed to create a "virtual wall." Like smart-

phones, introduced a few years later, Roombas have acquired new features steadily with a new generation on average every year. (They have also inspired a range of products from rival manufacturers.) Over 35 million units have been sold. According to Fortune Business Insights Inc., the worldwide market was nearly $10 billion in 2020 and is estimated to increase from almost $12 billion in 2021 to $50.65 billion in 2028.

On the Amazon.com website, iRobot describes the most advanced model, the S9+ (retailing for about $1,000 plus supplies), as "our smartest, most powerful robot vacuum yet." Using onboard processors, sensors, and artificial intelligence in the cloud, it can navigate its way around furniture to cover the entire area of a room. It features a docking station into which collected dirt is automatically emptied at the end of a run; it can hold up to a month's worth of sweepings. It can learn owners' preferences, distinguish among rooms, and recommend extra cleanings "when pollen count is high or during pet shedding season." Since robotic dogs and cats have gone out of style, the Roomba S9+ also is equipped with brushes that resist tangling with pet hair and a high-efficiency filter that "traps 99 percent of cat and dog allergens." Unlike most previous models it is sensitive enough to avoid bumping into objects and rolling over pet waste, which it can photograph and transmit to an absent owner by text message. No wonder many owners treat it as a beloved household member with a personality of its own. It *is* the robotic pet.

Adam Smith might applaud the Roomba as a triumph of the liberal world order he had endorsed. Thanks to the global marketplace for design ideas, chips, and mechanical parts, he might remark, a division of labor—Roomba is designed mainly in the United States by an international team and manufactured in China and Malaysia —has benefited consumers worldwide. Smith would nonetheless disapprove of the economic nationalism of both the

United States and China that has made managing high-technology manufacturing chains so challenging.

Yet Smith might also make a different kind of observation, highlighting the technology's limits rather than its capabilities. For while Smith lauded ambition and entrepreneurship, he also recognized that it might benefit the community more than the striving individual. In part 4, chapter 1 of *The Theory of Moral Sentiments,* he presents a secular parable of "the poor man's son, whom heaven in its anger has visited with ambition, [who] admires the condition of the rich. He finds the cottage of his father too small for his accommodation and fancies he should be lodged more at his ease in a palace." Paradoxically he works feverishly to achieve a life of leisure supported by a retinue of servants.

> He makes his court to all mankind; he serves those whom he hates and is obsequious to those whom he despises. Through the whole of his life he pursues the idea of a certain artificial and elegant repose which he may never arrive at, for which he sacrifices a real tranquility that is at all times in his power, and which, if in the extremity of old age he should at last attain to it, he will find to be in no respect preferable to that humble security and contentment which he had abandoned for it. It is then, in the last dregs of life, his body wasted by toil and diseases, his mind galled and ruffled by the memory of a thousand injuries and disappointments which he imagines he has met with from the injustice of his enemies, or from the perfidy and ingratitude of his friends, that he begins at last to find that wealth and greatness are mere trinkets of frivolous utility, no more adapted for procuring ease of body or tranquility of mind than the tweezer-cases of the lover of toys.

Smith was not necessarily urging his readers to shun economic and social ambition and embrace rustic simplicity, although he could not resist wondering, "How many people ruin themselves by laying out money on trinkets of frivolous utility?" His point was rather that individual striving, while perhaps futile, creates support for countless families and communities as a positive unintended consequence. The stomachs of the wealthy, he observed, had no more capacity than those of the humble. The rich are envied most for what we would now call gadgets, "numberless artificial and elegant contrivances for promoting . . . ease or pleasure." The benefits of wealth and power may be an illusion, but it is one that "rouses and keeps in continual motion the industry of mankind."

The example that intrigued Smith most was the advancement of watch mechanisms. Connoisseurs of watches, he wrote, were selling their old models, which could be two minutes or more fast or slow, for others accurate to within a minute in a fortnight. But those men, Smith observed, do not really need such accuracy. Conventional timepieces are sufficient for keeping appointments, and the owner of a costly watch does not necessarily want to know the precise time of day. "What interests him," Smith continued, "is not so much the attainment of this piece of knowledge, as the perfection of the machine which serves to attain it." (Centuries later, the American essayist Fran Lebowitz expressed a similar sentiment on the useless precision of digital timekeeping: "Nine-seventeen is fake time because the only people who ever have to know that it's nine-seventeen are men who drive subway trains.")

The Roomba, Smith might learn, was only part of a movement called the Internet of Things (IoT), linking appliances with thermostats, door locks, security cameras, entertainment systems, smartphones, digital personal assistants like Amazon Echo, and other devices in networks controlled by artificial intelligence. It is

the latest version of the life of ease that Smith's ambitious contemporaries sought, but without the personnel issues that arise when employing flesh-and-blood household staff, a utopia of technological efficiency and convenience to its enthusiasts.

There are tens of millions of smart houses. The data service Statista reports that in 2019 there were already 35 million smart homes in the United States, and it estimates annual smart-home revenue at $47 billion by 2024. The Roomba, the Echo, and other connected devices create a kind of domestic technological theater, in which their apparently seamless interaction gratifies the owner in the manner described by Smith. The historian Neil Harris has called our fascination with observing machinery at work the "operational aesthetic." Decades ago, spectators flocked to see the automatic milking of cows at a dairy near my present home, and tourists would marvel at newspaper presses through plate-glass windows the publishers had installed to dramatize the mass communication of the day. While cheap digital timepieces are more accurate than the most precise mechanical brands, many collectors of luxury watches still cherish display cases with sapphire crystal backs displaying hand-finished escapements and gears. Seeing a robotic vacuum return to its dock and discharge its sweepings with no human contact can be an entertaining spectacle, like observing the mechanism of an expensive mechanical watch.

Yet Smith also probably would refer back to his remark about gadgets satisfying minor needs but failing the greatest challenges. No robotic vacuum can supply the suction of a full-sized upright or canister model, or clean deeper carpets. In 2020, *Consumer Reports* found that a top-of-the line robotic vacuum captured only 20 percent of the talc and sand swept up by a leading upright counterpart. So households with robots still need to clean periodically using full-sized equipment. There is initial trial and error in teaching the robot the proper spaces to clean and to avoid. And

even if a robot can discharge itself into a dock, there is still no commercially available domestic robot that can eventually empty the dock and put out the debris with the rest of the trash. So the master of the machine must still clean up for it at some point. And the novelty of watching the robot complete its assignment can wear off as we see it day after day, just as Smith saw that strivers would grow dissatisfied once their goals were achieved. Today's social psychologists have a phrase for that: the "hedonic treadmill."

Smith's critique of material goals and consumer culture for the individual—the other side of his recognition of their value for society—was the contrast between technological conveniences and ultimate concerns. The convenience of small luxuries and gadgets like tweezer sets, Smith wrote in a famous passage, "keep off the summer shower, not the winter storm, but leave [the individual] always as much, and sometimes more exposed than before, to anxiety, to fear, and to sorrow; to diseases, to danger, and to death." Despite Scotland's renown as a center of medical education, Smith rarely discusses epidemics, yet he had to be aware of their impact. Smallpox was endemic in eighteenth-century Britain, and while its distribution and impact in Scotland has been controversial—the most common estimate is that it accounted for ten percent of all deaths—there were periodic epidemics with a far higher incidence. Inoculation with the live infected material, often by untrained practitioners, was common, especially during an outbreak, but sometimes deadly. In fact Smith's patron, the young Duke of Buccleuch, inherited his vast estates from his grandfather because his father had died of the smallpox. The lifetime pension that Smith received when he was engaged as the duke's tutor on the Grand Tour gave him the freedom to write what became *The Wealth of Nations*.

The success of twenty-first-century science in developing effective vaccines would have impressed Smith and other eigh-

teenth-century Britons living before the adoption of vaccination around 1800. Yet Smith also probably would have invoked the contrast between the amenities and conveniences of networked app-controlled devices managing our "summer showers" and the remaining challenges of "winter storms." Consider U.S. life expectancy. While our futurists and visionaries have been foretelling the possibility of virtual immortality, the previous decades-long growth of American longevity has been reversed. Even before COVID-19 appeared, life expectancy had been declining since its all-time peak of 78.4 years in 2014, due to increased death rates in middle age. Hopes for effective anti-Alzheimer's medication have failed; the most recent candidate for treating the disease, Aduhelm, was still unproven in spring 2022. Meanwhile, between 2000 and 2018 reported deaths from Alzheimer's disease rose over 146 percent. One in ten Americans over sixty-five has Alzheimer's dementia, according to a report from the Alzheimer's Foundation. The impressive gains in the memory of devices have done nothing to retard the threat to human memories.

Could household automation be not only irrelevant to fundamental human welfare, but harmful? As an omnivorous reader, Smith would no doubt discover in our medical literature the well-established dangers of sedentary living (he loved "long solitary walks by the Sea side") and the virtues of getting up regularly to perform minor chores, such as turning lights on and off, adjusting the thermostat, and vacuuming the room, the same sorts of fidgeting that the Roomba and the entire Internet of Things are hailed as replacing. In fact the very speed of improvement of robotic vacuums may be a hazard in itself, as obsolescent models add to the accumulation of used batteries and environmentally hazardous electronic waste.

As the sustainability movement grows, there are signs of a revival of the humble carpet sweeper, invented in 1876, as sold by

legacy brands like Fuller Brush and Bissell. They offer recycled plastic parts, independence of the electric grid, and freedom from worry about hackers downloading users' home layouts from the robots' increasingly sophisticated cloud storage.

Perhaps getting up and moving things around the house will be the next operational aesthetic.

Pantheons of Nuts & Bolts

American Heritage of Invention and Technology
Winter 1989

The term *museum piece* is high praise for a portrait or a landscape painting but a put-down for a potentiometer, and in this paradox the great international collections of technology and science find their challenge. "Science, as a puzzle-solving enterprise, has no place for museums," wrote the historian of science Thomas Kuhn. "Unlike art, science destroys its past."

Of course, engineers and scientists seldom discard their old instruments and products wantonly; what Kuhn meant was that the debris of the past ceases to be of interest to practitioners and students, and it was never meant for display anyway. Yet museums put obsolete machines and wrong answers on show in what they hope are valid contexts. How they do this says much about curators and much about cultures and nations.

There are dozens of technology and science museums around the world. Some of the most imaginative and rewarding are very small, but three of the biggest stand out for interpreting the history of a broad range of technologies and sciences to international audiences. In order of their founding as separate entities, these are the Deutsches Museum, in Munich (1903), the Science Museum, in London (1909), and the National Museum of American Histo-

ry (formerly the Museum of History and Technology), in Washington, D.C. (1964), a part of the Smithsonian Institution. They have in common prestigious locations, display areas that would fill football fields, vast research collections, staffs of professional curators, more than a million annual visitors, and both government and private support.

All of them devour money. Ever since Oskar von Miller, founder of the Deutsches Museum, first invited visitors in to push buttons and turn cranks at the beginning of the century, the popularity of these institutions has ensured extra-high conservation and repair bills. Changes in technologies, public concerns, and taste have tended to keep the lifetimes of "permanent" exhibits short, and all three museums are constantly reinstalling themselves. The alternative, no matter how splendid the collection, is dwindling attendance, as I discovered on a tour of the rich but gloomy galleries of the Paris Conservatoire des Arts et Métiers.

The diversity of a great technology museum's visitors—from families and school groups to researchers, professionals, and obsessive hobbyists—would baffle book publishers and film producers accustomed to targeting their audiences. And nowadays most of these visitors expect exhibits with mass-media production values. Furthermore, one event like the medical waste scandal of the summer of 1988 can put an innocuous technological artifact like the Smithsonian's disposable plastic-handled scalpel in a whole new light. By contrast, while the objects in an art museum may need to be restored and even reattributed, they almost never need to be reinterpreted.

All three museums mix technology and science. A museum of science almost has to display the tools—that is, the technology—of scientific discovery, and a good museum of industry must present the scientific constraints under which machines and processes work. The alliance—or even unity—of science and technol-

ogy seemed self-evident until recently. Oskar von Miller originally planned to lay out the Deutsches Museum as a series of concentric rings, beginning with matter and energy and extending through physics and chemistry to technology. In the same spirit the management of London's Science Museum declares in its 1988 souvenir booklet that "from the start, many scientists [have] seen their business as . . . a 'useful art,' to be applied to invention and the improvement of manufacturing processes."

Utility, not contemplation, begat the technology museums. As has been pointed out by the historians Eugene S. Ferguson and George Basalla, all these collections can be traced to the industrial fairs of the nineteenth century and that age's "native enthusiasm for technology . . . huckster ethos and uncritical spirit." But the only large national museum that really maintains that spirit today is the Halls of Metallurgy and Transportation of Moscow's 545-acre Exhibition of Economic Achievements of the USSR (VDNKh), built as a Stalinist Tomorrowland. Still, decades of professionalism have not erased the commercial heritage of the great technology museums. Their founders were industrialists and engineers. (Prince Albert founded the predecessor of the Science Museum, but he did so with the proceeds of the Exhibition of 1851.) The museums' displays interpret a material world; in fact, "A Material World" is the title of the latest technology exhibit at the National Museum of American History. Usually, they leave the purely aesthetic side of technology to the industrial-design collections in art museums.

To go from a fine arts or decorative arts gallery like the National in Washington or the Victoria and Albert in London to its nearby technological sister is to see almost all pretense of contemplation abandoned. In a fine arts museum at least a few people in each gallery may be absorbed in trying to understand a particular

work; in a technology museum almost no visitor really analyzes a machine.

Art museums honor the unique work; technology and science collections illustrate the mass-produced object and the repeatable experiment. The former scorn replicas and copies (except sculpture casts); the latter use them freely. Most important, great art museums still tend to deny time and context in their permanent displays; technology and science museums have been affirming them more and more. The most scholarly new technology museum exhibits, such as "Engines of Change" at the National Museum of American History, include extensive printed and audiovisual interpretations.

And technology museums like the three examined here can be national in a way the "national" galleries of fine arts seldom are.

London

The Science Museum, in London, contains a collection of nineteenth-century machinery that is quite possibly unsurpassed anywhere. Its predecessor, the South Kensington Museum, was founded at the height of Britain's industrial transformation, and was the fruit, as the curators put it, of "the confidence and prosperity of a generation for whom Britain's manufacturing industry led the world." As the "national museum of industry in the country which 'invented' industrialization," it can show off Richard Arkwright's spinning frame and Charles Babbage's Difference Engine, the pioneering mechanized calculator. In its great East Hall reside the Newcomen engine, which first put steam to industrial use, the Puffing Billy locomotive, which showed that steam could power transportation, and a cluster of the mightiest nineteenth-century steam engines, the culmination of an age. For admirers of the Vic-

torian world, it is truly a power trip. (The Deutsches Museum also has an impressive steam display.)

The Science Museum has an aristocratic side that recalls the decorative arts collections with which it was once united. Here George Ill appears in a context known to few Americans. He was the patron of the superb Collection of Apparatus for the Education of the Royal Children, begun by J.T. Desauliers in the early eighteenth century. Triumphs of noble patronage as well as of artisanal skill are represented by Jesse Ramsden's magnificent theodolites and telescopes, George Adams's extravagantly decorated Universal Microscope (made for George Ill), and Viscount Mahon's elegant 1777 cogwheel calculator.

Like many another great inheritance, this treasure has its price: a choice between crowding the display areas and banishing important objects to make room for better interpretation of what's left. The Science Museum until very recently preferred crowding. One critic in 1977 described its textile department as a "Victorian exhibit" offering "a sure recipe for visitor boredom," and a British historian of science damned the museum with faint praise in 1985 as the "most spectacular" of the "great industrial and technological mausoleums." But the management has become more concerned with teaching about technological issues and is displaying fewer objects more carefully. The medical floor contains a masterly exhibit of ideas as well as of instruments.

What directions will the Science Museum's future exhibits take? They seem safe from antitechnology revisionism. The management doesn't deny "problems" and "challenges," but it still defines industry as "the agent which makes available to many people the products which science makes possible." An introduction to the museum declares in bold type, "The liberation of mankind from toil, begun by the steam engine, continues today."

In the end, though, it is not ideology but the objects themselves that make the London Science Museum one of the world's most memorable. A curator's reply to criticisms in 1978 is still valid ten years later: While agreeing on the need for change, he noted that a "more spacious display, and one giving more importance to the social and economic context, can only be achieved by removing interesting technical material, and the balance of advantage is after all a matter of opinion, and the opinion is partly a matter of fashion."

Munich

If the Science Museum is the world's outstanding collection of historic technological artifacts, then the Deutsches Museum, supported by generations of industrialists, is the strongest in documenting the contributions of scientists and engineers to production. And it is even more German than the London Museum is British. While fine arts museums usually organize their collections by national schools, the technology museums tend to bear national messages. The Deutsches Museum began by devoting itself, as an early English-language pamphlet put it, to "the technical development of all civilized nations," but it did so as "a national German institute"—"the work of the whole German Empire."

Emperor William II laid the cornerstone in November 1906, and even today one of the museum's most prominent rooms is its Hall of Honor (*Ehrensaal*) for German engineers, scientists, and industrialists. Between the Hall of Honor and the physics halls lie rooms with the original collections of the great eighteenth- and nineteenth-century German instrument makers. The new Hall of Road Vehicles, opened in 1986, begins with the museum's hundred-year-old Benz three-wheeler, still in working order, mounted on a gleaming platform.

From the start the Deutsches Museum has had a program of national education. Its founder, Oskar von Miller, wrote in 1926 of its need "to instruct students, workers, etc., as to the effects of the multifarious applications of science and technology . . . to stimulate human progress, and to keep alive in the whole people a respect for great investigators and great inventors." In the more specific words of the Australian writer Donald Horne, the museum celebrates "the originals of the working apparatus used by German scientists at the time Germany began to take over from Britain as Europe's most innovative industrial society."

The museum became a monument to Germany's belief in achieving national prosperity through scientific and technological education. Through war, defeat, and inflation Miller kept his commitment to a vast building program that had been conceived at the height of the empire. He saw the museum's "masterworks" of science and engineering as inspirational; similarly, Georg Kerschensteiner, who developed the museum's early educational programs, expected the exhibits to encourage "reverence" for achievement. The museum used to sponsor a four-day visit each year by three hundred nationally selected workers and students and award diplomas for the six best reports they submitted about the experience. And every schoolchild in Munich was required to visit the museum every year. In 1987, 625,000 of the 1,430,000 visitors were students, and more than sixty courses were offered for both teachers and students.

The Deutsches Museum's critics, like those of the Science Museum in London, have accused it of neglecting the many problems created by technology and by its military use and abuse. The engineering backgrounds of its curators, the still-close participation of industry, and even the professionalism of the blue-coated attendants who operate some of the exhibits—all have seemed to take technology almost to the point of technocracy. This may be

changing. The museum's director, Otto Mayr—who once was in charge of the National Museum of American History—has declared that explaining technology is not enough. He wants the museum to be a place "to discuss positive and negative aspects openly but objectively." The Deutsches Museum should come across "not as an advertising medium for the technical establishment, but as an intellectually independent educational institution and a mediator between the technical establishment and public life." This will surely require, though, a new, more delicate relationship with those industries that have contributed so much of what is outstanding in the Deutsches Museum.

Washington, D.C.

The Smithsonian Institution's National Museum of American History, one of the largest museums in the world, has done the most among these three to emphasize the social interpretation of technology. As a parent museum the Smithsonian is older than the London or Munich institution, but it was essentially a natural history collection with some scientific instruments until it received thousands of industrial artifacts from the 1876 Centennial Exposition in Philadelphia. George Brown Goode, an assistant secretary of the Smithsonian, subsequently created an arts-and-industries collection and proposed the first plans for a separate technology museum.

Goode believed in progress. He thought a display of machines could build public appreciation and support for technological improvement. In this he resembled Prince Albert before him and Oskar von Miller after. Until fairly recently all important technology museums presented history in terms of development and refinement, not costs and benefits; technology and science were essentially good and peaceful. In the hands of the engineer-curators succeeding Goode, who died in 1896, the museum's objects

were arranged to tell a story of betterment, especially of the small advances that made great ones possible. Curators immersed in the detailed knowledge of machines and structures traced those machines' histories the same way their colleagues in the paleontology museums followed the evolution of plants and animals. And why not? Goode was himself an ichthyologist.

Between World War I and the Depression, the curator Carl Mitman consciously followed the examples of London, Munich, and Paris in his campaign for a separate national museum of engineering and industry. After World War II his successor, Frank Taylor, mobilized support for a museum combining technological, political, and cultural history in what he would call a Palace of Progress.

When Taylor's Museum of History and Technology finally opened on the Mall in 1964, it proclaimed the same message as its European counterparts, telling the story of the long-term amelioration of our standard of living wrought by scientifically informed technology in the hands of industry. But it broke ground by putting exhibits on American political, social, and cultural history in the same building as the technological and scientific artifacts. At first this merger of cultural and technical history was mainly the happy result of a real estate deal. But twenty-five years of curatorial osmosis have further blurred the never-sharp line between technology and civilization.

The link has had its political benefits too. The next best thing to actually being wrapped in the flag is to have its care in one's budget, and both the original Star-Spangled Banner and the first Old Glory reside in the National Museum. Even before "National" and "American" were added to its name, and "Technology" removed, in 1979, President Lyndon B. Johnson could describe the museum at its dedication in January 1964 as bearing "the ripe

fruit of America's historical harvest," showing "'what kind of people we really are"—resourceful, hardworking, optimistic.

So the museum opened with its own national slant on technology to match the British and German versions. As Arthur Molella, chairman of the museum's Department of the History of Science and Technology, points out, someone seeking to learn the origin of the telegraph would get a very different answer at each museum. LBJ's own honor roll of techno-relics—Whitney's cotton gin, Singer's sewing machine, McCormick's reaper, Edison's phonograph, Bell's telephone—do not dominate the current museum, but today's displays continue to tell the story of how European technologies from theodolites to locomotives were adapted by Americans to meet the demands of the frontier.

The National Museum of American History presents surprisingly little current science, as distinct from technology. This is changing. The new permanent installation "A Material World" includes a popular interactive video that lets visitors zoom in on electron micrographs of familiar substances or watch, for instance, what a lead baseball would do to a bat. A major new exhibit on the history of American science is now being planned, but there will never be much space for science unless the Smithsonian expands the museum or spins off part of it elsewhere.

The museum's populist character helps set it apart. London's Science Museum literature emphasizes selectiveness, as though the curators formed an admissions committee: "To earn a place in [the] collections, each new object must make a specific contribution." The Smithsonian's curators must be selective too, but they seem far more receptive to the private donor and have displayed such homegrown products of American ingenuity as Martin Nielsen Rasmussen's Junkyard Telescope, assembled from thirty automobile flywheels and magnifying up to thirteen hundred times. Oskar von Miller, who advised Americans to emphasize the role

of democracy in their museum, would have been pleased. And he would have agreed with a remark the museum's director, Roger Kennedy, made about the "A Material World" exhibit: "How do you present objects that are related to many, many people, not just the rich and great, in a serious way? That's hard work." While the Deutsches Museum, if only because of its far greater size, urges visitors to "follow the didactic construction" of its layout rather than wander without plan, the National Museum of American History has hired a cognitive psychologist to advise on tailoring its displays to visitor habits.

Especially during Roger Kennedy's directorship, which began in 1979, the museum has become ever more willing to offer the public a social critique of technology. For example, in "Engines of Change," a label for a sample of early machine-woven cloth points out that washing all these new textiles meant more work for women. In a companion volume, the curators observe: "The consumer lives better; the quality of life has risen. But the costs, at worst the cost of the nuclear threat, have sometimes been so high that they may invalidate the benefits."

Several small experimental exhibits in the summer of 1988 brought this new attitude into sharp focus. "The Scientist in American Society: Who's Using Whom?" shows how the physicist Charles Townes, having developed the maser and laser with military support, has been unsuccessful in arguing against a multibeam x-ray laser space shield in the Strategic Defense Initiative program. "Pesticides on Trial: Miracle Chemicals or Environmental Scourge?" traces the background of Rachel Carson's book *Silent Spring* and observes that scientists "continue to arrive at contradictory conclusions about the potential long-term danger of pesticides." "Measuring Minds: Scientific Sorting or Pigeonholing with Puzzles?" displays the technology of early intelligence testing and reviews its use to support racial and ethnic biases. Similarly

probing exhibits planned for 1989 include "Twentieth-Century Collecting," about the problems that face cultural historians trying to gather artifacts representative of twentieth-century American life, and "Who Wears the Pants: Men, Women, Power and Appearance," about changing gender roles and societal norms. This new wave of displays, so candid about the trade-offs science and technology have brought, disturbs some visitors connected with industry—not because the objects raise new questions but because it is unsettling to lose control over the public presentation of one's profession.

The trend toward a more critical view of technology is bound to shift the balance of power in museums from those who specialize in the functioning of things to those who concentrate on social origins and effects. But social historians—whether in Munich, London, or Washington—cannot claim a uniquely privileged outlook on technology's past; an understanding of development from the viewpoint of engineers and inventors is indispensable. At any rate, the social interpretation of technology is now dominant in Washington and is gaining influence at least in Munich too.

The result is that the exhibits at the National Museum of American History have begun to pivot around consumption while European exhibits, critical or not, reflect production. Roger Kennedy's description of "A Material World" as the first "comprehensive examination of the changes in the lifestyles of Americans as a result of material influences" points the way. Visitors are supposed to stop and think about the things themselves, and the materials they're made of, but tourists at the show have taken it, more broadly, as "a practical exhibit of American life" and even a display of "everything that's affected our lives."

The most fascinating contrast with that American exhibit can be found not in London or Munich but at the Moscow VDNKh. There, in the Hall of Metallurgy, ingots and lengths of tubing are

proudly displayed under glass; in the Hall of Transportation individual items of railroad equipment are shown, each in near-isolation. While Americans know the finished forms of technology perfectly well, they are puzzled when asked to consider the substances and bits and pieces behind them. Soviet citizens, on the other hand, see the substances, parts, and components without any sense of their fitting into a working system or consumable products. And so every museum, whatever objects it contains, inevitably becomes a display of cultural history.

Oppenheimer and the Technological Sublime

Milken Institute Review, November 6, 2023

After what seemed like an hour of scrutinizing seating plans of New York's AMC Lincoln Square Theaters, I secured the sole premium seat left for the first run of Christopher Nolan's film *Oppenheimer*. Earlier that day, *The New York Times* had jolted me into action with a review of the technology used by Nolan under the headline "For Some Films, Go Big or Go Home." It seems only 30 screens in the world, 19 of them in the U.S., were equipped to exhibit IMAX as 70mm film.

Actually, the real surprise here is that any full-blown IMAX-equipped theaters exist, and that Nolan had gone out on a limb to make a movie in the exotic format. Ordinary 70mm film is rare enough. The French comedian-director Jacques Tati virtually bankrupted himself producing his final satirical masterpiece, *Playtime,* in 1967, then needing ultrawide screens and special equipment to project. Having seen it years ago, I can testify that the astounding level of detail—a grown-up Parisian version of Pieter Bruegel the Elder's children's games—can be fully appreciated only at the original scale.

But there's another way to look at it. In a world of technological wonders, most of which seem like magic to everyone who never got beyond high school physics, there seems to be room for

what amounts to retro tech—wonders of an earlier era that survive because . . . well, that's worth exploring.

Glorious Throwbacks

Back to *Oppenheimer* for a moment. To those viewing the 70mm IMAX version, the capabilities of the format were at their most stunning in the Trinity bomb test sequence and in the final vision. Almost equally striking, though, were the results of using 70mm IMAX to film more intimate scenes. The medium rendered masterly performances, settings, makeup, and costumes even more vivid, and made *Oppenheimer* sublime in the colloquial sense of superb.

"Technological sublime" is a favorite phrase of American historians, referring to wonders like the Brooklyn and Golden Gate bridges, the Statue of Liberty, and the Hoover Dam. There's also a second sense of sublime defined by the Irish statesman and philosopher Edmund Burke in 1759:

Whatever is fitted in any sort to excite the ideas of pain and danger, that is to say, whatever is in any sort terrible, or is conversant about terrible objects, or operates in a manner analogous to terror, is a source of the sublime; that is, it is productive of the strongest emotion which the mind is capable of feeling.

And in that Burkeian sense, Nolan's Trinity fireball in 70 mm IMAX format was in a class of its own.

Motion pictures are still called films, but they mostly reside either on streaming servers, on optical disks, or, for theatrical exhibition, on specially encrypted anti-piracy hard drives to be mounted in matching theater projectors. Most movies are thus lighter than a disk drive or weigh nothing at all.

The plastic film for IMAX, by contrast, is sublimely substantial. All told, the projection print is 11 miles long and weighs 600 pounds. Other 70mm IMAX statistics are equally jaw-dropping. Each IMAX camera costs a half-million dollars, and over the

course of making Nolan's three previous blockbusters—*The Dark Night, The Dark Night Rises,* and *Dunkirk*—three of them were ruined. The camera, by the way, is as noisy as a small diesel engine, and some of the photography takes place near the actors' faces—a terrifying experience that can bring out the best in portraying psychologically fraught situations.

It's easy to conclude, then, that 70mm IMAX is a legacy format that should have been replaced by a new generation of digital cameras. In ways it is, indeed, an anachronism. For example, the control module for the projector is a virtual emulator of the two-decade-old Palm Pilot personal digital assistant, now a curiosity on the order of, say, a Betamax video recorder.

But this anachronism is still alive and kicking (at least a bit). Not only did the IMAX Corporation and Kodak develop a special black-and-white film stock for *Oppenheimer*, IMAX is planning to build four new 70mm cameras over the next few years. The lesson is that the survival of legacy technology often depends on the ingenuity, courage, and marketing savvy of the users to translate its unique advantages into commercial success.

Paradoxically, the ubiquity of home theater and streaming helped to create the 70mm IMAX renaissance. What prophets of the all-digital future did not realize was that it created a new market for the extremes of analog. According to the Associated Press, some enthusiasts drove eighteen hours round trip to see the ultimate version of *Oppenheimer.* I personally noticed how many of the New York audience were young people who might never have seen real film projected, even in 35mm format.

More Glorious Throwbacks

The success of *Oppenheimer* left me wondering how many other analog devices have overcome obstacles of size, cost, and limited utility to hold their own in a digital world. Vinyl audio recordings

come to mind, of course, as do still film cameras like the gorgeously minimalist black Leica M viewfinder series. But hard-core sublime survivors often have something more—apparent disadvantages that somehow translate into the opposite.

Take the Nagra IV series of portable reel-to-reel tape recorders, a longtime favorite of filmmakers and wiretapping FBI agents alike. It never had a prayer of remaining commercially viable after the introduction of digital audio recorders. But the Swiss-based Nagra continues to service vintage models and there's still a narrow niche in which they are superior. According to NPR, Nagra analog audio recorders remain state-of-the-art in recording loud and sudden sounds like gunshots.

Another Swiss company with a much higher profile has nurtured the life of its legacy analog products even longer than Nagra. Among Rolex watches, famous for resisting fast fashion and evolving at stately paces, the one I consider most sublime is the mechanical GMT Master II. It is less accurate and more fragile than a $20 Casio, let alone any old $200 smartphone. Even the coveted Daytona model, best known as Paul Newman's Rolex, has chronograph features inferior to that of a smartphone.

Don't worry, though. The Rolex is not going the way of the Filofax. Customers unwilling to spend a year or two on the waiting list—e.g., your stereotypical Wall Street bros—pay thousands extra to jump the line. And the company is building three new factories to better meet demand after years of seeing scalpers cream off the premiums.

There are ironies within ironies here. While the watches themselves reflect (the best of) 19th-century technology, the new factories are decidedly 21st century. Huge computer numerical control modules guide machines that yield hair-thin parts without human intervention.

What applies to Rolexes (and other ghastly expensive analog watch brands) doesn't apply to ultra-high-end still cameras. The photographic sublime was long the Hasselblad 500C camera—say, fitted with a Planar f/2.8, 80mm lens like the one used by astronaut Wally Schirra during the 1962 *Mercury 7* mission. Another Hasselblad, in the hands of Bill Anders aboard the command module of *Apollo 8* six years later, captured the iconic image *Earthrise*.

Hasselblad is no longer a candidate for analog sublimity, though, because the professionals who shell out five figures for cameras value utility over nostalgia. The Swedish company discontinued the successors to the 500C line in 2013. Today all its "medium format" cameras in production are digital.

For connoisseurs of the retro analog sublime, vacuum tube audio may be the ultimate frontier. They may not be suitable for accompanying home projection of films like *Oppenheimer*—nearly all home theater amplifiers are solid-state—but it is the ultimate in purism. Best of all, tube amps are no museum pieces. They are still in development, with engineers further perfecting the perfected, like IMAX film.

The most recognized vacuum tube products are made in the U.S. by a long-established upstate New York State company, McIntosh Laboratories. (Steve Jobs's trademark application for his fledgling home computer was originally turned down despite the minor spelling difference. But after several years of negotiation, he obtained a license for the "Macintosh" name for an undisclosed fee.)

The ultimate in McIntosh tube amplifiers, the MC1502, now sells for $13,000. With 150-watt output and 16 vacuum tubes (which many audiophiles prize over silicon chips because the resulting sound is warmer), it delivers 600 watts of power and weighs 118 pounds—sublime specifications, indeed. For best per-

formance it can be paired with McIntosh's top tube preamplifier, the C2700, which adds another $8,000 but weighs in at a mere 50 lbs.

It has always been challenging to prove the superiority of one technical medium over another, for one person's sublimity may be another's overkill. What matters is not necessarily measurable differences but subjective perception—even the power of suggestion created by advertising, marketing, and product design. As the sociologists William Isaac Thomas and Dorothy Thomas observed almost a hundred years ago, if people believe something to be true it can become true—the Thomas Theorem.

Stopping Time

So what differentiates enduring legacy technologies from the ones left to gather dust in the attic? One obvious decider is star power. A Christopher Nolan has the chops to justify not only maintaining a technology that would otherwise have been retired but investing to improve it. Rolex, for its part, has wisely paid an unparalleled roster of athletes and other mega-influencers to sprinkle fairy dust on the GMT Master II and its other classics. Stefan Kudelski, founder of Nagra, was his own celebrity within the Hollywood community, winning three Academy Awards achievement among other honors. McIntosh Labs' proudest tribute was the Grateful Dead's "Wall of Sound" show at San Francisco's Cow Palace in 1974, featuring 48 McIntosh MC2300 amplifiers delivering an over-the-top 28,800 watts of power.

Ownership also matters. IMAX is a publicly traded company that is not immune to Wall Street's impatience, but 70mm IMAX might not exist if it had been the property of one of the studios that lives and dies by next quarter's profit. As a privately owned company, Rolex has been able to resist what might have been shareholders' demands to extend the brand to other luxury goods

and overproduce new models. Rolex's will remain scarce by design even after the new factories open. McIntosh, for its part, is also privately held, and by owners who seem to be maximizing something other than profits.

Another subtler element to survival: While some retro technologies are doomed by progress, others paradoxically hitch a ride on it. While the manufacture of a Rolex includes labor-intensive elements, automation is key at crucial stages of manufacture and testing. Keep in mind, moreover, that Nagra's enduring support of reel-to-reel recorders is probably subsidized by profits from the parent company's success in solid-state models and innovations in digital security technology.

Conversely, a purely analog technology, no matter how superior to digital versions, will always rest uneasily if it lacks a deep pockets owner to bask in the reflected glory. Color collotype, the finest art reproduction system—it uses as many as 27 multiple gelatin-covered plates rather than the usual four halftone separations—ended in North America with the shutdown of Black Box Collotype in Chicago in 2004. It survives in only two shops in Japan that depend on orders from the nation's Imperial Household. Seems that shrines and temples, with priceless centuries-old works that are showing their age, can commission vibrant replicas that roll back time while the originals are displayed only on rare occasions.

* * *

I have no interest in owning any of the sublime analog devices I have praised above—the gorgeous Rolex is a mugger magnet. But I am glad to know they exist, and that rich amateurs and traditionalist pros support them, just as I am gratified that the Japanese imperial family still extends their patronage to the nation's shrinking pool of master artisans.

More broadly, I'm pleased the drive for efficiency that dominates corporate thinking seems to give way occasionally in the face of the potential for the sublime. The gifted artists and technicians who made the 600-lb, 70mm IMAX version of *Oppenheimer* possible have helped us rediscover the profound feeling described by Edmund Burke centuries ago.

The Icon of Icons

Milken Institute Review, October 13, 2023

There is a paradox in great design: Once a classic is established, it is often difficult to design something better looking as well as more functional. For example, once there was a brick-like, rectangular cellphone design, the marketing battle devolved to second-order issues like button location and camera software. Of course, there will be frontiers where there is still room for genius, but the focus has shifted from product design to design thinking.

Hold Up a Second . . .

While that sinks in, let us celebrate the century when design titans roamed the earth, transforming mundane objects with the magical wands of mid-century modernism, soothing Depression-era anxieties with a vision of a streamlined ultra-functional future.

Of all the magnificent designosaurs, none left a more striking legacy than Henry Dreyfuss. It wasn't because of how his restyled locomotive and car interiors of the New York Central's Twentieth Century Limited in 1938 redefined luxury and promised a post-scarcity high-tech utopia. Rather, as the Cooper Hewitt, Smithsonian Design Museum in New York, which owns Dreyfuss'[s] papers and organized a landmark exhibition of his career in 1997, spotlighted, Dreyfuss's public-spirited decades of tinkering with the thousands of icons initiatives are reverberating well beyond the 288 large-format pages of his *Symbol Sourcebook:*

An Authoritative Guide to International Graphic Symbols, first published in 1972 and still in-print.

To our icon-satiated sensibilities, much of the exhibition was familiar, but the curators included several intriguing insights into the complexities of the glyphsmith's craft. Consider the wheelchair icon representing disability access. It looks perfectly neutral, but the original design did not reflect aspirations of self-reliance of people with disabilities. The current revised symbol, by contrast, is confidently self-propelled.

Other cultural issues are more challenging to resolve. Before the scheduled 2020 Tokyo Olympics, the symbol for an *onsen* (hot spring) was three wavy lines emerging from an oval—a symbol familiar to all Japanese but confusing to international visitors who sometimes mistook it for hot soup. After designers added three human figures (two adults and a child), some Japanese were offended that a purely symbolic icon had been degraded for foreigners' sake. Others suggested that it seemed to depict boiling in a cartoon cannibal pot. (PS: The conflict-averse curators did not, as far as I could see, approach the fraught signage of all-gender restrooms.)

Original drawings of symbols that indicate a door should be opened with a "push" or a "pull" by UCLA graduate students illustrate another sort of problem that continues to confound designers after a half century of head-scratching: finding a purely graphic, minimalist representation of these most basic interactions with the built environment. One symbol looks like a balloon or beachball being compressed, the other like a piece of taffy being stretched. Designers seem to have given up on pure glyphs, opting instead for including the words, thereby dashing the dream of language-free communication. I have never seen a wordless push or pull symbol on a door, anywhere. On the other hand, I have seen many people push on the door labeled "pull."

Symbols and Ideology

It is too bad that the limited space of the exhibition galleries—what was once the wood-paneled rooms of Andrew Carnegie's Fifth Avenue mansion—gave short shrift to the weirdest part of international symbol history, the left-wing origins of trans-national picture languages. Dreyfuss acknowledged his debt to the leading interwar symbolic school, the Isotype movement (among others) and included an essay called "Education through the Eye," by artist and author Marie Neurath, the widow and collaborator of Isotype's founder.

Marie Neurath's husband Otto, the genius behind the system of Isotype glyphs, was one of the most brilliant and certainly the most eccentric of the interwar Austrian economists. A deeply learned but heterodox Marxist, he was an outlier who irritated his more conventional colleagues. "Especially disruptive was the nonsense that Otto Neurath asserted with fanatical force," Ludwig von Mises later recalled of the group's meetings.

As a boy in the late 19th century, Otto Neurath had been fascinated by the hieroglyphics in the Egyptian department of the recently opened Museum of Art History in Vienna, and the expressive power of silhouettes. His admiration didn't stop there. The pharaohs had built a magnificent, long-lived society with a command economy run by noble administrators who managed purely with payments-in-kind (that is, without money). This was just the system, he believed, for organizing the socialist society of the future. No wonder another exasperated colleague called him "an ancient-Egyptian romantic economist."

Otto Neurath dedicated himself to enlightening the working class to economic realities by creating graphic displays for an institution he founded in his native city, the Museum of Economic and Social History. (Vienna in the 1920s was [a] hotbed of socialist experimentation, including ambitious public housing still in

use almost a century later.) Neurath's idea was to use hieroglyphic-like symbols to represent quantities like, say, a thousand of tons of steel.

His design partner was an equally enthusiastic leftist artist from Germany, Gerd Arntz, who had a genius for translating concepts into linoleum cuts. An unemployed worker (or multiples of them) was represented by the outline of a slouching man with a cloth cap. A string of such glyphs could have an impact surpassing that of a dull old bar chart.

Through the 1930s into the postwar era, Isotype was an international success. The project's masterpiece, published by in 1939 and now available free online, was *Modern Man in the Making*—Big History at its best, in striking but functional color, and now a highly collectible rarity.

After Neurath's death, the project worked with a former Bauhaus design teacher Herbert Bayer in 1953. The effort was funded and published by Walter Paepcke, the Container Corporation of America CEO, today best known as founder of the Aspen Institute. Meanwhile the anthropologist Margaret Mead cooperated with an Austrian-born entrepreneur and Neurath disciple, Rudolf Modley, who brought Isotype methods to America as a supplier of graphic charts to publishers (including the *World Book Encyclopedia* I used in elementary school).

Isotype and the Mead-Modley project for promoting international understanding through symbols were the main source, though not the only source, of Dreyfuss's reference book. Otto Neurath would have been delighted by the exhibition and its attention to the progressive side of his movement—there is an entire wall of strike-fist images! He would also be pleased to learn that the Austrian government has revived his museum. Yet given his hopes for a planned economy with no place for money, he surely would be disappointed that the Isotype system had evolved into

the lingua franca of global capitalism in its transportation facilities, factories, and offices.

Plus Ça Change...

The ultimate irony may be that the heirs of the devoted communist Gerd Arntz—who is not mentioned in the exhibition labels—have licensed doormats in the forms of Arntz's hare and hippo symbols. And they've asserted family copyright in the work that Arntz created while working with Otto Neurath, including the aforementioned much-celebrated strike fist. (The version of the fist you probably know was adapted for the Harvard 1969 student protest strike by a member of the Class of 1963 named Harvey Hacker.)

This intergenerational triumph of capitalist property rights reminds me of the retort of the sociologist Erving Goffman to his Marxist colleague Alvin Gouldner, who complained that their publishers were commodifying their work. "Al," Goffman replied, "I don't mind commodification if I can be an expensive commodity."

5. Information

From Slip to Chip:

How Evolving Techniques of Information Gathering, Storage, and Retrieval Have Shaped the Way We Do Mental Work

Harvard Magazine, November–December 1990

We used to think of electronic data processing as a substitute for paper. Now we know better. Often, an electronic file is a mere preparation for print, and by making hard copy cheaper and more convenient than ever, computers are ensuring that we generate more and more of it.

There is another side of paper's preeminence in managing information. It is the remarkable persistence of the folio—the sheet or slip of paper—in organizing mental work.

The designers of computer software, understanding the force of our habits, have returned again and again to that humble and ubiquitous rectangle, the file card. A flyer for Oberon Resources of Columbus, Ohio, advertises the abilities of its text database program, Notebook II Plus, to store, sort, retrieve, and cross-reference note cards. *The Wall Street Journal* reports a new product call HyperPad, an IBM-based version of the Macintosh software

HyperCard: "Using images of cards and push buttons that can be drawn on screen, it can link files to create a Rolodex-like directory that one can 'flip' through." Three of the world's largest computer companies are litigating the right to use a set of graphic symbols that feature file folders, sheets of paper with folded-back corners, and waste baskets: a graphic user interface, as it is called.

It is not surprising that a new medium should use the metaphors of the old; we still are "driving" our automobiles, after all, long after the retirement of buggy whips. And that is just the point. Mental techniques, like transportation or manufacturing technology, grow on a framework. Many of the habits and skills crucial to the use of computers, whether in commerce or scholarship, rest on a paper-based revolution of the nineteenth century.

In 1948, at the dawn of the computer age, the architectural historian Sigfried Giedion wrote in *Mechanization Takes Command*: "The slow shaping of daily life is of equal importance to the explosions of history; for, in the anonymous life, the particles accumulate into an explosive force. Tools and objects are outgrowths of fundamental attitudes to the world. These attitudes set the course followed by thought and action. Every problem, every picture, every invention, is founded on a specific attitude, without which it would never have come into being."

The deeper the change, the more elusive the records sometimes are—especially when the shift is in the form of a records themselves. Fortunately, there is enough evidence, from counting house and library alike, to draw the outlines of the change. Objects like desks and filing cabinets, and their manufacturers' claims, tell something about what people were thinking. The paperwork revolution may not have depended unconditionally on any nineteenth-century invention, but it flourished in league with industrializing societies and expanding economies. New processes for papermaking and paper finishing, for woodworking and

metalworking, for high-speed printing, for duplicating outgoing letters, and ultimately for typewriting brought down the cost of producing and storing paper records.

Still the greatest changes were conceptual, not material. In about 150 years, they reflected a new European and American way of working with data. It is not hard to understand because it is part of our lives. What takes more effort is the Old Information Regime. The attitudes that prevailed before about 1750 did not prevent experiments in the use of slips of paper—by Catholic churchmen, for example, monitoring parishioners in early seventeenth-century France. But these techniques do not appear to have spread.

Look at some illustrations of the paper environment of merchants, officials, and scholars at work, from the late Middle Ages to the late eighteenth century. Of course they worked with individual documents—letters, bills of exchange, deeds, charters—and scrupulously preserved enough of them to support centuries of humanities dissertations. But often they kept their master records in bound books, usually recording events and transactions as they happened. An exhibit on Greek life during the Ottoman Empire from the Benaki Museum in Athens was recently on display at Princeton University's Firestone Library. A single manuscript codex of a monastery in Pontus spanned over 250 years, from the middle of the seventeenth century to the eve of the First World War. Cash accounts, minutes of meetings, catalogues of manuscripts in Mount Athos and neighboring monasteries, and other information follow each other apparently with no attempt to separate different kinds of entries. And why should there have been? Ships, too, keep a single logbook for each day's navigational records and events. The "black box" recorder on commercial aircraft is an electronic variation of the same idea, though it usually is inspected only in the event of an accident.

A special kind of journal was the commonplace book. I should say *is,* because men and women keep them and occasionally publish them. It is a personal selection of memorable passages, either transcribed as they are read or entered under headings in a blank book divided for the purpose. *Commonplace* originally was no fighting word; in ancient rhetoric it simply meant an idea of wide application. But as originality grew in esteem, commonplaces seemed . . . commonplace. The old-fashioned schoolchild's copybook, with its headings, was a late survivor.

When the learned made notes before the late eighteenth century, they often wrote in the margins of books. Professor Owen Gingerich of the Harvard-Smithsonian Center for Astrophysics has some beautiful early astronomy texts with ample space for, and embellished by, this kind of note. Some early notebooks were journals in which whole volumes might be abstracted, but others used the technique of the commonplace book.

Thomas Hobbes, according to *Aubrey's Brief Lives,* "had in the head of his Staffe a pen and inke-horne, carried always a Notebook in his pocket, and as soon as a notion darted, he presently entered it into his Booke, or els [sic] he should perhaps have lost it. He had drawne the Designe of the Booke (*Leviathan*) into Chapters, etc. so he knew whereabout it would come in. Thus that booke was made." Even a work as learned and magisterial as Edward Gibbon's *The Decline and Fall of the Roman Empire* seems to have been composed from the author's memory and probably supplemented by notebooks. Here was a literary concept of intellectual production on the threshold of the industrial age.

By the early twentieth century, most professional scholars had committed themselves to a more systematic recording of facts. Many or most businesses were introducing new types of standardized paper information systems. The United States and imperial

Russian governments were even using Herman Hollerith's early punch card systems in census tabulation.

From about 1775 to 1914, the information habits of men and women changed in four related ways. The paper environment changed from hierarchical to alphabetical, from closed to open, from hidden to visible, and from individual to collective. The change was usually quiet and not always conscious; it is easier to find it in manufacturers' catalogues and student manuals than in the great theoretical works of the day.

Alphabetization was hardly the invention of the Enlightenment or the consequence of the age of the democratic revolution. But alphabetization is not such a bad barometer of egalitarianism. Most library catalogues before the nineteenth century were not the uniform alphabetical variety with which we are familiar. Libraries were divided into classes, and to find a book, one needed an idea of how it fit into the classifier's categories. If you wanted to find the biography of a churchman in one eighteenth-century catalogue, for example, you would have to learn by trial and error that the proper rubric was *Historia—Historia Ecclesiastica,* and then read through 25 pages until you found the book. There might be an index to the catalogue, but you would need to know the author's name to use it. Of course, there were no national or international cataloguing standards.

Some lists of people have always been in alphabetical order, of course, but there seem to have been relatively fewer in the eighteenth century than there are now. I am not aware of any college or university that still lists its students publicly by class rank; in fact, the Ivy League universities are probably unusual in separating student lists by graduating class to the extent they do.

In the eighteenth century, precedence was a serious matter. At Harvard and Yale, until around 1770, students in each entering class were "placed" on a list based less on ancestry than on

each family's position in church and state and on its ties to the institution. Scholarship and conduct could move a student up or down the ladder. According to Samuel Eliot Morison's *Three Centuries of Harvard,* the final blow came when one Samuel Phillips protested that his son was ranked below another whose father had less seniority as a justice of the peace. Processions and other ceremonials, Morison points out, continued in order of seniority. It was the paper record that was alphabetized. Here is one foundation of the nineteenth-century information order: bureaucratic expediency displacing unmanageable custom.

The link between alphabetization and record-keeping innovation became even more apparent one hundred years later, in the office of the U.S. surgeon general, when, according to Theodore Schellenberg's *History of Archives,* a man named Fred C. Ainsworth became head of the Record and Pension Office in 1886. Ainsworth introduced alphabetical files on veterans, by regiment, using "index-record cards" for medical claims. A master file was assembled on each veteran using cards from many sources.

Books, like people, were also more likely to be placed in a strict alphabetical order. The history of library catalogues in the nineteenth century also shifts away from hallowed categories, and even from separate author entitled catalogues, toward the single dictionary catalogue first used by the Boston Mercantile Association in 1844.

Book catalogues also led the second great change in the filecard revolution: openness. The Mercantile Association catalogue was still a printed, fixed one. All known catalogues before the late eighteenth century were intended as complete, with space for adding a few items between the lines, or perhaps an eventual supplement. The idea of indefinitely expandable knowledge that had not yet arrived.

Librarians used slips of paper to make these catalogues. Sometimes they retained them for future editions, but the catalogue itself, like the scholar's journal or the merchant's account book, was supposed to be complete, self-contained, and fixed in order.

The first known proposal for a true card catalogue dates from about the same time as Harvard's decision to go alphabetical—the earlier 1770s. In 1775 the abbé Rozier, an agricultural scientist, published an index to the papers of the Paris Academy of Sciences since 1666, in which he introduced a new information-storage medium: the playing card with an alphabetical heading. The index was printed on only one side of the page. The abbé proposed using cards instead of recopying manuscripts, and he offered an illustration of how a single item could be catalogued under four headings: *tumor, engorgement, epiploon,* and the author's name, *Portal,* using four cards. The abbé Rozier recognized two hundred years ago what we call a record and a field. But he could not conceive of knowledge as so fluid that the card (much less an electronic equivalent) could be a substitute for the printed book. Ultimately, the information from the cards would be transferred to the blank pages.

When the French Revolution arrived, nationalization of monastic and aristocratic libraries provoked the next step in openness—the idea of a card catalogue meant to be consulted as cards and probably never printed. In 1791 the Constituent Assembly issued rules to the curators of these collections for numbering the books in their libraries and then using the playing cards recommended by Rozier to make a uniform catalogue entry for each, including author, title, format, date, place, and publisher—everything, except classification, that we expect in a late twentieth century catalogue entry. The library was to retain one copy and send another to the new national union catalogue. One sign of the slow

progress of file-card thinking was that many librarians sent traditional bound catalogues instead.

Why did card catalogues gradually triumph, at least in the United States, in the nineteenth century? The early information explosion was one reason. Between around 1850 and 1875, the number of U.S. collections of over 25,000 volumes increased from nine to 100, and those of over 100,000 from zero to ten. The printed catalogue was still the librarian's ideal, but it was becoming a costly luxury, especially since readers wanted title and subject entries as well as listings by author. The most recent books, in greatest demand, would always be missing from a printed catalogue. Librarians kept these records on cards to prepare for new printings, and librarians reluctantly let readers consult these files. Harvard was one of the first universities, starting in the 1850s, to have a public card catalogue. In 1877, the American Library Association adopted the present 75-mm x 125-mm standard. It was almost immediately mistaken for 3" x 5" outside the library profession, infuriating the cataloguing genius and metric fanatic, Melvil Dewey, to the end of his life.

The standardized card acknowledged a new alphabetized, paper information order: endlessly expandable, boundlessly flexible, always open to new entries, and equally convenient for removing old ones without a trace. A collection of books was always in process.

This attitude proved contagious. Business looked to scholarship for paper information-handling techniques. Soon the Library Bureau, established in 1876 to supply equipment to librarians, found eager customers among banks, insurance companies, railroads, and publishers. In the late 1880s, with all the zeal of a later computing convert, the secretary of the Holstein-Friesian Association of America wrote the bureau that he had first seen a card file system in the Iowa State University library in 1882 and had

applied the idea to the 40,000 animals in the *Holstein-Friesian Herd Book*: "We are now using about ten thousand new cards per year, which henceforth must double every two years," he said. Here was a "cattle log" in the truest sense.

Visibility, along with uniformity and openness, was a third watchword of the nineteenth-century paper revolution. The nineteenth century had a passion for the overview, the survey, the panorama. Jeremy Bentham's celebrated panopticon, a radially designed prison where overseers could see without being seen, is only an extreme case.

In paperwork the passion for visibility and overnight appeared at first not in card filing systems but on the desktop. The nineteenth century was a great age of desks, and one of the most glorious was the 1874 invention of an Indianapolis furniture maker named William S. Wooton. Wooton's patent secretary, "The King of Desks," possibly used by Queen Victoria herself, let captains and even sergeants of industry survey all their papers at once. As decorative-arts historian Betty Walters first observed, the Wooton desk reflects the high point of the personally managed company, before modern departmental management triumph. Wooton's London dealers advertised in 1884: 'One hundred and ten compartments, all under one lock and key. A place for everything and everything in its place. Order Reigns Supreme, Confusion Avoided. . . . With this Desk one absolutely has no excuse for slovenly habits in the disposal of numerous Papers. . . . *Every portion of the desk is immediately before the eye"* (emphasis added).

While the stand-alone filing cabinet was replacing the Wooton pigeonhole matrix by the end of the century, visibility was still the watchword of paper information systems and a goal of early business organizers and systematizers. Its most lasting form remains the familiar tab card separating series of index cards or files with a projecting letter. Its inventor, James Newton Gunn, began his

career with the Library Bureau and became one of the first faculty members of the newly formed Harvard Graduate School of Business in 1908 and a leading management consultant.

The rise of the tab-separated file and the decline of the autocratic personally-arranged Wooton desk revealed yet another side of the new paper order: collaboration and collectivism. Samuel Johnson had composed his dictionary with the help of assistants who transcribed the passages he marked, but the plan and selection were his. Johnson had originally intended to write everything himself in a series of notebooks. By the time Jacob and Wilhelm Grimm were compiling their German dictionary in the 1840s, making a multivolume dictionary was already a team effort based on uniform citation slips. In their original preface to *Industrial Democracy,* composed in 1897, the social reformers Sidney and Beatrice Webb described their method of using "separate sheets of paper, uniform in shape and size, each of which is devoted to a single observation, with exact particulars of authority, locality, and date." And they linked this note taking to a collective method of inquiry: "A closely-knit group, dealing contemporaneously with one subject, will achieve far more than the same persons working individually."

The high point of old-style paper information, the first edition of the *Oxford English Dictionary* was directed by an editor of genius, James A.H. Murray. But it was also the product of over 1,200 volunteers in the United Kingdom and North America disassembling their own literature and sometimes ripping pages from their own books—the original deconstructionism. Between five and six million slips of paper were finally used. In France, there was even an "affair of the file cards" (or *fiches,* as they have been known in French since about 1865) around 1908, in which a war minister was revealed to have been using cards on the political

and religious sentiments of military officers, compiled by a circle of anticlerical freemasons.

By around 1900 card-file thinking was beginning to influence all paper management. Through most of the nineteenth century, people stored their paper records horizontally. Most antebellum U.S. government records, for example, were kept folded and bundled; the Navy used chests. The index card presented a different model: information on one subject, in a standardized format, stored upright rather than flat, in a drawer, divided by usually alphabetical guides and ready for additions or use by a number of people. The Library Bureau displayed its first models in 1893 at the Chicago World's Fair, and by 1912 the vertical file had the official approval of the U.S. Government.

All these changes together were revolutionary because, for better or worse, they replaced a literary or craftsmanlike model of mental work with a mechanized one. Gone was the union of memory, personal library, and notes in the form of book-sized digests. In its place was a pack of facts, often one to a standard piece of paper—literally, knowledge à la carte. Reduced, too, was the separation of learning from industry; thinking was industrialized and manufacturing was rationalized, with people like James Newton Gunn working on both sides. As a French student manual of 1900 declared: "File cards are indispensable for learning. All learned people use them. Nothing is retained without them. . . . It is not difficult to be educated, thanks to this means. The learned know this and are modest because of it." This outbreak of humility evidently subsided, but the card file remained in France as elsewhere; the word *fichier* entered the French language around this time.

Today, the file card remains a surprisingly durable hard-copy database. Few people still believe in the power of assembling facts, but many dutifully inscribe one fact per card as though they did. At least one library that has converted to an electronic catalogue

is retaining file cards to supplement electronic records of the Bible, Shakespeare, and other works that exist in many editions. There is a brisk trade in continuous-form file cards that will convert a computerized telephone directory to hard copy; the Rolodex company sells software for just this purpose. Some people have their business cards printed on stock that has been die cut for insertion in a Rolodex-style directory. Even looseleaf organizers marketed under trademarks like Filofax and Day Runner use the file card principle and format.

The index card and the vertical file, like other technologies, have been morally neutral. Consider the office of the national police in Berlin in 1935; it is very possible that their vertical file, like the International Style architecture of the room, dates from the Weimar Republic. Both the liberal welfare state and twentieth-century dictatorships have depended on these alphabetical systems. (According to a recent review in *The Times Literary Supplement,* Britain's MI5 counterintelligence service had a card index of 900,000 "suspects and other doubtful personalities" in June 1939 and 4,500,000 by the end of July 1940.) While Ronald Reagan has been the most celebrated political user of note cards for briefings since his entry into public life, he is surely not the only one.

There is a final irony in the rise of the index card and its immortalization in software. The decomposition of reading into facts and the reassembly of facts in support of an argument won wide acceptance as a scientific approach to writing. Yet scientists and inventors have been among the most tenacious believers in the old method of recording information: continuously, as it is acquired, in bound books. One distinguished physicist I know has maintained a series of large bound notebooks for decades, recording business conversations as well as scientific ideas as they have occurred. The openness and easy alterability of the note card file

would destroy the moral and legal protection of a record maintained in strict chronological order and—equally important—not organized around what data are supposed to mean.

The file card is almost certainly not our last metaphor for the organization of learning. Surely the application of artificial intelligence to searching large texts will soon permit much richer and subtler access not only to personal notes but to huge textual databases. I would not be surprised if these new information technologies lead to an electronic version of the old-style notebook, which could be indexed or reindexed at any point as a reader's or researcher's project evolved. But for now, we are still living in a house of cards.

Keeping Tabs

The History of an Information Age Metaphor

Technology Review, February 2005

How many college students today ever flip through trays of library catalogue cards? Some of them may never have used an actual tabbed file. But the tab as an information technology metaphor is everywhere in use. And whether our tabs are cardboard extensions or digital projections, they all date to an invention little more than a hundred years old. The original tab signaled an information storage revolution and helped enable everything from management consulting to electronic data processing.

The tab's story begins in the Middle Ages, when the only cards were gambling paraphernalia. Starting in the late 14th century, scribes began to leave pieces of leather at the edges of manuscripts for ready reference. But with the introduction of page numbering in the Renaissance, they went out of fashion.

The modern tab was an improvement on a momentous 19th-century innovation, the index card. Libraries had previously listed their books in bound ledgers. During the French Revolution, authorities divided the nationalized collections of monasteries and aristocrats among public institutions, using the backs of playing cards to record data about each volume.

The idea of a randomly accessible, infinitely modifiable arrangement of data flowered first in the United States. Not that

America had more books to organize. In 1820, the Göttingen University library in Germany already had 200,000 volumes; Harvard University had fewer than 118,000 books in 1861, when it became the first major library to use cards. The historian John Higham called the catalogue a "revolutionary" and characteristically American tool, which promoted specialization by grouping authorities together under topic headings and integrated the latest books rapidly—features we take for granted now.

It took decades to add tabs to cards. In 1876, Melvil Dewey, inventor of decimal classification, helped organize a company called the Library Bureau, which sold both cards and wooden cases. An academic entrepreneur, Dewey was a perfectionist supplier. His cards were made to last, made from linen recycled from the shirt factories of Troy, NY. His card cabinets were so sturdy that I have found at least one set still in use, in excellent order. Dewey also standardized the dimension of the catalogue card, at three inches by five inches, or rather 75 millimeters by 125 millimeters. (He was a tireless advocate of the metric system.)

Even the Library Bureau did not offer a convenient way to separate groups of cards, apart from thin metal partitions that wrapped around them, or taller cards. The tab was the idea of a young man named James Newton Gunn (1867–1927), who started using file cards to achieve savings in cost accounting while working for a manufacturer of portable forges. After further experience as a railroad cashier, Gunn developed a new way to access the contents of a set of index cards, separating them with other cards distinguished by projections marked with letters of the alphabet, dates, or other information.

Gunn's background in bookkeeping filled what Ronald S. Burt, the University of Chicago sociologist, has called a structural hole, a need best met by insights from unconnected disciplines. In 1896 he applied for a U.S. patent, which was granted as num-

ber 583,227 on May 25, 1897. By then, Gunn was working for the Library Bureau, to which he had sold the patent. It was to be a perfect match. The Bureau was becoming a leading supplier of corporate record-keeping equipment, offering "commercial grade" cards on wood-pulp stock.

The Library Bureau also produced some of the first modern filing cabinets, proudly exhibiting them at the World's Columbian Exposition in Chicago in 1893. Files had once been stored horizontally on shelves. Now they could be organized with file folders for better visibility and quicker access. Tabs were as useful for separating papers as for organizing cards. Since businesspeople were unfamiliar with the new technology, Library Bureau staff provided consulting services as well as equipment and supplies. By 1913, the company was advertising in the New York *Times* that it could supply a credit department with a 16-by-16-by-20-inch cabinet to "keep tab" on up to 14,000 customers. The Library Bureau also worked with Herman Hollerith, whose electrical punch card system later became the foundation of IBM.

James Newton Gunn went on to found one of the first consulting firms focusing on industrial engineering. He became an automotive and rubber industry executive. He helped found Harvard Business School and lectured at MIT, among other places. But the tab is his legacy. And it is ubiquitous: in the dialogue boxes of Microsoft Windows and Mac OS X, at the bottom of Microsoft Excel spreadsheets, at the side of Adobe Acrobat documents, across the top of the Opera and Firefox Web browsers, and—even now—on manila file folders. We've kept tabs.

The Mother
of All Invention

Atlantic, July–August 2010

The most unsung birthday in American business and technological history this year may be the 50th anniversary of the Xerox 914 photocopier. Although it was introduced at New York's Sherry-Netherland Hotel on September 16, 1959, commercial models were not available until March 1960. The first machine, delivered to a Pennsylvania metal-fastener maker, weighed nearly 650 pounds. It needed a carpenter to uncrate it, an employee with "key operator" training, and its own 20-amp circuit. In an episode of *Mad Men,* set in 1962, the arrival of the hulking 914 helps get Peggy Olson her own office, after she tells her boss, "It's hard to do business and be credible when I'm sharing with a Xerox machine."

The struggles, obstacles, and ultimate triumph of its principal inventor, Chester Carlson—beginning with his frustrations as a patent analyst in the late 1930s—seem ripped from a Frank Capra film. Few people thought a market existed for the machines, which went on to become ubiquitous. In fact, the 914's 17-year production run, which ended in 1976, was Methuselahian compared with today's technology product cycles. No wonder *Fortune* later called the 914 "the most successful product ever marketed in America measured by return on investment." Yet David Owen, the author of the well-received 2004 book *Copies in Seconds:*

Chester Carlson and the Birth of the Xerox Machine, was not asked for any interviews to commemorate the anniversary—and both *The New York Times* and *The Wall Street Journal* ignored the milestone.

Why no champagne? Although Xerox celebrated the 914 in fall 2009, it wants to move on from hardware-manufacturing alone to being what its Web site calls "a true partner in helping companies better manage information"—that is, a provider of business services, software, and new forms of paperless imaging. The 914 is a classic brand, but not a living one like the Swingline stapler or Bic pen. And although millions still make photocopies, the practice has been in decline.

But the analog 914 is worth remembering in the digital age. Carlson's creation was the catalyst for lasting changes in our use of information. Start with personalization. Even in the carbon-copy era, Americans and Europeans treated papers differently. European offices had central files, with letters stored in binders, indexed by skilled secretaries. American business pioneered decentralized, multiple sets of files in vertical cabinets. The photocopier helped to fill them, enabling the cheap and efficient spread of information—often with uncontrollable consequences: Daniel Ellsberg used a Los Angeles advertising agency's machine to duplicate the Pentagon Papers.

Personalization in turn promoted disaggregation: deconstructing and rearranging conventional information units. My own eyes were opened by a fellow graduate student's announcement in 1970 that he was annotating his own copies of journal articles for his files—a practice few had attempted in the days of malodorous wet-process copiers. Highlighters were introduced in 1962, shortly after the 914's appearance. Copy shops in Cambridge, Massachusetts, and other college towns began to bring corporate-grade machines to the masses for pennies a page, and individually select-

ed anthologies soon displaced the paperbacks that professors had assigned for a few chapters. The ensuing protests by publishers were a rehearsal for the 21st-century downloading crisis.

The photocopier prompted creation, not just the recombination of others' ideas. An alternative to the mess of the mimeograph and the expense of the offset master, the Xerox 914 opened a renaissance in self-publishing. The designer Aaron Marcus, a Yale art student in the late 1960s, remembers using an IBM typewriter with proportional spacing and sharp, single-use ribbons to design and produce books of his own. Indeed, the match between Xerox and IBM Selectrics (introduced in 1961, with interchangeable type elements) paved the way for 1980s desktop publishing.

The 914 also had an adverse effect: procrastination. Arthur Molella, director of the Smithsonian's Lemelson Center for the Study of Invention and Innovation, knew one prominent Ivy League scholar of the late '60s who spent hours each day photocopying journal articles for a book—and never completed it. Our own overwhelming hordes of digital information are the next chapter in that endless story.

For better or worse, we owe much about our information society to a former patent researcher's bold gamble. And David Owen's great history? It's an ebook, but print copies are available on demand—via the electrostatic process introduced by the Xerox 914.

"Information Age" at the National Museum of American History

Technology and Culture, October 1992

"Information Age: People, Information, and Technology," a new permanent exhibition at the Smithsonian Institution's National Museum of American History, may not be the first blockbuster show at a technology museum, but it sets a new standard for ambition and electronic complexity.

The presentation hardware alone would stock a superstore. There are 10 miles of cable, two theaters, a minicomputer, forty-eight personal computers, and forty-three videodisc players. One curator of the exhibit told me it would take a visitor two and a half hours just to see all the audiovisual presentations. A concluding "videowall experience" called "The New Age" is a composite of twelve television screens, each linked to a computer-controlled, synchronized tape player. Within the lifetime of many visitors, the entire computer power of the United States was less than that of the electronics assembled here.

"Information Age" is, among other things, technology about technology, just as there are films about film and television about television. Visitors are encouraged to pick up a brief guide imprinted with an individual bar code, scan it at five stations with interactive programs "to enter information into the exhibition's

computer network," and obtain a souvenir printout of their visit. Touch-screen presentations are spread throughout the floor. Interactive terminals offer experiences closer to science centers than to traditional historical displays.

The range of American experience here is equally daunting: Business organization, railroad operations, home entertainment, military command and control, industrial automation, and scientific research are represented. If there is any great theme, in fact, it is the close link between computing and communicating. While some parts of the exhibit are set pieces, such as the Kennedy-Nixon debates, others are unknown to all but a handful of enthusiasts and specialists. Still others are famous but rarely on public display, such as the ENIGMA machine.

Given the space allotted and the limits of human heads and feet, the Smithsonian has generally succeeded in introducing visitors to historical questions of information in society—as opposed, for example, to a more restricted definition it might have chosen.

"Information Age" has three main chronological sections—1832–1939, World War II, and 1946–today—which in turn have ten interactive centers marked by special symbols in the guide. The exhibition starts on a dramatic note. In a darkened passage, the visitor sees a painted street illuminated for a parade to celebrate completion of the first transatlantic telegraph in 1858, complete with the interior of New York's Trinity Church whence a sermon resounds on the blessings of international communication.

Around the corner is the anticlimax: the telegraph office closed before any commercial traffic could be accepted, the connection broken because of the limits of cable technology. This amusing but serious lesson in the hazards of technological pioneering is followed by a superb set of exhibits on the telegraph and telephone. Samuel Morse's telegraph is presented as an ingenious synthesis of off-the-shelf technologies and concepts: Joseph Henry's electro-

magnet, copper wire, print-shop equipment, batteries, and even an artist's canvas stretcher.

Two large walls of the first part of the exhibition continue the theme of instantaneous communication: the social and commercial logic behind printing and sounding telegraphs and their use in the military, in businesses, newspapers, firehouses, and hotels, and finally by private individuals.

The telephone and radio receive the same meticulous documentation (to give just two examples) with the parallel development of Alexander Graham Bell's and Elisha Gray's instruments from the harmonic telegraph, and the part that graduate physics education played in the development of vacuum tubes. Here, too, is the best of both worlds: a striking number of important original instruments along with labels that put them in a business and social framework—for example, the role of the telegraph-industry background of early telephone executives in delaying low-cost residential service.

Sharing the first part of the exhibit with communication is "Information Processing," devoted to the manual and mechanical information systems that supported the growth of 19th-century business and government. Here, the story is use rather than invention. A video presentation compares film footage of the bustle of the early-20th-century office with the clockwork computation of a Scheutz Difference Engine—human and hardware approaches to data processing.

The objects and labels continue the theme of organizational needs interacting with invention: a magnificent cash register, pneumatic tubes and baskets from the Chicago headquarters of Sears, an early Hollerith keypunch as used for the 1890 census, a variety of calculators, a free-standing and beautifully restored station from the pre-computer New York Stock Exchange. A reconstructed 1939 Main Street completes the picture of this earlier

information age with a series of shops and apartments displaying the latest in print, radio, and office machines.

World War II appears as a pivotal transitional zone between the protoinformation world of the 19th century and the true postwar information age. It also has two of the most unusual exhibits: a shipboard Combat Information Center prefiguring our now-ubiquitous windowless control stations and—a special treat—an ENIGMA cipher machine and weekly key list on loan from the National Security Agency. The Bell Laboratories, Harvard Mark I, Atanasoff-Berry, and ENIAC computers on display are physically imposing but difficult to interpret to nonspecialists within the space of an exhibit label. A set of video presentations of J. Presper Eckert explaining ENIAC helps solve this problem.

At this point, as though in some Freemasonic initiation ceremony, the visitor emerges from the intense but shadowy world of command center and decoding cavern to the brightly lit real information age. The 1832–1939 area was calm and ordered, complete with its cozy small town. That of 1946–today buzzes with one innovation after another and will confirm any visitor's sense of information overload.

Instead of the glass cases of "Communications" and "Processing," there is now a waist-height railing bearing the labels. Visitors proceed down a ramp and around sharp corners, as through a maze. It is in the 1946–1960 "Foundations" section that grim Cold War realities stand side by side with the rise of color television and transistor radios. While many of the objects, especially the early central processing units (CPUs) and peripherals, are battleship gray, others represent 1950s-style user-friendliness, such as the color-coded phonograph records ("Children's—yellow; International—sky blue; Classical—red; Popular Classical—midnight blue . . . Blues and Rhythm—cerise").

The evolution of computers in the 1950s and 1960s is represented by key parts of some of the most important civilian models: von Neumann's IAS, the RAND Corporation Johnniac, the ILLIAC, the Bendix G-15, and the IBM 650. For each computer, labels give succinct and readable information on its designer, use, and distinctive features.

Military influence on computer design is well represented within the limits of classification; the National Security Agency goes unmentioned in this part of the exhibition, as far as I could see. There are still some impressive and unexpected statistics, such as the need for 120,000 vacuum tubes in the early SAGE direction centers, and the military share of the transistor market in 1960: 48 percent by value.

From the 1960s, the exhibition focuses on civilian information technology, though the labels note the importance of their military precursors. The television displays alone have enough issues for a full gallery: the competition among color television standards, the rise of the networks, the political consequences of televised debates (naturally featuring Kennedy vs. Nixon in 1960), and the interaction of computerized political forecasting with television broadcasting.

The displays of post-1955 computer history also extend from the origins of software and large-scale banking and transportation systems to the rise of integrated circuits, personal computers, satellites, and networks. Perhaps inevitably, the closer the exhibition comes to the present, the more there is to explain and the less space there is to discuss it.

As electronics become more personal, the artifacts shrink. Some of the most important, software programs, are represented only by a diskette or two, with the packaging and manuals. There are a few big objects, such as the Federal Bureau of Investigation's 1972 fingerprint scanner and a device that can read pat-

terns of visitors' fingers. There is even an automobile body that, like a Prometheus in reverse, seems destined to undergo perpetual robotic assembly.

The exhibition ends with three interactive simulations—emergency telephone dispatching, foreign exchange trading, and television news production; a multimedia presentation on the demands of coping with the next phase of the information age and a series of impressive animation videos that provide a glimpse of it; and interactive simulations on customized manufacturing and a data base service.

Appreciating this exhibition demands several visits. Evaluating it is even more difficult. There is no precedent or standard. It is unlikely that any museum in the United States or Europe—Japan may be another matter—will try to mount another show on information history on this scale, especially since so many of the most important objects are here and since even the most generous corporate philanthropy has its limits.

On two grounds, the exhibition is an unquestionable success. First, the quantity and quality of objects are outstanding. Both the Smithsonian's own vast collections and corporate and private gifts and loans have been used to striking effect. The artifacts are generally in splendid condition, even those representing products that were in heavy use. Second, the labels offer impressive detail for anyone with the time to read them, or even a fraction of them. Not only are errors difficult to find, but the backgrounds and antecedents of the objects displayed are related with great care.

Where objects and interpretations meet, the results can be remarkable illuminations of technological change. Samuel F.B. Morse's adaptation of off-the-shelf technology, from canvas stretchers to composing sticks and printer's type, is shown with his actual transmitter. And there is no chauvinism: Charles Wheat-

stone's more sophisticated five-needle telegraph and other commercially oriented British telegraph instruments receive their due.

The display of the race between Alexander Graham Bell and Elisha Gray to develop the telephone makes the fascinating suggestion that Gray's background as a professional inventor may have held him back from realizing a commercially successful telephone; investors thought the harmonic telegraph, a related technology for sending multiple code messages simultaneously, had a brighter future. The combination of the two inventors' original instruments and the clear step-by-step, top-to-bottom story told by the labels make this a memorable segment.

Judging the exhibition's interactive features is a more personal matter. The bar-coded, punchcard-sized guide may delight many visitors. After entering my number once or twice, though, I began to feel that information was processing me. I resented it, mumbled something to myself about not having to punch in, and stopped interacting. I also began to wish that some of the money spent on electronics had been used instead for a better, conventional printed guide; as elsewhere, new information media had resulted in a loss of information. But my reaction, whether common or not, was surely part of the point of the exhibition. Even the crowded succession of displays in the second part does provoke some thought about information overload.

In making the two main divisions—1832–1939 and 1946–today—as distinct as possible, the organizers of the exhibition were likewise building discontinuity into the visitor's experience. This style of presentation has a price. It obscures the first division's admirable presentations of ongoing issues of the history of information that were already apparent in the 19th century. The information processing opening section is surely a warning of the perils of technological pioneering that are equally valid for today's startups. The secretary, literally cutting the red tape of old-fashioned

bundled letters to replace them in a newfangled 1868 Woodruff file, declares, "This 'efficiency' sure takes a lot of time." Surely her 20th-century counterpart might say the same thing about converting electronic files and learning to use new operating systems, graphic user interfaces, and word-processing software. (There is a counterpart of a harried male programmer facing a 1960s-vintage IBM 360 and grumbling, "This is the hundredth time I've run this program. I hate testing new software." But the point is different.)

A label interprets an 1870s telegraph as "shorten[ing] the time for decision making and increas[ing] the pace and stress of the business day." Much as I enjoyed playing at the simulated currency-trading terminal, I wondered why the earlier theme could not have been taken up. Does around-the-dock trading really promise greater profits for traders or social benefits from greater market liquidity? It was a question worth asking. And the printed code for telegraphic room service from a German hotel around 1900, with a code for each dish or request, is a delightful commentary on the ability of a new system to complicate life.

One of the most important insights of the computer age surely is how much 19th-century people were able to accomplish *without* computers. This point could have been made more forcefully in the label accompanying the atomic bomb casing; Joseph Weizenbaum has remarked that if electronic computers had been used to design the first atomic weapons, people would say that they could never have been built without computers.

The more benign objects and their labels in the 1832–1939 section testify to a level of skill and ingenuity as impressive as the best 20th-century hardware and software. The "Arithmeter," a superb 1869-vintage slide rule with multiple scales around a large cylinder, enabled its actuary-inventor to make more than 250,000 calculations per year.

There is a sad visual contrast between these tools of steel, brass, wood, and ivory and the boxy architecture of most recent computers. Some of the early electromechanical and electronic machines are impressive in their sheer size, but the early microcomputers on display such as the Altair are less understandable and more obsolete than 19th-century devices in good working condition. The idealism and enthusiasm of the early personal computer movement seem generations away after only fifteen or twenty years—casualties of their own success.

Summing up, "Information Age" has several outstanding features: thoughtful integration of communicating and computing technologies, a stunning collection of objects, important insights into the military role in information technology (though perhaps not enough about more recent controversies about the military and the decline of American consumer electronics). Whatever the motives of its underwriters, the exhibit is not the commercial promotion that some early critics in the daily press accused it of being. No exhibit made me want to buy a product or service; several were disappointments.

However, the exhibition misses chances to integrate information and history, separating Then and Now more sharply than it has to. Perhaps the greatest lesson of the exhibition is how, as information technology has advanced far more rapidly than expected, its predicted benefits have come more slowly. By making this point more explicitly, future revisions of the contemporary part could make "Information Age" the landmark that it deserves to be.

Paradoxical Proliferation of Paper

Harvard Magazine, March–April 1988,

Bad news for trees. Information technology was supposed to let us taper off paper. But we emphatically haven't. The paperless office, the bookless library, the printless newspaper, the cashless, checkless society—all have gone the way of the Empire State Building's dirigible mooring, the backyard helipad, the nuclear-powered convertible, and the vitamin-pill dinner. The Micro Millenium is turning out to be the Cellulose Century.

Futurists have never liked paper, except in forms that nobody ever asked for, like disposable underwear. As early as 1895 a pair of French satirists were predicting that the record player would bring "the end of the book." Around the turn of the century Jules Verne doubted there would be novels or romances in fifty to a hundred years. By the 1960s Marshall McLuhan was writing as though the Gutenberg Galaxy would collapse into a black hole.

Makers of computer hardware were equally unsympathetic. Not so long ago they treated printers as boring peripherals. When IBM introduced its original K in 1981, it didn't design to make the printer itself. But paper, that mere commodity, took its revenge. Paper prices began to rise. So did the shares of paper mills and office supply makers on the stock exchanges. In July 1986 General

Binding's earnings per share had increased 62.5 percent over July 1985. IBM's original printer contractor, Epson, now successfully makes competing microcomputers. On its way out is the old automated-office fantasy of spotless desks and electronic mail. In its place: an empire of vanity publishers swapping memorandums enhanced by bit-mapped graphics.

The statistics speak for themselves. From 1959 to 1986 America's consumption of writing and printing paper increased from 6.83 million to 21.99 million tons, or 320 percent, while the real gross national product rose 280 percent. One magazine for records managers estimated that between 1981 and 1984 alone, U.S. business use of paper went from 850 billion to 1.4 trillion pages. About 2.17 million tons of form bond were used in 1986. And between 1986 and 1990, printed material may rise from 2.5 trillion to 4 trillion pages. German ships that bring Mercedes and BMWs, Leitz and Zeiss instruments, and Heidelberg printing presses to the United States return laden with wastepaper for recycling—at last an export in which America excels.

From 1936 to 1986 the volume of U.S. mail increased from 80 billion to 146 billion pieces a year, and the postal service estimates a total volume of 170 billion pieces by 1990. In Manhattan, where volume is increasing at the rate of 10 percent annually, the post office is planning to spend $200 million on a new facility for handling old-fashioned paper mail. Meanwhile, none of the ten-odd American public electronic-mail networks has more than thirty thousand subscribers.

In the summer of 1987 newsprint production was approaching capacity (consumption had increased from 11.9 million metric tons in 1986 to 12.2 million metric tons), with prices rising and a 10-percent increase of domestic plant capacity planned for the next three years. A single newsstand in the Pan Am Building in New York stocks 2,500 magazines, and a trade association re-

ports that 265 more magazine titles were published in 1987 than in 1986. Even the Information Industry Association, which includes most of the leading database services as well as print media, distributes news to its members by a weekly (paper) letter, not an on-line service.

Barkers may have chilled the passbook savings account, but they have replaced it with a quarterly or even monthly statement. Consumers are still avoiding the home-computer-based on-line services that some banks and brokerages began to offer with a flourish in the early 1980s. And old-fashioned [checks] are thriving. In 1985 American banks processed 40 to 45 billion checks, according to a Federal Reserve Board official—more than 66 times the number of electronic funds transfers.

Credit cards may be plastic, but everything else about them is paper: a bank copy, a merchant copy, and one or two customer copies, three or four sheets of carbon paper, a monthly statment [sic] with return envelope—and a check. The automated-teller machine (ATM) is popularly called, for good reason, a cash machine. The newest models have as many as six cartridges holding three thousand bills each of one- to fifty-dollar bills, or up to $258,000; there were 4.4 billion ATM transactions in 1986. The Federal Reserve Board estimates that over $135 billion in greenbacks circulate worldwide.

Even in that paragon of postpaper planning, the research library, patrons are insisting on hard copy. They love the new electronic catalogues at the Library of Congress and the New York Public Library, where each terminal has its own little printer. The Rush Medical Library in Chicago, one of the few to disclose its paper consumption, used 188.2 linear miles of paper in its photocopy machines [i]n the year 1982–83 alone, the equivalent of over eight thousand 350-page seven-by-ten-inch books. In the early 1980s it was also using more than another hundred linear miles

of paper in its thermal and computer printers and in printouts of its serials holdings. As the director observed, "Many libraries are now acting as printing presses for electronically stored information, and as duplicators of printed materials."

Outside the library, academic paper use seem[s] to be increasing even faster. The Princeton University computer center, for example, used 5,765,000 pages of letter-sized laser paper in 1986, plus (including administrative use) 3,794 cartons of wide and 936 cartons of narrow green-bar impact printout paper—not to mention the paper used by the computer printers on campus. Harvard's computer printers use over 22.5 million pages a year, not counting the personally owned equipment of faculty and students.

It's evident that the more that people use computers, the more they want old-fashioned printed information about them. Ten years ago, even before IBM thought of introducing microcomputers, its documentation sales reportedly made it one of the world's largest publishers. Today, two series of fifteen to twenty volumes each of documentation are needed for the new IBM PS/2 disk operating system alone. For nearly all software, documentation and packaging account for the bulk of production cost. The inconvenience of photocopying manuals probably does more than any copy protection software to deter software piracy. According to Communications Trends Inc., of Larchmont, New York, computer magazine revenues will amount to $480 million in 1987, professional and textbook revenues over $300 million.

What went wrong with the assumption that electronics would take the place of paper? Why did almost nobody foresee that the microchip would be the best thing that has happened to paper since governments got people to accept the stuff as money? One reason may be that Americans have always been more conservative technologically than they have admitted to themselves, as the flop of metric conversions shows. We have not begun to adopt, for

example, any national videotex system like the British Prestel or the French Minitel, with its almost three million subscribers averaging nearly four minutes of daily use (American services combined still have only about 750,000 subscribers). But in Europe, too, there seem to be no trend way from paper. At least some of the prophets of an Information Age made several mistakes.

First, they didn't take their own idea of an information explosion seriously enough. They thought of information as a fixed quantity and of electronic information as a single replacement for the printed kind. Something different has happened. Computers (and microforms) are capturing much more information than was ever saved before and storing it incredibly compactly.

One of the largest numbers in the world must be the bytes of information stored in all forms. Once, the inconvenience of clay tablets, stone slabs, parchment, and even papyrus imposed a certain discipline, but no longer. Much less of our information is on paper than ever before, and of it may never appear as hard copy. But since the total is so high, even the occasional reproduction of a small part of it may bring a big jump in the [number] of pages actually produced. Even Ithiel de Sola Pool, who frowned on paper as a media "luxury" in *Technologies of Freedom* (1983), conceded that "the use of paper for display, reading, and current work may grow." Paul Saffo, of the Institute for the Future, in Menlo Park, California, acknowledged in the July 1987 *Personal Computing* magazine that paper is an "interface."

Second, people have good reasons for craving their information on paper. Reading things [on] computer screens is relatively inefficient, about 20 to 30 percent slower than print, according to industrial psychologists. Charles Bigelow, who won a MacArthur Fellowship for his work as a computer-based type designer, has pointed out that current screen resolution of 60 to 75 dots per inch would have to be improved tenfold for excellent visual

quality. This in turn would demand 64 to 100 times the storage of current office computers.

Even when high-end computer screens become as legible as mediocre print—which won't be soon—paper will still be more secure. The cheapest newsprint, doomed as it is, may not fall apart for decades; a power surge from a cranky air conditioner can wipe out a computer's memory in an instant. This isn't a problem for organizations as such. They back up their accounts receivable and other vital records in bombproof vaults. (Even this isn't foolproof; crucial records of Britain's Open University, with backup tapes, were destroyed recently in a fire at a temporary warehouse.) Personal files may have no such protection. As employees do more computing, they will need—or think they need—more hard-copy backup. The more people use personal computers at work, the more information there will be to back up. Nor is this just an American habit. The Japanese, the world's greatest connoisseurs and recyclers of paper, cram their offices with the stuff.

In fact, the security of hard copy isn't just habit. It's law. You can file federal tax forms electronically to get an early refund if your accountant has the proper IRS-approved software, but you'll still have to certify the electronic form with another one in writing. You can't serve an electronic summons or present an electronic birth certificate. Licenses, passports, insurance policies, contracts, securities—the law nearly always demands a paper document, since more than a voltage spike is needed to wipe it out, and more than a password to alter it. Banks once tried to "truncate" canceled checks (their jargon for giving customers a microfilm print on request in place of the real thing), but most gave up.

Naturally, the more important a government transaction, the more paper the law seems to demand. Norman Augustine, vice chairman and chief executive officer of Martin Marietta, cites another aircraft maker's estimate that each time a new military

airplane flew over the fence at his plant, paper accounted for 27 percent of its cost. The federal Procurement laws and regulations themselves, he also reports, fill 1,152 linear shelf feet; a single bidder for the C-5A transport aircraft contract submitted 1,466,346 pages [24,927 pounds]. Meanwhile, the Internal Revenue Service, charged with administering an eight-hundred-page tax-simplification bill, employs a professional staff of forty to do nothing but develop new forms. The instruction book for 1987 returns has increased to two hundred pages from its former maximum of about one hundred fifty.

Third, the gains of office work at the e of manufacturing jobs have increased the number of document-generating people. In the electronics and electrical equipment industries alone, according to one publisher's study, production jobs fell from 1.35 million to 1.24 million from 1984 to 1986, while white-collar jobs increased from 854,000 to 919,000. Even if each office worker's use of paper hasn't changed, more positions mean more paper used.

But all these new workers are using paper differently, thanks not only to computers but also to photocopiers. When the Xerox Corporation introduced its 914 dry photocopier in 1959, one of America's leading industrial consulting companies estimated that no more than five thousand machines would be needed in the whole country. Instead, office workers discovered that they could build up private files to reduce their reliance on others, and that they could share their data and opinions with an almost unlimited number of colleagues.

In carbon-paper days, making more than a carbon or two could be a terrible chore. No more than seven or eight people could get a document simultaneously unless somebody took the trouble—and trouble it was—to duplicate it from a master. This limited the number of people who could see or were expected to see a document. At a community college where I taught in the

1970s, copies of the dean's authorization for my office key went to six other administrators, thanks to the photocopier. And once many people were able to receive information at the same time, they expected to. Collators, automatic document feed, two-sided copying—each advance in photocopying came about because more and more people expected to get more and more information, with each technological advance making the information easier to transmit.

The result: In corporate life, and to an even greater extent in law and government, access to information means physical distribution of paper. *The Wall Street Journal,* citing a personnel *Journal* study, reports that up to 70 percent of office workers' time is spent handling written material. In one growing suburban area, Fairfax County, Virginia, the monthly agenda distributed to each member of the board of supervisors now weighs up to twenty pounds, not including categories of papers that are not distributed with the main package.

Finally, paper is proliferating because electronics has blurred the distinction between original and copy. Until the mid-1970s, a book editor receiving a professionally typed proposal could assume safely that the author had sent it to [no] more than a few others. It was too much work to type a dozen or more copies on speculation. With each new generation of electronic typewriter and each new form-letter software program, it became easier to spread letters of inquiry Johnny Appleseed style. Laser printing may soon make academic the difference between master and duplicate. Already it isn't always possible to tell a laser-printed original from a photocopy, and vice versa. A few laser printers actually double as photocopiers. And this surely means more "personal" and transparently personalized letters in the future. The cults of the $250 cigar-sized fountain pen and the handwritten business note probably reflect the devalued sincerity of executive typewriting.

All these changes have something in common. Paper is flourishing, not in spite of but because of electronics. Powerful microprocessors have made high-speed computer printing possible. A new $2,000 laser printer may have more kilobytes of storage than the microcomputer that drives it. Automated canceling and address recognition have saved the postal service from collapse, just as magnetic imprinting has allowed [banks] to handle oceans of [checks]. While the original Xerox 914 was electromechanical, a new high-speed autofeeding, collating photocopier—the McCormick reaper of paperwork—is really a hybrid of camera and computer. The vast mailings of organizations from the Moral Majority to the Audubon Society to L.L. Bean would be unmanageable without sophisticated computer support. (In 1986, 44.7 billion pieces of bulk mail were sent in the United States.)

There is every reason to think that electronics will drive, not drive out, print and paper as forcefully in the next decade as it has in the last. Satellite text transmission, which has made possible eight regional editions of the *Wall Street Journal*, four of the *New York Times*, and a new national paper (*USA Today*), now has brought same-day transmission of the *London Financial Times*. Typeset-quality laser printers may be within the reach of small businesses soon. DataQuest Inc., a market research and analysis firm in San Jose, California, estimates that close to 250,000 page-makeup software packages were sold in 1987. American offices bought 200,000 facsimile machines in 1986, and the market is expected to increase at an annual rate of 20 to 30 percent at least for the next several years.

What of attempts to suppress paper files in offices? As Pool himself observed, "When no paper files are kept because bulk storage of them is too expensive, a new paper copy may be derived from the bulk electronic files every time an item needs to be seen, and then that copy can be thrown away [.]

Meanwhile, the speed of change in electronic media will continue to make paper more important than ever for data storage. As a National Research Council report pointed out in 1985, we can't assume that electronic records will be readable for a fraction of the two- to three-hundred-year life expectancy of acid-free paper. Information stored on tapes and floppy disks—and even on laser disks, it seems—degrades slowly but steadily. As obsolescent hardware is scrapped, reading older computer records becomes a challenge. Some Vietnam-era tapes now can be read only by one or two working computers in the world. Today's laser-disk texts may fare no better.

Paper, by contrast, is robust. Future generations or beings, even if they can't read it at first, can stare at our texts while awaiting their Champollion. When paper starts to crumble, we can just microfilm it or photocopy it onto new paper; xerography, applied to old documents, may be the first information technology in history to yield a copy superior to the original. Even soaking paper, burning it, or slicing it into ribbons may not erase its message for the determined, as the reassembled records of the U.S. embassy in Teheran attest.

What a compliment, then, the shredder is to paper's ubiquity and durability. The U.S. government buys several thousand shredders a year, according to a leading Washington-area dealer, and industry spends another $60 million annually. Oliver North's infamous Intimus Model 007-S, a White House favorite, can crosscut sixty feet of paper a minute into 7,500 pieces a sheet, and the conveyor-belt-fed Intimus Model 580E can digest a filled three-inch loose-leaf binder. Yet paper is also more secure than conversation or electronic databases; the kind of bugs that penetrate it will never tell.

Sometimes electronic media do win over paper. Ninety percent of securities trades take place as electronic book entries (backed

up, of course, by vaults of paper certificates). Recordings and photocopying have overwhelmed sheet-music publishing, already suffering from the piano's long-term decline and the educational computer's recent rise as a bourgeois totem. Telephones seem to have endangered personal letters but, interestingly, not greeting cards. In offices, banks, and libraries, bulky, obsolete, flammable stacks of wood-fiber sheets (including the soothsayers' dire prophesies for them) seem entrenched for a perpetual transitional decade. If the Soviet Union, as speculation has it, relaxes its fierce scrutiny of the photocopier, it will be the most fateful event in paper history since the invention of third-class mail. We will refine the last barrel of oil—it takes the equivalent of at least fifteen hundred pounds of petroleum to make a ton of paper—before we cut the last southern pine. The computer, ironically, has turned us from pencil pushing to print pumping.

The Perpetual Passion for Paper

AEI American, May 16, 2013

Is paper obsolete? A Canadian who had a stash of new-style polymer $100 bills probably would disagree. He kept them in a coffee can near a radiator and they melted. Others have complained that Canada's new individual notes stick together and resist folding. Canadian authorities insist problems are exaggerated and that the new plastic money is much harder to counterfeit than traditional rag-content paper. Still, it's only a matter of time before counterfeiters imitate the technology, as they have with other safety features from watermarks to holograms, at least well enough to fool time-pressed cashiers.

Could the solution be to eliminate all currency in favor of digital transactions? Barron's ran a cover story asking if we've reached "The End of Cash?" The author called the disappearance of cash "slow but inexorable." Yet he had to acknowledge at the outset that the federal government printed a record 8.4 billion notes in 2011. While the piece asserted that "upscale merchants are doing away with cash registers," the only one it mentioned was Apple stores. And even they do accept cash, despite urban legends otherwise.

Paper is definitely becoming less *important* for financial transactions. The Federal Reserve Bank of Cleveland's website makes this point graphically. Cash accounts for only 0.2 percent of the

value of funds transferred; the volume is overwhelmingly electronic. But that doesn't mean paper money has been withering. Nearly half of all transactions—49.4 percent, according to the Fed—are still in cash. Somebody has failed to inform tens of millions of consumers about the "post-cash, post–credit card economy." Most futurist gurus and journalists who extol it, whatever their politics, have little contact with the 25 percent or more of the population who, according to the Fed, are "unbanked or underbanked" and rely almost entirely on cash payments, with the exception of the debit cards now encouraged by Social Security and other government agencies.

And paper remains invaluable even for the millions of people with ample credit. Globally, the increase in Chinese consumption of paper over the last five years has more than offset the decline in U.S. production, according to the Environmental Paper Network, a nonprofit promoting conservation and recycling. And according to the *Economist,* global paper use per capita is up by 50 percent since the dawn of the personal computing age in 1980. (Thanks to the prodigious paperwork of the expanding European Union, Brussels's multilingual bureaucrats have brought Belgium to the number one world per-capita rank in paper use.) Paper may be less vital for conveying breaking news than it once was—according to the *Times Literary Supplement,* Charles Lindbergh's 1927 solo transatlantic flight alone increased newsprint consumption by 25,000 ton —but it can offer four advantages: prestige, utility, permanence, and security.

As routine communications have become largely electronic, paper's role as a mark of status has only grown. Can an exclusively electronic diploma, passport, or military commission document even be imagined? Will the bride's family announce a wedding with advertising-supported Evites, and will the photographer supply only digital files recording the event? The more important the

gesture, the more imperative a handwritten note, in part precisely because people find handwriting more difficult now. Even a commercially produced card signals that the sender has taken the trouble to visit a shop, select the proper design, find a stamp, address it, and mail it. One recent European experiment showed that even for a high-technology job announcement, many more potential applicants replied to postcards than to email announcements. And America's continued printing of one-dollar bills signals support for the U.S. note as a reserve currency. (At the other end of the range, the $3 billion in hundred-dollar bills printed last year are used mainly overseas.)

In periodical publications, the web-only option often makes sense, but the e-book is far from taking the place of print. A printing signals the strength of a publisher's belief in a book and its willingness to take a risk. Editors and reviewers increasingly rely on electronic proofs, but books issued only electronically are seldom reviewed in major media—web or print—and bought by surprisingly few libraries, at least in my experience.

Paper also remains surprisingly practical. If you doubt this, go into any big box office supply store and you'll find that paper and writing equipment still occupy at least the same floor area as electronics. Sales of pencils continue to increase; in the recession year of 2011, wood pencil production rose by 6.8 percent. Many multifunction copier-printers include flatbed scanners that can convert notebooks into electronic files. Software handwriting recognition will continue to improve, and there are high-tech pens that even make simultaneous paper and electronic records.

And paper's utility crosses generations. In August 2012, the Chronicle of Higher Education ran the headline "Students Find E-Textbooks 'Clumsy' and Don't Use Their Interactive Features." Texts and other e-books are not products but licenses for limited uses of copyrighted files; they generally have zero resale value.

Dominique Schurman, CEO of the 450-store Papyrus chain, told the *San Francisco Chronicle* that "teenagers are discovering stationery and greeting cards almost as a novelty . . . a great way to communicate and be noticed." Paper reaches back centuries. Scholars around the world are still studying paper fragments that are up to a thousand years old from the synagogue depository in the Jewish community of Cairo and the parchment texts of the Monastery of St. Catherine at Mount Sinai.

Paper—even the cheap, alkaline kind—also appears more durable than it did during the "brittle books" panic of the 1980s. The novelist Nicholson Baker attacked some librarians and archivists as vandals in his book *Double Fold* for discarding rare originals of books, magazines, and especially newspapers when making microfilm and electronic backups. (Some of Baker's targets have in turn accused him of oversimplification and ignorance of their professions, but other librarians have at least tacitly acknowledged his point. The Duke University Library is preserving in perpetuity a 5,000-volume collection of historic newspapers rescued and donated by Baker.) Electronic data can be fragile, too. Many information professionals now acknowledge that the preservation of digital content on physical media may be an even bigger challenge, since drives crash, optical disks and flash media degrade, and file formats become almost unreadable. They are especially concerned about "born-digital" works with no version in an analog format like a printed publication or LP record. Thus, paper remains the backup material of last resort, even though it is usually a poor medium for beginning research; electronic databases are far more efficient.

Finally, paper is surprisingly secure. Despite counterfeiters' deviant ingenuity, a careful eye can still detect phony bills and documents far more easily than network managers can spot new worms and viruses with greater destructive potential. Journalists

may mock the Japanese for clinging to their fax machines, but faxing can be more rational than sending sensitive information like Social Security and credit card numbers in unencrypted e-mail, as even many corporate users still do. As for voting security, even tech enthusiasts like Rep. Rush Holt, a Democrat from New Jersey, have concluded that paper is still unsurpassed by any electronic voting system.

For all the attractions of gold to prophets of apocalypse, precious metals and jewels are not so useful in actual emergencies. If the electric grid has been hacked, how do you get past the vault time lock to your safe deposit box? And if you can, how do you get change when using Kruggerrands to buy sacks of potatoes?

A practical rehearsal not so long ago proved the point. The Cleveland Fed's graph shows a distinct spike in currency printed in 1999. This was in anticipation of computer malfunctions resulting from the failure to patch software to deal with the millennium rollover—the Year 2000 or Y2K problem, as it was called. While actual disruptions were much rarer than optimists expected, Chairman Alan Greenspan paid tribute to the virtues of paper money in a speech in September 1999, calling the extra supply the "precautionary inventory."

So the next time you write down another password on a sticky note and put it on your computer monitor, remember: Something can become less *important* but more *essential*.

The Prestigious Inconvenience of Print

Chronicle of Higher Education, March 9, 2007

"Power to the People" was a 1960s slogan embraced by the electronic visionaries of the 1970s, who heralded a new era of universal communication and access to knowledge. Thirty years after the birth of the personal computer and more than a decade after Netscape launched the World Wide Web as we know it, their goals seem within reach, if not already achieved.

We, the people, have been empowered. We can send what are basically free telegrams to people around the globe, create and distribute photographs and video at little or no cost, broadcast our ruminations through blogs, and browse many of the world's greatest art museums and library collections—all from our own desks. Public libraries and Internet cafes around the world assure free or cheap access to those still without home computers. If that isn't progress, if this isn't empowerment, what is?

Yet there is a catch. In 1976, the same year that Steve Wozniak and Steve Jobs released the Apple I, which started bringing computing into the home and the classroom, the economist Fred Hirsch published *Social Limits to Growth* (Harvard University Press). Grossly oversimplified, Hirsch's argument was that even as societies become wealthier, many consumer goals remain unmet.

For example, the supply of what is considered prime real estate is restricted; only so many people can own an apartment fac-

ing New York's Central Park or on Chicago's lakeshore without plunging entire landscapes into the shadows of their buildings. The prices of many rare books have increased more than a hundredfold in the economic expansion since World War II, and a few major paintings are starting to break the nine-digit mark. The growth of an educated work force, combined with frequent mergers and acquisitions, means that there are more talented people than ever shut out of top management—which receives an ever-higher multiple of average wages and salaries. Even some use of public roads may go to the highest bidders now that governments are beginning to levy significant congestion charges for driving during peak times. As the number of vehicles increases, it isn't clear how high per mile tolls will go to keep traffic moving.

Whenever more people with more money pursue objects, spaces, services, and media imprints that are limited in supply (as opposed to those that can be multiplied and reduced in price through technological innovation), progress may look like a frustration machine. Surveys taken in the 30 years since the Apple I and Hirsch's book suggest that happiness has not grown with increased wealth or electronic access.

Unknown creators may dream of being discovered on the Web, but celebrities get prime placement in conventional news media. Even for a manifesto forecasting the end of printed books, one of cyberspace's founding gurus, Kevin Kelly, used not a blog but all the positional might of *The New York Times Magazine* (May 14, 2006)—with a striking cover image by Abelardo Morell, an award-winning photographer and specialist in bibliophile photography. And although the *Times* posted dissenting as well as supporting comments in its online "Forum," it was without such trappings of position.

As a former acquisition editor at a publishing house, I can testify that impatient critics of the printed book are getting it wrong.

Conventional print publishing is a daunting business. No matter what an organization's size, it faces challenges unknown to wikians and bloggers. A printed book, as one production editor pointed out to me, is really a machine with a half-million parts, any one of which can go wrong.

While purely electronic publishing has the same challenges with texts themselves, print introduces new realms for errors and disputes in paper, printing, and binding. Conscientious editors of major illustrated books have been known to camp out at the printer, sometimes continents away, to see final proofs and avoid potentially ruinous last-minute surprises. Predicting sales is an occult art, with its dual risks of unmet surges in demand and huge write-offs and remainders. U.S. tax treatment of warehoused unsold copies is notoriously unsympathetic.

Yet such bugs are also positive features. If a well-known publishing house takes the risk on a book, even a despised so-called midlist title, readers are at least subliminally aware that an investment of tens of thousands of dollars is at stake, that the author's writing is worth a gamble. While some industry pundits have proclaimed print-on-demand to be the future of publishing, there will always be a positional advantage to the conventional book. It says somebody thought enough of this writing to run off a whole batch. What's more, there are many design features that on demand printing can't equal.

Because progress has made communication so efficient, the prestige of inconvenience extends to personal life, too. That's why electronic greeting cards, while still readily available, have never replaced those in the drugstore racks. "Paper is for lovers," *The New York Times* declared recently. "Despite the e-volution of correspondence, paper Valentine's Day cards are still in style." The recipient appreciates not only the physical card suitable for display and graphic frills like metallic foil, but also the fact that

somebody has gone to the effort of buying, inscribing, addressing, stamping, and posting it.

And although executives may spend hours sending e-mail communications and instant messages, their most important sentiments are likely to be expressed as handwritten notes—one of the reasons for the luxury fountain pen industry's niche in the digital age. Legislators and their staffs are also said to take handwritten letters more seriously than e-mail notes, although it remains true that an original and thoughtful electronic message will be more influential than canned talking points in any format.

Despite all the predictions of the end of printed books dating from the rise of the PC and the Macintosh in the early 1980s, census figures show that the number of authors more than doubled in that decade. Surely the efficiency of word processing had a lot to do with that burst. And even after declining from an all-time high of 190,078 titles in 2004, the preliminary 2005 total of new titles reported by the R.R. Bowker Bookwire service was nearly 150,000 (cloth and paperbound combined)—a significant increase over the 113,589 titles published in 1995, just before Netscape's release popularized the Internet.

Yet newspaper readership has been declining significantly: Daily newspaper circulation is down an average of almost 3 percent over the last six months, in the wake of a decade-long slide. Meanwhile, although the statistics for the United States are hard to find, it does not appear that paid opportunities for Web-based writing have offset losses in print publications. A recent Canadian survey of freelance writers reported a decline of average pretax income from about $26,500 in 1995 to $24,035 in 2005—not adjusted for inflation.

As a researcher, I'm delighted that there's so much free, or usually advertising-supported, content. But as a writer, I'm concerned that outlets are declining as aspirations are rising. Writing

programs seem to specialize in the one genre, the short story, that has suffered most from the decline of general-interest magazines. Few bloggers have made a living from their writing, and many of them seem to have begun with experience or connections in print publishing.

The Web is simultaneously helping to undermine some of the most socially valuable parts of conventional media. By eroding the advertising base of print newspapers and magazines, the Web is not threatening their existence, but it is indirectly depleting marginally profitable yet vital services.

For example, even as the number of published books has soared, newspaper book-review sections have dwindled. And at a recent panel of Nieman Fellows at Harvard University, Kevin Cullen, a reporter and Pulitzer Prize winner at *The Boston Globe*, warned of the future of the investigative reporting that has exposed so many government abuses in recent decades: "The only place we see it is in the print media, and I don't know if we'll see it five or 10 years down the road," he observed, "and that scares the hell out of me." Television networks, too, have been closing their foreign bureaus.

In sum, just as luxury watches remain in demand while most people carry cell phones that give the time with virtually observatory-standard accuracy, the Web will never destroy older media because their technical difficulties and risks help create glamour and interest. At the same time, however, the Web does nibble at their base, creating new challenges for writers, musicians, and other members of the media.

On a positive note, one recent study implies a surprising strategy for cultivating reading and book buying. Andrew Abbott, a professor of sociology at the University of Chicago and chairman of a task force that studied library usage by all parts of that university, reported in the October issue of the *University of Chicago*

Magazine: "The more an individual uses books, the more he or she uses electronic-research resources, and vice versa. . . . At the very least, the survey data provides no evidence that traditional research practices are being replaced by electronic ones. Thus, the replacement hypothesis—a standard idea in library literature—must be rejected."

The possibility follows that the more sophisticated students become as users of search engines and online databases, the more likely they will become readers, and perhaps buyers, of books. The knowledge-hungry person will need and appreciate print, just as many serious readers of traditional books in an older generation became the gurus of today's electronic scholarship. As Abbott observes, "[T]here was no evidence that younger people were somehow 'more electronic.'"

By questioning either-or commonplaces about students and reading, the study suggests many promising directions for teaching. We have only begun to use print and digital resources to enhance and extend each other. College teachers in the humanities can now draw on decades of scholarship in the history of the book and of reading to help their students understand all of the features of print—formats, typography, jacket designs, binding—that form part of the cultural impact of books and periodicals even today.

For example, the dimensions and design of *The New York Times Magazine,* never present in databases like LexisNexis and Factiva or even the *Times*'s own public Web archives, amplified Kevin Kelly's message. More and more rare-book departments in university libraries welcome not only faculty and graduate research but undergraduate use. The goal in the next decade or so should be to prepare students to be discerning users of, and contributors to, all media. An excellent starting point on the Web is the site of the Society for the History of Authorship, Reading, and Publishing (at http://www.sharpweb.org).

Despite the enduring positional advantage of print-plus-Web over Web-only, Internet authorship of all kinds will also continue to flourish as a counterbalance to conventional media. Yes, the Web might be promoting a pseudodemocracy harking back to the class society of Victorian England, when W.S. Gilbert's Grand Inquisitor lampooned ordinary Britons' dreams of glory in *The Gondoliers*: "When everybody's somebody, then no one's anybody."

But empowerment isn't entirely an illusion. To balance the cleric's dour judgment, we should recall the cheerier conclusion of the Dodo in *Alice in Wonderland*: "Everybody has won, and all must have prizes."

The Impending Information Implosion

"I seriously doubt that there has been any information explosion," said Tom Wolfe. How about an implosion? What about the cost, ease of access, variety, and clarity of information?

Harvard Magazine, November–December 1991

Questioning the information explosion seems to be as willful as recruiting for the Flat Earth Society. One major astronomy project alone, the Digital Sky Survey, will store and analyze ten million megabytes of information over the next ten years to produce a three-dimensional map of one million galaxies and a million stars in the earth's own galaxy, among other objects. The *abstracts* of a recent London meeting on sequencing the human genome take up 350 printed pages.

From 1980 to 1989, public electronic mailboxes increased from 210,000 to 1.8 million, institutional mailboxes from 220,000 to 6.8 million. Traffic on the National Science Foundation network (NSFNET) alone increased from about 190 billion characters in July 1989 to 645 billion characters in July 1990. Palm-top organizers surpassed that processing power and memory of the first personal computers of a decade ago at a tenth the price. A single CD-ROM disk can replace two thousand library-card-cat-

alogue drawers. So crucial are information networks to profits that in 1986 the president of American Airlines said that if he had to divest the airline or its Sabre reservation system, he would keep Sabre.

Print media, too, seem to be multiplying. Richard De Gennaro, Larsen librarian of Harvard College, predicts that the College library holdings will double from the present seven million volumes in twenty years. Widener Library is already 500,000 books above its three-million book capacity. To make room for the 70,000 volumes added each year to Widener and Pusey libraries, Harvard has begun to build massive outlying depositories for environmentally sensitive, less frequently used materials.

A University of Texas publication reports one estimate that "the amount of knowledge generated by man [sic] throughout history will more than double by the end of the twentieth century" and that Americans consume "approximately 7 trillion words a day" in written and electronic forms.

Even so, many people are wondering whether information overload is the only problem. As early as 1984, the political scientist Langdon Winner questioned the "revolutionary" rhetoric of computer people as "Mythinformation" in the electronic engineering magazine *IEEE Spectrum*: "Exhausted in Madison Avenue advertising slogans, the [revolutionary] image has lost much of its punch." And in 1986, the media scholar Brian Winston could call the information revolution "an illusion, a rhetorical gambit, an expression of profound ignorance, a movement dedicated to purveying misunderstanding and disseminating misinformation." Even the author of *The Right Stuff* himself recently turned technology critic. On a 1990 Public Broadcasting Service (PBS) symposium, Tom Wolfe wondered aloud whether electronic advances had made information more available. "I seriously doubt that there has been any information explosion," he said.

What if the information *ex*plosion is driving an equal and opposite information *im*plosion (a word apparently first used by the French critic Jean Baudrillard), affecting have-nots most severely, as all shortages do, but also touching middle-class and even well-off people? A college classmate who teaches at a leading law school recently pointed out that his library could deliver superb legal bibliographies in minutes but that he had written to the Louisiana Highway Department four times in vain for a map. My friend had discovered that the total quantity of information and the number of channels for delivering it matter less than how hard it is to get when one needs it.

> John Maddox compared scientific information to a salami that can be cut in thick or thin slices. Many scientists are now convinced that the salami is noy growing as fast as the number of slices.

Even the Flat Earthers have a point. Sometimes the local picture matters as much as the global one. Who takes a great-circle route to the supermarket? And since it's well-known that the long run is a series of short runs, it's time to pay as much attention to the *present* of information as to its future.

Nobody has a definition of information satisfactory for both theoretical and everyday use. But when any of us wants to know something, we recognize information when we see it. It is as easy to quantify—as pages or minutes or square inches or bytes—but difficult to measure. John Maddox, editor of *Nature*, recently compared scientific information to a salami that can be cut in thick or thin slices. Who can quantify the importance of the results in papers? They are like blips on a radar screen that do not disclose whether the craft is a two-seat trainer or jumbo jet. And

many scientists and librarians are now convinced that the salami is not growing as fast as the number of slices.

The new *Encyclopedia Britannica* isn't much longer than the fabled eleventh edition of eighty years ago. The years required for schooling at all levels have not changed significantly, though more people do of course get higher degrees now. Some subjects have been cut back to make room; societies forget things as they learn others.

There are at least four ways to judge whether we have better or worse information: cost, ease or difficulty of access, variety of sources or viewpoints, and clarity. None of these has improved unambiguously over the last generation.

Consider cost. Processing and storing information electronically is cheaper than it ever was, and it is getting cheaper all the time. But the lower cost of hardware is leading to more powerful computers at the same price points, running fancier releases of the same software, rather than to cheaper machines.

New information technologies, even those that decrease in real cost, increase the cash and (equally important) time cost of information. We have more mailboxes to maintain and check. Fax and electronic mail are parallel channels with their own hardware and service expenses, and neither reduces the national overhead of postal and express shipping routes. First-class postage has increased from 6 cents in 1970 to 29 cents in 1991.

It is true that the marginal cost of long-distance telephone calling has decreased significantly after the breakup of AT&T in 1984—a savings offset for many people by higher local rates and a smorgasbord of costs from "access" to "wire maintenance." Competition among long-distance carriers now seems to be in marketing rather than in price cuts or technical improvements. Long-distance information itself, once free, now costs 65 cents per inquiry after the first two for AT&T residential customers. Out-

of-town telephone books are also no longer supplied gratis. This may or may not work to the benefit of telephone customers, but it hardly represents cheaper information. (At least we had Reaganism rather than Thatcherism. One British columnist recently had fifteen minutes to find a telephone book or get directory assistance near Trafalgar Square. He failed).

The toll-free 800 information services of the 1970s and 1980s remain an outstanding accomplishment but are threatened by the 900-line concept. *The Wall Street Journal* reports that the French government's regular (toll) tourist information number now offers only a recording that gives another 900 number at fifty cents a minute—presumably plus tax and service. Other foreign tourist offices may follow. "Clearly, companies are looking to migrate 800 services to 900 numbers to produce revenue," a telecommunications consultant at Booz Allen & Hamilton told *USA Today*.

Similarly, pay-per-view television threatens even premium cable as we have known it. Scott Kurnit, president of the Viewer's Choice division at Showtime, has declared in *Entertainment Weekly* that "free TV is no more than a fluke, a lack of technology forty years ago, rather than a birthright. They just didn't have a viable means of scrambling signals back then, or they would have."

Print media prices have also been headed upward. The daily *New York Times*' new 50-cent price compares with 15 cents in the early 1970s, and *The Wall Street Journal* has quintupled in price from 15 to 75 cents. (The national edition of the *Times* also sells for 75 cents in the Midwest and Southwest.) Most other dailies are expected to increase in price from between 25 and 35 cents to between 35 and 50 cents. *The Economist* has calculated that its own British after-inflation price more than doubled between 1960 and 1990.

Many paperback publishers began repricing aggressively in autumn 1990, but the trend is older. In the 12 years from 1977 to

1989, according to the 1990–91 *Bowker Annual,* average cloth prices increased by 108.7 percent, but paperback prices grew by 179.9 percent and are now 41.4 percent rather than 30.9 percent of clothbound averages.

Prices of professional and technical journals rose two and three times faster than the Consumer Price Index in the 1980s and are expected to rise even more sharply in the 1990s, according to a recent *Publishers Weekly* article. The Association of Research Libraries (ARL) reports they increased by 51 percent between 1985 and 1990 alone. It's true that there are more journals, and that some, though not all, have more pages annually, but information can hardly be called more affordable.

Electronic databases are still for deep-pocketed researchers. *InfoWorld* reports that most services charge between ten and fifteen dollars for retrieving a single *Business Week* article that would cost sixty cents to photocopy.

The jump in the number and price of journals has helped convert the problem of price in public and academic libraries to one of access. To maintain their serials budgets, libraries have cannibalized book acquisition funds. The 94 members of the ARL bought 570,000 fewer books in 1989 than in 1985, a 16[-]percent decline. The Berkeley university library reports a drop of nearly 50 percent both between 1981 and 1992, and between 1990 and 1991. Berkeley has canceled more than $400,000 worth of journals subscriptions. Yes, there are interlibrary loans, but despite electronic networking, they can still take weeks; and, of course, users at the lending library lose access during the term of the loan.

Washington hasn't been setting a good example for the private sector. In 1988, the Washington, DC office of the American Library Association published a chronology of the eighties called *Less Access to Less Information by and about the U.S. Government,* deploring "a continuing pattern of [the] federal government

to restrict government publications and information dissemination activities." Among other things, it reported that since 1982, one fourth of the government's sixteen thousand publications have been eliminated.

According to *The New York Times,* Bill Kovach, curator of the Nieman fellowships at Harvard, believes the popularity of restrictions on the press's coverage of the Persian Gulf war "has established a new standard in terms of the amount of information the government is willing to give its people." The total number of official secrets created by the U.S. government did, it is true, decline from an all-time peak of 15 million in 1985 to 6.8 million for the year that ended September 30, 1990, but the 1990–91 statistics should see a big jump again. Of course, the exact number, compiled by the Information Security Oversight Office, is classified.

Thinking of calling for information in the civilian sector? Don't count on finding the number. Seventeen percent of the telephones in New York City and about 40 percent of those in Los Angeles are now unlisted—partly as a reaction to automatically dialed, recorded sales spiels, another Information Age blessing. Many of the published L.A. numbers list no address. And don't assume that a professional directory is an alternative. The fax and electronic switchboard explosions have increased the demand for new telephone numbers, making old area codes and exchanges obsolete.

Cities, for all their misery, were once fountains of information for ordinary people. Now they are becoming ground zero of the information implosion. In the words of one New York City school administrator recently reported in *The Washington Monthly*: "Extant data systems contain an abundance of information which is underutilized due to deficit staff knowledge and abilities due to inaccessibilities." But the situation of New York's and other urban libraries is no joke; it's a tragedy to the children and adults who depend on them. The president of the New York Public Library

reports that budgets for books and periodicals have been cut by almost 40 percent. Most of the branches of the Brooklyn Public Library now are open only part of the day, three or four days a week. Even sidewalk newsstands have decreased in number from 1,325 in 1950 to 298 in 1991, according to a spokesman for their operators, with almost none outside Manhattan.

And as Brooklyn goes, so evidently goes Bakersfield. *The Los Angeles Times* has abandoned home delivery and newsstand sales in Central California and in other Western cities like Phoenix, Tucson, and Salt Lake City. Sociologists at the University of Minnesota say that urban newspapers throughout North America are discontinuing rural delivery at the very time when farms and small towns need economic and political information most. A 1998 article in the Minneapolis–St. Paul *Star Tribune,* one of these papers, acknowledged a rural "information shortage" as a result of these very policies.

Whatever might be said of price and accessibility, variety would seem to be improving. The number of books in print continues to grow. After years of losing ground to chains, independent bookstores are thriving again. Fiber optics will soon make it possible to view 150 channels of cable television. Samir Husni, a journalism professor at the University of Mississippi, has found that an average of more than five hundred new magazines a year (out of a total of more than three thousand in the United States) were started in the four years beginning in 1987.

Viewed close up, the range of choice is not quite so appealing. Fewer antiquarian booksellers can afford to maintain open shops. Of the nine books I considered assigning when developing a course at Princeton University in the history of information in spring 1990, five were out of print or out of stock. The greater efficiency of computerized book ordering, both for retailers and for individuals, doesn't help much if the book isn't available. And if

you think on-demand publishing is the answer, look at the prices, which can be more than one hundred dollars for a paperbound microfilm printout of a four-hundred-page history book.

It's true that the variety and quality of professional publications are at an all-time high. In fields like law, medicine, education, engineering, and, of course, computers, there is a feast of material—much of it remarkably jargon-free. If only media for presenting public issues were so diverse! When Albert Robida (see "World's Greatest Futurist," *Harvard Magazine,* January–February 1990) founded *La Caricature* in the early 1880s, there were over eighty daily newspapers in Paris. Freedom of entry into publishing for the ordinary journalist may have reached an all-time peak, extending to a petit bourgeois artist from the provinces. But even in New York City a hundred years ago there were fifteen daily newspapers in addition to the weekly and foreign-language press.

We take for granted that only the largest studios can assure national distribution of a feature film, but this wasn't always so. The University of Southern California historian Steven Ross has pointed out in *The American Historical Review* that in the days of the two-reel film before the First World War, labor unions and other organizations could produce films for only a few thousand dollars, and did. It was the growing expense of films in the postwar years that shut dissenting voices from the motion picture marketplace. Higher production standards arrived at the expense of variety. (Cable television may reverse this process, but it's still too early to tell).

For all the marvels of desktop production, the cost of entry into trade publishing has also soared. In the late teens and twenties, the brash young publishers Albert Boni and Horace Liveright were able to start the Modern Library with a capital of $12,500. Richard Simon and Max Schuster had only $4,000. Of course small publishers are starting now with even less money in real

terms, but it is far more difficult for them to bootstrap their way out of niche markets. Whether opportunities in cable television can offset the losses of independent publishing houses and general interest magazines remains to be seen.

While we usually don't give the clarity of information the same priority as its cost, accessibility, and variety, we recognize it when it's changing. With increasing computer power, resolution of video terminals and letter quality of printers have been increasing as costs have been dropping. The problems of high-definition television (HDTV) are now more political and legal than technical.

At the same time, underlying data are becoming less clear. A 1989 poll of business economists found an increasing majority, 72 percent, dissatisfied with the quality of data. They named inadequate staffing of government statistics-gathering agencies more than any other factor.

But we are also losing clarity because users lack the background knowledge to display properly the statistics they do have. In his provocative book *How to Lie with Maps,* (University of Chicago Press, 1991), the Syracuse University geographer Mark Monmonier points out the serious problems that computerized mapmaking has introduced, including distortions of gray scales by laser printers and confusing use of bright hues by amateurs overwhelmed by their color publishing capabilities. "With no guidance and poorly chosen standard symbols," he writes, "users of mapping software are as accident-prone as inexperienced hunters with hair-trigger firearms."

Sometimes making things clear to computers indirectly makes them more opaque to people—as when prices are not marked on electronically scanned merchandise. The customer who remembers a lower posted price may then have to stroll with the cashier across aisle after aisle to the shelf in question. For years, postmarks have revealed only A.M. or P.M., and now they may

say something like "Northern New Jersey" rather than an actual post office. Unliked their mechanical or even electric ancestors, electronic alarm clocks generally don't display the actual time and the alarm setting simultaneously. Already consumers have been turning away from digital-only wristwatches to analogue displays and digital-analogue hybrids.

As more information is transferred to nonprint media, clarity becomes a major issue. "One of the biggest banes of my existence," said Tom Wolfe at the PBS symposium, ". . . is microfilm. . . . [T]he research that I now don't do because of the existence of microfilm is . . . maybe that's what holds me back. . . ." In fact the average public or university library microfilm user benefits from few of the impressive but expensive advances that corporate librarians and archivists have been using. An article from a back issue of a magazine that would take a few minutes to find in a bound volume now requires tedious threading and rewinding.

Even more advanced technology may not offer more clarity. The computerized directories of some large office buildings are actually more difficult to use than the conventional kind. A visitor must approach them and usually scroll through a few screens before finding the right name instead of simply spotting it on a listing on the wall. This feature may appeal to building managers intent on barring salespeople for rival developments, but it's hard to see how it benefits tenants or visitors.

If there is an information implosion, how serious is it? Many professional people are now much more concerned about their skills than about their all-around knowledge. Of the graduate students in leading economics programs surveyed a few years ago, 65 percent rated "being good at problem-solving" and 57 percent rated "excellence in mathematics" as "very important" in economics, while only 10 percent gave the same status to "having a broad knowledge of the economics literature" and 3 percent to

"having a thorough knowledge of the economy." (Fully 68 percent said the last was "unimportant.") As if to prove their point, the best-compensated employee at Salomon Brothers last year was a 31-year-old mathematician who earned a bonus of $23 million.

The real pitfall is not to overvalue or undervalue information, or the amount of information available, but to be mesmerized and anesthetized by it. George Orwell wrote in *The Road to Wigan Pier* (1937) of "the queer spectacle of modern electrical science showering miracles upon people with empty bellies. You may shiver all night for lack of bedclothes, but in the morning you can go to the public library and read the news that has been telegraphed for your benefit from San Francisco and Singapore. . . . What we have lost in food we have gained in electricity. Whole sections of the working class who have been plundered of all they really need are being compensated, in part, by cheap luxuries which mitigate the surface of life."

The good news is that the problems of information are transitional. The bad news is that the transition appears about to go on indefinitely.

The Rise of
the Plagiosphere

Technology Review, June 2005

The 1960s gave us, among other mind-altering ideas, a revolutionary new metaphor for our physical and chemical surroundings: the biosphere. But an even more momentous change is coming. Emerging technologies are causing a shift in our mental ecology, one that will turn our culture into the plagiosphere, a closing frontier of ideas.

The *Apollo* missions' photographs of Earth as a blue sphere helped win millions of people to the environmentalist view of the planet as a fragile and interdependent whole. The Russian geoscientist Vladimir Vernadsky had coined the word *biosphere* as early as 1926, and the Yale University biologist G. Evelyn Hutchinson had expanded on the theme of Earth as a system maintaining its own equilibrium. But as the German environmental scholar Wolfgang Sachs observed, our imaging systems also helped create a vision of the planet's surface as an object of rationalized control and management—a corporate and unromantic conclusion to humanity's voyages of discovery.

What NASA did to our conception of the planet, Web-based technologies are beginning to do to our understanding of our written thoughts. We look at our ideas with less wonder and with a greater sense that others have already noted what we're seeing for

the first time. The plagiosphere is arising from three movements: Web indexing, text matching, and paraphrase detection.

The first of these movements began with the invention of programs called Web crawlers, or spiders. Since the mid-1990s, they have been perusing the now billions of pages of Web content; indexing every significant word found; and making it possible for Web users to retrieve without charge and in fractions of seconds, pages with desired words and phrases.

The spiders' reach makes searching more efficient than most of technology's wildest prophets imagined, but it can yield unwanted knowledge. The clever phrase a writer coins usually turns out to have been used for years worldwide—used in good faith because until recently the only way to investigate priority was in a few books of quotations. And in our accelerated age, even true uniqueness has been limited to 15 minutes. Bons mots that once could have enjoyed a half-life of a season can decay overnight into clichés.

Still, the major search engines have their limits. Alone, they can check a phrase, perhaps a sentence, but not an extended document. And at least in their free versions, they generally do not produce results from proprietary databases like LexisNexis, Factiva, ProQuest, and other paid-subscription sites or from free databases that dynamically generate pages only when a user submits a query. They also don't include most documents circulating as electronic manuscripts with no permanent Web address.

Enter text-comparison software. A small handful of entrepreneurs have developed programs that search the open Web and proprietary databases, as well as e-books, for suspicious matches. One of the most popular of these is Turnitin; inspired by journalism scandals such as the *New York Times*'s Jayson Blair case, its creators offer a version aimed at newspaper editors. Teachers can submit student papers electronically for comparison with these

databases, including the retained texts of previously submitted papers. Those passages that bear resemblance to each other are noted with color highlighting in a double-pane view.

Two years ago I heard a speech by a New Jersey electronic librarian who had become an antiplagiarism specialist and consultant. He observed that comparison programs were so thorough that they often flagged chance similarities between student papers and other documents. Consider, then, that Turnitin's spiders are adding 40 million pages from the public Web, plus 40,000 student papers, each day. Meanwhile Google plans to scan millions of library books—including many still under copyright—for its Print database. The number of coincidental parallelisms between the various things that people write is bound to rise steadily.

A third technology will add yet more capacity to find similarities in writing. Artificial-intelligence researchers at MIT and other universities are developing techniques for identifying nonverbatim similarity between documents to make possible the detection of nonverbatim plagiarism. While the investigators may have in mind only cases of brazen paraphrase, a program of this kind can multiply the number of parallel passages severalfold.

Some universities are encouraging students to precheck their papers and drafts against the emerging plagiosphere. Perhaps publications will soon routinely screen submissions. The problem here is that while such rigorous and robust policing will no doubt reduce cheating, it may also give writers a sense of futility. The concept of the biosphere exposed our environmental fragility; the emergence of the plagiosphere perhaps represents our textual impasse. Copernicus may have deprived us of our centrality in the cosmos and Darwin of our uniqueness in the biosphere, but at least they left us the illusion of the originality of our words. Soon that, too, will be gone.

Writers, Technology, and the Future

Wilson Quarterly, Autumn 2012

These are hard times for those who live by the pen. But technology will not decide their fate. The future of writers—and the articles, novels, and nonfiction books they create—ultimately rests with those who read them.

Writing for a living is a unique profession. It's also a relatively young one, dating essentially from the 18th century; the literary historian Alvin Kernan has called Samuel Johnson's 1755 letter to Lord Chesterfield, in which Johnson proudly declared his independence of aristocratic patronage, "the Magna Carta of the modern author." There's a kaleidoscope of genres and a scale of incomes from effectively subminimum wages to seven figures. Most of all, writing is a profession that millions of people would like to join, at least part-time. To the alarm of critics such as the essayist Joseph Epstein, one survey revealed that more than 80 percent of Americans believe they have a book in them.

Today, many worry that technology, an ally of authorship since 19th-century innovations slashed the cost of printing, may no longer be so healthy for Samuel Johnson's ideal of writing supported by the purchases of a growing literate public. Fifty years ago, almost a generation before the introduction of personal computing, the prospects for authorship looked bright. *The New York Times* reported in 1966 that publishing executives were concerned

that their industry's profitability might make them the target of hostile corporate takeovers. The next year, CBS paid a premium price of $280 million in a friendly acquisition of the venerable imprint Holt, Rinehart, and Winston. IBM and RCA had already bought into the burgeoning publishing industry, believing that the growth of college enrollments promised an expansion of the book market.

The Great Society era seemed a bonanza for publishers and authors, the vanguard of the new "knowledge workers" celebrated by the popular management guru Peter Drucker. Trade book publishers saw revenues grow 10 to 12 percent annually in those golden years, including an 18-percent jump in 1966 alone. Textbook publishers did even better. Books of all kinds were in high demand.

Sadly, the idyll was short lived. In 1969, when President Richard Nixon called for a large increase in federal support for the arts and humanities, he noted that many cultural institutions found themselves in "acute financial crisis." By 1971, publishers were struggling with inflation and stagnant markets. Not only was the Great Society's plan for leveling upward in trouble; the New Frontier's notion of diffusing high culture downward to the masses was also losing ground. Campus protests and countercultural lifestyles had alienated many in the middle class from the universities and what they represented. It did not help that the style of youthful rebellion had changed, with early activists such as Mario Savio, leader of the mid-1960s Free Speech Movement at the University of California, Berkeley, and a serious graduate student who went on to a physics scholarship at Oxford University, giving way to the likes of the Yippie pranksters Abbie Hoffman (author of *Steal This Book*) and Jerry Rubin.

Today, publishing is the weakest link in the old media-entertainment-education nexus. Rupert Murdoch's giant News Corpo-

ration is spinning off its lagging newspaper and book publishing operations from its Fox entertainment business. Houghton Mifflin Harcourt, a venerable book publisher, filed for Chapter 11 bankruptcy earlier this year, laden with $3 billion in debts.

There are many other gloomy signs for the future of reading and writing. The plight of newspapers is well known, summed up in the Pew Research Center's report *State of the News Media 2012*: The papers' print advertising revenues dropped by $2.1 billion in 2011, while online revenues increased by only $207 million—a 10:1 differential, even larger than in the previous year. Magazines have also been losing circulation and advertising, reaching what *New York Times* media correspondent David Carr has called, with some exaggeration, "the edge of the cliff."

Most authors consider retail bookstores a cornerstone of their effort to build an audience for their books—places where the personal recommendations of staff members and readers' accidental discoveries can work wonders. (John Kennedy Jr., who once startled me with a telephone call inviting me to write for his magazine *George,* explained that he had come across my book while looking for another in a store.) But bricks-and-mortar booksellers are reeling. The bankruptcy of the Borders chain last year shuttered almost 400 stores. The other major chain, Barnes & Noble, is struggling. The news is worse among independently owned bookstores. Their leading trade group lost more than half its membership between 1993 and 2008.

No wonder even some of the most commercially successful authors see the heavens darkening. In February, the popular novelist Jodi Picoult (50 million copies in print) told a reporter from *The Times* of London that the trend toward electronic publishing, with its lower royalties, has been reducing her income. "If you sell the same number of books now as you did a year ago you will

make a third less money," she said. "In America my sales are now just shy of 50-50 print to e-books this year."

Some detractors of the publishing industry, such as the author and marketing specialist Seth Godin, foresee a totally new world: "Who said you have a right to cash money from writing? . . . The future is going to be filled with amateurs, and the truly talented and persistent will make a great living. But the days of journeyman writers who make a good living by the word [is] over."

Such dire predictions are hypnotic. Cultural pessimism was a growth industry even in what we think of as print's golden age a century and more ago, when a burgeoning literate public was not distracted by radio or Hollywood, let alone television. The taste for gloom is so strong that it even brings old books back to life. The philosopher Allan Bloom's *Closing of the American Mind* (1987) became a surprise million-copy popular hit and was recently reissued in a 25th-anniversary edition. The critic Sven Birkerts's *Gutenberg Elegies* (1995) has likewise been reissued. These and other gloomy tomes have recently been one-upped (one-downed?) in curmudgeonly provocation by the science writer and cultural critic Nicholas Carr's *The Shallows* and the English professor Mark Bauerlein's *Dumbest Generation*. No wonder some psychological researchers believe that negativity bias is an innate feature of the human mind.

Yet despair is not universal. When I spoke with him by telephone, David Fenza, executive director of the Association of Writers and Writing Programs, the largest academic organization in creative writing, argued that publishing is more vigorous, and more open to a diversity of voices, than ever. He rejected the idea that it's harder for writers to succeed, observing that greater numbers of prose writers than ever before are able to sell 100,000 copies of a book, and greater numbers of poets to sell 10,000 copies. In many universities, the creative writing major has become an

alternative to pursuit of the conventional English degree, attracting many students who love reading but not necessarily the latest hyper-specialized scholarly trends in the humanities.

That is only one reason to hope that a more vigorous and participatory culture is arising among at least some young people. The short story, which once flourished in popular magazines, has found a modest revival in *One Story,* a nonprofit print magazine that now has 15,000 subscribers and will soon be complemented by a new publication for teenagers. Book industry statistics also argue against cultural despair. American book publishers reported small but notable gains in the number of books sold (print and digital) and in net revenue during the difficult years from 2008 and 2010, according to *The New York Times.* (The numbers have since remained essentially flat.) Children's books have been a particular bright spot, thanks partly to continuing enthusiasm for the Harry Potter stories. Of course, pinched revenues are disappointing, and newspaper and magazine closings hurt writers and readers. But is today's hyperangst justified, especially at a time when many industries would be happy to be in steady state? After all, as the *Atlantic* blogger Derek Thompson points out, the revolution in digital music slashed recording industry revenues by 57 percent in just a 10-year stretch after 1999.

However, there are two sets of pressures that rightly concern authors: the squeeze and the crush. The squeeze is the result of technology's dilution of attention time and spending power; the crush is the product of overreach by oligarchic intermediaries and insurgent information consumers.

The squeeze, a growing supply of words competing for limited amounts of reader time, is partly a reflection of the popularity of writing as a career. Technological change has lowered what economists call the "barriers to entry" in writing. This phenomenon helped push the number of books published in the United States

from 240,000 in 2003 to more than 347,000 in 2011. Technology has also allowed the already prolific to become more so. The invention of the typewriter in the 1860s made editors' lives easier, but hardly changed the pace of writing itself. (Think of the literary output of Dickens and Thackeray, or the nearly 20,000 letters Thomas Jefferson is known to have written.) Computers have been a different story, as the experience of the masterly British historian Roy Porter shows. "The steady stream of books," the *Guardian* said in Porter's 2002 obituary, "became an avalanche once he had mastered the computer."

There is also more pressure on established writers and editors to generate content. Newspaper staff must now blog, tweet, and write Facebook posts in addition to doing their primary jobs, an existence Dean Starkman of *The Columbia Journalism Review* characterizes as a kind of journalistic hamster wheel. The quest for Web traffic, he argues, has been diverting precious resources from the core mission of journalism. In 2010, Demand Media, operating sites such as eHow.com and employing thousands of minimally paid freelancers, published 4,500 articles per day, mainly on practical topics from health and careers to home repair, and drew more Web traffic than *The New York Times*. The early assumption that high-quality professional writing would prevail on the Web has proved too optimistic.

If the squeeze is putting pressure on writers' income, the crush is threatening it more radically. The crush is not the direct result of electronic publishing, which is not inherently good or bad for writing as a business. Indirectly, though, the electronic book brings with it two opposing but equally disturbing trends, monopoly and piracy.

Today, the challenge to writers is not so much oligopoly as the prospect of hegemony by a single company, Amazon. Until recently, authors could regard it as one of their best friends. It

has let large and small publishers alike find readers, especially for backlist titles and other slow-selling books few retailers would stock. It has encouraged discussion of books among its customers, let authors set up personal pages on its site, and made it easier for customers to discover other books by favorite authors.

With the advent of Amazon's aggressively promoted Kindle readers, the picture has darkened. The long-tailed, friendly underdog has been turning alpha Rottweiler. Unlike vendors of competing readers and tablets, including Apple and Barnes & Noble, Amazon wants to do more than sell platforms for reading the electronic content it sells. It appears to be promoting self-publication through its site as an alternative to—indeed, a replacement for—conventional publishing. (Seth Godin briefly worked with Amazon in one such effort to supplant traditional publishers.) In his annual letter to shareholders this year, Amazon CEO and founder Jeff Bezos argued that "even well-meaning gatekeepers slow innovation," a jab at publishers. He was surely cheered when the U.S. Department of Justice filed an antitrust suit charging Apple and five major publishers with colluding to keep the prices of e-books high and prevent price-cutting competition between Amazon and its rivals. (Three of the publishers recently settled the claim.) Critics of Amazon argue that its ability to market bestsellers at a loss threatens publishers' ability to promote new authors. They fear that the company will make nightmares of downward-spiraling compensation come true. Senator Charles Schumer (D-NY) has criticized the Justice Department, arguing that "the suit could wipe out the publishing industry as we know it."

The novelist Scott Turow, president of the Authors Guild, acknowledging that Amazon has been good for him personally and calling the Kindle "a great innovation," has nonetheless warned, "It's only rational to fear what they're going to do with this accumulation of power." Steve Wasserman, writing in *The Nation*,

cites what Amazon has already done: When the 500-member Independent Publishers Group refused to accept its demand for deeper discounts on IPG members' products, it deleted almost 5,000 of the publishers' digital titles from its site. One independent publisher in Texas declared what many publishers and writers have come to believe: "Amazon seemingly wants to kill off the distributors, then kill off the independent publishers and bookstores, and become the only link between the reader and the author." At that point, writers could be almost completely at its mercy.

Piracy is the inverse of monopoly. Though there is disagreement about its extent, illegal e-book sharing hasn't reached the levels of theft that plague film studios and music labels. For some writers, the real threat is not piracy itself but pressure to reduce prices to discourage illegal copying. As the novelist Ewan Morrison has suggested, "In every digital industry the attempt to combat piracy has led to a massive reduction in cover price: the slippery slope towards free digital content."

Frightening as they are, the squeeze and the crush do not portend an unavoidably dark future. Previous economic and technological crises have been crucibles of innovation, spurring the emergence of new genres and drawing in new writers. Edgar Allan Poe's puzzle-based mystery stories such as "The Murders in the Rue Morgue" and "The Gold-Bug" were a commercially minded response to the Panic of 1837, as the Poe scholar Terence Whalen has argued, that introduced the scientific detective to literature. The Panic of 1893 hurt traditional subscription-based magazines but gave rise to a new breed of inexpensive, mass-circulation counterparts that placed heavier reliance on advertisers for revenues. Some of the greatest writing successes of the 1930s were businessmen who had been bloodied by the Crash of 1929: Yip Harburg, who wrote the lyrics of "Brother, Can You Spare a Dime?" and the songs in *The Wizard of Oz,* and Benjamin Graham, who dis-

tilled the hard financial lessons he had learned in *Security Analysis,* now considered a canonical work on "value" investing.

It's no less true for being a cliché that problems are opportunities. The travails of newspapers are due in part to the public's impatience with chronic formulaic similarity. As the historian and director of the Harvard University Library, Robert Darnton, a onetime police reporter, observed in a classic 1975 ethnographic study of journalists' tribal ways, "Nothing could be less competitive than a group of reporters on the same story." Technology has exposed mercilessly what critics and insiders have long acknowledged.

The structural problems of journalism leave room for innovation, as they did more than a century ago, when the 38-year-old Chattanooga newspaper publishing prodigy Adolph S. Ochs, nearly bankrupt after the Panic of 1893, somehow found backers for a takeover of the struggling *New York Times,* turning it into the first elite newspaper priced for the masses. Are there new Ochses in our midst? The greatest disciple of Benjamin Graham, Warren Buffett, has been acquiring newspapers even as Rupert Murdoch has been spinning them off.

Like newspapers, the print encyclopedia business had a chronic problem, in its case the impossibility of keeping many entries up to date. Yet the nemesis of commercial encyclopedias, Wikipedia, has its own structural limitations. Open editing may correct errors and pile up references and images, but it's not suited to creating the kind of intellectual synthesis that the classic 11th edition of the *Encyclopedia Britannica* achieved more than a century ago. Could a 21st-century counterpart of that landmark work be the future of the encyclopedia?

What of the average writer? Nobody ever aspired to be an average writer. Apart from technical and contract writing, the profession has always been what economists call a tournament,

a competitive environment with only a few big winners, whose successes motivate the rest. It's very possible that the solid middle of the profession will erode further, and a few favored authors will pull farther ahead. The median may decline, but the glittering prizes will remain.

The future depends more on writers themselves than on technology. If they accept the proletarianization thesis, it will become a self-fulfilling prophecy. If they can show how copyright and good compensation are in the long-term interest of the reading public, if they can mobilize readers to help defeat would-be monopolists of various kinds, if they can use social media to enhance relations with readers, there will still be many disappointed writers, but there will also be new kinds of opportunity. Optimism may fail; pessimism can't succeed. As the sociologist Erving Goffman, whose first book, *The Presentation of Self in Everyday Life* (1959), has sold 500,000 copies, put it when his Marxist colleague Alvin Gouldner complained of being treated like a commodity by the publisher they shared: There's nothing wrong with being treated like a commodity as long as you're an expensive commodity.

Journalism in the Age of Page Views

A REVIEW OF

All the News That's Fit to Click:
How Metrics Are Transforming the Work of Journalists
by Caitlin Petre

Milken Institute Review, August 16, 2022

Caitlin Petre, a teacher of media studies at Rutgers, has delved into the impact of a technological revolution on the working conditions of journalists at the (pre-bankruptcy) *Gawker* and *The New York Times,* along with the operation of one of the leading services for measuring reader engagement, called Chartbeat.

Chartbeat may be unfamiliar. Subscribers can discover how many people are reading their publications online, along with their geographic locations, their external source of referral if any, how long they spent reading each story, how frequently they visit, how active they are as readers of an article (as measured by an interaction every five seconds or so)—and as they used to say, much, much more. Indeed, as the pun in the service's name implies, it is like one of those hospital bedside monitoring devices in an era

when clicks (and corresponding advertising and subscription revenue) assay the health of a publication.

The significance of data supplied by Chartbeat and its major competitor, Google Analytics, is, Petre notes, ambiguous—unlike old-style metrics like miles driven or sales booked. Is it better to have the largest number of page views per staff member, for example, thereby creating an incentive to publish as many pieces or as possible? Or is it more important to publish fewer pieces receiving more careful reader attention and more circulation on social media? Should management share statistics freely with each journalist, or should they be kept relative confidential?

From the reporter's point of view, metrics can be a threat to professional identity. Recall the sort of work analysis developed by the industrial efficiency engineer Frederick Winslow Taylor in the early 20th century. Before enthusiasm cooled, "Taylorism" swept not only U.S. industry, but even Soviet plants emulating American mass production. In both cases, managers worked out a single "best way" and indoctrinated often-unhappy workers to follow it.

In studying journalists and other educated professionals, there is no simple script for writing a story like Taylor's famous study of optimizing manual coal-handling with special shovels and ergonomically optimal motions. (Or satirizing it, as in Charlie Chaplin's *Modern Times*). It is up to journalists to adapt their writing strategies to build audience engagement and advertising revenue. Twenty-first[-]century managers thus seem to get best results when they present dashboards like Chartbeat as challenges to journalists' ingenuity and creativity that offer the great advantage of offering virtually instant digital feedback.

This is part of the trend called "gamification," like promoting the users of the Google-owned, socially driven Waze navigation app from "baby" to "royalty" in return for mileage clocked and

(unpaid) editorial work offering traffic alerts. Reflecting good game design, Chartbeat accentuates good news and presents data in a way that respects journalists' professional identities. Petre notes that, to many journalists, an icon of a broken odometer—an off-the-chart needle—validates their professional judgement by dramatizing, even "reenchanting" what they have been intuitively doing right.

One of Petre's most interesting observations is that in this new, digitally monitored game of journalism, writers and editors share ideas about the boundary between "clean" and "dirty" pursuit of page views. Despite the freewheeling style of *Gawker*'s founder Nick Denton, its staff members had only scorn for other sites' tactics like counting every slide on a slideshow as a separate visit. *New York Times* editors were, of course, equally scornful.

Another insight concerned the *Times* itself. As a reader of both the HTML and print versions of the Grey Lady, I have detected a double personality—and Petre's research confirms this. *Gawker* editors shared detailed statistics collection with the publication's individual writers—presumably to discover whether their page views justified their salaries, to put it crudely. *Times* editors, for their part, practice (in Petre's words) "information containment," revealing metrics to reporters only when it suits a managerial objective like increasing morale. This is symptomatic, Petre believes, of the hierarchical culture of the *Times* and of the superior status it continues to attach to its print edition despite management's belief in a digital future. In any case, the author has observed that metrics were used mainly to confirm editors' existing judgements.

Petre thus finds more to admire in the freewheeling *Gawker* that she studied than in the *Times,* where information asymmetry between masthead editors and the rank-and-file impeded the latter's ability to assert collective power. She points out that the American Newspaper Publishers Association supports the classifi-

cation of journalists as professionals, while their major union, the Newspaper Guild, prefers the status of workers. She is cautiously hopeful that greater access to data may help equalize power in the newsroom.

Because Petre's field work began in the dark ages of 2013, she brings the industry up to date in her concluding chapter—notably on the forced sale of *Gawker Media* in 2016 after a $140 million judgment against it in favor of former wrestler Hulk Hogan (Terry Bollea) after a lawsuit secretly financed by Facebook co-founder Peter Thiel. That very event, which came as a surprise to most First Amendment experts who had followed the trial, raises a question outside the scope of Petre's book. Was not that blow to freedom of the press the consequence of pursuing metrics and the revenue that they brought?

Metrics—whether dashboards or statistics of likes and retweets—have entered the lifeblood of journalism as people are energized by antipathy. Petre's concern is the professional ethos of journalists dealing with management, but they have other bosses: sometimes their newsroom peers, and sometimes their culturally or politically passionate readers.

During the trial, Hogan/Bollea's lawyers cited an internal staff memo of *Gawker* founder Nick Denton boasting of the 8 million page views of the tape of Bollea in bed with his best friend's wife — over twice the site's previous record — leading to a rare 20[-]percent bonus for *Gawker* staffers. Testimony also revealed that *Gawker* had used viral marketing to accelerate sharing of the video.

Defenders of management by metrics might object that *Gawker* was an extreme case, not only because of Denton's devil-may-care style but also because this verdict was unusual in that it was bankrolled by a billionaire with apparently unlimited commitment to take the case through appeals.

Yet even *The New York Times* nearly became the victim of the (more decorous) pursuit of engagement. In June 2017, the editorial page editor of the *Times,* James Bennet, was putting the finishing touches on an editorial about the shooting of Republican congressman Steve Scalise at a Congressional baseball game. It seemed an excellent opportunity to show how Republicans, too, were exposed to gun violence.

Determined to complete editing in time for the next day's print edition, Bennet changed the unsigned editorial's language to suggest that the former vice-presidential candidate Sarah Palin had inspired the mass shooting in Arizona in which Rep. Gaby Giffords was wounded.

Bennet's revised text stated incorrectly that Palin's advertisements had drawn targets over pictures of opposing candidates, while the targets were actually superimposed on congressional district maps rather than photos of individuals. The digital form of the article was corrected almost immediately. But Sarah Palin (represented by some of Hulk Hogan's lawyers) nonetheless sued both the *Times,* and Bennet, who took full responsibility in his testimony. The jury agreed that the error had been negligent rather than malicious, the standard in libel cases involving public figures.

Bennet had been hired back from *The Atlantic* partly because of his revival of that venerable magazine as a digital powerhouse. (For a few years I was one of the magazine's bloggers and, briefly, a columnist.) *The Washington Post* reported that on his return Bennet had "a mandate to shake up the staid opinions section—to 'move faster,' one performance review urged, and 'make changes that are more disruptive.'"

His employers should have been more careful what they wished for. Ironically, an editorial sensibly calling for dialing down extreme language (Scalise had been shot by a fanatical anti-Republican) seemed to be amplifying polarization.

In 2020, Bennet's further pursuit of traffic-building controversy led him to publish an opinion piece by Tom Cotton, the Republican Senator from Arkansas, calling for military suppression of the violent urban disorders that had followed the death of George Floyd. The *Times*'s Op-Ed pieces often don't reflect the views of the editors. But following complaints from *Times*'[s] staff members, an official *Times* editorial note regretted publishing the piece. Bennet resigned shortly thereafter.

The Hulk Hogan, Sarah Palin, and Tom Cotton cases illustrate the pitfalls of the new information ecology. Metrics—whether dashboards or statistics of likes and retweets—have entered the lifeblood of journalism as people are energized by antipathy. Petre's concern is the professional ethos of journalists dealing with management, but they have other bosses: sometimes their newsroom peers, and sometimes their culturally or politically passionate readers.

According to a recent Pew Research Center survey, two-thirds of journalists say social media has had a negative impact on American journalism, and over a quarter say a very negative impact. The paradox is that the more the impact on the public is measured by services like Chartbeat, the more trust in journalism has declined—from over 50 percent in the 1990s to little more than a third now, according to Gallup. In our new Inflammation Age, enragement is engagement.

Where does journalism go after Sara [sic] Palin and Peter Thiel are done with it? How long will the gamification of news endure? Caitlin Petre does not address these questions, but her field work and analysis are a fine jumping-off point.

Edward Tenner: Philosopher of Everyday Things

PRINT Magazine, January–February 2004

INTERVIEW WITH STEVEN HELLER

Edward Tenner has drawn a singular path in academia that traces the practical and symbolic impact of design and technology on our lives, from revolutionary inventions to everyday objects. He received his PhD in European history from the University of Chicago, was a book editor at Princeton University Press for 16 years, has held visiting appointments at the Institute for Advanced Study in New Jersey and in Princeton University's Geosciences and English departments. He is currently a visiting scholar in the University of Pennsylvania's History and Sociology of Science department and senior research associate at the National Museum of American History's Lemelson Center in Washington, D.C. Tenner's 1996 book, *Why Things Bite Back: Technology and the Revenge of Unintended Consequences,* discusses how many great innovations, such as chairs, eyeglasses, helmets, and keyboards, have somehow altered our evolutionary course and, despite laudable intentions, have both helped and hurt us. Reclining chairs, for example, were originally promoted for their health benefits, but encouraged a sedentary lifestyle and obesity. In his latest book, *Our Own Devices: The Past and Future of Body Technology,* Tenner explores how human ingenuity often surprises—for good and ill—inventors and designers, as in

the transformation of the common box cutter from a simple tool into a weapon. In this interview, Tenner discusses the role of the designer, the contribution of the user, and the importance of ingenuity, style, and pragmatic foresight in creating the things we just can't live without.

HELLER: In the introduction to *Our Own Devices,* you write that a heckler at one of your lectures asked you to cite the most important of the world's countless inventions. I'll make my question a little easier: What is the most important advancement of the 20th century, and why has its design made such an impact on culture and society?

TENNER: I'd nominate the joystick, the work of the now-obscure French aviator Robert Esnault-Pelterie, who incidentally also popularized the idea and word "astronautics" and developed ideas key to spaceflight. The joystick was the first new controller in hundreds of years. It recognized the new degrees of freedom inherent in aviation, but it has also proved immensely adaptable in everything from microscopy to video gaming. Even some experimental cars now are managed with joysticks rather than nautically derived steering wheels.

HELLER: What do you consider the most significant graphic design of the past century?

TENNER: For lasting and positive influence, I doubt anything beats the London Transport's ensemble of structures, signs, posters, publications, and maps—largely the work of Frank Pick, Edward Johnston, and architect Charles Holden. It reflected an ideal of ultrarational, benignly hegemonic public authority, rather like the BBC's Broadcasting House of the time. [Architecture writer] Nikolaus Pevsner later called the Underground "England's greatest visual education center." The basics of the design have

remained, but the system has not kept up, even if its great heritage has been largely preserved.

HELLER: Our Own Devices explores both inventive genius and "user ingenuity." How does the latter ultimately impact the design of things?

TENNER: I mention that after World War I, well before mine-owners required safety helmets, demobilized U.S. soldiers had brought their military models to the coal fields. There's also a great tradition of user-tinkering in sports: Children first started putting skateboards together in the 1950s. Today, BMW sells a board for $500. In California, another generation of kids began to modify their bikes to race on motocross tracks in the 1970s, eventually calling them "BMX." This type of bike came to dominate the industry, and one reason for Schwinn's financial troubles was its early dismissal of the movement.

HELLER: Are these ingenious users also inventors? Or are they adapters?

TENNER: Users are co-inventors. Sometimes they're anonymous innovators, and industrial designers refine those innovators' experiments and make them economical to produce in quantity. More commonly, it is the advanced customer who pushes designs to the limit and suggests improvements. The M.I.T. economist Eric von Hippel has found that in some industries, user requests account for over 70 percent of innovations.

HELLER: You wrote a fascinating essay on "deviant ingenuity," or how criminals have transformed innocently designed tools into efficient weapons or other threatening things. Should designers worry about an item's ancillary uses? Is there a way to prevent designs from being perverted?

TENNER: Abuse is hard to predict. Most of it probably begins not with systematic study but with a chance observation that spreads on the street—for example, ceramic fragments from spark plugs, or "ninja rocks," can be used to break automotive safety glass silently. And some safety modifications have adverse consequences, too. Think of the "child-proof" medicine containers that many older people find adult-proof. I think designers would be better off focusing on user safety and environmental consequences than trying to second-guess the criminal mind.

HELLER: In *Our Own Devices*, you describe how technology influences fashion, which influences politics, which influences the commonplace, which has symbolic as well as real impact on us all. You cite a particularly interesting example in shoelaces. Pragmatically and symbolically speaking, how has the design of shoelaces made a difference in our lives?

TENNER: Shoelaces initially had an ideological side: Thomas Jefferson consciously adopted them as democratic alternatives to the buckles worn by most 18th-century gentlemen. Probably, they have lasted as long as they have, not only because automated machinery was developed early in the 20th century to make excellent ones, but because the idea allows such variation in the geometry of the lace and the styles of lacing; experienced hikers tighten and loosen laces according to terrain. And in some places, even the colors of laces reflect identity. Here is the kind of ethical question you mentioned. Should a shoe-supply maker or vendor discontinue styles and colors if they become gang favorites? Or will the gangs just find some other form of identity?

HELLER: In addition to functionality, style hooks the consumer. Target stores, for example, sell generally what other mall emporia sell, only more attractively packaged. Does style have cultural value other than as a commercial hook?

TENNER: Absolutely. Works transcend the self-seeking motives of their patrons all the time. After all, countless Renaissance and early modern paintings and sculptures in today's museums were expressly conceived as image-building for royalty, peers, and prelates. So why deny illustrators and vehicle designers their due just because they're making money for their bourgeois employers and clients?

HELLER: In one of your essays, you show special interest in the breeding of "national" dogs—animals that symbolize a culture, a people, an ideology. You talk about a particular breed's functionality, but also its symbolic importance. In that vein, can design itself be seen as a function of nationalistic impulses?

TENNER: Designs may appear to begin in chauvinism, but they seem either to go international or to perish. The German shepherd dog was supposed to embody all the national virtues, but the German army preferred Airedale terriers until the First World War. Then, despite all the anti-German propaganda of the maelstrom, Rin Tin Tin became a global superstar, and English people and Americans wanted shepherds, even if they renamed them "Alsatians" and "police dogs." Significantly, the Nazis abandoned their signature Fraktur [typeface] during the Second World War to govern their European conquests more efficiently. The Matryoshka nesting dolls—supposedly tokens of old Muscovy—were invented by a Russian nationalist in the late 19th century, taken from a Japanese set of hollow Buddhas. In turn, they have been reinterpreted in cultures around the world.

The real danger probably lies, not in nationalism as such, but in the excesses of design utopianism. The Russian-born critic Boris Groys wrote a wonderful book translated as *The Total Art of Stalinism,* arguing that esthetic dictatorship was what the Russian avant-garde had in mind all along, and that Stalin twisted their aspirations against them.

HELLER: Are you saying that design is often a political instrument?

TENNER: Yes, even though neither major U.S. party—nor the Green nor Right-to-Life—has a strong design identity. I'm not sure British politics did either, at least since the Wars of the Roses, although British uniforms from the Beefeaters to the Grenadier Guards continue to make powerful national statements, and London is the last holdout of the national procession. (Even Hitler wore a British military mustache—not the German handlebar style—and a Sam Browne belt.) In the U.S. now, even political cartoonists have lost interest in donkeys and elephants. The most powerful quasipolitical symbol of the moment, especially among youth, may be the Linux penguin.

HELLER: What is the role of "art" in a technological world? Can the expressionist influence the pragmatist in some way?

TENNER: When it comes to objects themselves, I confess to liking designs so usable that people forget all the hours that went into them. I wrote a piece for *The New York Times* Op-Ed page on the design philosophy of the original Dreyfuss Associates Bell System handset, observing how "liberated," post-breakup consumers went out and bought more expressive but less functional and durable equipment. Now they may be treating fonts similarly.

Expressionism in technology may be at its most powerful in the design of video games, and game enthusiasts have found ways to add automotive-style excitement to their CPUs with biomorphic shapes, transparent panels, and lighting effects. But there's also a temptation to sell a technically mediocre product with excellent expressionist design. Or a worse product.

I remember seeing Oskar Fischinger's brilliant film *Muratti Greift Ein* at the Museum of Modern Art a few years ago, with its flawlessly choreographed cigarette maneuvers. Here was a genius of media technology, someone whose influence persists to this

day, helping to peddle carcinogens, even if some defenders call the work a veiled send-up of Nazi regimentation—whatever his political intentions, it was stunning. In fact, the cigarette, once the very soul of 20th-century modernity in the automated machinery that produced it and its short-term enhancement of mental performance, was also a triumph of packaging, magazine advertising, and posters. We have only started to explore the ethical side of technology and design.

HELLER: I've often wondered whether ethics inhibit design. Shouldn't freedom reign?

TENNER: Ethical goals have sometimes stimulated design. The philosopher Otto Neurath developed his Isotype system for presenting vital data in pictographs to enlighten the Viennese proletariat. But socially conscious design can also have unintended consequences. I've seen examples of the style adopted by the Nazis. [Design] went through a transitional stage in the 1950s and 1960s, when prominent idealists hoped that symbols could promote cooperation across cultures. Now it is merely the shorthand of global capitalism in airports and train stations and on packaging. More seriously, I'll bet many 20th-century graphic artists sincerely believed that supporting their dictatorial regimes was the highest ethical commandment.

I agree that designers and other creative people can never do their best work or help society in the shadow of a cloud of moral self-doubt or exaggerated political correctness. The results of utopianism have been so dismal that "do as thou wilt" may indeed be the better part of the law. But there are also cautionary tales like that of the Soviet graphic pioneers who were killed in the purges of the 1930s. Patronage helped close their eyes to what was happening around them. Esthetization can be a form of anesthetization.

6.
Artificial Intelligence

Rook Dreams:
New Chess Software Makes it Easier for Younger Players to Reach the Top of the Game—and Harder to Stay There

The Atlantic, December 2008

This past fall, the world championship match in Bonn, Germany, wasn't the only thing stirring up chess enthusiasts. ChessBase 10, a beefier new version of the massive database program that is the tournament player's gold standard, had arrived.

In 1997, when IBM's Deep Blue multiprocessor computer defeated the world champion, Garry Kasparov, rapid gains in electronic chess seemed likely to diminish the game's challenge and glamour. Instead, the Web has built participation at the base and refined concepts at the summit. A new cohort of competitors is playing stronger chess than ever—but its emergence is changing the game in unexpected ways.

ChessBase, introduced for Atari in 1987, is now a compendium of 3.75 million games reaching back more than five centuries. Compiling statistics, including the results from games just downloaded from the Web, it also shows percentages of games won after various alternative moves. The heritage of chess thus becomes a vast, branching cave to be explored game by game.

Jon Edwards, a chess teacher and the 1997 U.S. correspondence champion, says that players still grow through hours of replaying great games; ChessBase just makes that process more efficient. Young Bobby Fischer huddled in the New York Public Library stacks with Russian magazines, constantly resetting pieces. Today's contenders can play through new games online and onscreen, adding their own games to the ChessBase record and learning more rapidly from their mistakes.

Knowing thine adversary has never been easier. Even the victorious defending champion Viswanathan Anand has said he can't afford to have a favorite opening. Under pressure because of efficient scrutiny through databases and analysis engines like Fritz (another popular high-level software program that works out new moves), top players must prepare more variations than ever.

Meanwhile, aspirants have overcome distance. Michael V. Cossette, a chemical-process engineer who became a state junior champion in high school, in 1973, recalls that the chess club nearest to his home was a full hour away. In 2008, free chess sites offer databases, online play, and tutorials worldwide.

Today's initiates constitute the latest of three great recruitment waves. The first, in the 1930s, was prompted by the Soviet drive for prestige through chess victories. The second was inspired by Bobby Fischer's televised defeat, in 1972, of the Russian superstar Boris Spassky. The third began in the early 1990s, with the rise of the Internet and the emergence of an underemployed intelligentsia in the former Soviet empire that found even modest tournament prizes in hard currency preferable to poverty.

This wave has generated more grand masters than ever, and they are getting stronger younger. Spassky had become one at a record 18, Fischer at 15; in 2002, the Ukrainian Sergei Karjakin was only 12. The Norwegian Magnus Carlsen, a grand master at 13, in 2004, is ranked fourth in the world.

The intelligence researchers William Dickens and James Flynn have suggested that when a generation of young people becomes serious about an activity—as black high-school students turned to basketball in the 1950s—a self-reinforcing "social multiplier" of institutions that recognize and develop talent emerges, raising performance. ChessBase and other analysis programs, and the virtual communities that have sprung up around them, have had a similar effect, according to Edwards and other masters.

But there is a catch. As computers have hooked more contenders and augmented their skills, preparation time has increased. There's never been much money in full-time chess playing, and now the commitment needed to keep up with the game makes it harder to moonlight in a different profession. One of Edwards's star students reluctantly gave up his promising pro career to attend law school. And some highly rated amateurs quit, too, as Cossette did in 2001. "It isn't a sport anymore," he observes. "It isn't a game. It's a research project." For him and many other professionals, it's too much like work.

Not all top recreational players agree. Many love computer-assisted analysis and exploration. As a teacher, Edwards believes youth chess is great preparation for college and life. But in chess as in life, technological edges can cut both ways.

Checkmate: Can Artificial Intelligence Win the Long Game?

Milken Institute Review, July 24, 2023

Are we at the dawn of a new age in which artificial intelligence will transform not only production, commerce, and communication but also domains of thought once considered limited to human geniuses? One case study offers some hints.

In the history of computing, perhaps the most widely tracked benchmark of excellence has been in an ancient game with an unrivaled searchable historic database of 9.2 million matches (and counting). It's a contest of pure skill with no element of chance, a game both of global understanding and of passionate nationalism. I'm talking about chess, of course.

Some Ancient History

Chess has been linked to computer science ever since the latter's birth as a discipline. Alan Turing, the mathematician whose PhD dissertation built the foundation of modern computer theory, prized the game as a test of the power of algorithms even before technology existed that could execute them. In 1951, he used a printout of his code to play a virtual computer against a human opponent. It took 30 minutes for each move and the algorithm lost—but Turing had proved that a program could play a game

to the end. (Decades later, world champion Garry Kasparov defeated the program in just 16 moves but called the program "an incredible achievement.") Within two decades, though, hardware was beginning to catch up with Turing's vision and that of later artificial intelligence pioneers.

Enter Gordon Moore, cofounder of Intel, who predicted in 1965 that the number of electronic switches (transistors) that could be packed onto a microprocessor would double every 24 months with commensurate improvement in execution speed. He created one of the most formidable and longest-running challenges in the history of technology. And while Moore was hardly the first tech entrepreneur to make bold predictions about the wonders awaiting us, his landmark paper was the first to foresee growth in exponential terms—and on a timetable previously unimagined.

Napoleon's armies, after all, had covered no more distance per day than Caesar's almost two millennia earlier. And in the modern era, the pace of rail and auto travel rapidly reached practical plateaus. Even jet airliners' speeds hit a wall within decades of the first flight, as the commercial failure of the supersonic Concorde in 2003 would demonstrate.

Intentionally or not, Moore's prediction became what has often been called, in the phrase of the sociologist Robert Merton, a self-fulfilling prophecy. It implied that there was a solution for every physical and chemical obstacle that skeptics raised about it over the years. As one barrier after another fell to the ingenuity of Intel and its rivals, it seemed reasonable to conclude that if you didn't see a way forward you weren't thinking hard enough. It's only fitting, then, that Intel became the first corporation to sponsor a world championship chess match, when Garry Kasparov and Nigel Short founded a short[-]lived Professional Chess Association as a rival to the traditional International Chess Federation in 1993.

Chess became even more important for the branding of Intel's iconic competitor. IBM proved a natural successor in chess sponsorship since it excelled at the design of single purpose hardware along with the software to animate it. IBM's program Deep Blue, running on a dedicated IBM-built supercomputer, made history when it defeated Kasparov in 1997. While the foray into chess was largely a public relations project, the mathematics of Moore's Law suggested that, before too long, Deep Blue's muscle would trickle down to PCs.

Every so often in the years since, there have been hints that the engineers were falling behind Moore's Law. Yet Moore's prediction survived its apparent obstacles. Indeed, an homage to the 75th anniversary of the transistor in *Science* magazine pointed to new ways forward in speeding computation that no longer depended on increasing the number of processors that could dance on the head of a silicon chip—for example, designing processors to work faster and offloading tasks to specialized companion chips like the graphics cards that have proved so useful in everything from video to cryptocurrency mining.

Game of Kings and Transatlantic Nerds

The 21st century has proved the point. More efficient code multiplies the impact of processor speed in enabling computer power, and chess once more has been a landmark test bed. The most important force in this movement emerged 6,000 miles from Silicon Valley in a British artificial intelligence startup called DeepMind. Its algorithm, unlike that of Alan Turing's original program and its successors, was modeled after human learning: the neural network.

DeepMind was still deep in red ink when Google (now Alphabet) acquired it in 2014. By 2020, it was turning a profit. Meanwhile it had created a sensation by mastering the game of Go.

In the 1980s, one of my advisors on acquisitions at Princeton University Press was the Nobel Laureate physicist Philip Anderson. A Go enthusiast, he believed correctly that the techniques making progress in chess would be ineffective in mastering Go, which Deep- Mind's website points out is 10^{10} (you got it: a googol) more complex. When Deep Blue defeated the world chess champion in 1997, the most powerful Go program was far from ready for prime time.

The secret sauce of AlphaGo, DeepMind's Go program, was its ability to learn by playing billions of games against itself to learn winning strategies. Under Alphabet auspices, the program rapidly achieved master level. By 2019, Lee Se-dol, the 18-time world Go champion from Korea, announced his retirement in the face of "an entity that cannot be defeated."

The conventional open-source program Stockfish was already beyond human grandmasters' skills when neural networks appeared on the chess scene. Magnus Carlsen, the current world chess champion, and Gary Kasparov, the former world champion, are two of the strongest players who have ever lived, with ratings of 2882 and 2851, respectively, on the ELO scale, which is based on results of tournaments. Stockfish surpassed them at ELO 3531, and it has plenty of company. There are now some 125 chess programs (aka "engines") that have higher ratings than the flesh-and-blood champs.

Thus the triumph of a spinoff of AlphaGo, AlphaZero, attracted more than a little attention by defeating Stockfish, the gold standard of chess play in December 2017. Garry Kasparov told the website Chess.com that Alpha Zero "approaches the 'Type B,' human-like approach to machine chess dreamt of by Claude Shannon and Alan Turing instead of brute force."

In the Machine Age

Where is chess now, 25 years since Big Blue's defeat of Kasparov and five years since AlphaZero's rout of Stockfish? For answers, I turned to a uniquely qualified expert: Jon Edwards, a former Princeton information technology administrator who has taught and coached 5,000 players and who in 2022 won the world championship of the International Correspondence Chess Federation, the first American in 40 years to hold the title.

Once dependent on postal services, correspondence chess came into its own with email and the web in the 1990s. It is a deliberative subculture within the game, without conventional time pressure but with an honor code of independent play that many felt had become impossible to enforce as chess engines fit for PCs and middle-class budgets gained prowess.

Before the turn of the millennium, the ICCF's rules were firm: Using electronic aids was cheating. But the dam broke. When Jon Edwards returned to tournament play after a five-year hiatus, he lost game after game to competitors who had adapted to the newly permitted digital tools before he decided to join the crowd.

Face-to-face contests at tournaments still bar the use of digital paraphernalia in real time—AlphaZero is not allowed on the premises. But now that engines and databases of games are so fully integrated into the chess ecology, over-the-board players can only remain at the top by using digital tools in their preparation. The leading pros' teams thus include technology experts as well as master sparring partners.

One consequence of the tsunami of computer resources available for over-the-board play, according to Edwards, is that far fewer standardized sequences of opening moves remain competitive. Of course, some openings were always considered stronger than others. But the best players were still able to win with weaker ones by using online databases to find promising follow-ups. Now

those opportunities are largely blocked, at least at the highest levels of play where human and machine work hand in hand.

Over-the-board players spend hours with chess engines before each tournament. They study likely opponents' games, looking for Achilles heels. Computerization lets both sides prepare much more systematically than they could before the turn of the millennium, so there are few surprises in the openings. Chess engines have also studied endgames exhaustively—I'll say more about that later—so the middle-game has become the most contested ground.

A brief digression: Do higher ELO scores imply that chess engines know the game of chess better than the human grandmasters they outrank? Edwards cites a key difference between human and machine. Each of the giants profiled by Kasparov in his five-volume analysis of chess greats had a clear set of strategic principles and an ideal position in mind. While chess engines could defeat them, the engines' intelligence is savant-like, lacking an understanding of how they achieve their victories.

There are implications here for the use of chatbots in education and business. It is now possible for chatbots like ChatGPT to generate impressive performances—especially if the inevitable blunders are edited out—without being able to explain the principles leading to successes. AI researchers have a name for this: the interpretability problem. Edwards and other top correspondence chess players do have this understanding. And while the machines make it easier to become a good player online, the same doesn't apply to great play.

Edwards says the latest chess engines "have basically created a very high barrier to entry." Only the most affluent (or dedicated) correspondence players can invest in the hardware and software that can sustain chess play at nosebleed levels. Pre-2000 correspondence chess was egalitarian. One of the greatest appeals of the game—no expensive equipment necessary—is thus in decline.

Chess on Steroids

As in other sports, elite chess players (whether correspondence or over-the-board) are a tiny minority of players. The positive side of chess computerization is that it has broadened interest in the game rather than narrowing it, as some had feared when computers first toppled the grandmasters.

For starters, the new environment has increased access to databases and instruction that accelerate the development of human skills. It has long been possible to gain experience online and to consult databases that evaluate options at every stage of the opening—in particular, how often a move has resulted in a win, a loss, or a draw. Moreover, while championship-grade chess computers may carry five- or six-figure price tags, the costs of digital assistance for all but elite tournament players are among the lowest of any sport.

Consider the fact that one popular website, ChessBase, offers access to the historical record of almost 10 million games—and for an annual fee of only $50. In December 2022, its competitor, Chess.com, claimed 100 million members worldwide.

Moreover, current and would-be grandmasters, both over-the-board and online, need not worry that Moore's Law and the stunning software that complements the advanced chips will come close to "solving" the game anytime soon. For while processor power continues to compound and database software becomes ever more efficient, the benchmarks for chess dominance become more challenging at an even faster exponential rate.

To see why, consider digital data resources for chess called tablebases. Imagine any six pieces placed on a chessboard in any legal configuration. There are a mind-boggling number of sequences of moves that could be taken to end the game. But there are USB drives capable of storing the computed outcomes of every

such position. So once a game is down to six occupied squares, it is in effect over as far as the computers are concerned.

Here's the rub. Edwards notes that it took from 1977 to 2005 to expand the tablebase exhaustively from five to six pieces. A seven[-]piece tablebase is available, but it is a workaround originally posted on the website of Moscow State University that builds on the six-piece model rather than being computed from scratch. Going from seven to eight pieces with new calculations, even given new processors created by the relentless march of Moore's Law, is likely to take two or three decades.

In other words, the hurdles are immensely high to get to the next benchmark in which computers can claim a brute-force hammerlock on a game that is accessible to mere mortals. And similar barriers affect fields of exploration far more important than chess. This has been most evident at two data-hungry corners of contemporary science: genomics and astrophysics.

While the cost of data storage has been steadily decreasing, the thousands of billions of bytes (terabytes) of data collected from DNA sequencing on the one hand and by instruments like the James Webb Space Telescope on the other have been overwhelming server storage. The ironic result: a surge in use of tape drives, not long ago disdained as relics of the 20th century because, while their storage potential is immense, access is much slower.

Technology and Chess of the Future

In coming decades, we will undoubtedly see programs that can explain their decisions. Edwards showed me an example of how ChessBase, which uses its own version of neural networks, can analyze a position in a way a flesh-and-blood grandmaster could—a still-rare example of machine intelligence that can articulate the reasons behind its decisions.

But neural networks will not be a perfect substitute for human teaching and coaching, which depend on understanding the psychology of individual players. Just as medical diagnostic software might be more accurate than physicians' unassisted judgment, an empathetic doctor may still have the edge in determining the treatment that best fits the personality as well as the pathologies of a particular patient.

By no coincidence, the human competitive chess scene has not collapsed. On the amateur side, technology is producing mixed results. Edwards points out that speed chess, augmented by computers, is booming online. But the outlook for correspondence chess is more problematic. Already 99 percent of correspondence games played under 21st-century rules end in draws as the computers virtually eliminate head-slapping errors—and, more subtly, induce stalemates as competitors iterate toward common strategies.

Edwards became a champion, he observes, because the last 40 games in the tournament he won ended in draws. Will aspiring Generation Z tournament players have the requisite patience?

The most serious long-term challenge to correspondence chess and to advanced analysis of chess may be the stagnation of discovery. Much of the history of the game has been marked by the detection of clever ideas called TNs—theoretical novelties. Edwards reports that grandmasters used to come upon a new TN roughly weekly. Today, even with teams of expert researchers in support, such insights appear far less often—and when they do, they are the product of neural net analysis.

Note, too, that the repertory of truly competitive openings has been reduced. Alpha Zero, Edwards recalls, found the French opening to be "suboptimal" in two hours—a discovery it had taken him 15 years to make on his own.

* * *

The most important lesson of computer chess may be the contrast between its uncanny consistency and the results of chatbots like the notorious ChatGPT. Modern chess engines are incapable of what appears often in generative software like ChatGPT: an eruption of nonsense amid otherwise impressive text.

To be safe, the chatbot user needs to know enough to verify the answer, just as an airline pilot must be able to operate controls when autopilot fails.

In this light, the fallibility of even the greatest human grandmasters is not a bug but a feature. Over-the-board chess is still a physical as well as a mental contest that can last five hours or longer. And chess engines allow spectators of televised matches to evaluate the giants' moves in real time. Much of chess may have been mapped, and the frontier may be closing—but the rodeos can be as thrilling as ever.

Finally, we may not have heard the last of human versus computer. People are beginning to train software to detect the flaws of seemingly unbeatable programs. Aided by automated analysis, an amateur was able to defeat one of the leading Go programs in 14 of 15 games in early 2023, playing without live electronic help. When the victor created distractions elsewhere on the board, the *Financial Times* reported, "the bot did not notice its vulnerability." The ultimate human skill may be our ability to use machines to fool machines.

7. Animals

What Wall Street Can Learn from the Dung Beetle

Animals also earn, spend, save, and invest—often more sensibly than we do.

Money, May 1985

Judging from their advertising, bankers, brokers, mutual fund managers, and insurance people are the nation's leading animal lovers. The bulls, bears, stags, rams, lions, TIGRs, CATS, workhorses, and cash cows they use in their campaigns could fill a small zoo or populate a farm. But while financial institutions tend to corral such creatures only as mascots, the relationship between animal behavior and economic ideas is not so frivolous.

Both students of animal behavior and those of economics are concerned with how limited resources are allocated. Animals may never exchange goods or services in the human sense, but like us they have to make a living. Once they have acquired food, they spend the energy it generates—getting more food, reproducing, and perhaps defending a territory. Sometimes they save resources for future consumption, and in a few cases they invest them. Economists and even ordinary citizens concerned with earning, spending, saving, and investing their resources have much to learn from simpler species.

Earning a living is the most pressing economic problem. Like many a successful businessperson, an animal is likely to be a specialist. As the Ohio State University ecologist Paul Colinvaux has pointed out, the animal world is not as ruthlessly competitive as it seems. Zebras, wildebeests, and Thomson's gazelles, for example, all graze the same African savannas, but each munches a different kind of vegetation. Warblers of related species look for caterpillars in different parts of the same trees.

Most animals have predators; and any search for food raises the possibility of becoming food. But they tend to be rational risk takers. John Staddon, who teaches psychology and zoology at Duke University, has found animals' strategies for dealing with risk to be akin to those of people in similar circumstances. Well-fed creatures, having a lot to lose, avoid risks. Animals closer to the margin of survival are far more likely to take chances. That's one reason bears approach human settlements during hard winters.

In spending their time and energy, animals also turn out to be, like people, price sensitive. Howard Rachlin, a psychologist at the State University of New York at Stony Brook, and his colleagues have taught laboratory rats to "buy" food by pressing levers on a machine that dispenses a variety of nutrients. But when one kind of food requires less frequent pressing than another, they switch to it readily—as people do when they substitute one detergent for a more expensive brand. Of course there's a difference between rats and people as consumers. Rats base their decisions only on price. They haven't yet learned brand loyalty.

Rather than look for a caterpillar here or there, some animals wait for a big score. The biologist E.O. Wilson of Harvard has called these animals the bonanza strategists. When they find a concentrated source of high-quality food, their job begins. Consider dung beetles, for example. With their formidable armor, they appear clumsy. But when they encounter a feast—their customary

food is what you might suppose—they prove admirably equipped to protect the booty for themselves and their young. The male of the species *Kheper platynotus* cuts spheres the size of tennis balls from elephant dung and may push them several meters to find just the right burial spot. People experience windfalls too—inheritances, lottery winnings, invention royalties. At these times, they'd do well to act as quickly and surely as the dung beetle to put the money where it can't be got at by those who specialize in taking advantage of individuals in such circumstances.

Other animals—apart from their accomplishments in foraging and defense—are admirable savers. These aren't always the largest and most intelligent beasts. To the contrary, brainy animals like chimpanzees and dolphins, who live in an environment where nutrients are abundant, generally don't have the need to put food away and are able to spend a lot of their time communicating with their neighbors. That's not unlike children who grew up in the prosperous 1950s and '60s and have had low savings rates ever since—but spend plenty of time on the phone. The best savers tend to be found among the social insects. Larger animals haven't developed the same complex, disciplined societies that let these insects hoard their energy reserves. When King Solomon advised sluggards to study ants, he had in mind not the ones that share our picnics in North America but the harvester ants of desert regions. Within their networks of tunnels, these ants excavate chambers for storing seeds. E.O. Wilson, visiting the traditional site of Solomon's throne on Jerusalem's Temple Mount, found that harvester ants were still there.

Unlike the harvester ant, the honeybee has used its energy-storing—that is, saving—ability to extend its range to areas with cold winters. Few human seasonal businesses are so successful in the yearround maintenance of a highly skilled work force. According to Thomas Seeley of Yale, honeybees are able to gather enough

nectar in the warm months to generate the energy necessary to burn a 40-watt light bulb throughout the winter. Yet, contrary to folklore, an individual honeybee worker is not terribly productive. It devotes only a third of its day to actual work, a reasonable but not extraordinary amount by human standards. As a business, though, a beehive yields an excellent return. In fact, a strong hive can satisfy all its own requirements with 200 kilograms of honey and create a surplus of 40 kilograms for the beekeeper, or a profit of 20%.

Like cash-rich companies vulnerable to a hostile takeover, animals that amass their resources create tempting targets for competitors, who must be chased away. Animals that diversify their hoard by spreading it out have to spend energy both in distributing it and in finding it again. Both approaches to saving have their champions. An impressive larder hoarder, as biologists call members of the first group, is the northern conifer squirrel, studied by Christopher Smith of Kansas State University. It cuts down thousands of cones from trees in a territory of up to three acres, harvesting them in the order of the energy value of their seeds and accumulating a hoard of up to 500 pounds. The squirrel then digs holes in moist ground, where it buries the cones. This keeps the cones closed and thus prevents mice from getting the seeds. Conifer squirrels also collect mushrooms, which they place on tree branches to dry before storage.

Other squirrels are wary of putting all their savings in one basket. The common backyard variety discovered the advantages of diversification long ago and added to them something of the secrecy of a Swiss bank account—a strategy called scatter hoarding. (In fact, one Swiss bank has used a squirrel in its advertising.) Lucia Jacobs, a Princeton University graduate student, has made the economic life of this unassuming animal the topic of her PhD dissertation. A job description for a scatter-hoarding squirrel

would call for the ability to hide 3,000 acorns over a wide territory during September and October. Then the creature should be able to recover a large percentage of them and reproduce and care for baby squirrels until April. According to Jacobs, squirrels can judge the value of food accurately. Like human portfolio strategists who weigh potential reward against risk, squirrels will travel greater distances to gather nuts if they think they'll find larger quantities when they arrive.

Hiding acorns is as much investment as it is insurance or savings. A squirrel with a small hoard may only survive, Jacobs points out, but one with a good reserve of acorns is far more likely to produce more squirrels. And reproductive success is every animal's investment goal.

In the interest of reproduction, animals conserve not only food but the energy in their environment. The Australian Mallee fowl is as suitable as any mammal to be an investment broker's logo. The roughly 30 eggs laid by the female every year are kept in a pit constructed of vegetable material and sand. For 10 to 11 months of the year, the adult male birds maneuver the fermenting vegetation and the soil cover to keep the temperature of the interior within a degree or two of 92°F, despite widely varying weather conditions outside. Even when the Australian ornithologist H.J. Frith applied artificial heat to a nest, the papa bird shifted soil with uncanny precision to stabilize the temperature.

It's not unusual to observe animals more concerned with reproduction than with getting a living or with storing reserves. That's because natural selection has made self-perpetuation the mark of animal success, not good eating or display. The prevailing notion of human success might be summed up by the bumper sticker that reads: HE WHO DIES WITH THE MOST TOYS WINS. But if animals wore bumper stickers, theirs would probably say: HE WHO DIES WITH THE MOST DESCENDANTS WINS.

Animals have two strategies for investing in their young. Biologists have invented various names for these behavior patterns, but one way to think of them is as two mutual funds: the mosquito portfolio and the elephant trust.

Mosquito portfolio animals are generally small, short-lived, widely dispersing, and simple. They thrive because they are consummate opportunists, always ready to reproduce in astonishing numbers and then to move on to new resources. Many fish and annoying insects follow this strategy. The mosquito portfolio invests in thousands or hundreds of thousands of extremely risky penny stocks. The managers pay little attention to them, knowing that, given their numbers, some will make it. You'll never see a frog parent help its young learn to hunt as, say, a bear parent will.

The elephant trust has a philosophy much like that of a bank trust department that concentrates its assets in a few well-known companies. Its management chooses only a handful of stocks but watches them intensely. It not only nourishes them at great cost but also helps them learn their environment well enough to be self-supporting. Elephant trust animals are large, intelligent, and long-lived. A nursing baby gorilla or a line of goslings following their mother show the elephant trust strategy at work.

Biologists have discovered that for the elephant trust, as on Wall Street, there is no such thing as a free lunch—or a free worm, beetle, or mouse. Feeding one baby means giving up (momentarily, at least) a chance to invest in others in the litter—just as buying one stock means forgoing another. And animals foraging for their young may be less able to avoid predators, thus jeopardizing their chances to produce more offspring later. Robert L. Trivers of the University of California at Santa Cruz has even called this phenomenon parental investment.

For both mosquito portfolio and elephant trust animals, there are certain investment strategies that increase the odds of success.

Take timing, for example. People want to buy into a growing company during a period of growth in the economy. Animals face a similar opportunity when their population is enlarging. As Henry Horn of Princeton has pointed out, those who can reproduce rapidly in the early stages of an expansion are getting a kind of compound interest. Their genes will be part of a larger share of a larger number of animals. Of course when enough animals or people are trying to get in on the ground floor, there is always the chance of a crash—and population crashes do occur in nature. With lemmings, for instance, a period of avid feeding and reproduction is often followed by starvation and death as the animals flee their crowded conditions. (Contrary to popular belief, lemmings do not commit suicide.)

There seems to be no area of human business activity that animals have not thought of first. Take advertising. Biologists suspect that the peacock's tail really does attract peahens—at a big energy cost to the male bird who must grow the feathers and lug them around. Animals are also capable of completing amazing construction projects. Beavers transform their environment with dams of up to 2,000 feet in length, and they use teamwork to maintain them. Yet the beaver demonstrates the danger of viewing animals as deliberate thinkers and planners; its behavior seems to be triggered in part simply by the sound of running water. In fact, in one experiment a European beaver hearing a recording of this sound built a dam over the loudspeaker.

Of course beavers once were decimated by human admirers of their fur, just as peafowl are still being bred in aviaries. The central economic concern of animals, in fact, is people. The pace of human reproduction, for example, threatens other species, although Western man took an enormous step when he substituted status symbols for descendants as a mark of success. The most successful animals are those that have been shrewd or lucky enough to

tag along with a big winner—a tactic IBM-compatible equipment vendors discovered much later. The future belongs to such unpopular creatures as the rat, the cockroach, and the housefly—and to the lovable opportunists as well. Investment in cute behavior pays off, as any pampered pet can tell you, in getting more advanced animals to find your food for you.

Indeed, we may be underestimating the financial skills of our four-legged friends. In England a sheep dog named William has been picking stocks with such success that over the past 12 years he's amassed a portfolio worth about $109,000. Securities analyst Robert Beckman reads William lists of stocks and when William barks, Beckman orders that issue for the dog's account. Canines in England can own property and don't have to pay taxes.

Constructing the German Shepherd Dog

Raritan Quarterly Review, Winter 2017

Human history and dog history have been inextricable for thousands of years, but human meddling with canine natural selection has been accelerating. Already in his 1997 book *Imagined Worlds,* the physicist Freeman Dyson speculated that the electronic design of organisms may be the dominant technology of the twenty-first century and pointed to the ethical issues that would arise if a child could order, through Computer-Assisted Selection/Computer-Assisted Reproduction (CAS/CAR), a dog with multicolored spots that crows like a rooster. Dyson's prediction envisions a dramatic departure from dog-breeding practices of the past, but there are two continuities: dog breeding, especially of this push-button variety, continues to raise ethical questions; and the development of new varieties, together with unforeseen political and technological changes, leads in the long run to unintended positive and negative consequences.

Dog breeding has been largely the province of enthusiasts rather than geneticists or animal behaviorists, and therefore motivated less by animal health and fitness. Dogs are often unwitting bearers of cultural meaning; they can serve democratic, aristocratic, and fascistic purposes. The values of breeders, the ambitions of organizational entrepreneurs, the strategies of military and police officials, the whims of socialites, and even the genres of media

producers play a part. One of the most striking results of these interactions is the German Shepherd Dog, whose early career as a breed was entangled with German nationalism and biological racism but who has since become, both as a working and a household dog, one of the world's most popular and ironically cosmopolitan companion animals.

The breed as we know it emerged from diverse and relatively obscure provincial origins around the turn of the twentieth century. While the archives of the dominant breed organization, the Verein für deutsche Schäferhunde (SV) in Augsburg, do not appear to have been used widely by outside scholars, and some important early publications are rare even in Germany, the men and women who shaped the German Shepherd Dog were proud of their work and left ample records. (Many though not all punctilious fanciers refer either to German Shepherd Dogs or to Shepherds rather than to German Shepherds; "Dog" is an official part of the breed's name.)

The Shepherd was formed by a series of groups: working shepherds, elite dog fanciers and breeders, police officials, public and private guide-dog organizations, filmmakers of the silent era, and a cadre of amateur and professional organizers and journalists. "There are wolves, dogs, and German Shepherd Dogs," according to a breeders' aphorism from the early twentieth century. Even today, many breeders and handlers of other varieties believe the Shepherd fancy follows its own rules. For example, Shepherd owners consider the diameter of the standard American Kennel Club ring inadequate for displaying the breed's prized fluid trotting gait. And the numbers support the breed's popularity: Between 1996 and 2016, the Shepherd moved from third to second place in American Kennel Club registrations. It remains the overwhelming choice of German police and military authorities, and a Shepherd stars in the popular German-Austrian television

detective series *Kommissar Rex*. Indeed, in Germany the Shepherd has become a ubiquitous living monument and export object, and the inspiration for the ongoing manufacture of national dogs, not least the Canaan Dog of Israel.

It is not only the fluid motion of the Shepherd that makes it unusual but also its versatility as a working dog and its potential to form strong bonds with men and women of the most diverse backgrounds. Malcolm B. Willis, a geneticist and breeder and the leading academic student of the Shepherd, has remarked, "They cannot track as well as Bloodhounds or work sheep as superbly as Border Collies or guard as aggressively as some Dobermanns but on all-round merit there is no equal to a well-trained German Shepherd." The American writer J. Allen Boone recalled his companion, the early Shepherd film star Strongheart, for "goodness . . . loyalty . . . understanding . . . enthusiasm . . . fidelity . . . devotion . . . sincerity . . . nobility . . . affection . . . intelligence . . . honesty," and thanked him for teaching "new meanings of happiness . . . of devotion . . . of honor . . . of individuality . . . of loyalty . . . of sincerity . . . of life . . . of God." J.R. Ackerley said of his unruly bitch Tulip that "she repudiated the human race altogether—that is the remainder of it. *I* could do with her whatever I wished—except stop her barking at other people." And the Princeton philosopher George Pitcher wrote of the Shepherd that he and his housemate adopted that she was "a mother figure. . . . [W]e felt as long as she was there, we were in some inexplicable way, if not exactly safe from all harm, then at least watched over."

Shepherds have become one of the most international of dogs, favored not only in Europe and North America but in South America, Australia, and South and East Asia. And while champion dogs have changed hands for huge sums, Shepherds have, if only by force of numbers, resisted the socioeconomic stereotyping that marks some other breeds. For example, they were the favorite of

Geraldine Rockefeller Dodge, the philanthropist, famous for her luxurious kennels and the sumptuous Morris and Essex shows. (She was said to have welcomed up to two dozen of her Shepherds to share her mansion and even her bed.) But Ackerley's Tulip was adopted, as his biographer revealed, from the home of his working-class male lover serving a prison sentence for burglary. And on a German trip in the late 1990s, I saw a beautiful Shepherd protecting a flock of street people in the Stuttgart public gardens.

This versatile breed came into its own in only fifteen years, between the establishment of the SV in 1899 and the outbreak of the First World War, though there were centuries of dog breeding by shepherds and at least one elite breed society before Rittmeister (Cavalry Captain) Max von Stephanitz (1864–1936) and his associates began their program. Von Stephanitz's *Der deutsche Schäferhund in Wort und Bild,* published by the SV itself, was issued in a 776-page sixth edition in 1921 and, known simply as *Wortbild,* remains a standard reference for the breed. By the outbreak of the First World War, both the successes of the movement and its paradoxes were evident, and they became even more so in the interwar years. Germany's defeat did more to spread the Shepherd internationally than the Reich's rise had ever done.

Little in the breed's early history predicted its present ubiquity. Well into the nineteenth century, working dogs in Germany were of minor interest to genteel owners, who still used categories established in the sixteenth century, when Dr. John Caius in England had distinguished "generous" dogs from "rustic" ones. Rustic dogs included herding and guarding breeds, a not terribly interesting category nevertheless superior to the "degenerate" breeds performing the most menial tasks like turning spits in kitchens. A canine hierarchy was thus mapped to the human social order, with hounds, setters, spaniels, and other hunting breeds

for men (and ornamental ones for women) at the top and tinkers' curs and turnspits beneath.

Considering the elite background of the SV's founders, the breed's origins were distinctly humble. Shepherds in Europe, and especially in the German principalities, were marginal men and thus unlikely selectors of a future superbreed. While some communal shepherds returned each evening, many lived outside the village and often had to remain out of touch with it for weeks. They customarily skinned not only dead sheep but also other animals and often intermarried with skinners, forming a kind of extended caste. "Schäfer und Schinder sind Geschwisterskinder" (These ones herd sheep, those ones skin, they're all kin) was a common rural proverb, reflecting a prejudice against both groups. In the popular mind of early modern Central Europe, shepherds were healers and weather prophets, but also could be sorcerers, according to the massive folklore dictionary *Handwörterbuch des deutschen Aberglaubens,* published in the early twentieth century.

In the late eighteenth and early nineteenth centuries, some of this stigma was lifted, and German sheepherders enjoyed what later seemed a golden age, improving their status and probably (though this is hard to prove) allowing them to select stronger and healthier dogs for breeding to their own stock. During the Enlightenment, German princes and their improvement-minded officials began to import and interbreed merino sheep—their lightweight fleece was the original miracle fabric—with local varieties that produced coarser wool. At least from 1800 to around 1860, the German sheep population increased steadily: from 16.2 million at the turn of the century to 28 million in 1861. The number of herding dogs probably grew significantly if not proportionately. But during the later nineteenth century, sheep raising declined. For the formation of the German Shepherd Dog, it may have been crucial that urban elite interest in the breed was growing during the very

decades when the sheep population was plummeting—even while other livestock, such as horses, were gaining in numbers.

German pedigreed dog breeders followed many of the patterns described by the historian Harriet Ritvo in her study of English animal culture: orientation toward appearance, novelty, and fashion rather than structural soundness or behavior. Indeed, German fanciers consciously copied English practices and imported English and Scottish breeds, partly out of dynastic attachments of the North German aristocracy dating from Hanoverian days, but mainly because the English were established masters of the dog show. E. von Otto, a veteran of the early Shepherd movement, acknowledged in his 1925 book on the breed, "Dog sport came to us from England, where it had already been cultivated for about twenty years. . . . With the dog shows [of the 1880s], accomplished English exhibition dogs arrived, whose purebred appearance and balanced forms, pedigreed breeding and foreign origin, together with their lively behavior in the ring, made a powerful impression."

From their admiration of English dogs, German fanciers in the late nineteenth century turned to local breeds. They do not seem to have made as sharp a distinction between sporting and nonsporting breeds, or between rural gentry and ambitious urban fanciers, as Ritvo attributes to British breeders and owners. The classic dog of the landed nobility was in fact a guarding rather than a hunting breed, the Deutsche Dogge—known in England as the Great Dane even before the rise of Germanophobia. A number of other indigenous dogs seemed better candidates for development than the Shepherd. The earliest society to promote a local breed was the Teckelgesellschaft (Dachsund Society) of 1888, and this courageous but sometimes destructive badger hound became a popular companion in Germany and abroad. Dog-breeding enthusiasm was high among the North German nobility, but also in

the lowest strata of the petty bourgeoisie; the tax collector and policeman Louis Dobermann (1823–1894) of Apolda in Thuringia was only one of a number of backyard breeders who scouted the local dog fair for material. Dobermann's colleagues and successors made up a network, at first without formal organization or stud book, that produced fearsomely aggressive terriers (pinscher) for a growing market.

In the 1880s and early 1890s, then, German dog breeding had three divisions: a trade in hunting dogs, Great Danes, and other rural breeds; an urban fancy devoted to English-style show dogs (*Luxushunde*); and a socially mixed world of experiment with terriers and other working breeds, serving city fanciers as well as policemen and watchmen and aspiring to the luxury market. Shepherd dogs seem to have been part of this third sector, and there were two main varieties, according to von Stephanitz: the shepherd dogs of Thuringia—smallish, short-haired, gray, curling-tailed, prick-eared, and aggressive or "sharp" (*scharf*); and the longer-haired, larger, often floppy-eared, straight-tailed, more even-tempered Shepherd of Württemberg, still a major (though declining) sheep-raising area. (It is not clear that these varieties were as distinct as von Stephanitz and other fanciers thought: His photograph of the Thuringian shows a straight rather than a curling tail, and in the photograph of the Württemberg variety, the coat does not appear long as described.)

Upper-class interest in the Shepherd began around 1882, when one Jägermeister Freiherr von Knigge of Beyerode exhibited two dogs at a show in Hanover. But there seems to have been no breed organization for the rest for the decade. Then in 1891 a group of fanciers formed a club called "Phylax, Society for Breeding German Shepherd Dogs and Spitzes," which met for the first time in Berlin to consider establishing breed standards and shows. Soon a stud book was established, and in 1893 the first field tri-

als were organized; Phylax was devoted to the Thuringian type, but soon dog shows in southern Germany introduced the Württemberg type. In an 1895 contest, a judge described the society's prize animal, Phylax von Eulau, as a "seductively beautiful, purely wolf-colored, high-stepping, short-backed, very large wolf mix (*Wolfsbastard*), which would do ten times more credit to a menagerie with its wild facial expression, hard movements, and wild behavior, than it could ever perform working behind a herd of sheep." By 1897 both Phylaxes, the society and the dog, moved from Berlin to Apolda. The society faded from notice, if it did not formally dissolve, but breeders and journalists in the specialty press continued to have high hopes for the Shepherd.

Thus by the late 1890s the German Shepherd Dog seemed to be on its way to consolidation into Thuringian and Württemberg types. But at this point a new group of fanciers and breeders appeared and transformed a divided hobby into an organized national movement with a coherent if inconsistently followed ideology.

We know comparatively little about the leaders of the SV, which was incorporated on 22 April 1899 with headquarters in Munich. The founders came from the upper middle class: three sheep masters, two factory owners, an architect, a mayor, a judge, and an innkeeper. While there were no active military officers, a number of the leaders, especially Arthur Meyer of Stuttgart (the first secretary) and E. von Otto (a sporting magazine publisher and writer), had served together in the same Guards regiment. Meyer and von Stephanitz had been visiting herding competitions all over Germany—already a sign of widespread interest—and resolved to start a new society upon finding a dog originally named Hektor Linksrhein at a national dog show in Karlsruhe. Hektor, renamed Horand von Grafrath, was entered as the first dog in the SV pedigree book. Von Stephanitz and his associates singled out this dog not so much for appearance as for performance and tem-

perament: intelligence, strength, obedience, and loyalty, traits that became the foundation of the German Shepherd Dog movement.

Max von Stephanitz's family seems not to have been from the old landed or military aristocracy. His father was a rich Dresden rentier, a cultivated man who studied chemistry as a hobby. The family owned no dog but traveled around Europe with a parrot before the father's death. As a gymnasium student with this cosmopolitan background, von Stephanitz had won a prize for a French oration he was said to have delivered with native fluency. Wishing to become a gentleman farmer, he nevertheless entered the officer corps at his mother's urging. He was at one time posted to the Veterinary College in Berlin, though he took no degree, and his course of study there is not clear. As a young officer he seems to have enjoyed the equestrian life with dogs of various breeds, but while on maneuvers in the early 1890s he saw a dog herding sheep apparently without direction and was fascinated, though not to the point of buying one. In 1898 he was promoted to captain but resigned from the service for personal reasons and soon thereafter bought an estate in Grafrath, Upper Bavaria, a small town only about an hour by rail from Munich.

Von Stephanitz was not a great breeder, nor an influential trainer, nor an original contributor to the study of dog health or behavior. This city youth turned horseman and then country squire blossomed instead as a tireless publicist and proselytizer, and (within dog-breeding circles) a master organizer and politician. The history of dog breeding is fraught with internecine rivalry and division. For example, dachshund fanciers were divided between urban and hunting factions, and before amalgamation in 1921 there had been as many as three rival Rottweiler societies. What makes the history of the German Shepherd Dog different is the discipline and the regulated goals of the breeders. Von Stephanitz created a uniform breed standard for the Shepherd that al-

lowed for a range of physical appearance while insisting on working qualities such as herding, hunting, and guarding skills.

In the 1921 *Wortbild,* with memories of war and its intense Anglophobia still vivid, von Stephanitz attacked the English dog fancy and its violations of structural soundness and working character in not only the bulldog, but also the Old English Sheepdog. Von Stephanitz saw the originally slimmer working breed transformed by fanciers into an unnatural, distorted creature, "a dancing ball of hair" that he did not find lovable. In fact an important reason for the Shepherd's early popularity was the fashion for its British counterpart, the rough collie. The collie had been bred for different terrain, without the Shepherd's crop-protecting behavior, but above all it had been selected for beauty of form, with a slender head and rich coat that reduced its value for herding and protection. With the patronage of Queen Victoria herself, the collie had transformed from a working dog to the ultimate luxury dog. In Edwardian England one collie sold for £1,500 at a time when the best gun dogs fetched no more than 200 to 300 guineas. By 1908 Germany had two rival collie clubs, and champions were worth as much as 20,000 marks. In fact, the collie fancy apparently remained sufficiently strong in Germany that the 1938 edition of the *Meyers Lexikon* encyclopedia, after duly noting the Shepherd's "pure German descent and pure German breeding," went on to acknowledge that "[c]ollies are more elegant."

Aware and resentful of the collie's prestige among German dog lovers, [v]on Stephanitz and his circle were constructing an alternative dog suitable for elite male owners and reflecting the values of bourgeois men who espoused hierarchical and military values. They were countering the prestige of all things British on the Continent. The SV were socially engineering their project with relatively new technology: publications with halftone photographs providing more accurate impressions of conformation, and rail-

road shipments of crated dogs for breeding (in place of local and regional exchanges by shepherds and others). SV activities seem to have had no special cachet outside the dog world and were a subculture even within it. Whether or not von Stephanitz profited financially from his leadership or writing, there is no doubt about his passion for the breed he helped shape, attracted as he was to the Shepherd for its potential to respond to training with intelligence and spirit.

Despite its idiosyncrasies and the singularity of its founder, the SV was also swept up in several broad historical developments characteristic of its epoch. We can look at its activities in three ways: as the elite cooptation of a craft product; as the cartelization of biological production; and as standardization (Germans had become the leaders of the international standards movement by the 1920s). And all of these were put into the service of nationalization, the definition of the Shepherd as the all-German dog to the exclusion of previously plausible candidates with older organizations promoting them.

Throughout the nineteenth century, European and North American elites had been searching out craft knowledge, recording it, and adapting it to the emerging industrial economy. Max von Stephanitz was no scientist, much less a Darwin, but *Wortbild* shows evidence of the same wide-ranging reading and ceaseless correspondence, as well as an interest in the experiences of all sections of society with animals.

Tending sheep demands strength and skill, including veterinary first aid, assistance at lambing, and recognition of the animals' many diseases. The dog is not only an essential working partner but the only immediate defender against predators and thieves. Von Stephanitz did not live among shepherds or apparently show any interest in the economic problems of sheep raising. The selections shepherds had made, and their methods for commanding

dogs, on the other hand, fascinated him and other Shepherd fanciers. Observing the dogs and shepherds at work had engaged him with the breed. Working shepherds had disregarded looks and bred dogs for structure, stamina, and intelligence—"good, capable dogs" that reflected "a purposeful selection"—but could not continue as stewards of the breed, at least in those areas where sheep raising had declined most sharply.

The survival of herding skills, if only on a small scale, was essential to von Stephanitz's definition of the Shepherd as a working dog. A Shepherd must be able to work sheep. Thus a number of *Schafmeister* (head shepherds on large estates) were among the original founders of the SV. Field trials were prestigious events within the organization, and shepherds were encouraged to join with half-rate dues. But for all his engagement with pastoral life, von Stephanitz and his associates were not promoting a country idyll. Businessmen and professionals were more represented than agriculturists on the SV board. In its tenth year the SV's board included (besides von Stephanitz and another retired Prussian cavalry officer): owners of a Magdeburg dog-biscuit factory and a Stuttgart printing plant, a teacher in Hannoversch Münden, an art dealer (*Kunstanstaltsbesitzer*) in Gross Steinheim am Main, and a businessman (*Kaufmann*) from Greiz in Thuringia. And their efforts to define and stabilize the breed corresponded to a major movement in Germany and other industrial societies of the time, namely, the formation of cartels to divide markets and control output. Significantly, the umbrella organization of breed clubs for hunting and working dogs was incorporated in 1908 as the Kartell der Rassezuchtvereine und allgemeinen Verbände, later the Deutsches Kartell für Hundewesen. The Reichsgericht having ruled in 1897 that the formation of cartels generally did not infringe on freedom of commerce, the name "cartel" had evidently become fashionable.

Neither the SV nor the Kartell could, of course, monopolize the reproductive capacity of dogs, purebred or otherwise, but the ability to define and enforce standards for registration in a dominant breed club can bring profit as well as prestige. What colors and coat textures are acceptable? How serious a fault is a missing tooth? And should a dog be disallowed if it resisted inspection of its mouth, as some breeds routinely did? Even for a "working" dog, conformation goes beyond health and fitness to aesthetic questions and almost arbitrary systems of signs. Just as human athletes advance and retreat in competition when technology changes to reward finesse on one hand or power on the other, so conformations of dogs can move in and out of favor. While kennels were very small, the high price of breeding-quality dogs and the cost of maintaining them made standards of vital concern.

Within six months of the SV's incorporation, in September 1899, the organization's general assembly in Frankfurt approved a breed standard that Arthur Meyer and von Stephanitz had prepared. The SV's attempt to define a high performance standard—an athletic, self-confident herding and protective dog that could also be a reliable housedog tolerant of children's sometimes rough play—was a challenging goal that required constant guidance. It would also be a trial-and-error process until there were large numbers of dogs that could breed true. In 1901 the breeder Max Hesdörffer attributed the high prices of attractive specimens in part to the fact that "even dogs of outstanding value yield a substantial percentage of defective progeny."

In practice the breed standard was not used to exclude dogs from the pedigree book. To the contrary, as von Stephanitz wrote in 1921, the SV was unique among the purebred dog clubs in opening the stud book to as many dogs and bitches as possible, relying on breeders' and owners' own characterizations. Other association leaders sought exclusiveness. The SV instead fos-

tered the competitive pursuit of breed standards by laying down a broad foundation stock (to use a phrase of breeders) for skillful selection and matching. And von Stephanitz encouraged members of "all occupations and sections of society (*Stände*): from princes of royal blood to the small cultivator or simple artisan and worker, united by love for our dog and the striving to advance its cause." Like many another late-nineteenth-century enthusiast, von Stephanitz became a cultural entrepreneur, turning what had been an avocation into a symbol of national moral renewal. In practice, the growing price of a purebred Shepherd, the costs of upkeep, and the need for exercise space and time made his constituency a bourgeois one. And von Stephanitz's cavalry rank and use of military metaphors undoubtedly appealed to his relatively prosperous audience.

Crucial for the SV's project were the energy and firmness of von Stephanitz and his patriarchal direction of the breed. His prompt, detailed, and often humorous replies to questions encouraged still more correspondence. In 1906 he personally logged over 9,000 letters and cards at a cost of about 550 marks; by 1908 fully 17,000 letters at a cost of 1,148 marks. What makes these figures all the more remarkable is the still-small membership of the SV in these years: only 900 in 1906 and 1,540 in 1908. Von Stephanitz was counseling and recruiting Shepherd owners and breeders as well as advising members and organizing shows and field trials. He also was developing his skills in print with the handsomely illustrated introduction to the breed in 1901 that was the first edition of *Wortbild*. Through the early 1920s the SV depended less on its formal organization than on his personal influence on breeding and judging.

Yet institutional growth did become increasingly important. The Civil Code and Reich Association Law of 1896 enabled the SV to begin construction of a national network of local chap-

ters operating under its model bylaws, admitting only paid-up SV members, and having their own arbitration boards. Between the local group (*Ortsgruppe*) and the headquarters was another level, the league (*Verband*), composed of local groups and assisting the weaker ones as well as servicing members with no local group of their own—and especially keeping peace within the local groups. There were detailed procedures for expulsion and for appeals of local group decisions. The bylaws encouraged establishment of many small groups of as few as four or five nearby members who could meet regularly and recruit others; the SV offered prizes for the most successful group and individual. There was even a calendar listing responsibilities of local officers, including submission of the annual report by 3 January of the new year. Above all, "The local groups are all children of the great mother SV," and the SV's three-tiered structure was designed to cure their "children's diseases."

As a network for promoting the breed, the SV was not secession-proof, but—and perhaps von Stephanitz's military training was an inspiration—it threw up multiple obstacles to the factionalism that had prevailed among other breed clubs. Its rapid growth also let it provide services that in turn increased its attractiveness, especially owner's liability coverage that the SV had negotiated with a large insurance firm and access to legal counsel retained by the SV, not to mention advice from von Stephanitz as well as from neighbors in one of the local groups.

Von Stephanitz's boldest and most fateful stroke was his promotion of police and military use of the Shepherd. In November 1901 he published a pamphlet recommending the dog for protection and tracking and circulated it to every police office in Germany, emphasizing the dog's intelligence, strength, trainability, and tenacity. The German army initially remained cool to the military

potential of dogs and in any case preferred Airedale terriers, just as the civilian German fancy had fallen in love with collies.

From the 1880s until 1914, German police forces were not necessarily as professional as those in England or France, but at least in Prussia they were growing in size and powers in response to a perceived (though probably imagined) increase in crime. Perhaps without realizing it, Max von Stephanitz had chosen a part of Bavaria where village communities closed ranks behind local lads' poaching of mountain and forest game while in turn dreading the growing ruthless, commercialized theft of their own sheep. Part of the "essence" of the German Shepherd Dog, then, was the protection of the owner, his family, and his property; photographs in SV publications proclaimed the Shepherd's gentleness toward children. Not that a Shepherd should be easygoing and approachable. On the contrary, von Stephanitz suspected promiscuous friendliness as a threat to the dog's bond with the owner. In the bitter aftermath of the First World War, von Stephanitz denounced animals that had been allowed to make friends even in the owner's circle, and urged owners to have their acquaintances strike and shove away young dogs that persist in approaching them, lest they become "xenophilic [*fremdenfreundlich*] rather than loyal to their master, like our mistaken enthusiasts who place world brotherhood ahead of love of country and service to the homeland." Such canine pacifists did not deserve to be called *German Shepherd Dogs*.

If a Shepherd was always prepared for defense—even in herding trials it had to protect the shepherd from a stick-wielding "criminal"—it needed education in the use of force. Fortunately for the SV, police were already using dogs in patrol work. In Berlin, rampant speculation, climbing rents, and the construction of massive working-class tenements seemed to endanger public order. By the early years of the twentieth century, Prussia had a

mixed system of state-directed and municipal police forces, steadily increasing in numbers and cost and in practice beginning to merge into a single system. The police were also coming under increasing military influence, often recruited from former noncommissioned officers accustomed to administering military discipline and crowned not with the former top hat or English helmet but with the spiked *Pickelhaube* of glazed pressed leather. There was actually little evidence for the existence of a substantial criminal class, and criminal convictions were in fact declining in Prussia in the early years of the SV. The political scientist Albrecht Funk believes the expansion of policing responded more to the fears of the bourgeoisie than to observable criminality. Yet the expanding police believed they were fighting a war with a burgeoning underworld, and this context helps explain the rising interest in police dogs.

Indeed, police officials throughout Europe were beginning to work with dogs in the early twentieth century. While dogs had long been used to help guard warehouses and prisons, dog patrols on public streets were still unusual. The Dobermann Pinscher may have originated in small-town police circles, but in Thuringia it was employed in the countryside as *Gendarmhund*. In the city of Ghent, Belgium, where modern police dog training seems to have begun with local shepherd dogs in the late 1890s, exercises focused on sniffing out "vagabonds," and well into the 1920s patrols were only at night. Illustrations both in von Stephanitz's works and in specialized manuals for police dog handlers place the dogs not in dense city working-class districts or in the passenger railroad stations where they often are used in contemporary Germany, but in the countryside, or rather in the rural outskirts of cities where a solo officer might feel threatened by ambush and whence reinforcements could not be readily summoned. Manuals have almost nothing to say about the use of dogs for crowd con-

trol. On the other hand, *Wortbild* 6 (1921) features Shepherds climbing trees after suspects, fording rivers, barking at the door of a (gypsy?) wagon, and helping a game official pick a contraband rabbit from an elderly peasant woman's capacious basket on a forest path—a parody of Little Red Riding Hood, in which the wolf turns in Grandma for a biscuit (fig. 4).

Before von Stephanitz, early "urban" police-dog use in Germany began not in the great capitals but in smaller cities and towns, as literally pet projects of energetic police directors like the autocratic Dr. Otto Gerland of Hildesheim, who introduced twelve "herding" dogs in 1896. Little is known of their background, training, or effectiveness, but they seem to have been used mainly for night patrols in outer districts. Von Stephanitz's breakthrough sometime after 1901 was in Berlin, where the Prussian Interior Ministry established a central dog-training school in Grünheide. By 1908, the SV was spending about 4,000 marks of its 56,000-mark budget on police training (outside of competitions), plus another 2,000 marks in member contributions. That year, 208 of the 339 police dogs competing nationally were Shepherds, and the 1909 SV stud book reported proudly that they had swept the prizes.

The protective and police training of dogs became a form of canine theater, in which "criminals," "aggravators," and "decoys" (names have varied with the nationality and time period of the trainer) simulate attacks and provocations. As an American trainer wrote in 1926, "Contrary to accepted belief, the shepherd is not an aggressive dog. He is not so ready to attack. In fact, the shepherd will not do this unless he has been put through a thorough course of training." Protective role-playing, which began well before the popularity of the Shepherd but which cannot yet be documented, reached maturity with Konrad Most (author of a 1910 manual that introduced modern ideas of systematic behav-

ior reinforcement) and other German military and police trainers, who came to work extensively with Shepherds. It had set routines, such as conditioning dogs to refuse food from strangers by rubbing their noses with tobacco after they had taken a treat from a decoy—bait and switch, so to speak. An initially unsure animal could often become a fearless companion, trainers believed, after gaining good habits and confidence through these simulations.

Just as the structure and appearance of the Shepherd was being standardized, so were systems of training with the formation of police dog societies—initially using a variety of breeds. The SV helped diffuse their methods to its civilian members. Methods and equipment were both codified. There was a widely adopted set of commands and corresponding behaviors as building blocks for more complex training. A dog learned first to guard a hat and coat, and then a prisoner. (Clothes often did make the man in the utility-dog world; Belgian police dogs were literally schooled to obey the wearer of a uniform, not an individual officer-handler as is customary now.) A small industry began to supply police and civilian trainers with odd-looking sporting goods. Special wooden dumbbells (*Bringsel*) helped teach retrieving. An adjustable hurdle of boards that could be built up gradually helped train dogs to scale nine-foot walls, and collars with internal barbs—supposedly dull but still nasty looking—took over where a verbal *Pfui* failed. And most strikingly, there were thickly padded suits with oversized sleeves, hot and not always completely bite-proof, that von Stephanitz believed could, if too heavy, encourage dogs to attack fiercely in practice while hesitating in pursuit of a real suspect not wearing the familiar coat. (SV appears to have left decisions on equipment and methods to individual owners and trainers.) Despite the SV's efforts, many officials and members of the public remained skeptical of the value of dogs for routine police work.

While some experts with experience of many breeds believed like E. von Otto that "[t]he future [in police work] belongs to the Dobermann," officials were impressed by the tireless work of von Stephanitz's rank and file. The police at first mixed breeds to avoid inflating prices, but the Shepherds had a plus: equally courageous and intelligent dogs, especially Airedales, did not always take training equally seriously. By 1914, the *Kriminalpolizei* kennel, apparently personal rather than official, of Police Commissioner Friedrich Decker of Wiesbaden had already produced one of the most celebrated bloodlines. The shepherd's dog was turning into the police dog.

Yet the transformation was halting and fitful. While von Stephanitz believed that protection fulfilled the essence (*Wesen*) of the Shepherd, success in "man-work" (as opposed to the tracking that was also taught) did not entirely improve the breed's working qualities. For example, a dog in police or military service must not be gun-shy; since panicking at loud noises may result from highly sensitive hearing, it is possible that some dogs adept at perceiving (for example) distant shepherds' whistles were eliminated from the gene pool. "Sharpness" or "gameness" also has drawbacks. The ideal of trainers became and in many cases remains an edged weapon, or an elite commando, eager to attack yet always under control. But despite over sixty years of systematic research, the genetics of canine aggression are still imperfectly understood. Even today, other guarding dogs of various breeds sometimes savage the sheep they are supposed to be protecting, for example. Shepherds could tolerate rough play by children, yet unintentional human signals could trigger apparently unprovoked biting, especially among shy dogs biting out of fear. And sharpness also complicated canine reproduction; sharp bitches were known to fight with stud dogs.

Further, the popularity of the breed was testing the coherence of von Stephanitz's program. Already in 1901 Max Hesdörffer was applying the dread term *Luxushund*—and still worse, applying it favorably. Many buyers without the patience, open space, or ability to train a Shepherd still fell in love with the breed. The SV, thriving on expanding dues and registration fees, had no way to exclude them. It did reject commercial dog dealers but equally could not weed out avaricious "amateur" breeders. Selection for appearance, the bane of the rough collie, was apparent in the Shepherd. A later study concluded from records of show-ring and working championships that the breed had split into showing and (much smaller) working lines as early as 1909.

The First World War delayed but also amplified both the triumph and the crisis of von Stephanitz's program. The army command, unlike the police, had been skeptical about the combat value of dogs. It was the front-line troops of belligerent nations who began using them in sentry and patrol work. When the Eighth Army command began to supply trained watchdogs in response to troop demand in November 1914, the SV took the lead in supplying them, and Konrad Most became head of the program. Changing military technology turned the army dog from the crude attack weapon that it had been for centuries to a skilled partner, for example in communication lines and leading medics to wounded soldiers. In Oldenburg, beginning in 1916, under the patronage of the Grand Duke, dogs (especially Shepherds) were trained as guides for blinded troops. The army, with thousands of dogs donated and lent by SV members, established dog schools and field kennels. In all, Germans provided twenty thousand dogs for military service; Shepherds replaced Airedales as Germany's preferred military breed.

The German loss of the war, and the ensuing political and economic turmoil, advanced rather than curbed both German and

foreign interest in the Shepherd. Domestically it was a rallying point for nationalism, which began to take anti-Semitic and racist (*völkisch*) form in the postwar editions of *Wortbild*. It was plausible that so many links with the despised Hun would have stigmatized the breed after the rise of wartime Germanophobia and the fall of the Emperor. But the consequences of Germany's decline were more complicated. As more recently in post-Soviet Russia, guard dogs were both responses to crime and objects of speculation bred in commercial kennels. Often captured, retrained, and beloved by British and American troops, Shepherds found new popularity as "Alsatian wolf dogs" in England and as "police dogs" and "shepherd dogs" in the United States. German hyperinflation promoted exports of champion stock. The SV, tempering chauvinism with pragmatism, began to market English-language translations of *Wortbild* and other materials. Geraldine Dodge began her long career of Shepherd breeding on her two-thousand-acre estate Giralda Farms in Madison, New Jersey, where Max von Stephanitz appeared as a judge at the 1930 Morris and Essex show. Von Stephanitz's anti-Semitism (he believed Jews had a hereditary aversion to dogs and kept them only for profit and ostentation) and eugenics (he thought dog breeding should teach Germans the value of selecting the fittest) might have had many sympathetic American readers in the 1920s, but not his belief that only Germans could pursue an activity like dog breeding and training for its own sake rather than for gain or prestige.

Decisive in the 1920s was the unexpected match between biological and mechanical-optical technology: the trained dog as film star. First Strongheart, a German police-trained dog with the original name of Etzel von Oeringen, and then Rin Tin Tin were able to thrill silent-era audiences with virtuoso athleticism combined with the appearance of human intelligence and judgment, often in a law-enforcement role—the result of native ability and loving

education. "From a crouching position," wrote J. Allen Boone, Strongheart "could leap over the head of a man six feet tall, and do it with what seemed to be effortless ease." Before retraining by Larry Trimble, Strongheart had "marched like a soldier" and "had no sense of fun, no joy, no affection," after having been made "a four-legged 'dreadnought.'" Winning Strongheart's confidence, Trimble made him into a consummate canine actor who could feign the fiercest aggression on screen without actual injuries, while remaining his owner's loyal companion. The original Rin Tin Tin was also a German military dog, adopted from a field kennel in France as a puppy by the American Sgt. Lee Duncan in 1918 and trained, according to Duncan, with techniques he had learned from an English-speaking German prisoner of war. The feats of these dogs made them some of the best paid film stars of the time; they also gave the breed a worldwide fame of which even von Stephanitz had never dared to dream. And overseas success amplified German attention, as Rin Tin Tin became the most popular film actor in Berlin after 1926. On a more sinister note, as the American historian of Japan Aaron Skabelund has documented, the Shepherd was becoming the favorite combat dog of Japanese imperialism in Asia, in preference to indigenous Japanese breeds.

On the other hand, the rise of Hitler, an SV member and one of many Shepherd owners in public life at the time, helped bring a sad end to von Stephanitz's career. For all his bigotry, *völkisch* sympathies, anti-Semitism, and anti-feminism, von Stephanitz appears to have worked cordially with distinguished Jewish breeders and trainers like his admirer Ernest Loeb, who emigrated and became "Mr. German Shepherd" in the American Kennel Club, and the Vienna police department's animal behavior expert Dr. Rudolphina Menzel, who contributed her own skills to the Jewish self-defense force Haganah in Palestine. The founder was so identified with the Shepherd that he resisted the National Socialist

government's plans to merge the SV into an umbrella domestic animal organization including poultry and rabbit fanciers. (Von Stephanitz despised chickens, "which almost invite persecution with their cackling and impertinent forwardness and foolishness, with their brainless running about and fluttering." A chicken breeder became the new head of the SV.) He was removed from the chairmanship in 1934 and died in 1936.

In the Second World War, German dogs, including tens of thousands of Shepherds, were systematically requisitioned using dog-tax registrations, and many champions died. Yet the breed recovered and remained equally popular in the Federal Republic and the German Democratic Republic. Reunification added tens of thousands of members to the SV and incidentally dispelled the image of the Wall dogs as fearsome killers; most had been untrained, love-starved decoys, "harmless embodiments of their own myth," in the words of the journalist Peter Schneider in his 1990 essay on dogs and Germans. But as George Foreman discovered in 1974 when the Shepherd accompanying him to Kinshasa, Zaire, for his fight with Mohammed Ali awakened memories of the hated Belgian-era police dogs in the populace, legend, history, and biology are inseparable parts of the Shepherd heritage.

The rise of the German Shepherd Dog shows the power of biological modification through social engineering. With a limited scientific background but endless energy and a talent for publicity and organization, Max von Stephanitz constructed a coalition around new breeding and training methods building on centuries of folk selection and training. As a publicist, von Stephanitz deftly linked agrarian traditions, military concepts of authority, and bourgeois concerns for the protection of property, all in an organization claiming to transcend social class. Police officials, journalists, equipment manufacturers, and thousands of owners joined a community combining competitive sport, small business,

and socializing. Face-to-face groups and a national organization complemented each other. The prestige of the Prussian cavalry reinforced von Stephanitz's fatherly guidance. (And patriarchal he was. The Shepherd, he wrote, "always submits with a sure sense to the most powerful one in the house, the commander, and that is the *man*." He continued that when he used to summon his children indoors, his dog Audifax would go outside on its own, round up the little ones from the garden, and shepherd them "like a lamb dog, cautiously but relentlessly," inside.) A relative latecomer, the Shepherd rapidly displaced other hunting and working breeds to become the de facto German national dog. In 2014 it still ranked first by a wide margin in German purebred-puppy registration.

Von Stephanitz's success shows that—contrary to some analyses of civil society—authoritarianism and private civic initiatives can go hand in hand. The SV was effective in part because the breed standard was fixed (except as modified from time to time by von Stephanitz), and open opposition to the SV as a kind of breeding cartel led to dissenters' exclusion from prestigious showing and breeding opportunities. The SV's efforts meshed with those of other societies for police dogs, medic dogs, and working dogs, and this network in turn cooperated with Prussian administrators and others. Wilhelmine Germany thus had a vigorous associational life that, in the SV's case, could gladly furnish the growing police establishment with new instruments of social control. And like other associations, the SV itself appears to have been a target of the National Socialist Party in the later 1920s and early 1930s, when both rank-and-file party members and activists recruited and organized in ostensibly unpolitical political groups. The political scientist Sheri Berman believes that this Nazi strategy accelerated bourgeois flight from mainstream politics and the end of the Weimar Republic.

While von Stephanitz's nationalism has been discredited and the Shepherd today is as close to a truly international animal as any breed, one warning of the Captain has continued to be valid: Commercially motivated dog breeding endangers the health and genetic soundness of animals. Breeding, whether for conformation or temperament, requires such careful planning and has such high costs that it cannot maintain standards while becoming a profitable business. Because temperament is so crucial, yet so genetically complex, dog breeding and even puppy-mill operations are still a craft industry in comparison to the industrialized world of hybrid corn and chickens. Reports of hip dysplasia and allegedly defective intelligence have been increasing. Almost twenty years after Freeman Dyson's prophecies, the promise of dogs genetically engineered for temperament as well as health has still not been realized. In fact, the organic agriculture movement has so stigmatized technological intervention that puppies conceived by artificial insemination are ineligible for registration in Germany.

It is not completely accurate to say, as the writer Susan Orlean recently argued in a *New York Times* op-ed essay, that the breed is in decline. In an age of mass customization, the attraction of standards has faded, or, rather, there are many more to choose from. For example, law enforcement agencies in Europe and the United States prefer Belgian Malinois to Shepherds for their allegedly keener sense of smell and sharper temperament. Some Shepherd owners and trainers pay premiums for dogs bred to the more traditional standards of the former German Democratic Republic and pre-1989 Czechoslovakia. Yet friendliness toward strangers and other dogs, a taboo for von Stephanitz and the Nazi regime, is now seen more positively by many owners with families. And this trend in turn has encouraged so-called designer dogs with parents from what the buyers hope are two complementary purebred lines—the Golden Shepherd, the Shepadoodle, the Shug, and the

Shollie. Many owners prefer to call themselves "parents" rather than "masters" of their dogs. Animal behaviorists have rejected the aversive training techniques popularized by Konrad Most and von Stephanitz. (One prominent midcentury expert, William Koehler, even advocated a form of waterboarding in extreme cases.) Canine behaviorists, following ethologists of wolves, have rejected the idea of fixed alpha dogs in a pack—as well as training strategies, including so-called Alpha Roll wrestling, for asserting human dominance.

The Shepherd's success is paradoxical. It was, as the wildlife biologist Glenn Radde has pointed out, the embodiment of modernity vis-à-vis the Great Danes of the landed nobility, yet it soon became a hallowed tradition. Originally bred for working qualities, it attracted some enthusiasts more concerned about appearance than health and soundness. Inspired in part by ethnocentrism and racism, it appealed across borders and ethnic lines as few other breeds have. Volunteered by their owners for German victory, Shepherds were spread by the stunning defeat of the Treaty of Versailles. Most of all, the triumph of the German Shepherd Dog shows how much of our everyday world depends on unpredictable interactions between the unforeseen and the unintentional. We can only speculate about what genetic modifications, if adopted widely, will bring.

Citizen Canine

Wilson Quarterly, Summer 1998

Often I walk or run around a half-mile path near my apartment, a simple asphalt loop encircling soccer and baseball fields, playgrounds, and basketball courts. Morris Davison Park is the green of a global village. Professional urbanists and cultural critics may deplore our landscape of garden apartment complexes (like mine), housing tracts, and shopping centers, but my neighborhood travels show that families from all over the world love it. People with origins throughout Europe, in East and South Asia, in the Middle East, in the Caribbean and Central America all happily gather to walk, talk, play, and rest here. To see their cosmopolitan soccer teams on a spring or summer afternoon is to witness the beginnings of a fresh transformation of American identity.

Bigotry and ethnic tensions are not dead, and Plainsboro, New Jersey, is no utopia, but the congenial scene at my local park is confirmation of what modern genetics has revealed, the unity of the human species. The dogs that accompany my fellow citizens are also conscious that they form a single species. They vary far more in size, color, and temperament than we people do, but in their vivid and seemingly indiscriminate interest in one another they betray no apparent breed consciousness. (Chihuahuas are said to prefer their own kind, but it is more likely that they are simply, and sensibly, most interested in other small dogs.)

Many of my foreign-born neighbors are already Americans, and still others are well on their way to Americanization. Already the children speak to their parents and among themselves in English. We say that these families are becoming "naturalized." Their dogs are newcomers, too; indeed, so are all dogs with owners, even if the dogs' ancestors have been on American soil for a century or more. The dogs, however, will never be entirely naturalized. They are, in a sense, perpetual newcomers.

For all their emotional intimacy with owners and their families, dogs remain conditional citizens. Americans without criminal records need not register with the authorities, as Europeans often must, but in most places they do have to register their dogs. It would take a four-legged Foucault to anatomize our elaborate regime of surveillance over dogs—the taxes, the tags, the inoculations, and above all the human control of reproduction that has made possible the profusion of canine physical and mental traits.

The dog's conditional legal status is only the beginning. Like any greenhorn, it must learn, often painfully, the ways of its hosts. It may be spared the need for table manners, but it must learn human conceptions of appropriate behavior. It is expected to modify its innate concepts of territoriality to suit the human propensity toward sociability, to refrain from jumping on dinner guests, and to respect the otherness of the postal carrier's uniform instead of considering it a provocation. When we pet some adorable puppy, we are also educating it. Reared in isolation, many dogs become aggressive or shy, or indeed both at once.

The burden of learning does not, however, fall only on the dog nation. Children equally learn the ways of an alien folk. Children must come not to fear dogs, yet they also must learn rules of caution, such as not approaching an unfamiliar dog without asking the owner. They must avoid running from a dog. When they are older, they may learn the disconcerting fact that the sight of a

running child may trigger a hunting response in dogs, including some small, cute breeds. Of course, they may also learn how much cleaner a dog's mouth is than a human mouth. The worst bite is a human bite, my mother said. Science has proved her right, as usual.

Humanity, unlike dogdom, has not been satisfied with the distinctions between the two conjoined species. In the last hundred years or so, it has increasingly mapped its own political and ethnic identities onto the nation of dog. Out of the variegated world of dog breeding and training, it has extracted symbols of history and character.

A cultivated, telepathic dog might give an amusing interview. It might quote David Starr Jordan, the ichthyologist who was Stanford University's first president: "When a dog barks at the moon, then it is religion; but when he barks at strangers, it is patriotism!" But human politics, it might remark, is, was, and will remain meaningless to its kind: *ubi bene ibi patria.* Where my kibble is, there is my fatherland. Dogs indeed have special human loyalties, but these precede the rise of nation-states by hundreds of years. They have been specially bred by different kinds of groups—classes, occupations, and trades—for particular uses: Sight hounds, retrievers, herding dogs, watchdogs, even draft animals, are attached respectively to nobles and hunters, sheep raisers, property owners, and small tradespeople. How can a dog trace geographic affiliations, it might well ask, if human beings are so confused?

Scholarship and scientific research on dog origins remain in their infancy, with years of archaeology, genetic analysis, and documentary research still needed. Specialists question many of the assertions of breed histories, such as the close kinship of the Tibetan Mastiff and the Neapolitan Mastiff, or the Egyptian ancestry of all greyhounds and other sight hounds. (Independent origins

are more likely.) The Peruvian Inca Orchid, a nearly bald variety said to have been kept in luxury and protected from the sun by the rulers of the Inca Empire, appears similar enough to the Xolo, or Mexican Hairless, that Mexican fanciers do not recognize it as a separate breed. Both in turn are closely related to the Chinese Crested, but it is not clear when and in which direction the ancestors of these breeds were transported.

Some breeds are of more recent, and more reliably known, origin. The Teutonic Dachshund has Gallic Basset Hound blood. The Australian Shepherd was developed by Americans, possibly from the stock of Basque herdsmen. (Ironically, the "native" dingo, which long ago crossed to Australia from Eurasia, is reviled by European Australians as a livestock pest, accused in one celebrated case of stealing and killing an infant.)

Our canine informant might continue that dogs are most comfortable when they enjoy a close working bond with people in a given terrain performing a certain job—patrolling and defending a territory, hunting—or simply sitting in a human lap. Each of the dozens of types of herding dogs in the world is accustomed to a certain landscape and specific sizes of sheep or cattle. Industrialization indirectly promoted still other breeds. Factory workers of the River Aire in Yorkshire bred large terriers for chasing rats and pursuing (often forbidden) game, creating the ancestors of today's gentrified Airedales. (English gamekeepers, in turn, crossed bulldogs with mastiffs to create a new breed, the bull mastiff, that could take down a poacher and hold him without devouring him.) The high spirits prized by today's Airedale breeders and trainers reflect the raffish culture of the dog's original blue-collar enthusiasts.

When European settlers in the New World and other outposts began creating new varieties around the 18th century, they were not exercising their fancy but blending the structure and behavior of existing breeds to suit new conditions: thus the Newfoundland

and Chesapeake Bay retrievers and such distinctively British legacies as the Rhodesian Ridgeback and the New Zealand Huntaway. Folk breeders paid no attention to borders. Mark Derr, a leading dog writer, speculates that the Catahoula Leopard Dog descends from colonists' curs and indigenous dogs, with traces of red wolf and Spanish Mastiff mixed in. But while it is found along the Gulf of Mexico from Mexico into Florida, Louisiana has claimed it as its state dog since 1979 and pointedly employs Catahoulas as guard dogs on state property.

Today, even as the cult of national dogs flourishes, geography imposes fewer limits than ever on how far a breed may range. The upper classes of Europe and North America have been transporting dogs for centuries—George Washington ordered a Dalmatian from England—but few people could afford to do so before efficient transportation by rail, road, and air was generally available. Our cultivated guide dog might conclude its remarks by reminding us that the same pathways helped make heartworm a national rather than a southern problem.

Even the most learned poodle probably could not analyze the subject further. It is one thing to recognize that people have changed dogs and quite another to understand what these changes had to do with human self-consciousness. And even to people, the beginnings of national dogdom were gradual. The literary scholar Harriet Ritvo has studied how the abolition of bullbaiting in the 1830s led fanciers to begin the bulldog's transformation to house pet and competitive show animal. The viselike jaws were turned into stylized jowls, and polygenic traits such as large heads and short legs were maintained generation after generation. The early breeders were not trying to make a national statement. Nevertheless, their kinder, gentler bruiser proved the perfect canine complement to England's existing cartoon emblem, the beefy, foursquare yeoman John Bull. The bulldog was more a creature

of enthusiasts than a common companion, and it was never accorded any official status, yet it became an indelible national emblem of tenacity, applied to doughty Englishmen from Thomas Henry Huxley ("Darwin's bulldog") to the plainclothes policemen of Oxford University.

National dogs seem to fall into two groups: mascots and monuments. The former is a natural greeter, a goodwill ambassador; the latter is a stern standard bearer. (Whether mascot or monument, few of these breeds enjoy *official* recognition as national dogs.) A similar distinction between the familiar and the distant applies among the human celebrities who embody national qualities—think of Benjamin Franklin and George Washington. But where Franklin was a wise if eccentric uncle, mascots are metaphorical children, loved as much for their foibles and mild misbehavior as for the positive side of their character.

The distinction is not absolute. The Irish Wolfhound, for example, despite the imposing size and aristocratic bearing that make it so much a classic monument dog, is part mascot. Centuries of breeding after the disappearance of wolves and other large predators from Ireland have given it such a sweet temperament that it is no longer fit to hunt wolves or defend sheep, just as few bulldogs would be eager to jump at the nose of an enraged longhorn. As a symbol of Irish culture the wolfhound still retains impeccable credentials; according to tradition, Saint Patrick himself worked with wolfhounds during his youthful period of captivity among the Irish and thus was able to call them off in Gaelic when he returned as a missionary many years later. Wolfhounds are features of Saint Patrick's Day parades in the United States, but it is unlikely that an IRA cell would have any use for one.

Conversely, a mascot is not held to a high performance standard. Tony Blair swept Britain's 1997 general elections with a campaign ad featuring a bulldog rejuvenated after years of Tory

torpor by the prospect of New Labor. (The spokesdog, Fritz, was only three, so it was no great feat.) The breed's alleged health problems and distant heritage of blood sport could equally have made it the symbol of all that Blair and his associates sought to purge from a "re-branded" Britain, but it had a nationalist subtext that Labor's official red rose could not match, even if some Scots thought the bulldog was too English a breed.

The poodle, especially the miniature poodle, is an unofficial mascot dog of France, even more childlike than the bulldog. In the early 19th century, the standard poodle was as much a German as a French dog, fit to serve in Goethe's *Faust* as an incarnation of Mephistopheles. As more people moved to Paris and provincial cities, the *Pudel*'s French cousin, a duck hunting dog, or *caniche*, was selected for compactness and trainability. It was not only a favorite performing dog, and the earliest dog of the hunter's blind, but the signature pet of bourgeois urban apartment dwellers. Yet the more beloved the poodle became, the less fearsome. Standard poodles are physically and temperamentally excellent protection dogs, yet are disqualified symbolically from such service. Much dog work is pure theater, and a poodle guarding a nuclear missile site, no matter how intelligent and even fierce, is simply miscast. (Even among mascots, it has an awkward position: Would you rather be a powerful person's metaphoric bulldog, or that person's poodle?)

The dachshund was the third classic mascot of the 19th century and, like the poodle, a citified hunter. The Teckel Society—Teckel and Dackel are the dog's more *gemütlich* names—was founded in 1888 and is one of the oldest German dog organizations. Some owners continued the breed's original work of hunting badgers, but for friend and foe of Germany alike the dachshund remained the "wiener dog," endowed by its distorted anatomy with an eccentric dignity and musculoskeletal problems to match. Even

more beloved than other mascot dogs, and often courageous and persistent, it has been sadly unable to defend self or country. With the outbreak of World War I, even native-born British dachshunds faced abuse and death in the early waves of British jingoism. The last dachshund in the international spotlight was the unfortunate Waldi, the emblem of the 1972 Munich Olympics, who presided over yet another tragedy.

Even before 1914, though, another type of national dog was emerging: the monument dog. Germany had an old monument dog, the Deutsche Dogge, another mastiff variant and a fearless protector. A dachshund on a pedestal would be laughable, a Deutsche Dogge plausible. But the Deutsche Dogge needed a lot of room, indoors and out, had an appetite that could challenge even the average Junker's bank account, and lived only about a decade. Perhaps even more damning, many foreigners thought it was originally Danish—it is called the Great Dane in the English-speaking world—even if it seemed an unlikely product of such a small, peaceable nation.

Nearly a hundred years ago, a group of German fanciers made a fateful innovation in the culture of national dogs. In 1899, only a year before the significance of Gregor Mendel's long-neglected papers on genetic inheritance burst into the awareness of scientists, these fanciers formed a German Shepherd Dog Society, the SV, to develop what they considered the outstanding qualities of one of Germany's native breeds. The cofounder of the SV, a retired Prussian cavalry captain named Max von Stephanitz, was no Junker. He had grown up in a cosmopolitan, well-traveled Dresden household and was familiar with the breeding customs and dog shows then part of the vogue for all things English among the Continental upper class. Like other dog fanciers, von Stephanitz had noted the elegant lines of the Rough Collie, Queen Victoria's favorite and the outstanding international luxury dog of the day.

After observing the autonomous herding skills of sheepdogs in western Germany, von Stephanitz (with another former officer) resolved to bring a new spirit to elite dog breeding, emphasizing the folk breeder's cultivation of character, intelligence, and working ability over mere looks. A fierce nationalist, he promoted these pursuits as a distinctively German alternative to the frivolous and superficial ways of foreign breeders. Realizing that fewer and fewer dogs would ever actually herd sheep, he still insisted on the field trial as the ultimate test of a pedigreed dog and extolled the loyal and protective character of the shepherd. The shepherd would retain the working virtues that Britain's effete collie had lost. Von Stephanitz's tireless publicity, massive correspondence (up to 17,000 letters logged in a single year), and persuasiveness with police officials brought quick popular recognition, though no official status, for the new breed of German Shepherd Dog. During World War I, the centrally organized SV was able to mobilize so many shepherds for the army that the breed displaced the Airedale terrier as favorite.

Von Stephanitz, a Saxon who had served Prussia and then moved to an estate in Bavaria to oversee his informal network of breeders and fanciers, epitomized German national fusion in his own right. And the breed standard that he and his associates developed merged what they considered the best traits of a number of regional varieties of sheepdog in Central Europe, especially strains from Thuringia and Württemberg. Express crate shipment via a national rail network let breeders combine varieties that could have remained distinct breeds; Belgium alone has three recognized sheepherding breeds. Indeed, it is not clear how many of the dogs originated on "German" soil: Glenn Radde, a Minnesota geographer and anthropologist and pioneering student of the breed, believes that much of the foundation stock came from non-German-speaking Central Europe. Nevertheless, by 1938 the leading

German encyclopedia *Meyers Lexikon* was proclaiming the shepherd's "pure German descent and pure German breeding."

Despite the use of masquerade names such as "Alsatian" and "police dog," Hollywood only helped confirm the German-ness of the breed during the first decades of the century, when its early canine stars Strongheart and Rin Tin Tin (both the products of German police or military kennels) paraded the shepherd's athletic prowess before international film audiences. The innocent dachshund remained stigmatized, but the shepherd became a token of a valiant foe, and a luxury import item akin to optics and racing cars. Many American police departments still believe so strongly in the original bloodlines and methods that they pay premiums of thousands of dollars for German-bred, German-trained shepherds, hoping to find dogs that fulfill von Stephanitz's police-dog ideal: "joy in work, devotion to duty, loyalty for his master, mistrust and sharpness against strangers and unusual things."

Other peoples have followed the Germans in the manufacture of monument dogs. Whether or not in conscious imitation, Japanese breeders of the early 20th century began to purify the largest of their indigenous spitzlike strains, the Akita, to remove traces of the European dogs to which it had been bred during its fighting days in the 19th century. Japanese breeders, according to one history of the Akita, created a hierarchy of colored leashes and honorific forms of address for the most accomplished dogs. Shepherds and others could earn titles of *Schutzhund* (protection dog) I, II, and III, but Akitas that progressed from *Ara-inu* (beginning dog) all the way to an exalted training title such as *O-hana Shi-inu* (released dog) were honored with a red leather collar decorated in gold with a shogun's crest. By 1919 the Akita was a designated national monument, and other breeds soon received the same distinction.

The German connection helped produce at least one even more surprising monument dog. In his history of the shepherd breed, the fiercely anti-Semitic von Stephanitz denied that Jews could understand the "essence" of the shepherd, but he evidently recognized honorary Aryans. Among the contributors to the magazine of the SV was Dr. Rudolfina Menzel, chief consultant to the Vienna police department and one of the leading specialists of the Shepherd world. Menzel and her husband emigrated to Palestine in the 1930s, where they became dog breeders and trainers for the Haganah, the Zionist military organization. And when shepherds and other European breeds wilted in the Middle Eastern heat, Menzel began to develop a new, desert-hardy dog from the fittest and most intelligent of the pariahs that followed the Bedouin camps.

Until comparatively recently, Jews shared some of Muslims' cultural misgivings about dogs. In the Eastern European shtetl, dogs were suspect as the guardians of the gentry's estates and as the fighting companions of an often hostile peasantry. The Zionist dream of a Jewish state in Palestine changed aversion into enthusiasm. The local dogs of the Middle East, with whom the Bedouin could be alternately affectionate and harsh, were the survivors of rigorous natural selection, and close to their uncorrupted, spitz-like ancestors. Despite their nomadic history, the dogs turned out to be fiercely territorial as well as intelligent and self-reliant, able to signal an outsider's approach with two distinct barking tones. Were these not the dogs of ancient Israel, ready to emerge from centuries of neglect and to defend a land of their own at last?

The Canaan Dog, like the shepherd, has no official status in its homeland, yet it also is used widely by public authorities in Israel, and even as overseas celebrities adopt the breed, locally and internationally it continues to represent national values.

Native residents and settlers are not the only creators of national dogs. Peoples all over the world may be skillful practical owners of regional varieties, but shaping a breed demands familiarity with the biological, legal, and social aspects of dogdom—a body of knowledge that arose little more than a hundred years ago in Western Europe and North America. Just as the system of Scots clan tartans was elaborated by English textile manufacturers, just as Captain von Stephanitz appropriated the craft skills of working shepherds, Western sojourners have been adopting and fostering what they perceive as "native" breeds in various corners of the world.

In Afghanistan, it was British diplomats and military officers serving under the British protectorate that prevailed from 1839 to 1921 who began to put together narratives of the Afghan Hound as a breed—this at a time when Afghanistan was still a tribal, nomadic society with no fixed political identity. Mary Amps, the wife of an English major stationed near Kabul after World War I, bought valuable specimens of the dog from tribesmen. Her writings and letters not only defined much of the breed's history but helped create a national consciousness of the Tazi Hound, as it is called locally.

Some foreigners have gone a step further, promoting breeds that were not yet recognized locally. Another English overseas couple, the husband in this case a diplomat on Malta, recognized in a large local rabbit-hunting dog the descendant of animals painted on the walls of the tombs of ancient Egypt. They christened it the Pharaoh Dog, worked with other breeders and fanciers in the United Kingdom and then in the United States, and ultimately helped it achieve recognition by the American Kennel Club in 1983. It is now the official hunting dog of Malta.

Yet another diplomat, an American named David D. Nelson, and his wife, Judith, delighted their Turkish hosts in the mid-

1970s by recognizing among the diverse herding and guarding dogs of east-central Anatolia the Kangal dog, named for a leading family and town of its region. As the Nelsons note on their World Wide Web site devoted to the dog, "the Turkish villager has little concept of 'breeds.'" In the absence of a Turkish national kennel club, and despite the preference of urban Turks for imported breeds, the Nelsons succeeded in raising Turkish government consciousness. Now there are two state kennels in the dog's home province. Today the Kangal appears on a Turkish postage stamp and, like the Akita in Japan, is one of a number of breeds prized as a national asset for a combination of beauty and courage in the face of fierce predators.

Some academic biologists dispute the Nelsons' claims and are skeptical that there are any real distinctions among Turkish breeds, but, as interest in the Kangal grows in Turkey and the West, the standard is becoming a self-fulfilling phylogeny. Turkish scientific opinion seems to support the Nelsons' view that the Kangal is a long-established breed. Like other newly recognized breeds, it will need careful management and selection to retain the qualities that attracted owners to it in the first place. (Only a rigorous new system of breed wardens organized by von Stephanitz saved the shepherd from ruin through commercialization in the 1920s.) Yet narrow as the biological base may be, it still supports a monument.

The creation of national animals by cosmopolitan enthusiasts has not ended. The Inca Dog of Peru, for example, follows a breed standard developed by fanciers in Bremen. The Fila Brasileiro, with the build of a mastiff and the nose of a bloodhound, the unofficial monument dog of Brazil, is prized by owners there for its fierce territoriality and suspicion of strangers. But one of its chief promoters is a Brazilian-born breeder and writer named Clelia Kruel, who lives in Texas, where he manages a Fila Web

site. Urban Brazilians may prefer shepherds and Dobermans, but, according to the site, the Brazilian Center for Jungle Warfare has judged the Fila "the *best* dog for jungle work." "Faithful as a Fila" is a Brazilian proverb.

While the Chihuahua, unlike the Xolo with its proud Aztec ancestry, began as the darling souvenir of Anglo tourists, it has proved surprisingly popular among Hispanic Americans, to judge from their favorable reaction to opinion polls on a controversial Spanish-speaking dog in a Taco Bell commercial. Nor is this the only welcome addition of humor to the formerly hard-bitten world of canine nationalism: Cobi, the mascot of the 1992 Barcelona Olympics, was officially a Gos d'Atura Catala (Catalan Herding Dog) but existed mainly as an unrecognizably stylized cartoon figure by the local artist-designer Javier Mariscal. No Catalan seemed to mind that foreign journalists regularly misidentified the breed as a Pyrenees.

As with most technologies, there are glaring paradoxes in dog breeding. When a mascot or monument dog becomes a global success, as the shepherd did, its country of origin may lose much of its control over selection and quality. (This has been a serious issue among Akita breeders in Japan.) Though most people distinguish between individual animals and the images associated with their breed, dogs are sometimes made to suffer for atrocities committed by totalitarian or racist police employing the breed. Residents of Kinshasa, Zaire, took violent offense at the German Shepherd Dog that accompanied George Foreman for his 1974 world championship match with Mohammed Ali; it recalled the dogs of the hated Belgian colonial police. And military mobilization, which initially promoted the shepherd in its homeland during the First World War, nearly wrecked it in the second. Though Hitler was an SV member who exalted the shepherd as a quasi-official national totem through the 1930s, he also requisitioned thousands of the

finest breeding dogs for war service, and many or most never returned. (Today, the overwhelming majority of German military and police dogs are shepherds.)

The ultimate national-dog paradox may be that Americans, so receptive to the mascot and monument breeds of other nations, have never had a pure-bred candidate of their own. Just as we have a succession of presidential libraries across the land supplementing our national archives, we have a trail of presidential dogs, from Warren Harding's Laddie Boy (an Airedale) to Bill Clinton's chocolate Labrador retriever Buddy, and a diverse lineup of military and police dogs. Few traces remain of our native American dogs, at least outside Alaska. Enthusiasts have only a slender basis for a truly autochthonous breed on the Canaan Dog model. One biologist, I. Lehr Brisbin, has found and bred a wild strain near the Savannah River nuclear plant that he has identified as descended from the earliest native dogs, but these Carolina dogs, as he has called them, do not have American Kennel Club recognition yet, let alone a postage stamp.

Americans seem to reserve their affection and enthusiasm for mixture itself. In 1990, the chairman of Japan's Toyota Motor Company caused an international uproar when he declared that Americans built inferior cars because they were a "mongrel race." Americans may have been embarrassed by the quality of their Fords and Chevies at the time, but they never wavered in their commitment to the glories of crossbreeding. Around the same time, when Robert Dornan, then a Republican congressman from California, used a talk show to propose a bill to designate a national dog, the winner of the show's poll was the "great American mutt."

My neighbors in the park don't necessarily want to merge their cultures or their genes into a vast, old-style melting pot, but neither are they happy with ideologies of purity. The pluralism reflected in the mutt cult has, at least for the time being, suspended

the search for a national culture and purpose that was so prominent in the 1950s and '60s. But there is an equally unforeseen side of the pedigreed dog fancy. As sites on the World Wide Web suggest, the establishment and maintenance of "pure" bloodlines is a national and international sporting activity. It brings together people of the most diverse backgrounds in new communities, just as the assorted dogs of Davison Park are giving older and newer Americans occasion to meet each other. Animals are not only good to think with, as Claude Lévi-Strauss wrote. They are good to link with.

Why Dogs Bite Back

Oxymoron, volume 2, 1998

The dog is a wolf that came in from the fringe. Did it arrive around a hundred thousand years ago, as mitochondrial DNA evidence suggested in 1997, or closer to ten thousand years ago, at the end of the last Ice Age, as most archaeologists still believe? Was it enough to breed rescued or abducted pups that had bonded with their human captors, selecting for new generations prepared to acknowledge human dominance? Or, as most biologists now believe, was it the wolves themselves that adopted as their territories the bounds of human settlements, as house mice, seagulls, and starlings have made themselves at home? Can we imagine semi-tame wolves, living at the margin of these communities, continuing to hunt on their own, but also cooperating with human hunters, protecting their new pack from rival wolves and other predators? Even in historic times, individual wolves may have struck implicit deals with humanity; the wolf of Gubbio, with whom St. Francis of Assisi made his celebrated pact, ceased attacking the citizens after it was provided with food.

Some biologists have compared the dog as we know it to an adolescent wolf, frozen in an awkward liminal stage, alternatively submissive and aggressive. Young wolves make barking sounds; mature ones don't. A Russian scientist named D.K. Belyaev, developing more manageable foxes for the Soviet fur industry, selected animals for tameness alone. The more docile foxes turned out to have canine coats, ears, and breeding cycles. They even barked.

Their flight distance—the space they would allow before running off—diminished. Belyaev's work suggests that the crucial step both for humanity and for canids probably was not the initial association. It was the human power to select which puppies would live to reproduce, to choose (directly or indirectly) the most tameable and trainable animals. And whether a hundred, or ten millennia ago, some wolves stepped over the line. Even today, breed standards depend on widespread destruction of puppies deemed unfit, and on the spaying and neutering of many others.

The dog occupies the border between predator and prey. Some wolves kill and eat dogs when they get a chance, but even well-trained herding dogs sometimes feast on neighbors' sheep. German Shepherd dogs turned into notorious forest marauders during the 1920s boom of the breed in its homeland. Even in the American suburb, the dog walks an awkward line. Only after hours of patient training does it begin to understand our legal and social ideas of where lines are drawn. What is a sidewalk? Whose territory is it? And who controls the grass between sidewalk and curb? Before the automobile, we routinely considered the dirt roadway in front of the house within the margins of our living space; word of the change has still not reached some dogs who persist in chasing cars down paved streets.

Unlike the dog, the bear does not begin to think about fringes and edges. It is a near relation of the dog, having developed from transitional fore-bears during the Miocene Age (23.7 to 5.3 million years ago). The first known true bears, Paul Shepard and Barry Sanders tell us in their excellent book, *The Sacred Paw,* were "the size of a fox terrier." But the bear is as indisposed to observe genealogical affinities as territorial niceties. It is too solitary to become a subordinate part of a human pack. pack. Like wolves, bears have long tested the fringes of human settlements, but they have never made a pact. The nineteenth-century American per-

former Capen "Grizzly" Adams killed mother bears and raised the cubs as pets and exhibition wrestlers; so have modern Russian circus trainers. But there are no domesticated bears.

Sadly or fortunately, the bear had nothing to offer us. Many hunting behaviors of wolves, especially encirclement of prey, were preadapted to the needs of herdsmen. The Welsh Corgi's nipping, the Border Collie's fiercely fixed *eye* are wolf traits, bound and limited. German Shepherd dogs may look wolflike to the untrained eye, but they are no closer to wolves genetically than other dogs. They have lost half of the biting force of wolves. Along with other dogs, they have lost much of the wolf's keen perception. Even the Shepherd's fluid trotting gait is haphazard compared to the wolf's meticulous tread. Only in this diluted strength could the powers of wolves serve humanity. But what economic use can there be for a bear? A performing poodle may be a *showing fool,* delighting in the applause of a crowd. A circus bear, declawed and muzzled, enacts a captive's counterfeit of dance. Wolves might come in from the cold, so that their descendants are felt to need sweaters and descendants are felt to need sweaters and even booties; bears had no choice but to stay at the fringe of an expanding, human-dominated world unless shot or captured. If the hive became the emblem of human industry, the bear remained its nemesis: *Beowulf,* wolf of the bees.

Thus the dog became a partner of the hunt, helping to search the fringe of settlement for food, repel predators, and deter thieves. The bear remained all three: foe, burglar, and occasional meal. But it was something more, a flesh-and-blood superhuman. Even in cultures most affectionate toward the dog, its name is invariably an insult, a stigma that centuries of protest by its admirers have not effaced. The bear, even in degraded captivity, never fully lost its dignity. It shares our plantigrade (heel- strike) walk, unlike the dog and most other land mammals. As Shepard and Sanders put

it, it is "an ideogram of man in the wilderness" and a reminder of our lost nature, "wily, smart, strong, fast, agile, independent."

To our ancestors the bear, unlike the dog, was almost divine. In the Indo-European languages its original name, like the ineffable name of God in Hebrew, has been lost and replaced by euphemisms that translate as, for example, *The Brown One*. The bear was rarely perceived as nurturing to humanity, like the she-wolf that saved Romulus and Remus; it is hard to imagine sleeping with bears, as people of all backgrounds have been known to sleep with dogs. Nor was it thought an accursed creature to which humanity might revert. A human touched by the dog's madness was rabid and self-destructive; identified with the bear's fury he might be a berserker and invincible in battle. In Jewish scriptures bears were agents of divine vengeance, exterminating the children who had mocked the prophet Elisha.

With the clearing and exploitation of Europe's forested borderlands, beginning in medieval times, the fringe and the bear were pushed back. And the bear was displaced from memory as well, emblazoned perhaps in the aristocrat's arms but no longer displayed (as often in the early middle ages) on a family tree as a literal ancestor. King Arthur, whose name is linked with Latin and Welsh words for bear, became the new aristocratic totem. And the dog and bear began to encounter each other in a new marginal zone, the fringe of Europe's growing cities, in open-air drinking places where the chief amusement was observing and wagering on contests between dog and bear.

For Elizabeth I, the bear pit was both personal delight and civic spectacle. She kept dogs and bears at court and protected plebeian bear gardens. When the queen traveled, her noble hosts made her feel at home. A contemporary wrote: "[I]t was a spoort very pleazaunt of theez beasts: to see the bear with hiz pink nyez leering after hiz enemiez approach. . . ." Such bears, costly im-

ports from distant forests as they had been when Caligula had brought four hundred of them from Germany to battle dogs and gladiators, usually held their own against the dogs that were set upon them. The same eyewitness thought it enchanting to watch the shaggy survivor "shake hiz earz twyse or thryse with the blud and the slaver about his fiznamy." But it was clear to which species the future belonged.

It became even clearer as Europeans pushed back the fringe of their dominions in the sixteenth and seventeenth centuries. Spanish conquerors of the New World set mastiffs and wolfhounds on the native peoples, first in the Caribbean, then on the mainland. Rewarded with Indian flesh, dogs were trained to attack and devour the natives on command. With these beasts, the conquistadors terrified bearers and laborers, and forced elites to surrender their gold and silver. The English, for all their professed horror of Spanish atrocities, read unintended lessons in accounts of the ravages of Spanish dogs. By the early seventeenth century they were illegally diverting mastiffs from metropolitan bear gardens and bull pits to help subdue the Indians of the northern woodlands. Dogs were thus the shock troops of what Alfred W. Crosby has called Europe's ecological imperialism, preparing the way for the horse, the pig, and the cow. And this relationship may have existed in the East as well; medieval Poles referred to German warriors as dog-faces.

With the suppression of the European bear garden in the early nineteenth century, the conflict between dog and bear returned to the boundaries of settlement, the forests of Eastern Europe and the mountainous and swampy margins of North America. The bears shared the lot of human fugitives. A letter from a bear hunter published in an 1830 newspaper reported that the ideal dog is one combining the nose of a "deer[-] or fox-hound" with the dog of the kind used in the West-India[n] islands to hunt the maroons

or runaway slaves." Experienced Southern hunters would work bear dogs in teams, led by a veteran strike dog, a bear specialist that had lost interest in other game. Some dogs joined in the attack; others were there mainly to bark.

Decade by decade, the fringe of bear territory receded as the hunters and their dogs advanced. In 1902, Theodore Roosevelt and his party pursued a bear in Mississippi; it took the dogs and hunters several days to find a young Louisiana black bear that killed a dog before it was lassoed and tied to a tree. When the press reported that Roosevelt had refused to shoot it, and a cartoon exaggerated the bear's youth, bear-dolls became a transatlantic hit. But the reality was more sober, and somber. Another hunter dispatched it with a knife. (Roosevelt, who incidentally coined the phrase *lunatic fringe*, detested the dolls.) By the interwar period, the hunters in William Faulkner's story *The Bear* and their dogs were searching the still wild undrained bottomlands of Mississippi cotton country for the awesome super predator Old Ben, *solitary, indomitable, and alone*. It was the dog, Lion, a tamed raider of livestock brought in from the wild, that found Old Ben and was disemboweled in helping bring him down, signaling the beginning of the end of the bear's habitat.

Over fifty years after Faulkner's original story, the fringe is still shrinking. Vacation houses and resorts are penetrating ever farther into it, and animals are receding. Extensive forests have indeed grown back since Roosevelt's and even Faulkner's days, but they are wilderness no more. When bears raid new suburban developments, they go for the dog food. Many of the remaining bear-dogs, unlike the half-feral Lion of Faulkner's tale, have been turned by their radio collars into scent-tracking cyborgs; and the bears they seek are wanted no longer for their fur or meat, but only for a tiny kernel within their massive bodies: gallbladders as raw material for the Asian pharmaceutical trade. In national parks

in North America and elsewhere, authorities "protect" them, but surveillance and tutelage have a price. Increasingly monitored, tranquilized, transported, and shocked by remote control to condition them against garbage raids in national parks, bears are now almost as managed as dogs have been for thousands of years.

The dog's world has changed, too. The great majority of dogs will see bears and other game only on television screens. The fringes that dogs occupy are largely the boundaries of human territories, military and industrial installations. A hundred years ago, European police began to deploy dogs on the fringes of cities as backup for officers and as trackers of human game. The protective dog was no longer the licensed marauder of the conquistadors and colonists but a four-footed civil servant, systematically schooled in the use of force. In the First World War the dog, and especially the German Shepherd dog (existing in its present form only since around 1900)[,] was a messenger, sentry, and paramedic at the edges of conflict rather than a combatant. Early in this century the Japanese began to breed the influence of foreign dogs out of their Akita, burnishing its legend as a native bear-dog of the northern forests, but using it more for protection and ritual display than for hunting. Fanciers invented a special variant of the Japanese language for addressing it and persuaded the government to declare it a national monument, which it remains.

Dogs attack people today no longer in an atavistic, antinomian burst of predation but, often, in a nervous panic: *shy biting*, a behavior first noticed among overbred animals during the Rin-Tin-Tin-inspired Shepherd boom of the 1920s. The dog is no longer our pathfinder in the wooded and mountainous fringe. During the Cold War it even lost some of its ferocity as a guardian; most of the dread Shepherds patrolling the East side of the Berlin wall were unmasked as harmless, tail-wagging pooches, once the barriers fell.

Yet the dog is pushed into other front lines. If the killed bear is mined for traditional drugs, the living dog is an involuntary experimental pioneer of new synthetic ones. Sharing eighty-five percent of our genes and more of our hereditary diseases than any other species, dogs have a partly anthropocentric genome project of their own. A Russian dog, Luba, entered space before the first human cosmonauts and astronauts. And bomb-sniffing Belgian Malinois (Groenendaels may well speak Flemish, but the Malinois are AKC-recognized Francophones) precede American Presidents. But few dogs enjoy or endure these challenges. Most live under a kind of house arrest. Some of these have shock collars that sound warning buzzers when the wearers approach the yard's perimeter, zapping dogs that continue into the forbidden fringe. Whether or not their ancestors chose domestication freely, dogs must live with it.

Within the house they must now coexist with a new and more daunting bear, not the great furry sort but the miniature plush-upholstered ones that have proliferated from a single newspaper cartoon of Theodore Roosevelt and the adorable cub (no matter that the real captive weighed about 230 pounds). Teddy, with stereotypical juvenile features that, experiments suggest, appeal to adults rather than to children, has taken the battle to the dog's literal home turf, the family. His blankly loving expression, his perpetual invitation to cuddle and confide, is the dog's only challenge in its remaining specialty: uncomplicated, unconditional devotion. James Serpell, a biologist studying human-animal interactions, has underscored our ambiguity about dogs. We know that we exploit dogs in tasks that are repugnant to them and can and do have them destroyed almost at will; we also know that they sometimes appear to betray our trust. If dogs never lie about love, teddy bears never have to look guilty.

So, in human living rooms and bedrooms the hereditary rivalry persists, setting canine fecundity against the productivity of global low-wage ursine industry. Toy hospitals report that dog attacks, along with adult revenge, send teddy bear casualties their way. The model for the original Winnie-the-Pooh, belonging to the illustrator E.H. Shepard rather than to A.A. Milne, no longer exists: Shepard revealed in 1970 that dogs had destroyed it during the Second World War.

WHY THE HINDENBURG HAD A SMOKING LOUNGE

8. Innovation and the Future

World's Greatest Futurist

Test-tube babies. Dr. Strangelove. Fast food.
Albert Robida saw them coming.

(Albert Robida, *Harvard Magazine*), Jan.-Feb, 1990

Albert Robida, a French artist and writer born in the revolutionary year 1848, is an odd candidate for the title of World's Greatest Futurist. A tall, gangly man who reminded people of Don Quixote, he loved the past and feared the future. He doted on medieval literature, architecture, and costumes. According to a grandson, when Robida died in 1926 he had never made or received a telephone call.

Yet Robida was uncannily right about our century. He foresaw much of the First World War, the Second World War, perhaps the Third Ward World War. In his art and writings, he anticipated the Russian Revolution, television courses, picturephones, theme restaurants, hydrofoils, country-club prisons, radical feminist lawyers, fast food, revisionist historians, test-tube babies, Dr. Strangelove, Third World militants, and revolution for the hell of it. Long before Disney or *son et lumière*, Robida envisioned historical reconstruction like Disneyland's Main Street and Colonial Williamsburg. He was as adept at sketching comically ferocious Knights in armor as at portraying elephant-snouted natives of the planet Saturn.

Of course, Robida was wrong about some things. The Germans and the Chinese haven't partitioned the United States. Creditors never seized Constantinople for nonpayment of debts. Ex-

cept for Frisbees, there are still no flying saucers, and transatlantic subways exist only on the drawing boards of visionary engineers.

Robida (pronounced roe-bee-DAH) loaded his work with satire and whimsy, which may have hurt his reputation among historians of science fiction—a profession even he didn't foresee—but there's a new appreciation of Robida among academics. One leading scholar in the field, Marc Angenot of McGill University, has written sardonically, "Robida's vision persuades us that what we take to be our Real World is merely the absurd nightmare of a 19th-century petit bourgeois artist who was disturbed by the first electric light bulb and the first stirrings of feminism!"

Robida was certainly celebrated in his own lifetime. A contemporary called him "the Jules Verne of caricature," and he did have a lot in common with Verne. Although Robida was twenty years younger, he began to draw professionally only a few years after Verne's first major novel, *Five Weeks in a Balloon*, appeared. Both rebelled against the careers their fathers had intended for them. Verne dropped out of law school; Robida left his clerk's position in a notary's office. Robida's family was much poorer than Verne's, but both men were provincials who made good in Paris and then left it. By the time he died at the age of 78, Robida had written and illustrated thirty or so books of his own, illustrated at least half a dozen literary classics and books written by his contemporaries, enlivened magazines with thousands of drawings, and produced numerous albums of lithographs and etchings.

Robida arrived in Paris at the age of eighteen from Compiègne, in the north of France, and was soon contributing his drawings to leading satirical journals. The time was ripe for mocking self-criticism. The French press was still under the scrutiny of Napoleon III's censors, but the Third Republic would free it from most restraints in 1871. New high-speed presses helped periodicals to flourish. By 1882 Paris alone had ninety daily newspapers (an all-

time high) and a score of satirical magazines. Department stores were helping to create a modern consumer society. Beginning with the exhibition of 1855, the French government had supported a Paris world's fair in every decade, with the latest technology on display. To an amazed public the changes of those years—electric lighting, the telephone, the phonograph, the Eiffel Tower, the Metro, the automobile—were at least as radical as those of our time. Robida, like Verne, was a fascinated (though alarmed) observer of this new technology.

Robida's first book, *The Very Extraordinary Voyages of Saturnin Farandoul* (1879), was a send-up of Verne, including a mock hero who ventures around the world, and even to Saturn, and has a series of amusingly bizarre encounters with Verne's most popular characters. While Verne provided his eager readers with endless scientific and technological detail, Robida gleefully ignored any fact, physical law, or mechanical problem that might impede the breathless pace of his story. Verne's adventurers are made of iron, Robida's of papier-mâché. Robida's text was often little more than a scaffold for displaying his extravagant and highly imaginative drawings.

In 1880 Robida became the founding editor of a weekly satirical magazine, *La Caricature*. He contributed much of the art himself, especially in the first seven or eight years of publication, and his color covers and elaborate foldouts were superb. *La Caricature* mixed cynicism and social chronicle. It poked gentle fun at the era's fashionable summer resorts, literary trends, art shows, military life, and other aspects of French bourgeois society. But it also portrayed a worldly and amoral city full of showy courtesans, rakish men-about-town, cuckolded husbands, and wayward wives.

One of Robida's first imaginary inventions in *La Caricature* was, characteristically, a hidden video recorder for investigating a

mistress's fidelity. Technological humor soon became a specialty of Robida's contributions to *La Caricature*. In the 1880s, even while editing his journal, he produced two books about the future, intended as satirical warnings rather than actual predictions. *The Twentieth Century* (1883), set in the 1950s, is the story of a young woman seeking to make a career in Paris who quickly discovers the city's remarkable customs and technological marvels. Notre Dame Cathedral has become an airship station with a restaurant spanning its towers. There has already been a "great blowup" of all the world's military powers in 1910, and spontaneous explosions of bombs stored by Russian nihilists resulted in the flooding of Russia in 1920, isolating it from the rest of Europe. *War in the Twentieth Century* (1887) is a story of the mobilization of France's armed forces in 1945 against an unnamed enemy in a confrontation that involves chemical, aerial, submarine, and tank warfare—and even the efforts of a corps of psychics whose brain waves can induce an opposing commander's surrender.

Robida's premonitions of calamity continued to dominate his work. In the early 1890s he published a sequel to *The Twentieth Century,* entitled *The Electric Life,* in which electrical power stations that occasionally malfunction alter the world's climate, creating a new and terrifying kind of electrical storm. Later in the story, there's a deadly leakage of a biological-warfare substance. The exhausted victims of this new age are sent off for rehabilitation in a national park that has been created around a picturesque, unelectrified village in bucolic Brittany. In a young people's serial entitled *The Infernal War* (1908), which Robida illustrated and almost certainly helped author Pierre Giffard to shape, London burns, German soldiers dig trenches in London's Regent's Park, and the Japanese invade San Francisco.

When the chemical warfare and large-scale slaughter of the First World War made Robida's visions of future conflict in *La*

Caricature seem more prophetic than satiric, a Paris publisher reprinted an 1883 issue that carried scenes of an imagined Australo-Mozambique war, with artillery exchanges, poison gas attacks, and submarine battles. Robida's last book, *Engineer con Satanas* (1919), evoked a new Dark Age, in which survivors of a future world war are reduced to using spears, clubs, and bows and arrows.

The other side of Robida's preoccupation with death and destruction was a passionate nostalgia. His favorite novels evoked a romantic past. To him the castles and cathedrals of medieval France represented a chivalrous civilization that greed, industrialization, and utilitarianism were destroying. He deplored photography as an inferior substitute for painting, and he pilloried Émile Zola and other naturalist novelists mercilessly for their obsession with poverty, disease, and crime. A patriarchal father of five sons and two daughters (he was said to have treated his wife as a child too), he scored the liberalization of France's strict divorce laws.

Three kinds of change fascinated Robida: the industrialization of war, the replacement of art with mass-produced culture, and the rise of socialism, feminism, and other movements. As a conventional bourgeois Frenchman, he feared them all. He was a soldier only briefly, during the siege of Paris by the Prussians in 1870, but subsequent events left an indelible mark. During the Commune of 1871 he lived through the bombardment of one of the world's greatest cities, the proclamation of a revolutionary government, and the summary execution of thousands of its supporters by the regular French troops, mostly from the provinces, when they occupied the city. To escape first the radicals and then the government forces, he slept on straw in a damp, pitch-dark cellar. He could tell that the next European war wouldn't be a gallant tourney among cavalry officers.

Robida was no pacifist, even after the shattering loss of a son in the First World War. He told a young interviewer in the early 1920s that France needed a strong land, sea, and air defense. But he also realized that scientific and technological superiority would become as important as the numbers of men and equipment. Some of the new forms of combat in his work were imaginative elaborations of known armaments, such as submarines for underwater skirmishing and assaults on conventional ships, as well as giant cannons that hurled shells containing asphyxiants. Others were combinations of existing weapons, sometimes—as when he mounted heavy artillery on observation balloons—ones that deliberately defied physical law. And new forms of war seemed all too likely, as governments mobilized chemists to produce suffocating shells, lethal sprays, and deadly bacterial agents.

In Robida's visions of future combat, civilians become fair game, and scientists seek superweapons to destroy entire cities. In 1914, H.G. Wells conceived of an "atomic bomb," but the idea of leveling cities was Robida's. As early as the 1880s, he introduced a Strangelovian German inventor named Doctor Fridolin Rosengarten, fighting in the Nicaraguan civil war, who finally blows up his adopted capital to stop the murmuring of the inhabitants. In 1887 he wrote of a substance called The Liquidator that turned the enemy into health-giving mineral water. In *The Infernal War*, a material described only as Plutonite destroys a city.

Robida realized that destruction on such a scale would be psychologically traumatic. In *The Infernal War*, a quarter of all combatants become insane and are taken to special hospitals for what would later be called shell shock. He sensed that the war of the future would be total. Although Europe's colonial empires were at their zenith, he knew they would collapse within generations, and that European dominance would come to an end. Not that he was happy about that: Like other satirists of his day, Robida had

no qualms about drawing Africans as cannibalistic savages and Asians as the Yellow Peril. Yet underlying the racist clichés was an astute realization that what we now call the Third World would eventually come to use European science and technology against Europeans, and against itself. In 1884, he imagined the leaders of African, Asian, and Oceanic resistance to British rule receiving the latest in European military training under assumed names and returning later with their own forces to conquer England—besieging Windsor Castle and the Tower of London, scalping members of Parliament, and driving Queen Victoria into exile.

In *The Electric Life*, Robida predicted that science and technology would spread "about equally over the whole surface of the globe," putting all peoples on virtually the same level. They would possess "the same explosives, the same perfected machines, the same means of attack and defense." In *The Twentieth Century*, he even has a Jewish state with a capital in Jerusalem, and an African capital complete with parliament buildings, heavy industry, streetcars, and a high-rise hotel.

For all his alarm about new media, Robida portrayed them compellingly, and even worked in one. In 1888, he wrote a shadow play for the trendy Chat Noir cabaret about a Paris of the future, its skies filled with lighter-than-air passenger craft; while stage directions may not have survived, silhouetted figures and powerful lighting must have combined to create a memorable animated fantasy. Often, Robida's accent was on the perils of mass culture. In *The Twentieth Century,* traditional easel painting is joined by "photo-painting," the color reproduction of existing masterpieces. Musicians have become obsolete. For a modest annual fee, a handful of pianists, cellists, flutists, and clarinetists produce sounds that can be piped to every floor of a house. Even the culinary arts give way to large "alimentary factories,"

which dispatch entire meals to customers' kitchens via pipes and pneumatic tubes.

In *Stories for Bibliophiles* (1895), Robida and a collaborator named Octave Uzanne predicted that phonographic recordings would supplant printed literature. Walkman-style, people would connect a miniaturized, portable player called the *phono-spirograph* to earphones for "exercising the muscles and nourishing the intellect." In *The Twentieth Century* Robida had described a kind of large-screened cable television (the *telephonoscope*). He and Uzanne describe the *kinetograph*, a similar display for prerecorded programs, including the news of the day: "We will see new plays as easily as if they were performed at home; there will be the portraits and better still, the moving physiognomies of famous men, of criminals, of pretty women. . . . It will not be art, it is true, but at least it will be life itself, natural, unadorned, neat, precise, and often even cruel."

The greatest changes that Robida foresaw were not technological but social. His feelings about them were mixed. The drawings he made during the siege and Commune reveal a man amused and even delighted by the small episodes of revolution (such as former imperial police having shaved their whiskers to join the new republican force), yet horrified by the destruction it brings. In *The Twentieth Century*, France is going through the latest in a series of ritualized revolts to establish a new government every ten years; there are even medals for the most ingenious barricades. A feminist battalion for the rights of women fights alongside the male defenders of the rights of man. Alarming and futile as revolution was to Robida, he seemed to understand its irresistible romantic appeal.

Robida guessed correctly that revolution would lead to unheard-of liberties with the historical record. In *The Twentieth Century*, a fortyish historian named Félicien Cadoul makes a bril-

liant career by "proving" that Louis XIV never existed, and Napoleon never fought a battle. Feminism was silly to Robida, and feminist leaders appear in *The Twentieth Century* as domineering bluestockings. Yet among his few positive characters are young women considering careers in law, medicine, literature, and science. If experience eventually leads them to prefer an old-fashioned marriage to a career, they've got better sense than most men. Interestingly, Robida educated his daughter Emilie to be a successful graphic artist, a career she continued until her married name, Robida-Boucher.

Courtship and even chance encounters by telephone and picturephone occur constantly in Robida. Regular airship services let engaged couples test their compatibility in prenuptial honeymoons, holding down the divorce rate. Polygamy, especially the Mormon variety, also fascinated Robida, and he portrayed a Mormon England in which policewomen escorted men who resisted marriage to bachelors' prison, where women guards attended them. In Robida's twentieth century, the family isn't indispensable: One of his heroes, the first (fictional) test-tube baby, was grown in the laboratory.

In this brave new world, courts sentence convicted criminals to rehabilitation at a rural resort where communal fishing brings out their gentler natures. Robida's antidote to change was nostalgia. He was shrewd enough to see that the destruction of nature and tradition would lead urbanites to seek peace and diversion in the colorful costumes and peaceful landscapes of their ancestors, as in *The Electric Life*'s Disney like park, to which his people of the future return so they can recapture the "peaceful and somnolent nineteenth century."

Robida's chef-d'oeuvre was in fact not a book but a historical display: an entire fancifully created street of medieval and Renaissance Paris built full-size according to his precise plans and

under his direction for the Paris Universal Exposition of 1900. A sumptuous album of the exhibit, produced in color and black and white by Robida, shows the masterly detail with which he brought the old city back to life. Still, he knew that he couldn't really turn back the clock, as he did in one of his later novels.

Robida was alarmed by the pace of his own time, yet he understood that future generations might consider the late nineteenth century a quaint and charming episode. His discomfort with the present seemed to free his imagination to re-create the Middle Ages while at the same time allowing him to see into the twentieth century. Other futurists have missed the mark, with extremes of utopianism or pessimism; Robida sensed correctly that a mixture of delight and horror, efficiency and catastrophe lay ahead. Even his lack of scientific and technological education often worked to his advantage. Undaunted by physical laws and engineering problems he had never studied, he asked himself not what *could* work, but what would be in demand if it could be *made* to work.

There's more than a touch of irony (which surely didn't escape Robida) in the fact that he owed much of his success to the very techniques of mass production and wide-scale distribution he so deplored. He produced few easel paintings for sale; almost all his work was intended for reproduction in magazines and books. A contemporary critic called Robida a happy man who lived in the past and in the future. He was right. Robida looked at the best and worst the future might bring—and grinned at both.

We the Innovators

How People Transform Inventions in Ways they Can't Foresee

U.S. News & World Report, January 2000

Life must be lived forward but understood backward, declared Kierkegaard. Science and technology are no exception. The way to verify our sense of what will be is to live long enough to experience it. In the here and now, our only recourse is to look to the past, groping for analogies. Hindsight shows us that a theory may spark a brilliant stroke—the next transistor, for example—or launch a fiasco like the Soviet discovery in the 1960s of a new state of H_2O called polywater. An idea could be as fundamental as movable type—or as evanescent as the mimeograph.

The explosive growth of new ideas makes these comparisons harder rather than easier. Of hundreds or thousands of concepts that promise to be revolutionary, most will have some hidden flaw or excessive cost. Of the remainder that are technically sound, some will fail politically, socially, or culturally. And of the rest that could work, only a few will have a major, lasting influence on our lives. Personality and chance may count for more than elegance or effectiveness. They are qualities that can tip the scales. Scientific and technical life can be unfair.

First came Sears. Julius Comroe, a physician and medical historian, pointed to the value of the past with the wonderful word "retrospectroscope." Not long ago at a library sale, I found a book that brought home the meaning of that term: A facsimile reprint of the Sears, Roebuck & Co. catalog of 1897, all 786 pages of it. It is a mirror not only of how Americans lived a hundred years ago but of how we see our future today. Sears was the Web merchant of its day, claiming to process between 10,000 and 20,000 letters a day. It had risen just as quickly: It had been incorporated only two years earlier in 1895. Like today's start-ups, it fought ingeniously against its older competitors. The Sears catalog was formatted, for example, to be slightly smaller than that of Montgomery Ward, so that consumers would stack the one atop the other. Sears appealed to consumers in the very same ways that we see in today's television and print advertising for electronic commerce. Just as some of our Web-based businesses lampoon their conventional rivals as seedy, overpriced bumblers, Sears decried the "unreasonable" profits of conventional retailers. It accused jewelers, for example, of spending their days gossiping with neighbor merchants and reading newspapers when they were not "cleaning and polishing . . . the old shopworn goods" to deceive customers. Sears promised absolute honesty and superior service by a staff of up to 700. The catalog, which Sears called "The Consumers' Guide," even suggested that most merchandise would be ordered direct by mail in the near future. Behind this claim was a communication revolution comparable to the Web a hundred years later: While shipments over 4 pounds had to travel by railroad express or freight, catalogs and correspondence could now travel inexpensively throughout the United States, thanks to rural free delivery, inaugurated in 1896. (Even globalization is not new. Sears claimed many international orders.) Like today's Amazon.com, Sears loved to boast about the size of its invento-

ry, in Sears's case a five-story building occupying a whole Chicago city block. Sears claimed to offer "everything in books." Its cavernous stockrooms adorn the catalog pages. Sears even sold a large line of groceries. The people of 1897 believed they were shutting out intermediaries, going directly to the cornucopia of consumer goods that, on the catalog cover, poured out onto the American farmland.

We are no longer living in a mainly rural country where "every farmer, ranchman, and mechanic can be his own blacksmith" (and cobbler and harness maker), as the catalog promised. But many of the controversies of this turn of the century are already visible. Doubtful medical information and addictive drugs? There were pages of patent remedies and even tincture of opium (laudanum). Cheap firearms on the street? The "Department of Revolvers" offered the Defender ("safe and reliable") for 68 cents plus a dime for postage.

But what of all the vast changes over a century and those to come? For these, too, an old catalog can help ask the central question: Why do the great innovations turn out to be such surprises? It is not because the science or technology is necessarily new. It is because along with the material side of innovation, technology, there is a more elusive but equally important behavioral side: [t]echnique. Objects don't materialize and change life. Rather, people find unexpected ways of using new things, ones the inventors might not have taken seriously. There is no saxophone among the catalog's musical instruments, though it had been invented in France decades earlier, mainly for military bands and symphony orchestras. Swing and jazz musicians reinvented the sax. And many brilliant ideas remain curiosities because they require exceptional technique. The theremin, a 1920s electronic instrument that ultimately led to today's advanced music technology, had no

moving parts but demanded such perfect pitch that only a few musicians could ever use it for concerts.

Communicating, like making music, demands techniques that change over time. All the instruments in the catalog were still acoustical, but telephones were also on sale there. Of course there were constant refinements, but users were already developing techniques for using a phone—the unwritten conventions and etiquette of conversations—which have not changed radically since then. These techniques remain even more important than the technological possibilities of communication. For example, the video telephone, already imagined by the French science fiction writer Albert Robida in 1883, was demonstrated as early as the 1964 World's Fair in New York. Home units were available early in the 1990s, and there are now inexpensive cameras and microphones that make Web conversations possible. But there is still no stampede to use them. Why? The camera would add an unwelcome burden to the technique of conversation. You would need to look your best, be careful about facial expressions (you're being recorded), and perhaps be forced to tidy up the visible background.

Automobiles existed in 1897 but do not appear in the catalog; they were still for wealthy urbanites. Henry Ford's genius was less in the technology than in the technique of car manufacture and design. He not only organized new workers to assemble the cars; he turned automobiles into tough, versatile powerhouses of rural America, with drive shafts that could work wonders with farm machinery. The Model T and other easily serviceable cars in turn helped educate a generation of Americans to be master tinkerers. Today some bold people still tweak automotive software for improved performance, but unlike Henry Ford, manufacturers now frown on modifications that might expose them to liability. The world of Ford, and of the Sears catalog, was amazingly open. There was even a page of watchmaking tools. The early 21st cen-

tury at least will be a time of opaque assemblies, components that can only be diagnosed and swapped, not fixed or improved. Today's major applications-software packages are written by teams often so large that no single person fully understands them.

The relationship of technology to technique is not limited to how people use and change things. Even more important can be the new and unexpected patterns of living that arise because of them. Thomas Edison's incandescent electric light—now the archetype of the brilliant idea—appears nowhere in the catalog, but central stations and wiring had already been spreading through the world's great cities for over a decade. The light bulb seemed to be a cleaner and safer alternative to gas jets and oil lamps, but in time it was much more. Just as the railroad was closing America's spatial frontier, the electric light was opening a temporal frontier, as the sociologist Murray Melbin has observed. Before it, the high cost of illumination dictated the rhythms of day and night and ensured that most people slept between nine and 10 hours a day. Shift work was rare.

Sleep Deprived

The electrical age that Edison inaugurated opened up the night for new kinds of entertainment, from the cinema to the Internet. According to the National Sleep Foundation, Americans are getting 20 percent less sleep than they did a century ago. The Web encourages long hours even more than television because it is fastest late at night. And the pace of competition requires more people to support the 24-hour, 7-day-a-week style of electronic commerce. Most of the hot firms' employees are not affluent technical staff but front-line warehouse and customer support workers. A memo announcing a midnight [e]-mail-answering marathon at one of these companies bore the headline "You Can Sleep When You're Dead." High school and college students are chronically sleep de-

prived, but that did not prevent one Ivy League career services director from recommending a Web recruiting site as "a valuable resource for students, who, if they so choose, can do all their job searching at 3 a.m." And as technology promotes sleeplessness, it also makes it more dangerous, whether in medical staff, equipment operators, or drivers. Today's $300 clock radios may be more polite buglers than Sears's $1.40 "Must Get Up" alarm clock of 1897, but the message is the same.

The revolution of the workplace does not seem evident in the Sears book, which has no fountain pens, let alone typewriters. Still, the catalog portends our time, and at least the near future: It ushers in the great age of paper. Early in the personal-computer era, futurists dreamed of paperless offices. Some still believe the Web will save trees. But they did not reckon with the techniques that arise in response to electronic technology. IBM passed up a chance to invest in the Xerox Corp. because its consultants saw dry copiers as replacements for the relatively small number of Photostat machines and did not realize the hundreds of new applications that users would find, including new genres of art. Laser and inkjet printers, the latest incarnations of dry copying, are used to process only a tiny proportion of all electronic data. But because the data are expanding so fast, more and more sheets are printed. High-contrast, flat-screen monitors are on their way, but it is not clear that any design will ensure both sharp text and bright color soon. More people will be getting their financial statements online, but they will want to run paper copies just to be safe. And one of the fastest-growing categories of computer products is premium-priced decorated and textured paper for promotional advantages missing in a Web site on a monitor.

Technique makes a vast difference among designers as well as among users. The products in the Sears catalog had to be designed with drafting instruments like the ones it sold. Today's electron-

ic tools, computer-assisted design (CAD) and computer-assisted manufacturing (CAM), make possible objects and structures that would have astounded the people of 1897, from Chuck Hoberman's spiky polyhedrons that miraculously self-expand into spheres to Frank Gehry's stunning buildings. The crucial element is not the machine but the creative ability to get the machine to do something new, something the machine's inventor probably did not think of. And innovation is often best when necessity or luck brings people into new fields. Consider the sneaker, early versions of which Sears was already selling. Many of the people who transformed athletic shoes in the 1970s and 1980s were strangers to the footwear industry. Nike's rise, for example, depended not only on Steve Prefontaine and Michael Jordan but also on coaches (Bill Bowerman), biologists (Ned Frederick), aerospace engineers (Frank Rudy), and architects (Tinker Hatfield). This is not new; Samuel Morse was a renowned painter before he turned to invention. But design revolutions are likely to be even more feasible in the future—and more perilous. It's one thing for a radically new running shoe to break down prematurely, as many early models did. It's another for new bridges and buildings to fail after a decade or two because simulations could not anticipate long-term changes in materials, uses, or environmental conditions.

The hidden long-term risks of new designs remind us that the Web economy is still so new that it is hard to say how robust it is. The original 1897 Sears catalog and other 19th-century reading materials have been crumbling because the hidden price of cheap paper was excessive acidity, which slowly destroys it. But even the poorly printed image has staying power. In the mid-1960s a history professor tracked down a rare remaining copy of the catalog and arranged a reprint edition. Now there are again thousands of copies, each of which might be a master for a new reprinting. Microfilming and photocopying to archival-grade materials can

preserve images for 300 years or longer. But can we say the same of documents of the Web economy? The electronic world, unlike the printed record, is evanescent. In 1996 I participated in a Discovery Channel Online summit on technology and design, produced by a gifted interviewer and marvelous designers. By 1998 it was unavailable on the Discovery Channel Web site. There is a commercial Web archive that downloads millions of Web pages and deposits tapes with the Library of Congress. The symposium may or may not be on one of the tapes or the company's servers. Suppose it is. Who will pay for accessing tapes? If copyrighted photographs were originally licensed by the sites for only a year or two, as those of the summit reportedly were, is it even legal to put them back on line? (Imagine a printed book with self-destructing illustrations and footnotes.)

Links to Nowhere

What will happen when online formats and browsers change, and then change again? Knowledge is imploding as well as exploding. Of course, some of the process is social forgetting; today's *Encyclopaedia Britannica* is not much longer than its predecessor listed a hundred years ago in the Sears book, partly because some subjects have been dropped to make way for others. But technological oblivion is a different and newer threat. No more hardware exists for some old tape formats. Devices only a few years old, like my Avatar Shark removable drive, can be suddenly orphaned when their makers go out of business. Floppy disks, magnetic tape (including video recordings), and even CD-ROMs are all decaying insidiously. Old software for converting archaic, i.e. 20-year-old, file formats won't work on current machines; their clock speeds are much too high. Commercial data archivists and librarians are discussing ways out, but they are far from a solution. Indeed, at

least one prominent site devoted to the preservation of Web data has several links to vanished pages.

Why wring our hands about the fate of obsolete information at the beginning of a new millennium? It's because we never can anticipate what posterity will want to know. The rediscovery of a text of Archimedes—visible thanks to new imaging technology—excites not just historians but mathematicians, who find inspiration in his methods. Yesterday's codes and ciphers offer ideas for today's and tomorrow's cryptographers. The treatises of 19th-century biologists are vital for preserving the genetic diversity that we will need for the next millennium's crops and pharmaceuticals. The technologies and techniques of the future will almost certainly continue to need small but crucial parts of our heritage. My Sears catalog reprint will always remind me of the naturalist Aldo Leopold's dictum: The first rule of intelligent tinkering is to save all the pieces.

Future and Assumptions

Britannica Yearbook of Science and the Future, 2000, pp. 114–29

Other primates, other orders of mammals, and some birds used tools. Chimpanzees even have regional cultures with distinctive ways of handling them. Humanity, however, is unique among animals not only in apprehending the future mortality of physical self but also in envisioning technologies beyond the individual lifetime and in the ability to invest in structures lasting many generations. African termite mounds are magnificent constructions, but a single rainstorm may destroy them. On the other hand, some ancient Roman buildings and other public works are still in use. We are a species of implicit futurists.

Our capacity to imagine coming things is not so easily exercised. Those who make predictions rarely escape bias—and of two kinds. Men and women who develop, produce, and market new technology need exceptional self-confidence. They see their products and themselves as agents of radical improvement. Yet venture capitalists remind us that of a hundred firms with a new idea, only a handful will ever be viable. In business circles, potential riches coupled with insecurity encourage the boldest and most radical predictions of social transformation. Even many scientists have financial interests and business ties that interfere with dispassionate assessment.

Social critics have biases of their own. Their careers may depend on opposing a conventional optimism that might well turn

out to be correct. Just as manufacturers and software producers have products to sell, critics have books and lecture tours to promote. To stand out, they may have to be bold. Nevertheless, their forecasts may overlook possibilities that neither they nor technology enthusiasts had foreseen.

There is no simple escape from either pitfall, but the history of technology can help us think about the future by recognizing and questioning our assumptions. As our tools for measuring and calculating grow in power and speed, the weak point in our thinking is more and more likely to be in our tacit understanding.

One way to approach this dilemma is to look back a hundred years, to one of the most versatile and gifted young reformers of his time, and to use his career to show the pitfalls of several categories of assumptions over the last century. History cannot predict, but it can expand our outlook and prediction.

One of the outstanding figures of the early 20th century was the economist Irving Fisher (1867–1947). First in his undergraduate class at Yale University, Fisher studied with two of the greatest American thinkers of his time, the mathematician and physicist Josiah Willard Gibbs and the sociologist William Graham Sumner, and wrote Yale's first PhD dissertation in economics. By 1898, he was a full professor at Yale.

Fisher had boundless and generally justified self-confidence. Although organized futures research was beginning only at the time of his death, Fisher was prominent in many of the advanced technology movements of his own era. He insisted that mathematical techniques should be used for practical goals. He dedicated himself not just to the advancement of economic theory but also to the enhancement of human life through science and technology. A wrong assumption, however, entangled his career and overshadowed his reputation.

Fisher was farsighted about many things. After contracting tuberculosis in 1898, he became a crusader for hygiene, exercise, and healthy living and coauthored a textbook, *How to Live* (1915), which ultimately sold more than 400,000 copies domestically and was translated 10 times. The Life Extension Institute, a preventive medical clinic he helped found in 1913, is still active.

An inventor since grade school, Fisher became a pioneer of the information age with a patented index-card system, a forerunner of today's rotary card files, which made him a wealthy man when Kardex Rand (the forerunner of Remington Rand) bought out his company in 1925.

Unfortunately for Fisher, his greatest public attention was to come from none of these accomplishments but from a prediction he made in October 1929, only 10 days before the stock market's precipitous fall, that stock prices appeared to have reached "a permanently high plateau." Fisher lost as much as $10 million in the market crash, and although he continued to advance measures to rescue the economy and continued his other crusades, neither his personal finances nor his popular standing as a prophet ever recovered.

What makes Fisher's case so fascinating is that recent studies have shown that his forecasting methods were justified from the data available to him, even with today's more advanced techniques. It was his assumptions about other factors in the economy, including the role of speculation and fraud, that proved to be Fisher's downfall. All his mathematical mastery—which gave him insights fully appreciated only decades later by a new generation of researchers—could not overcome these gaps. Fisher's history can give us clues to thinking better about the future.

Assumption: The Century/Millenium as a Unit

Consider how we think of epochs. Behind our fascination with the year 2000 (or 2001 for some purists) is not only that it is a round number. It is also the perception that a century or a millennium conventionally represents a natural milestone in human affairs.

Fisher's own birth and death dates, however, suggest an alternative view. Seventy-five or so years, a full human lifetime, are often a better measure. Politically, 1867–1947 marks a more distinctive era than the 19th or the 20th century as we know them. It coincides with the rise and fall of Germany's aspirations to world power, from the Prussian defeat of Austria in 1866 to the German surrender in 1945. The Meiji restoration in Japan's epochal modernization began in 1868. Technologically and economically, as well as diplomatically, America's surge also began after the Civil War.

The period from the Russian Revolution of 1917 to the breakup of the Soviet Union in 1991—74 years—has also been called the "short 20th century," marked by the reactions of the West to the prospect, and failure, of world revolution.

Some epochs can last considerably longer than 100 years. In Japan, the Tokugawa Shogunate that preceded the Meiji restoration had endured for nearly three centuries, from the early 1600s, and is often considered as a single period: Edo, from Tokyo's pre-Meiji name. In the West, historians often write of a "long 19th century" lasting from the French Revolution to the outbreak of World War I.

Our vocabulary is telling *prewar, postwar, interwar*; or *antebellum* and *postbellum*. Fisher lived through two great convulsions and many smaller ones. Today, despite nuclear proliferation, it is hard to imagine another great conflict of global alliances. Both optimists and pessimists tend to project into the indefinite future our present trend of the rise of world market economies,

and especially of global corporations, replacing the struggles of the great powers.

For near-term forecasting, this basis appears to be the most reasonable one, and, indeed, the present trend may persist for 75 years or 120 years or longer. It could also be reversed, and our beliefs about the future come not so much from rigorous analysis as from our lived experience. Fisher had every reason to expect a glowing future. He had married young into a wealthy family and had never experienced an economic depression. In the months before the 1929 crash, he had expanded his personal staff of secretaries and assistants with a costly home addition and had bought a luxury car. He must have been reluctant to consider negative scenarios.

All this does not mean that we should be pessimists or optimists but, rather, that we should be explicit about how we periodize our world and be ready to defend the landmarks that we choose in time. The millennium is an invitation to do this, but not a substitute for it.

Assumption: Technological Succession

Fisher's life reveals not only the difficulties of periodizing but also the coexistence of the periods—the life spans—of multiple technologies. There is a German phrase for this, *Gleichzeitigkeit des Ungleichzeitigen,* literally "simultaneity of the non-simultaneous." It is another way of saying that old things coexist for a surprisingly long time with new ones. We should avoid the assumption that changes in our lives will be a serial process of succession.

Consider information technology, Fisher's key invention, an index card having a notch that moves along a rail, built on a well-established principle—the rod that keeps library card catalogs in place. Libraries have been shifting to electronic catalogs, but thousands have not yet converted. In fact, some still use the

splendidly crafted original oak files from the American librarian Melvil Dewey's Library Bureau after more than 100 years.

More to the point, after further refinement, Fisher's idea remains an office mainstay more than 85 years after its introduction. Computers and personal organizers have scarcely displaced the rotary card files sold under the Rolodex and Bates trademarks. Business cards are as important as ever, and it is far easier to insert a card into one of these devices than to enter the data by hand. Likewise, it is usually easier to look up an address or phone number by twirling the knob of such a file than by launching a personal database program. In practice, name-and-address software is often used to print the data on sheets of die-cut, separable cards or in address books. Contrary to much 1980s speculation, in fact, computerization has multiplied rather than reduced paper consumption.

Paper turns out to be essential especially for advanced electronic work. Even the largest conventional computer monitors are much too small to represent the components of complex multimedia projects. These need storyboards of scenes or texts assembled onto large pieces of cork board or similar material. To affix these papers most professionals use pushpins introduced by the still-thriving Moore Push-Pin Company of Philadelphia in 1900. The pin's profile has changed little and is optimal for the purpose. Likewise, the mathematics faculty of the Institute for Advanced Study, Princeton, New Jersey, requested not just the latest in workstations and software for their new building but also slate blackboards, for which newer technologies such as colored markers on white surfaces are no substitute. Old and new are often symbionts rather than competitors.

Some older technologies may be surprisingly resilient for other reasons. Mechanical voting machines, for example, are expensive and cumbersome and need strict scrutiny against fraud. Neverthe-

less, many computer security professionals are concerned about their replacement by fully electronic systems. It is not yet clear whether it is possible in principle to build an electronic voting system that is fully secure and fully anonymous at the same time. Measures for authenticating electronic voting seem to make results traceable back to individual voters in a way that conventional mechanical counters do not. Internet-based voting systems could have similar problems. In fact, were it not for the anonymity issue, a system of passwords and personal identification numbers could have made possible telephone voting by voice mail menus.

Just as some categories of well known, apparently simple mathematical problems are expected to resist solution by the most powerful computers that even the cornucopian futurists now foresee, so also may there be areas of life in which older technology will remain firmly entrenched. In fact, a surprising number of our everyday things have changed remarkably little in the last 100 years. Instead of promoting radically new principles, advanced technology often extends the life of older ones. Internal combustion engines, for example, have persisted for more than a century despite recurrent complaints about their noise and pollution. Electronic communication and on-line shopping have had no measurable effect on distances over which these engines are driven. On the other hand, computerization has transformed the old engine design. Not only does computer-aided design (CAD) software draw and simulate new engines more rapidly but electronic systems in the engines themselves also help reduce noise and vibration to make them environmentally and economically competitive with electric- and natural-gas-powered models.

Historians of science and technology point out the high number of current technologies that are at least 100 years old. The first facsimile devices were introduced in the 19th century but found no market. A 1998 book on the telegraph is titled *The Victorian*

Internet, but it would be equally correct to call electronic mail a highly advanced and flexible form of telegram. Today's elevators may use advanced fuzzy logic—programming that uses probabilities rather than rigid decision patterns in responding to changing conditions—to reduce waiting times, but the concept of the elevator itself has changed little.

The safety razor shows how decades and perhaps centuries of refinement can succeed a single rapid innovation. King C. Gillette introduced his new product in 1903, and by the end of 1904 he had sold over 12 million blades. The company he founded still dominates its category. Its latest razor product has three blades and several other advanced features, yet it remains much closer to the principle of a single disposal blade than Gillette's first product was to the ancient but potentially lethal straight razor—still available and still producing the best shaves in expert hands.

Indeed, the approaching crisis of many computer systems unprepared for the year 2000 has revealed how much vital computer code is reused for decades. Conversion projects have brought many veteran programmers out of retirement.

Assumption: Technological Determinism

Razors bring up yet another issue in prediction: the complex interaction of technology and culture. One error is to imagine invention inevitably begetting other innovations. Fisher gave little thought to values beyond health, prosperity, and efficiency—that was one of his limits. Patterns of culture, ideas, and values, however, are essential in considering the future. The manufacture and sale of razor blades depend largely on standards of dress and appearance for both men and women. Steam irons, synthetic fabrics, and permanent-press finishes have much to do with a society's view of wrinkled apparel. Many early enthusiasts of the telephone, reflecting the same educated, genteel milieu as Fisher's, predicted that

it would be used to deliver sermons and symphonies. (They were not entirely wrong about technology and religion; in the proudly modernizing Iran of Mohammad Reza Shah Pahlavi, cheap tape cassette recorders in the 1960s and '70s allowed the underground religious opposition to circulate the sermons of the exiled Ayatollah Khomeini.)

A related deterministic assumption sees technology inexorably shaping culture rather than, or in addition to, shaping further technology. The mistake is expecting that innovations in themselves will change patterns of living. Many architects and designers of the 1920s and '30s believed that the common people would embrace dwellings and furniture designed around new materials like steel to proclaim their emancipation from the overstuffed world of the 19th-century bourgeoisie. Instead, the masses clung to upholstered comfort and disliked the award-winning structures designed for their benefit. Today, although buildings and furniture incorporate many new materials, their forms, especially in housing, are likely to be Victorian or Georgian as streamlined "modern" in inspiration.

New technology often embodies and extends existing trends in taste. Consider motion pictures, another technology that rapidly reached a high level and since has grown more in sophistication than qualitatively. The spectacular, audience-riveting action of early films, like Thomas Edison's *The Train Wreckers* (1906), were not unprecedented consequences of the new medium. To the contrary, as Nicholas Vardac showed in his 1949 book, *Stage to Screen,* early cinema made it possible to exhibit nationally and internationally the kinds of advanced effects that were already drawing audiences to the best-equipped metropolitan theaters. Those stages displayed elaborately painted panoramas as much as 120 meters (400 feet) wide and 18 meters (60 feet) high and presented effects like simulated molten lava and jockeys riding

live horses galloping on treadmills. Motion pictures did not create taste as much as they expressed it.

The modern bicycle appeared at about the same time. As the Dutch sociologist Wiebe Bijker has argued, its emergence depended not only on technical innovations like pneumatic tires, but also on complex relationships among groups of users. The upper-middle-class women who could have afforded cycles still wore stiff corsets, so early customers were athletic, affluent young men. The hazards of the high-wheel penny-farthing cycle—a bottle on the road could pitch a rider into a long, headfirst fall—actually enhanced its macho appeal. With pneumatic tires, a chain and sprocket drive, and a freewheel mechanism, the path was open to a "safety" model that appealed to young urban women seeking fresh air and exercise. It could also outrace the old penny-farthing design, which soon became a curiosity.

The Internet also is partly a response to established trends. Since the end of World War II, a host of new interest groups, hobbies, associations, and movements had been building memberships and establishing newsletters and mailing lists. In the same period, direct-mail marketing had boomed. By the 1990s millions of people were already accustomed to seeking out new affiliations and products through the mail—and to spending hours sitting before a screen (the TV) and using a handheld device (the remote control) to navigate. The Internet is, in one sense, the expression of a style of getting information that had been developing for years.

Of course, invention does help to change culture. Internet content reflects the public's long-term appetite for gossip and erotica that was evident even in 1950s media like *Confidential* and *Playboy* magazines. In applying such appetites to political questions, the Internet has reactivated an even older strain of American journalism, the scene of often[-]raucous local newspapers and pamphlets that flourished until the rise of more staid metropolitan

newspapers in the later 19th century. Today's scandalmongering World Wide Web sites like the Drudge Report would not have surprised many earlier 19th-century newspapermen.

Subtle cultural points can also block technically feasible and social plausible innovations. Videophones have been produced and marketed since the 1960s, yet in contrast to the Internet, they have largely failed. The great majority of our telephone conversations are not with the intimates with whom we would want a form of eye contact. They are often with strangers, and even though users could always turn off their own camera, there would always be the possibility of pressure to keep it on. This does not mean that our descendants might not use them but only that society and its assumptions about communication would have to change before they did.

Unfortunately for forecasters, culture does not take place on easily definable axes. Apparently contradictory trends can move in tandem, for example, faith in conventional biomedical technology and in alternative healing and herbal remedies. Opposites may be only apparent. For people conditioned to believe that there should be a remedy for all ailments immediately, "natural" medicine is yet another technological resource. Because scientific advance reinforces a culture of hope and expectation, paradoxically it is likely to continue to stimulate interest in the ideas of its holistic critics.

Assumption: Control

To Fisher and his optimistic contemporaries, nature could be understood and controlled. Underestimating the complexity of natural interactions, most of them still aimed at mastering, rather than working with, the rest of the living world. The 1920s saw a boom in Great Plains agriculture, partly on the theory that "rain follows the plow," that human activity would modify natural patterns to

support itself. One reason for the severity and persistence of the Depression was the resulting erosion of topsoil in what became the Dust Bowl.

We now understand that technologically based human activity has become part of nature. As Steven Pyne suggests in the accompanying special feature article "The Uncertainties of Environmental Forecasting," we have created an "industrial ecology" that makes Earth's future depend on our decisions on a global scale. The transportation technologies that have promoted regional and intercontinental human movements also create unexpected new biological regimes for humanity. Animals, plants, and microorganisms have been extending their range, sometimes prevailing in regions where they had been unknown.

The AIDS virus, one of the 20th century's more horrific surprises, is almost certainly not a new organism, but a series of technologies have made it a medical burden often compared to one that seemed conquered—tuberculosis. (Fisher's rare victory over the TB that threatened his life 100 years ago redoubled his energy and transformed him into a medical and social crusader). Long-distance trucking in Africa and hypodermic delivery of narcotics elsewhere have created an industrial ecology of disease. Blood banks have transmitted the virus inadvertently, and there is always a risk that tests will fail to identify new mutations. Likewise, relatively recent forms of duck and pig farming in China, together with air travel, have transmitted new strains of influenza virus around the world. In his accompanying feature, "Surviving the New Millennium," Robert Desowitz points to the resurgent risk of malaria in the United States because of population movements.

New technological systems can interact in bizarre ways with the living world. Investigation of the fatal 1976 outbreak of Legionnaires' disease revealed that the bacillus, soon called *Legionella*, was a surprisingly common one in the natural waters of the

northeastern U.S. As many as 15,000 people may suffer from it annually in the U.S. Because *Legionella* multiply at temperatures of about 25°–40° C (77°–108° F), they remained isolated until the widespread appearance of recirculating cooling towers and evaporative condensers—with their reservoirs of warm water—for climate control in buildings and industry and of whirlpool baths. The rise in popularity of central air conditioning and whirlpools reflect cultural as well as technological change.

Even machines can be indirectly at risk. The first generation of biocides reformulated against *Legionella* contained minute traces of tin that, once vaporized, were transported through air ducts and contaminated the heads of nearby computer mainframe tape drives, disabling data-processing centers around the United States in the early 1980s. Only rapid detective work by a team of IBM scientists, relocation of the hardware, and later reformation of the biocide averted disaster.

The Unassumed Future

If there is any tendency that our assumptions have in common, it is to imagine the future as an extended extrapolation of our recent experience. Not only Fisher but also most other leading social prophets have fallen into this trap. In a 1955 book, the great Hungarian-American mathematician John von Neumann predicted control of the weather and nuclear power too cheap to meter—both by 1980. David Sarnoff, head of RCA, predicted "a much shorter work week." The experts, nevertheless, are sometimes right in the long run. Fisher was being too cautious as well as too sanguine in 1929 when he said the market would continue at its peak. The postwar boom went beyond his wildest expectations, even though many of the companies in which he had invested were bankrupt in the Depression.

Although we should assume and extrapolate almost nothing, there is at least one trend on which optimists and pessimists about the future agree, without fully realizing it. It may be the basis for a new and more productive round of discussions of the future.

The future will be managed—that is, more and more things will be measured and controlled. One of the strongest tendencies in the later 20th century has been the application of electronic, chemical, and genetic knowledge to specify and tune the performance of a wide variety of manufactured and living things. Notebook computer owners, for example, are familiar with the power-management software that extends time between battery recharges. Battery technology has lagged the demands of faster processors and showier screens, but optimization can squeeze more minutes out of an hour.

Our behavior is already more extensively manipulated than we realize; businesses employ consulting mathematicians to compute the optimum time for keeping customers in a queue for service. In his accompanying article, "Communicating in the Year 2075," James Katz suggests another kind of management, the creation of new social codes to shield people from abuses without denying the benefits of new systems.

But management extends beyond the technological, to what was once considered the natural. The only way to save the diversity of life on Earth appears to be international cooperation affecting more than delimited protected areas, few if any of which were ever free from human influence. (For example, fires set by native Californians suppressed the "natural" scrub vegetation in favor of more diverse stands of oak. Controlled fires may be needed to retain these habitats.) At least one important conservation biologist, Daniel Janzen of the University of Pennsylvania, sees no future for whatever wilderness remains; species can be preserved only in "wildland gardens" where nature is manipulated to preserve

diversity. The roles of governments, international organizations, corporations, and indigenous peoples in management would have to be worked out. If such a plan succeeds, however, the wilderness as a source of awe is likely to be lost in the next century, even if its genetic heritage can be largely preserved.

The fact that the world will be more controlled in the future does not necessarily mean that it will be more predictable. The scenarios imagined by Gregory Benford in the accompanying feature "Expecting the Unexpected" illustrate a fundamental uncertainty about the centuries ahead. The American philosopher Nicholas Rescher has argued that it is impossible either to predict the future course of science or even to declare a question insoluble. Great scientists sometimes speculate on the agendas of their successors, but they are no more likely to foresee them than the great 19th-century physicists were able to sketch the outlines of 20th-century theories of gravitation and relativity.

Nor can we always predict what will happen to the ideas that we are formulating now. Some tasks are much harder than they appear. The French mathematician Pierre de Fermat's last theorem seemed simple enough to tempt countless amateurs, yet when a proof at last was published after more than three centuries, its length and complexity were daunting even to some accomplished mathematicians. Other research has consequences that almost defy imagination. Number theory, a 19th-century mathematical sidelight, became a foundation of cryptography; a Polish mathematician's analysis of the German Enigma cipher machine began the program that proved essential for Allied victory in World War II. It is quite possible that some of today's most abstract ideas, such as string theory, will have deep and socially radical implications in the next century.

There are no theoretical obstacles to some discoveries that have so far been elusive—for example, much cheaper and more

abundant energy sources after the false start of nuclear fission reactors and the slow development of fusion. Even the Romanian economist Nicolae Georgescu-Roegen, a pessimist, acknowledged the possibility of what he called a Prometheus III, succeeding the two previous generations of carbon-based fuels, wood and coal-petroleum. Moreover, we are far from the theoretical limits of efficiency and of emissions reduction in our use of existing sources. Indeed, the technology analyst Jesse Ausubel of Rockefeller University, New York City, has pointed out that we have been using steadily less fossil carbon per unit of output since the early 19th century.

Control also will have other constraints—the changes in fashion that have been a feature of life in early modern and industrial societies. If, for example, the wealthy attempt to produce "ideal" children through genetic manipulation, these offspring may find that once they have become adults, the body types, physical traits, and temperament that have been engineered for them have gone out of fashion, just as the ample male and female ideals of Fisher's youth gave way to the slender types of the 1920s.

The most likely outlook for the future, as the previous century's evidence and the reflections of our millennium-section contributors suggest, is a delicate balance between our expanded capacities to modify nature and society and the tendencies of both natural and human systems to exhibit novel behavior not accounted for in previous models. Fisher, who beat the most lethal disease of his time, would have seen this as reason not for despair but for redoubled effort.

The Future is a Foreign Country

How we choose to think about what lies ahead may be more important in creating a future we can comfortably inhabit than all the technological change tomorrow will bring.

The Wilson Quarterly, Winter 2006

In the early 1990s, I visited the Princeton house in which Albert Einstein had lived while a professor at the Institute for Advanced Study from 1936 until his death in 1955. It was one of many graceful Greek Revival structures built in the 1830s and '40s by a Massachusetts-born carpenter-architect, Charles Steadman, in what eventually became the fashionable western part of Princeton. For me, the real surprise in the house was Einstein's furniture, which had remained there as the property of the Institute. In the living room were several massive wooden cabinets in the neo-Renaissance style beloved by the upper-middle class during the opulent years after German unification in 1871. Einstein was known to scorn the pomp and formality of his bourgeois contemporaries. Why, then, were these giant pieces dominating the small, low-ceilinged space? One explanation is that the furniture had been inherited by Einstein's wife and cousin, Elsa, whose

tastes were more conventionally German, and for whom the pieces may have been a precious link to an otherwise-lost heritage. But that does not explain why Einstein kept them after her death and left them to the Institute in his will (though he stipulated that his house never become a personal museum or shrine).

The example of Einstein is a good introduction to certain dilemmas of contemporary thinking about the future, whose border we are always crossing. The first dilemma is whether to assume that changes will continue along current lines, or that offsetting forces will neutralize or even reverse them. This is a choice between extrapolationism and compensationism. The second dilemma is a choice between affirmation and balance—that is to say, between whether we should accommodate our tastes and surroundings to scientific and technological change or live a countervailing life. Einstein is a compelling figure for the study of futurism because values—the key to all futurism, no matter how objective it purports to be—were so important to him. The physicist Gerald Holton has underscored, for example, the influence of Goethe and German romantic philosophy on Einstein's quest for the unification of physics.

Let us consider, then, the merits of extrapolationism versus those of compensationism. Einstein and his scientific contemporaries had different ways of looking at future tendencies. The Hungarian-born physicist John von Neumann (1903–57), who believed in the generally benign power of future technology to improve the lot of humanity, could be called a conservative extrapolationist. In *The Fabulous Future,* a book of essays about the world of 1980 sponsored by *Fortune* magazine in 1955, he envisioned that atomic power would make energy too cheap to meter. He expected this almost-free energy, along with computer power, to enable us to select our climate, and he thought that we should be prepared for serious domestic and international debates

over how to use these newfound abilities. Though von Neumann's assertions have often been ridiculed, positive extrapolationism has sometimes proved justified. For example, reasonable flat charges for unlimited long-distance calling plans have been spreading, and most individual subscribers today pay a low flat fee for virtually unlimited Internet surfing. (Von Neumann's article, I should note, did not discuss these costs of information.)

Even in matters of energy, von Neumann's extrapolationism was not entirely wrong. Looking at the history of illumination from the domestication of fire by *Australopithecus* 1.42 million years ago to the introduction of the compact fluorescent lamp in the early 1990s, the economist William D. Nordhaus observed that the efficiency of lighting had increased from 0.00235 lumens per watt to 68.2778. From the heyday of ancient Babylonian oil lamps around 2000 B.C. to the early 19th century, the rate of increase in efficiency amounted to 0.04 percent per year. But in the two centuries between 1800 and 1992, it was fully 3.6 percent per year—and the quality of illumination was higher. So there had been a 1,200-fold improvement from Babylonian times to 1992. Nordhaus suggested that economists had been underestimating rather than exaggerating the impact of technological change on productivity and living standards. Today, rural Third World children can read by a light-emitting diode (LED) drawing only a tenth of a watt. A hundred watts can serve a whole village, according to the electrical engineer Dave Irvine-Halliday, founder of the Light Up the World Foundation. It is as though the 100-watt bulb in the architect lamp on my desk as I write this were divided into literally a thousand points of light.

Computing power has been increasing even more rapidly than lighting efficiency. The electrical engineering magazine *Spectrum* recently observed that, since the 1960s, the cost of producing transistors has dropped "from a dime a dozen to a buck for a

hundred billion." Gordon Moore, a founder of Intel, predicted in the 1960s that the number of transistors on an integrated circuit would double every year. The actual time has turned out to be closer to 18 to 24 months, but the predictive power of Moore's Law shows no sign of slackening. It is the bedrock of extrapolationism, since whatever the goal, the brute force of more-powerful circuits appears to bring it closer every year.

Compensationists, by contrast, may welcome these trends, but they point to their self-limiting side. For example, as artificial lighting has spread over the past 100 years, it has interfered with natural human sleep patterns, and sleep deprivation reduces performance, increases the rate of accidents, and may even shorten lives, thereby offsetting the benefits Nordhaus cites. Computational power has countless benefits beyond the personal computer, but it also increases expectations as new versions of applications require all the new power—and often more. Faster new microchips also run hotter and draw more power, increasing the likelihood of blackouts. And usability and reliability may actually decrease as processing power increases. That complaint is heard with greater frequency, for example, as luxurious new European automobiles grow more reliant on computer technology.

Higher expectations also tend to maintain real-price levels. Bill Machrone, former editor in chief of *PC Magazine,* has a law of his own: The computer you really want always costs $5,000—whether an Altair 8000B in 1976 or a top-of-the-line Apple Macintosh G5 with a wide-screen, flat-panel monitor today.

In environmental futurism, extrapolation is usually a sinister rather than a benevolent force. After *Limits to Growth,* the 1972 report to the Club of Rome, many extrapolationists (usually on the political left) viewed the unchecked growth of population and the spread of industrialization as preludes to famine and ecological catastrophe. Fortunately, the report was wrong. Despite

an expanding global population, food production per capita has been increasing rather than dropping. Where hunger exists today, it is more likely to be caused by inequities of distribution than by shortfalls of production. Most demographers now predict that the world's population will peak in the middle of this century, then decline. But the good news for humanity does not necessarily extend to many other creatures, environmental advocates reply. The world's bounty has been paid for by dangerous levels of nitrogen in fertilizer, leading to perilous runoff into natural waters and a different food crisis: the impending collapse of many fisheries.

The principal battles being fought these days between compensationists and extrapolationists are about energy and, especially, climate change. Countering the positive extrapolationism of John von Neumann is the argument of some geologists, such as Princeton University's Kenneth S. Deffeyes, that we have already reached a global peak of oil production. This analysis, first advanced by M. King Hubbert in 1974, may be wrong, but it's consistent with recent production trends and with the doubts of some specialists that the proved reserves of the major oil companies are as big as advertised. Its defenders also note that, in 1956, Hubbert correctly predicted the 1970 peak of U.S. domestic petroleum production.

Although many earth scientists are (negative) extrapolationists, most economists seem to have remained compensationists. Human ingenuity is "the ultimate resource," argued the late Julian Simon in a book of the same title. Economists can point to improved exploration techniques, new ways to recover previously uneconomical reserves, and, above all, a range of other energy sources (coal, biomass, natural gas, safer nuclear plants, solar power, and so forth). In addition, there are more-energy-efficient technologies, such as hybrid automobiles, that can be tapped if Hubbert was right. So the exponential development of technology

will offset the gradual decline of petroleum production—if decline is indeed inevitable.

Global warming is the great battleground between extrapolationism and compensationism. Whatever the role of human activity in increasing the concentration of greenhouse gases over the past two centuries, a significant increase in global temperatures appears inevitable in this century. At least until the 1980s, as the historian of science Spencer Weart observed in the journal *Physics Today*, climatologists doubted the very possibility of rapid change: "The experts held a traditional belief that the natural world is self-regulating: If anything started to perturb a grand planetary system like the atmosphere, natural forces would automatically compensate. Scientists came up with various plausible self-regulating mechanisms. . . . Stability was guaranteed, if not by Divine Providence, then by the suprahuman power of a benevolent 'balance of nature.'"

Today, both scientists and laypeople are more likely to envisage an unstable future and to worry about the robustness of natural systems. Yet the debate continues. The strongest positions are an extrapolationism that foresees likely catastrophic consequences and a compensationism that envisions a gradual trend with positive aspects that can be augmented by more market-based ingenuity. A leading exponent of the first alternative is Henry Jacoby, an economist at the Massachusetts Institute of Technology, who has used extensive computer modeling to arrive at a probabilistic view of global warming: There's a good chance that it will be gradual and amount to only a few more degrees Fahrenheit, according to Jacoby. There's also a small but disturbing chance that the increase could be as much as nine degrees. So limiting emissions will make little difference if temperatures rise slowly and by only a few degrees (to Jacoby, such limits are an insurance policy against the worst outcomes).

The reply of compensationists is not that nature can heal itself but that Simonian ingenuity will let us increase agricultural and industrial output while reducing greenhouse gases and even restoring the environment. The classic statement of this position is a 1996 essay by Rockefeller University scholar Jesse H. Ausubel. Ausubel cited encouraging long-term trends toward more-durable products (thanks to the use of stronger and lighter materials) and more efficient recycling. Those trends toward "dematerialization" and new energy technology could reduce emissions while letting the world return more agricultural land to its natural state; for example, with wood no longer a popular fuel, the forests of the northeastern United States have grown back in the past century.

What would Einstein say about these two models of the future? On the one hand, he believed in technological adaptability. He came from a family of electrical equipment entrepreneurs (though ultimately unsuccessful ones), and he even coinvented a new cooling system after reading about refrigerator explosions in Berlin. On the other, he did not try to foresee trends as von Neumann did. Einstein had little to say about the future precisely because he did not see it as being determined by scientists or engineers, or even by political constitutions. "Everything depends," he replied to a correspondent's questionnaire in 1948, "on the moral and political quality of the citizen."

There's another question about the future, an ethical and aesthetic rather than a predictive one, and it concerns the cultural ties between past, present, and future. The choice is between affirmation and balance—that is to say, between a material and artistic culture that reflects and even anticipates change, using new forms and materials, and one that cushions the psychological and spiritual shocks of change by adapting familiar and reassuring themes. Should we espouse—affirm—values that are tied to the latest scientific trends and our expectations of future progress? The Italian

futurist movement of the early 20th century called for the destruction of the West's ancient culture to prepare for a new hard-edged scientific and technological age. Adherents of movements such as Extropy (founded in 1988 and devoted to unlimited progress through advanced science and technology) believe it is our duty to develop ourselves physically and culturally into a superior version of humanity.

But others draw the opposite conclusion. Precisely because the pace of change is so rapid, they say, we should turn to the reassurance provided by established and harmonious forms. The art, music, and architecture of the future, and especially of the present, should not be about DNA, nanotubes, or quantum computing. Appealing to nature and spirituality, our cultural lives should soften the shocks of innovation. Within traditional Eastern and Western faiths, and especially in New Age movements, many technical professionals find a counterbalance to the often-disruptive realities of technology. Unlike extrapolation and compensation, which are styles of predicting change, affirmation and balance are responses to ongoing or expected change. They're not verifiable by experience; they're the conditions that help us deal with experience.

Tacitly at least, Einstein was on the side of balance. Immersed in mathematics and science, he showed little interest in the advanced literary and artistic trends that sought to evoke relativity. In music and literature, Einstein remained true to the humanism he had absorbed in his youth. He once called classical music "the driving force" of his intuition. According to Robert Schulmann, former director of the Einstein Papers project, Einstein's musical tastes were grounded in Bach and Mozart; Beethoven was too passionately emotional for him. He did admire and befriend one contemporary experimental composer, the Czech Bohuslav Martinů, but Martinů was a loner among the avant-garde. How would Einstein have reacted to more-recent music invoking his ideas?

Philip Glass and Robert Wilson's opera *Einstein on the Beach*, for example, which opened more than two decades after Einstein's death, would probably have bewildered him, with its cascade of multimedia images and its syllabic chanting. And he showed little interest in the ferment in painting and sculpture that characterized the interwar and post–World War II years.

It's probably in our visual surroundings, in architecture and design, rather than in music and art, though, that the tension between affirmation and balance is most apparent, especially in Einstein's case. Men and women may not often reflect on religious or philosophical principles, but they cannot avoid buildings, furnishings, and everyday objects. In design, too, Einstein resisted the harsh and hard-edged styles often associated with future orientation. He did praise the architect Erich Mendelsohn's Einstein Tower, a multistory astronomical observatory in Potsdam named in his honor, but he praised it for its curving, "organic" shape, which did not reflect the architectural avant-garde of the day.

Einstein never worked in his namesake building. He was happy in the conservative setting of Princeton. Fuld Hall, the main building of the Institute for Advanced Study, completed in 1939, is standard institutional Federal. After Einstein's death in 1955, the Institute hired the Hungarian-born modernist Marcel Breuer to design a housing complex for visiting academics, and one of the streets was named in Einstein's honor. But the great physicist had never shown an interest in Breuer's high modernism. Einstein believed that his work was to seek timeless truths, not set a trend; he did not care if the science of the future was done in a building of the past. But not every pioneer of advanced thinking has been as content as Einstein to work in familiar and comfortable surroundings. Charles Simonyi, for example, who made a fortune as master designer of Microsoft's application software, built an expansive,

architecturally innovative Seattle-area house that plainly reflects the ideas of an aesthetic and scientific avant-garde.

Both attitudes toward the aesthetic future—embracing novelty and buffering it—have played out since the 1920s, when technological modernism reached its high point. In 1927, the city of Stuttgart sponsored a residential development of the future on a scenic hilltop above the city. Some of Europe's leading modernist architects, including Ludwig Mies van der Rohe and Le Corbusier, built the extensive complex. But the workers who were to be residents did not want picture windows and tubular furniture. They did not care about the factory of the future. They simply wanted as little as possible to remind them of their industrial workplaces of the present. Rejecting modernist idealism, they preferred the upholstery and knick-knacks of the petite bourgeoisie. The complex was soon rented out to bourgeois intellectuals of Weimar Stuttgart, who were delighted to live in a community of tomorrow.

Today, little of the old industrial working class remains in the West. Most of us are now what the late management guru Peter Drucker called knowledge workers. There was a high-tech furnishings movement in the early 1980s, but today's professionals, by and large, are not interested in personal surroundings that evoke the Web. I saw this clearly in 2003 when I visited the "house of the future" on the Microsoft campus in Redmond, Washington. The house was actually a suite of rooms illustrating applications of new network technology. There was nothing overtly high-tech about the rooms; furnishings were warm, with lots of dark wood. The futurist component was the networked appliances, which could, for example, play back telephone messages with the callers' pictures or display a profile of someone ringing the doorbell. In this setting, technology represented security and support for an affluent way of life rather than a framework for living. Who

wants to be challenged aesthetically at home after a hard day of symbolic problem-solving at the office?

Our techniques of forecasting the future (material extrapolation and compensation) and our cultural strategies for coping with it (affirmation and balance) have something in common: They're both expressions of expectations that shape the real future. In 1948, the sociologist Robert K. Merton coined the phrase *self-fulfilling prophecy,* and we're still working on many of the predictions of that era. We're also reverting to the familiar in the face of change, buying sentimental realist paintings and reproduction antiques. The future is indeed a foreign country, but it's also a place that we ourselves design, usually inadvertently. In the end, the interplay of expectation and behavior is what *creates* the future.

Fortunately, there are times when optimism about tomorrow produces works that continue to inspire hope for a better future. Perhaps the most visible of these works today are certain of the great laboratories built during the science boom of the late 1950s to the early 1970s. At the Salk Institute for Biological Studies (1965) in San Diego, architect Louis I. Kahn combined special steel with a type of concrete that had originated in ancient Rome; he used natural light throughout and channeled it with innovative reflectors to below-ground levels. Nine years later, Alan H. Rider conceived the elegant administration building of the Fermilab National Accelerator (1974) in Batavia, Illinois, with curved towers that created a space inspired by the cathedral of Beauvais. A herd of bison roams the grounds, which were designed as a sanctuary for native plants and animals.

The two buildings combine exuberant hope for the future with profound respect for human and natural heritage. In such great material visions as these buildings, extrapolation and compensation, affirmation and balance, coexist magnificently. They make us temporal immigrants feel immediately at home.

A Place for Hype

A REVIEW OF

The Shock of the Old:
Technology and Global History since 1990
by David Edgerton

London Review of Books, May 10, 2007

A new golden age of technological hype seems to be dawning. This January, at the Consumer Electronics Show in Las Vegas, a small unfurnished booth cost $24,500. Some 2,700 companies proved willing to pay the fee, and 140,000 people visited the show. To coincide with it, Steve Jobs, the Apple CEO, launched the iPhone in San Francisco: a mobile phone with a touch-screen and other familiar functions: web browser, camera, MP3 player. Apple shares went up more than 8 percent that day, though the phones won't be released until June, will sell for between $499 and $599, and hadn't been independently tested. In January's issue of *Scientific American,* Bill Gates predicted "a future in which robotic devices will become a nearly ubiquitous part of our day to day lives." According to Gates, the South Korean government plans to get a domestic robot into all its households by 2013, while the Japanese Robot Association expects there to be a $50 billion a year worldwide personal robot market by 2025.

Ambitious predictions are all very well, but there have also been chastening reminders of previous rounds of misplaced hype. In *New Scientist* last November, the AI researcher Rodney Brooks forecast that at some point in the next fifty years a solution would

be found to the "recognition problem": a computer's inability to tell, as a two-year-old child could, whether an object is a hat, a chair, or a shoe on the basis of its general properties. Confident as Brooks was, he acknowledged that his own attempt to solve it in his 1981 PhD dissertation had been unsuccessful.

Academic scientists, medical researchers, and technological entrepreneurs are taught to avoid extravagant claims and to rely instead on sober peer review. Yet they are also aware that hype can help win research grants and capital funding and can affect share prices. An adequately supported project may fail, but an overlooked one will not succeed. According to the Thomas Theorem popularized by Robert Merton: "If men define situations as real, they are real in their consequences."

David Edgerton's *The Shock of the Old*, with its ironic echoes of bestsellers by Robert Hughes and Alvin Toffler, is not an attack on innovation as such. Rather, it is a call for a new way of thinking about technological change, not as a sequence of revolutionary discoveries, but as a complex and often paradoxical interaction between old and new: "technology in use" as opposed to an "innovation-centered" history.

We are said to be living in an age of unprecedented change; indeed, we have been told this in the popular media for the past century at least. Yet much of the technology that now surrounds us would have been clearly recognizable to previous generations. Edgerton doesn't fully explain this paradox, but he does provide many examples, four of which will serve to illustrate the complexities of technology in use: the horse, the Kalashnikov rifle, the B-52 bomber. and the flat-pack bookcase.

The horse may be the most surprising case. Edgerton emphasizes its continuing role in urban transportation and in warfare in the early to mid-20th century. Hitler's army marched on Moscow with many more horses than Napoleon's, and in 1945 the Ger-

man army had 1.2 million of them, possibly an even higher ratio of horses to men than in previous centuries of warfare. Horses and other draught animals are still widely used in poor countries: In India, as recently as 1981, animals produced more megawatts of power than all mechanized sources combined, and there were twice as many bullock carts as there had been at independence in 1947. Even in the United States, Amish farmers continue to work with horses, and there seem to be tens of thousands of non-Amish farmers with draught animals, including 3500 oxen teams in New England. Amish artisans continue to develop more efficient agricultural equipment, and have a worldwide market.

It's surprising how many supposedly pre-industrial tools survive in the allegedly post-industrial world. Advocates of development and technology may be embarrassed that horses are still used as draught animals, but they also ignore the proliferation of simple tools and labor-intensive maintenance. In the vast workshop districts of Ghana, known as 'magazines', motor vehicles from the industrialized world have for decades been adapted and refitted for rugged African conditions. They can be maintained indefinitely in this new state, using only simple parts, a sophisticated improvisation that Edgerton calls "creolization." "At dusk," he writes, "bright intermittent light from welding illuminates streets all over the world, issuing from maintenance workshops which might also make simple equipment."

Edgerton cites the Kalashnikov assault rifle, the AK47, and its descendants to illustrate how effective simplicity can be. Ever since the rifle's introduction in the Soviet Union in 1947 it has been a favorite of both guerrillas and their enemies. Of between 90 and 122 million assault rifles estimated to have been produced since the Second World War, between 70 and 100 million were Kalashnikovs. Together, these small arms have been responsible for more civilian deaths than attacks from the air or the gas chambers. Nu-

clear weapons, it was once thought, would transform warfare, but they were economically dubious from the start. If the $2 billion spent building the Hiroshima and Nagasaki bombs had been used for conventional weaponry, Edgerton argues, the war might have ended sooner. Likewise, Germany could have built 24,000 fighters for the cost of the V-2 project; each V-2 cost two lives to make and killed on average only one civilian.

The B-52 bomber illustrates a third argument: that the thinking of the military and industrial establishments of the richest countries has changed far less than we imagine. The B-52 was introduced in 1952 and no more were built after 1962, yet in the first Gulf War it dropped 31 per cent of all US bombs. In 2004, the same B-52 used to launch X-15 planes to the edge of space in the 1960s was the platform for testing Nasa's latest space aircraft, the X-43A, which was heralded as a dramatic breakthrough even though the X-15 had flown nearly as fast. The B-52 is expected to remain in service until 2040.

Fourth, and perhaps most significant, the globalization of the trade in wooden furniture is evidence of the conservatism, not the technological transformation, of the industrial order, and also of the continued dominance of rich countries. Ikea has sold 28 million Billy bookcases since 1978, manufactured from wood using conventional mass-production methods. Final transportation and assembly of Billy and other flat-pack Ikea products are left to unpaid consumers. (Ikea and its suppliers employ an estimated one million people worldwide; the founder of this family business is said by some to be worth more than Bill Gates.) The example is even better than Edgerton suggests: The global manufacture and shipping of inexpensive unassembled wooden furniture dates from the middle of the 19th century, when the Thonet brothers of Vienna established factories in the beech forests of Moravia to make virtually indestructible bentwood café chairs.

Edgerton uses stories like these to challenge many of the clichés of technology and business journalism and 'innovation-centric' political rhetoric. He is a formidable polemicist with an encyclopedic grasp of business and economic history and policy, as well as the history of technology, qualities which were manifest in his recent study of British military and industrial history, *Warfare State*. There are many revelations in *The Shock of the Old*, some of them grim: for example, whaling was revived in the 20th century mainly in order to produce margarine. By the 1990s, half of all antibiotics produced in the US were fed to animals, mostly to accelerate growth.

The book's most puzzling theme, though, is one that Edgerton explores only obliquely. Why are older technologies still so prevalent? Or to put it another way: Why have so many promising ideas produced less than we expected, at least so far? One 'miracle' after another has turned into a mirage. The future is running behind schedule. Just as the use of horses persisted well into the 20th century, so piston-driven internal combustion engines, developed in the 1870s and 1880s by Otto and Benz, continue to dominate passenger transport. The limited range of all-electric cars has (so far) doomed them commercially. Indeed, poor battery life continues to bedevil devices from cars to digital music players. The miles per gallon achievable by hybrid cars have been even more exaggerated than is the case with conventional cars. The trains that carry commuters in Europe and the US run on rails similar to those of the 1890s, while diesel trains use an air brake system patented in 1872. Magnetic levitation trains were in service as early as 1984 in Birmingham, yet are still largely at the demonstration stage; a disaster in which 23 people were killed disabled a German experimental project in September 2006.

What of medicine? Cancer survival rates continue to improve, but back in 1971 some of the senators who supported the US

National Cancer Act talked of achieving a cure by the Bicentennial of 1976. In rich countries, Aids is now considered a chronic disease rather than a plague; hopes for a vaccine have not been realized. In the mid-1980s one was predicted by the mid-1990s; in 1995, the date was shifted back to 2000. Treatments improve, but no cure is in sight. Bacteria remain just as alarming. In 1969, William Stewart, the US surgeon general, believed we could soon "close the book on infectious diseases." But overuse of antibacterial agents helped to promote resistance to antibiotics, leading to today's multi-resistant bacteria, the superbugs of newspaper headlines. Today's antibiotic innovation is a heroic attempt to hold ground thought secured fifty years ago.

Improved medication for progressive diseases such as Parkinson's has made for impressive gains in the control of symptoms. But, as the writer Phyllis Richman recently recalled in a piece for the *Washington Post,* in the 1960s she heard a cure was expected within a decade (the claim seemed credible because of progress made against tuberculosis, polio, and malaria), and similar predictions are made today. She repeats a familiar criticism of medical research: "There's a surer profit in developing another variation of a successful drug than in creating a new kind of drug, for which the clinical trials are not only apt to be more expensive, but the chance of failure runs higher and the approval process is likely to take longer."

The most significant recent breakthrough in the technology of power transmission, the discovery of high-temperature superconductivity in 1986, seemed to herald virtually resistance-free electric cables, but is still far from being a large-scale application. Consider, too, the crisis over climate change. Optimism about the introduction of nuclear power during the decades before Three Mile Island and Chernobyl may have diverted attention from the dangers of fossil fuel emissions. John von Neumann, the US's most

brilliant scientific-political adviser of the postwar decades, wrote in *Fortune* magazine in 1955 that once nuclear power generation had overcome the design limits of older hydrocarbon plants, "energy may be free—just like the unmetered air—with coal and oil used mainly as raw materials for organic chemical synthesis." Von Neumann was already aware of the likelihood of global warming from burning hydrocarbons, but saw it not as a cause for worry so much as a possible means for humans to control the climate: We would soon be able to warm or cool the world, or parts of it, mitigate storms and control rainfall. He didn't seem to doubt this would happen; his concerns were over conflicts between winners and losers after the global thermostat had been adjusted.

Von Neumann, who may have known more about computing than any of his contemporaries, believed that increased computer processing power would help make these and other advances—including transmutation of the elements—possible. What he apparently did not foresee was that computational power might have a conservative effect, by prolonging the lives of older technologies. Consider the Rolamite, a type of bearing patented in 1967 and celebrated in the media as a rare example of a basic new mechanical device. It is basically a band wrapped in an S-shape around two rollers moving in a kind of track. The band can be modified to delay movement until a predetermined force is applied; Rolamites have been used as accelerometers in airbags. But the most ingenious and complex applications predicted were never achieved. The major reason may have been that the Rolamite appeared on the eve of microprocessor control, and it became easier and cheaper to produce programmed chips than to etch patterns into mechanical Rolamite bands.

That so many of the claims made for revolutionary technology between the 1950s and the 1980s have been frustrated leaves us looking for explanations for the surprising technological stability

of the present age. There are two possibilities, one structural and one cyclical. The first starts from the premise that the three decades from 1885 to 1915 were unique in the history of technology. (The idea that there was a second industrial revolution, usually dated from 1871 to 1914, originated in 1915 with the Scottish biologist and planner Patrick Geddes, was popularized by David Landes in *The Unbound Prometheus* in 1965, and was affirmed most recently, though with a different starting date, by Vaclav Smil.) Highly developed craft skills, rapid growth in scientific and medical knowledge, and mass promotional techniques came together in the expanding cities of Europe and North America. The basic form of many of today's machines was laid down during these decades and they were mass-marketed surprisingly rapidly, from the Daimler-Maybach engine of 1885 to the Model T Ford of 1908, from the Wright Brothers' flyer of 1905 to the monoplane with joystick control—the basis of most subsequent aircraft design—developed by Louis Blériot and Robert Esnault-Pelterie a few years later. The Rover Safety Bicycle of 1885, designed by an Essex market gardener's son called John Kemp Starley, was the first widely successful design of the type that has dominated ever since. The Scottish vet John Boyd Dunlop introduced the first successful pneumatic tire in 1888, and most car and bicycle tires use essentially the same valve patented by George Schrader in 1893.

The same period also saw the extension of continuous processing for mass consumption, with systems that continue to be used today. The crimped bottle cap as we know it was invented in Baltimore in 1891 by William Painter and developed by his company, Crown Cork and Seal, while one of Painter's salesmen, the unsuccessful novelist King C. Gillette, collaborated with the engineer William Nickerson to create the first commercially successful disposable safety razor blade in 1903. Henry Ford's was not the only assembly line: The automatic lasting machine developed in

the mid-1880s by Jan Matzeliger increased the number of finished shoes a worker could produce from 50 to 700 a day, laying the foundation of the United Shoe Machinery Co, the international cartel of the 1890s that marketed—with a ruthlessness resulting in decades of antitrust litigation—factory equipment that remains the basis of today's leather shoe industry.

The period from 1945 to 1975 saw radical developments—commercial jet aircraft, antibiotics, and vaccines—but in retrospect the great leap forward during these years was in the miniaturization of electronics. In just three decades we went from publication of von Neumann's proposal for the stored-program computer in universal use today to the unveiling of the Altair 8800 as a "hobbyist" kit. Bill Gates dropped out of Harvard to develop software for the Altair and its successors. But the paradox remains that the functions of the iPhone, and of today's operating systems and computers, have long been routine.

The structural interpretation of this recent history of innovation is that we have now picked the low-hanging fruit of technology and that the future will be one of continued refinement. This seems to be Edgerton's point of view: He is a partisan of adaptation and improvisation. But a cyclical interpretation is also possible. We may be on the brink of a new era of change, following a thirty-year cycle of incremental improvements, such as the doubling of the Boeing 747's fuel efficiency since its introduction in 1970.

Edgerton does not discuss this alternative. The great strength of his book is its global perspective, which sees poor countries coexisting with rich ones by adopting and adapting. He gives the example of shipbreakers in India, Pakistan, and Bangladesh, who dismantle the obsolete vessels of the world's navies and shipping lines, and reroll and rework the steel in them. In this scheme of things, the plans of scientists and engineers in industrial coun-

tries are marginal indeed. But Edgerton's viewpoint has its limits. Many poor people in India and Africa can now make inexpensive calls using village cell phones. Edgerton's linear account sidesteps the intriguing question that can be answered only in real time: Will hopes of radical technological progress remain unfulfilled, or will nanotechnology, gene-based medicine, quantum computing, and other long-touted innovations eventually find widespread application?

The rhetoric of technological revolution can be hazardous; it can even help hold back innovation. In the 1950s, Lord Cherwell, one of Churchill's senior advisers, successfully recommended against modernizing the railways on the grounds that rail was 'obsolete', and that 'helicopters or other formats of transport' would make it less important. Indeed, the railways provide stunning support for Edgerton's argument; computerized analysis has enabled significant improvements in the wheel-rail interface, resulting in greater fuel economy and lower operating costs.

Some commentators are impatient with incremental change; Edgerton sees it as a sensible alternative to the cult of revolutionary transformation as expressed in the hype of the popular press. And so it is, up to a point. But cumulative improvement has left many diseases still incurable, though more humanely managed, and travel times for some air and road journeys have been increasing. (An airline flight from Philadelphia to Los Angeles now takes nearly an hour longer than it did forty years ago.) There may be a legitimate role for hype because of, not despite, the recent absence of anything as "novel or . . . significant as penicillin or the Model T." Hype may be an adaptive strategy for building morale and encouraging investment in the face of discouraging experience: The great majority of patents go unrenewed.

Edgerton is right to object to the setting of "the agenda for discussing the past, present and future of technology... by the

promoters of new technologies." And he recognizes that the well-meaning invention of "appropriate technology" for poor countries has been much less successful than grassroots ingenuity. However, solar-powered light-emitting diodes are already reducing indoor pollution, aiding literacy and protecting children's vision in rural India. Sometimes, technological hype is a sensible response to the intransigence of reality.

Tomorrow's Technological Breakthroughs: Hiding in Plain Sight

AEI American, November 28, 2013

As Paul Krugman details in a recent column, many mainstream economists are concerned that a depressed economy may be the new norm. The case "was made forcefully recently at the most ultrarespectable of venues, the IMF's big annual research conference," he writes. Robert J. Gordon, Stanley G. Harris Professor in the Social Sciences at Northwestern University, has dismissed the job-creating potential of technological optimists' favorite projects like biotechnology and self-driving cars, and concluded: "The future of American economic growth is dismal, and policy solutions are elusive." Among others, the economics Nobel Laureate Edmund Phelps—no determinist—has deplored the decline of America's innovative spirit.

But we should be skeptical of growing pessimism about the possibilities of technological innovation. A look back at the Depression era shows how many experts were similarly—and wrongly—myopic.

A new exhibition at the International Center of Photography (ICP) in New York casts remarkable light on the 1930s, a decade still synonymous for many people with images of gaunt-faced men in breadlines. Tragically, they were a large part of the story—but,

as the photographs of Lewis Hine (1874–1940) show, far from the whole story. The ICP has two separately organized shows. One features the disturbing pictures of slum conditions and child laborers that first earned Hine fame before World War I. Hine had turned to photography to document immigration and the ills of urban life, as well as of Southern textile mills. Foundations and relief organizations engaged him to report on their work.

Throughout these projects, Hine kept a dual view of early 20th-century technology as often oppressive but sometimes ennobling. His "Power House Mechanic Working on a Steam Pump" (1920) was posed to show not a downtrodden laborer but a Promethean athlete of industry. In an apparently unpublished poster design in this exhibition, Hine celebrated automatic machinery for helping spare "breaker boys" the often[-]life-threatening drudgery of separating impurities from coal by hand. In the early Depression years, he created a series of classic images of the construction of the Empire State Building by fearless riggers and riveters. "Work must develop, not deaden," he once wrote.

Hine's muckraking and celebratory works alike have been reproduced thousands of times. A much lesser-known project is the subject of the ICP's second exhibition, "The Future of America." The guest curator, Judith Mara Gutman, author of *Lewis W. Hine and the American Social Conscience*, discovered box after box of documents in the National Archives pertaining to Hine's work as chief photographer for a now-obscure enterprise of the Works Progress Administration, the National Research Project (NRP). The project, with a staff of 400 professional and support personnel, was the Roosevelt administration's response to concerns often heard today: that innovation would continue to make more and more workers redundant.

One photograph by Hine from an NRP report reflects these fears—a track walker (a railroad worker responsible for inspecting

and maintaining rails) at work on a right-of-way. New machines, including spike drivers, drilling machines, and mechanical track oilers, were displacing these once-ubiquitous generalists, the wall text notes. Advances in metallurgy were making possible more durable rails. Could such men be retrained and reemployed on the railroads or in other industries? Historian of technology Amy Sue Bix, in her book *Inventing Ourselves Out of Jobs?*, points to movements for a "technotax" levied on output of worker-displacing devices to provide relief and boost purchasing power. The NRP appears to have stayed clear of such controversial plans, and the idea was soon shot down, but not before achieving some mainstream support, for example in *Kiwanis Magazine* in 1935.

Hine's photographs show how many small changes in production techniques were adding up to a revolution that would be apparent only during World War II. An image of a man painting doll heads by hand may look quaint to us, but the rubber-molding machinery was new. Innovative looms could be switched between weaving silk and new synthetic fibers. While mechanical watchmaking today is an enthusiast niche, it was at the forefront of 1930s technology; Hine portrayed a skilled inspector using a "high-precision toolmaker's microscope, accurate to .0001 of an inch," in the Hamilton Watch Co. factory in Lancaster, Pennsylvania.

The real picture, as the NRP concluded, was complex. Some skilled workers remained highly competitive using 19th-century equipment, like one 72-year-old weaver working with a 100-year-old knitting machine in a Pennsylvania mill. (Indeed, it might still be in use somewhere, perhaps in Asia, for fine woolens; today, Swiss luxury watchmakers employ some 19th-century geometric lathes for finishing complex decorations by hand, even though robots now produce many of the most precise mechanical parts). People trained on new machines might be in the same shop with skilled traditional operators. Relatively more workers were semi-

skilled than skilled. There were more opportunities for women. While unemployment declined from about 13 million in the early Depression to around 8 million in 1937, many of the technologically displaced, like track workers, could not find new positions.

Gutman, who is completing a new book on Hine and 1930s industry, notes that new forms of labor-management cooperation in some industries were in part created by the 1935 National Labor Relations (Wagner) Act, a side of the Depression that has received less attention than front-page strikes such as the bloody Battle of the Overpass at Ford Motor Company in 1937. Hine's photography captures a patriotic optimism that, Gutman believes, helped assure the economy's productivity in the coming war. What struck her in reviewing Hine's work and the papers of the NRP was how—with collective bargaining, new technology, and workers' greater role—employers ceded some control, and unions accepted more of management's point of view. This compromise, she believes, helped revive the economy.

But Hine did not recognize, or was not given access to, many of the innovations that proved vital in the long run. One of his photos shows more efficient production of radios, but they were big, 1920s-style models. Meanwhile, in its factory in New Jersey, the Emerson Radio Co. had pioneered miniaturization with its "Peewee" model in 1932, beginning the transformation of listening from a wood-cased family console to a portable, plastic-housed set, the first step toward postwar personalized music. There are no aircraft assembly images among Hine's photos in the exhibition, yet the DC-3, introduced in 1938 as the NRP was winding up its work, was the first aircraft that could pay for itself from scheduled passenger revenue.

Bix has noted that many manufacturers, stung by criticism of machinery and suspicious of the left-wing background of NRP staffers, did not cooperate with the survey. Some of the most

advanced may have been sensitive about trade secrets. As a private photographer, Hine had only sporadic success in attracting commissions from companies seeking promotional photography, despite his skill and earlier fame. Thus even NRP's reports and Hine's photographs understated the potential for growth. Sadly, Hine died poor in 1940, but he may have been cheered the previous year by an appreciation in *Coronet* magazine displayed at the ICP exhibition: "Necessity taught him technique. He was stepped over, unnoticed, while the masters wrestled at the rear door of the Metropolitan.... His biting work will live long after academic fumes have blown away."

Hine's glimpses of the future—and those scenes he missed—remind us to be skeptical of technological pessimism. As the historian and economist Joel Mokyr (Robert Gordon's colleague at Northwestern) has reminded us, the idea that we have picked the low-hanging fruit of technology calls for a counter-metaphor that bring to mind Hine's photo of the toolmaker's microscope: "Technology creates taller and taller ladders, and the higher-hanging fruits are within reach and may be just as juicy."

The Shadow: Pathfinder of Human Understanding

Raritan Quarterly Review, Spring 2021

In April 2019, an image thrilled astrophysicists and amateur astronomers alike. After two years of work merging images from eight radio telescopes around the world, two hundred astronomers at thirteen institutions created a picture of a black hole. There would be no image of the object, which allows no light to escape. But beyond the black hole itself, outlined against the hot gas that it created, was a larger black area both researchers and journalists called its shadow. No other metaphor would capture the idea of secondary darkness. Creating a composite image required flying a ton of hard drives from participating observatories with a total of five petabytes of data (each over one thousand terabytes in size) and months of processing. It has become the most striking confirmation of Albert Einstein's general relativity theory in a hundred years, since Sir Arthur Eddington photographed a solar eclipse off the coast of Africa, showing that the mass of the sun had bent the rays of a galaxy when compared to reference photographs of the same stars' positions in the sun's absence.

The result of the Event Horizon Telescope, as the global project is called, should attract our attention to one of the most ancient yet little-explored themes of the history of science: the shadow as a first step in understanding nature and working with it, preparing the way for more complex images and tools.

The diagnostic power of the shadow did not start with scientific thought. It was long present in folklore. Among the South Slavs, for example, the bear is said to emerge from its cave on Candlemas (2 February) and look for its shadow. If it does not see it, it returns inside, and winter weather will last another six weeks. In Germany, foxes and badgers became the test creatures, probably because of the decline of the bear population. Nineteenth-century German immigrants brought such stories to Pennsylvania, transferring them to the closest local counterpart of the badger, the groundhog. As newspapers and magazines flourished in the 1880s and 1890s, the day's celebration in the tiny town of Punxsutawney became and remains a national event to millions unaware of its Old-World origins. The hapless groundhog is probably more apprehensive about the top-hatted local gentlemen surrounding him than about the weather. But Punxsutawney Phil's fame is proof of our belief in the shadow as an instrument.

Humanity has made the shadow a tool: to record time in space, to compress three dimensions into two, and to make the unseen visible. For all these purposes it has developed instruments for a richer understanding, yet as in theoretical physics, the shadow remains the tool of the frontier of understanding.

At the beginning of time measurement was the shadow. Early humanity still possessed no instruments, but as hunters they could note that the changing length of their own shadows could help estimate the time until sunset. The human body itself was probably the original timekeeper, just as the foot, span, and cubit were some of the first measurements of length.

Today we know that early hunting and gathering societies had ample leisure and a higher standard of living than early agriculturists, so that a more precise division of daylight hours was not necessary. That changed with the rise of complex, hierarchical societies. As early as 5,500 years ago, shadow-casting piles in the

Middle East were revealing the approximate time of day. It took millennia for the oldest surviving L-shaped sundials, like the one from the fifteenth century BCE in the Egyptian Museum in Berlin, to appear. The shadow was cast by a wooden cross. Only in 575 BCE, a gnomon (discerner or examiner in Greek) was placed in the middle of a dial by Anaximander. The shadow was a revelation of heaven; a Ptolemaic sundial in the British Museum represents a shrine of the sun god Ra-Horakhty. The time is therefore a self-projection of the deity by means of shadows.

But the sundial is best remembered for its practical rather than spiritual applications. The Hebrews probably derived their sundials directly or indirectly from those of the Babylonians, credited by Herodotus as inventors of the technology. The Egyptians may have been the first civilization to apply shadows to engineering; the great historian Otto Neugebauer proposed that they used the shadows of a model to achieve the strikingly accurate alignment of the Great Pyramid of Giza, and more recently the archaeologist Glen Dash has demonstrated another possible shadow-based method using only a gnomon, a cord, and a straightedge to track the sun on the autumn solstice. Yet it was the Greeks who first put the instrument to use in understanding the heavens and the earth. In the sixth century BCE, Anaximander of Miletus was using it for studying astronomical phenomena like equinoxes and solstices, building on the work of his teacher Thales, said to have brought knowledge of sundials and gnomons from Egypt. (Thales of Miletus may be best known for the feat of calculating the height of the Great Pyramid by comparing its shadow with that of his staff at a carefully chosen location; scholars disagree about his precise method.) The geometric knowledge of the Greeks helped them construct sophisticated conic sections for reading the time, for example the semicircle of Apollonius of Perga (ca. 250 BCE).

The Romans adopted the sundial surprisingly slowly; only in the mid-second century BCE did a public one appear in the capital.

Ancient Egypt remained an ideal laboratory for the scientific use of shadows. Three centuries after Thales, Eratosthenes, the polymathic director of the library at Alexandria, was able to estimate the radius of the earth. Alexandria is located approximately on the same meridian as Syene (now Aswan). There was a famous well in Syene that cast no shadow at noon on the summer solstice because the sun appeared precisely overhead. In Alexandria at the same time on the solstice, Eratosthenes determined that the sun cast a seven-degree shadow. To determine the distance as exactly as possible, he hired professional land surveyors to walk all the way from Alexandria to Syene, counting strides they had learned to standardize—a skill in demand because of the frequently shifting course of the Nile. They established the distance at about 5,000 stades (a footrace distance of the Olympic Games that became a common unit of measurement in the Mediterranean). Seven degrees out of 360 is approximately one-fiftieth of the Earth's circumference. Multiplying the distance by fifty yielded about 250,000 stades around the world. According to the *Dictionary of Scientific Biography,* the most likely conversion to modern measurements is 29,000 miles, not too far from today's estimated pole-to-pole circumference of 24,900 miles, Eratosthenes's own account of his method is lost; scientists and scholars have been debating his procedures since antiquity. (Ptolemy's geography, still used by Columbus in the fifteenth century with his own modifications, relied on another scientist's significantly smaller estimate. The master navigator and his patrons might have hesitated had they known the true distance of China from Europe.)

The sundial remained essential to timekeeping through the Middle Ages and into the twentieth century. Even after the introduction of fine mechanical watches, pocket sundials were a means

for the wealthy to demonstrate their (supposed) knowledge of astronomy and geography; cheaper models were ultimately offered to the less affluent. A vividly detailed pen drawing by the early sixteenth-century artist Urs Graf in the Kunstrnuseum Basel depicts a fashionably clad young man contemplating a pocket sundial, like today's Wall Streeter with his tourbillon-equipped Swiss watch.

In the sixteenth and seventeenth centuries, pocket sundials were prized throughout Europe, especially the collapsible ivory models from Nuremberg workshops, which could include compasses for precise orientation. But the sundial was also a timekeeper for the poor: A Saxon church order of 1580 dictated that communities that could not afford a clock to set religious services should buy a cheap sundial. In any case, the shadow remained, despite the practical difficulty of visibility on cloudy days and at twilight. Mechanical clock time was checked by sundials. By the eighteenth century, the accuracy of the best clocks far surpassed that of sundials. It seemed that, after millennia, the shadow would at last be replaced as a timekeeper.

Still, the history of measuring time by shadow was by no means over. First, the performance of the sundial cannot be compared directly to that of the mechanical or electronic clock. It remains closer to astronomical time, to the rhythms of the seasons and the sun with all their variations. It also is the most environmentally benign form of timekeeping. And its technical development has never ceased. A showpiece of the American Philosophical Society museum is an elegant universal equinoctial sundial of 1800.

Even in the first decades of the twentieth century, when a junior clerk named Albert Einstein was examining applications for telegraphic time regulation in the Swiss patent office—an inspiration for his later theories—French railroads were still using high-precision "solar chronometers" to assure the accuracy of station clocks. No longer a practical necessity, the shadow clock

became an intellectual and aesthetic challenge and an instrument for science education. In the later twentieth and early twenty-first centuries, scientists like Martin Bernhardt and Yves Opizzo continued to design innovative and extremely precise sundials that can be visited in the collections of the Deutsches Museum in Munich and the German Time Museum in Furtwangen in the Black Forest.

By the early modern era, shadows were used to explore space as well as measure time. Galileo led the way with his telescope. In the Aristotelian cosmos, all celestial bodies were perfectly spherical; only the imperfect earth had an uneven surface. (Think of John Donne's celebrated phrase, "dull sublunary lovers.") Galileo's observations destroyed this theory. He could perceive bright zones in the dark region of the moon and dark zones in the sunlit areas. As these shifted slowly with time, Galileo realized that they must be the moon's counterparts of Earth's mountains and valleys. It was the shadow of the former that let Galileo calculate their height: Some were taller than the Alps. Neither Earth nor moon were unique; heavenly and terrestrial bodies had similar forms. Published in his *Siderius Nuncius (The Starry Messenger,* 1610), these conclusions helped begin a decisive shift in the Western conception of the universe.

As the historian of science Gerald Holton noted, artistic training had prepared Galileo for this observation. As a student at Florence's Accademia del Disegno, founded in 1563 by Cosimo de' Medici, Galileo probably had learned to visualize the appearance of three-dimensional bodies and the shadows they cast; he had evidently become proficient enough to have applied for a position teaching geometry and perspective there at the age of twenty-five. In his book *Galilei der Künstler* (*Galileo the Artist*), the German historian Horst Bredekamp has suggested that it was Galileo's artistic training in depiction of light and shadow that enabled him to describe the mountains and valleys of the moon, defined by

shadows cast by the sun, in precise and elegant detail, verbal as well as visual.

Just as shadows in art and scientific observation permitted our first real understanding of the moon, they helped astronauts comprehend it when humanity first arrived there more than three hundred fifty years later. Dave Scott of *Apollo 15* noted that without familiar objects like trees, cars, telephone poles, or roads, astronauts cannot tell whether they are seeing a large boulder in the distance or a small rock nearby. The astronaut's own shadow, he observed, is the best guide to scale on the moon's surface.

On Earth, shadows have helped us understand new worlds under surfaces. The University of Würzburg physicist Wilhelm Röntgen, investigating cathode rays in 1895, found some so strong that they forced their way through solid objects and could create images of their interiors on photographic plates. Soon he saw that hidden things, like the bones of a human hand—an X-ray image, as he called it, of his wife's hand was an international sensation—could be revealed. The first X-rays were also known as shadowgraphs. As the art historian Martin Kemp has written, the discovery "provided for the first time a device that could enable us to 'see' in a way that is untrammeled by the restriction of our visual apparatus to a narrow band in the total spectrum of radiations. The conceptual leap was as great as the technical."

While Röntgen became a national hero and the first Nobel Laureate in physics—the rays are still called *Röntgenstrahlungen* in German—there were unintended consequences. As with many other processes of the twentieth century, applications spread rapidly, knowledge of long-term effects only slowly. Physicians, technicians, researchers, and patients suffered after repeated exposure, and the first safety standards appeared only after many deaths.

Even before the effects were known, the new shadow images enjoyed a dubious reputation in Europe and North America.

Would anyone be safe from technological voyeurism? The elegant London *Pall Mall Gazette* warned of "the revolting indecency of X-rays." Cartoonists recommended donning armor before leaving home. Serious advertisements offered "X-ray-proof underwear." More ominously, with revelations of the skeleton and human organs came reminders of human mortality, even if the technique promised to prolong life. The skull had fallen into disuse as memento mori, rarely seen in cemeteries by the nineteenth century. Now it reappeared.

Although modern medicine has highly sophisticated descendants of the X-ray radiation such as magnetic resonance imaging, a costly but popular option for many patients, black-and-white shadow images still dominate. And security officials at airports use sophisticated X-rays for shadow interpretation that with training can reveal the outlines of concealed weapons and explosive charges.

Shadow interpretation also was vital in twentieth-century warfare. Interpreters of aerial reconnaissance photographs could estimate the height of objects and measure daily changes despite camouflage, which can imitate shadows but not their variations over time.

The ultimate and saddest diagnostic use of a shadow occurred at the end of the Second World War. A famous photograph appears to show the shadow of a man who was fatally burned on the steps of the Sumitomo Bank in Hiroshima by the radiation of the atomic bomb. Radiation turned the stairs white, except for a darker area left by the man's outline. The steps and image have since been removed to the city's Peace Memorial Museum.

While human shadows remained a horrific memento mori for the nuclear age, the diagnostic value of others was a national secret for half a century. Only in 1995 did the American physicist Robert Serber, a former student of the Los Alamos director J.

Robert Oppenheimer and a key member of his team, explain his use of shadows cast by the Hiroshima bomb during a September 1945 visit to the city. Following the method pioneered by Eratosthenes, he was able to determine the height of the explosion and to calculate the size of the fireball by comparing shadows with the surviving objects that had cast them.

Fortunately, the peaceful global use of shadows has so far prevailed. In 2020, eleven Japanese researchers were part of the international team of the Event Horizon Telescope awarded the Breakthrough Prize in Physics for the image of the black hole.

In a remarkable continuity from antiquity to our own time, the shadow turns out to be a first instrument of understanding, just as the eyes of the earliest organisms could distinguish only light and dark. Color and three dimensions follow. Even now the Kepler telescope is discovering the existence of countless exoplanets by following fluctuations in light as the planets cross in front of their host stars. One of these, one hundred fifty light-years away, is potentially earthlike, according to researchers. Will we ultimately decode messages from its possible extraterrestrial citizens? If we do, it may be a shadow that first pointed us in the right direction.

SOURCES

Permission for reprinting of essays in this book is gratefully acknowledged to the following publications:

AEI American	Markets, Risk, and Fashion: The Hindenburg's Smoking Lounge
	The Perpetual Passion for Paper
	Tomorrow's Technological Breakthroughs: Hiding in Plain Sight
American Heritage of Invention and Technology	Pantheons of Nuts and Bolts
The Atlantic	The Mother of All Invention: How the Xerox 914 gave rise to the Information Age
	Rook Dreams
Britannica Yearbook of Science and the Future	Future and Assumptions
Chronicle of Higher Education	Suiting Ourselves
	The Prestigious Inconvenience of Print
Oxymoron, vol. 2	Why Dogs Bite Back
George	The Wreck after the Titanic
Harvard Magazine	Lasting Impressions
	When Systems Fracture
	The Life of Chairs
	Talking Through Our Hats
	From Slips to Chips
	Paradoxical Proliferation of Paper
	The Impending Information Implosion
	World's Greatest Futurist
Issues in Science & Technology (NAS)	Technophilia's Big Tent
	Mother of Invention
London Review of Books	A Place for Hype
Milken Institute Review	Heroic Capitalism
	The Virus and the Volcano
	COVID-19 and the Swiss Cheese Effect
	The 737 MAX and the Perils of the Flexible Corporation
	The Importance of Being Unimportant
	When Big Data Bites Back

Milken Institute Review	Oppenheimer and the Technological Sublime
	The Icon of Icons
	Checkmate: Can Artificial Intelligence Win the Long Game
	Journalism in the Age of Page Views
Money	What Wall Street Can Learn from the Dung Beetle
NEH Humanities	Digging Across Panama
	Steel Into Gold
Patient Safety Network	In Conversation with … Edward Tenner, Ph.D.
Popular Science	A Model Disaster
PRINT Magazine	Edward Tenner: Philosopher of Everyday Things by Steven Heller
Quality	The Meaning of Quality
Raritan Quarterly Review	Adam Smith and the Roomba
	Constructing the German Shepherd Dog
	The Shadow: Pathfinder of Human Understanding
	Confessions of a Technophile
Technology and Culture	"Information Age" at the National Museum of American History
Technology Review	Plain Technology
	The Trouble with the Meter
	Engineers and Political Power
	Keeping Tabs
	The Rise of the Plagiosphere
	The Shock of the Old
	Digital Dandies
	There's the Rub
U.S. News and World Report	The Dark Side of Tinkering
	The French Connections
	We the Innovators
Washington Post	If Technology's Beyond Us, We Can Pretend It's Not There
Wilson Quarterly	How the Chair Conquered the World
	Chronologically Incorrect
	Body Smarts
	Writers, Technology, and the Future
	Citizen Canine
	The Future Is a Foreign Country

INDEX

adventure travel 20, 23, 65–66, 68–70, 71, 75, 76
advertising 5, 7, 20, 92, 103, 115, 133, 144, 260, 308, 364, 372, 373, 395, 404, 415, 440, 443, 512, 574
Airbus 149, 154, 193, 194–95
Amazon xiv, 134, 158, 281, 398–400
Ambasz, Emilio xvii, 251
Amish xiv, 117–19, 264, 551
analog. See retro technology
antitrust xv, 29, 154, 156, 180–81, 182, 188, 399, 557
Apollo program 164, 168, 169, 389. See also NASA
Apple. See Jobs, Steve
Apprentice, The. See Trump, Donald J.
Arntz, Gerd 314, 315
artificial intelligence xx–xxi, 33, 190, 282, 284–85, 331, 391, 423. See also chess
AT&T xv, 28, 152, 156, 157, 158, 185–86, 188. See also Bell Labs
aviation: development of 48, 80–81, 130–31, 168, 194, 228; disasters 84–85, 92, 149–51, 160

Bauhaus xxvi, 181, 236, 243, 314
Bell Labs xv, 30, 156, 161, 185–91, 344
Bijker, Wiede 5, 530
Birdsall, Blair 173–75
black box 53–54, 56, 57, 59, 321
Bloomberg, Michael 7, 26
Boeing 149–54, 159, 161–62, 193, 195, 557
Bonner, John T. xxii, 228
book publishing 370–71, 384–86, 393–97
Breuer, Marcel 236, 243
building. See construction
Bunker, Archie 231, 241
Burke, Edmund 304, 310

Cadillac 131, 141
cell phones 109–10, 115, 126, 273, 277, 373, 558
chair, the: and the body 240; and the computer 248–49, 253; and control 244–45; cultural differences and xvii, 229–32, 234–38, 250; and defecation 232, 245; design of 243, 246–50; and health 228–30, 239, 245–46, 251; and hierarchy 231, 232, 234–35; history of 227; as metaphor 241–43

Checker taxi 100, 132
Chernobyl 4, 50
chess xxi–xxii, 419–20, 423–25, 427–32
Chicago 16–18, 56, 128–45
cigarettes 5, 7, 80
Clark, Kenneth xvi, 201, 204
Clark, Patrick 199–201
Clinton, Hillary 220
Clinton, William J. (Bill) 29, 33
clothing xvii–xviii, 97–98, 104, 106, 175–77, 244, 253–64, 267–71
coalmining 20–21, 73, 197–198
COBOL 29, 31
Cold War 130, 158, 188
Colinvaux, Paul ii, xxiii, 438
computer (personal) iii, iv, xxi, 34, 111, 156, 247, 273, 277, 307, 341, 345, 353, 356, 369, 377, 516, 527, 534, 540. See also information
Concorde 7, 48
conservation of catastrophe 10–11, 15, 57, 77. See also McNeill, William H.
construction 198, 211
Coronavirus. See Covid-19
Costa Concordia xii, 9, 12–13
cotton. See thread
Covid-19 xii, xiii, 65–68, 90–91, 92 287
crime 41–45

Darwin, Charles 197, 391, 455
Deutsches Museum (Munich) 138, 289–90, 291, 294–96, 299
deviant ingenuity 41–45
Dewey, Melvil 334, 526
Dress for Success 254, 262, 269
Dreyfuss, Henry 28, 156, 190, 311–12, 313, 314
Dzus, William 204, 205

Eastland 16–18
Edison, Thomas 134, 140, 159, 206, 259, 270, 515
Einstein, Albert xxv–xxvi, 206, 537–38, 543–45, 567, 571
Engels, Friedrich xvi, 201, 204
Esnault-Pelterie, Robert 194, 410
extropy 123–24, 544

Faulkner, William 32, 494
Fermi, Enrico 128, 130
Fisher, Irving 522–26, 528, 531, 532, 536

Ford, Henry 194, 514, 556
France xvi, 164, 166, 193–95, 201,
 209–11, 215
Franklin, Benjamin 72, 274, 478

Gates, William (Bill) 34, 38, 556, 557.
 See also Microsoft
Gawker 403, 405–06
General Motors 158, 161
Goethals, George 166, 167, 169
Goffman, Erving 315, 402
Golden Gate Bridge 171–74, 304
Google 156, 158, 391, 404, 425
graphic user interface 157, 320

Harvard 175–84, 247, 251, 255, 315,
 323, 325, 326, 334, 354, 378.
 See also shoes
hats. See clothing
health care 82–85, 87
Hindenburg 3–8, 22
Hitler, Adolf 9, 414, 467, 550
Hollywood 16, 154–55, 157, 237, 242,
 308, 396, 482
Huxley, Thomas Henry 197, 478

IBM 28, 158, 161, 190, 335, 351, 419,
 425, 444, 516
IMAX xviii, 303–05, 308
information: explosion of 377–88; history
 of 341–49; and index cards 324–31,
 323; and paper 319–21, 322–23, 328–
 29, 351–61; storage of xix, 320–22,
 323; theory 187. See also libraries;
 note-taking
Isotype. See Neurath, Otto

Jager, Peter de 27, 32, 38
Japan xiii, 75–76, 87, 100, 104, 229, 230,
 233–34, 237–38, 246, 277, 356, 495
Jefferson, Thomas 164, 194, 247, 250,
 274, 398
Jobs, Steve 30, 111, 157, 271, 307, 369,
 549

Kappelman, Leon 27, 29–30
Kelly, Kevin xiii, xiv, 121–26, 370
Kelly, Mervin 186–87, 188, 189, 191
Kennedy, John F. 163, 253, 260, 261, 275
Kraybill, Donald 117, 119
Kuhn, Thomas 3, 289
Kurzweil, Ray 121, 122

Lesseps, Ferdinand de 164, 169
libraries: catalogs in xix, 323–27, 324,
 377–78, 525–26; student use of 62–63,
 333, 374. See also information
Library Bureau 334, 335, 526
lifeboats xii, 11–12, 15, 17, 18, 73, 91,
 130
Linsky, Jack 204–05
Lipartito, Kenneth 188
Lovelock, James 121
luggage xiv, 113–14

magazines. See newsprint
Maitland, F. W. 101, 262
Mann, Steve 276
Marshall, Alfred 198
Maxon Motor Co. 206–07
McCall, Bruce 6, 7
McCormick, Bryce 51
McCormick, Cyrus 143
McDonald, E. F. Jr. 114–15
McGinnis, Enoch W. 21, 23
McKay, Gordon 178–79, 180, 183
McMahon, Thomas 176, 183
McNeill, William H. xvii, 9, 13, 57, 77.
 See also conservation of catastrophe
metric system xvi, 209–11
Microsoft xv, 34, 158, 335, 545–47.
 See also Gates, William
millennium bug. See y2k
Mitcham, Carl 124
Monty Python 245
moral hazard 73
More, Max 124
Morris, Jan 135
Moynihan, Daniel P. 34, 254
Mukerji, Chandra 162

Nader, Ralph 73, 161
NASA 22, 50, 161, 214. See also Apollo
 program
National Museum of American History
 (Washington DC) 281, 291, 296–301,
 341–42
Neurath, Otto xviii, 313–14, 415
newsprint 166–67, 352–53, 356, 364,
 366, 372–73, 384–85, 395–96, 398,
 401
New York Times, The 151, 152, 338, 370,
 374, 403, 405, 407–08
Nokia 109–10, 112
North, Gary 38

note-taking 322, 328, 338. See also information
Nye, David 121

OceanGate. See Rush, Stockton
Odlyzko, Andrew 190

Paisley 199
Panama Canal xv, 163–69
Pan American 153–54
paper: and alphabetization 323–24, 330; and computers xix–xx, 319–20, 351, 354, 356, 361, 371, 526; consumption of 352–54; and money 363–64, 365, 367; and record-keeping 320–23, 360. See also information
Pentagon, the 31, 33, 36, 59
Perelman, S. J. 144
Perrow, Charles 48
Petroski, Henry 15, 62
Philippi, Otto Ernst 200
Picturephone 188–89
Pierce, John 186, 188
Pirsig, Robert 98
plagiarism 389–91
polling 217–21
Pombal, Marquis de 72
Prietula, Michael J. 160
publishing. See book publishing
Puffert, Douglas J. 124
Pusey, Nathan M. 175

Quick, Jonathan D. 92

Rather, Dan 63
Reagan, Ronald 55, 330, 381
Reed, Walter 166
Regev, Ronny 155
retro technology 55, 305–07, 309
revenge effect. See unintended consequences
Rickover, Hyman 49, 51
risk: animals and 438; culture of 71; Hindenburg and 5; management of 72, 73; tolerance for 65, 72
Robida, Albert xxv, 385, 501–10
Roebling, John A. 171–74
Roosevelt, Theodore 19, 163, 165, 494
Rush, Stockton 20–24. See also Titan
Rybczynski, Witold 243, 247

Sale, Kirkpatrick xiii

Scarry, Elaine 245
Schatz, Thomas 154
Schoen, William 31
Schrader, August 202–03
Schwinn 132, 142, 411
Science Museum (London) 138, 291, 292–94
Scott, Phil 29–30
search engines 114, 390
Sears Roebuck xiv, 134, 138, 512–13, 516
September 11 attacks xii–xiii, 41, 45, 47, 59–61, 215
serendipity 191
Shannon, Claude 186, 187–88
Shockley, William 186–87
shoes: 275, 412, 517; and Harvard xv, 175–84; manufacture of 177–80, 557; quality of 97–98
Simon, Herbert A. 160
Smith, Adam xviii, 104
smoking. See cigarettes
Snook, Scott 83
Snow, Phoebe 20
Stalin, Joseph 214, 291
Stem, Dante 102
Stevens, John 166
Stevens, Ted 34
Stoll, Steven 119
Strauss, Joseph 172
suit, the. See clothing
Sullenberger, Chesley ('Sully') 81, 150
Sununu, John H. 213
Sutter, Joe 153
Syon, Guillaume de 5, 6, 7

tabs xix, 333–35. See also libraries, catalogs in
technium, the 122–26
technophilia 58, 127–28, 140, 290–301
Terkel, Studs 144
Thayer, Sylvanus 164, 193
Thomas Theorem 25, 26, 29, 36
Thorndike, Joseph J. 115
thread xvi, 198–202
Titan 19, 23. See also Rush, Stockton
Titanic 3, 5, 6, 9, 11–12, 13, 15, 16, 17, 19, 20, 23, 29, 91
tobacco. See cigarettes
Toyota 190, 487
transistor xix, 185, 187, 345, 539–40
Trump, Donald J. 91, 217, 218–19, 220
Tuchman, Barbara 98

unintended consequences iv, xi, 28, 79–87, 247, 267, 284, 415, 573
United Shoe Machinery Corporation xv, xvi, 179, 180–81
UNIX 32, 161, 190

vacuum tubes 156, 307-08, 345
Vaidhyanathan, Siva 114, 115
valves 202–04
van Zanten, Jacob 92–93
Vasters, Reinhold 42
Veblen, Thorstein 104, 105, 214, 257
Vernadskii, Vladimir 122
Vieille, Paul 194

Wallace, Anthony F. C. 22, 23
Wallace, John 166
Weber, William 103
Weinberger, Caspar W. 32
Welch, Jack 159
Western Electric Company 16, 28, 133, 156, 186, 188, 190
Wilson, Woodrow 165
Winner, Langdon 121
Winslow, Sidney 179
Wolfe, Tom xi, 254
Wozniak, Steve 369
Wright, Frank Lloyd xvii
Wyzanski, Charles E. Jr. 181–82

Xerox 157, 205, 337, 338–39, 357, 516

Yardeni, Edward 27
Yeager, Chuck xi
Year 2000 Problem. See y2k
y2k 25–39, 47, 367
Yourdon, Edward 26, 27